CRAFTING GENDER

EDITED BY ELI BARTRA

Crafting Gender

Women and Folk Art in Latin America and the Caribbean

DUKE UNIVERSITY PRESS Durham and London 2003

© 2003 Duke University Press

All rights reserved

Printed in the United States of

America on acid-free paper ∞

Designed by C. H. Westmoreland

Typeset in Adobe Garamond with

Pabst display by Tseng Information

Systems, Inc.

Library of Congress Cataloging-in-

Publication Data appear on the

last printed page of this book.

Contents

Illustrations

Acknowledgments

I would like to thank the Council for International Exchange of Scholars (CIES), for having granted me the Fulbright–García Robles research scholarship, which made it possible for me to put together this book. Thanks also to Ryan Long, Rob Sikorski, and Jean O'Barr, without whose support I would not have been able to spend a year at Duke University, where I completed most of the research necessary for compiling the anthology and where I wrote this introduction and my essay. I would also like to acknowledge the sincere generosity and friendship of Natalie Hartman, at the Center for Latin American and Caribbean Studies at Duke, whose support facilitated my work. I thank Cindy Bunn and Robert Healy, also at Duke, for their invaluable assistance.

Finally, of course, and as always, I thank John Mraz for his immeasurable and indispensable collaboration at every stage of this project.

Introduction

Does folk art exist? Or is it an anachronism, no longer meaningful and perhaps even reactionary? It is, without a doubt, a problematic concept. Still, folk art remains a sufficiently clear referent that enables me to communicate, from the outset, what I would like to discuss. Further, a better term does not exist at the moment to define this specific group of artistically designed objects. I avoid the perhaps simpler term, *art,* in order to emphasize that I am interested in discussing creative production that differs from "great" or "high" art. Removing the modifier does not magically grant folk art higher value or improve its subaltern, marginalized status.

My insistence on the term *folk art* is part of a larger effort to vindicate a particular form of artistic expression, to identify its difference. Its social origins, means of production, distribution, and consumption, and its functions veer from what we typically imagine art to be. Folk art persists without an accurate name. Perhaps this is due to the fact that those frequently portrayed as unknown, faceless artists create it.

I do not believe that one would be better served by turning to one of the 1001 names that have been thrown about for at least the past hundred years as if they were indistinct, interchangeable synonyms of folk art: *craft, handicraft, primitive art, touristic art, fourth world art, curiosities, outsider art, decorative art, ornamental art, savage art, the art of savages, applied arts, popular arts, ethnic art, native art, exotic art, tribal art, traditional rural crafts, cottage industry production,* or *village art.* Not everyone considers these terms synonymous, but distinguishing them often creates additional problems. For example, one scholar explains that "folk art is the derivative art from a high art form in the same culture, whereas what we call primitive art is the most

highly developed art form of the cultures in question" (Blocker 1994, 30). The problem arises on considering not the art but the society that produces it as primitive; and on considering folk art as nothing more than the derivative of an allegedly superior art form.[1]

Women and folk art share a common fate in Latin America and the Caribbean: though ubiquitous, both are almost as invisible as they are disrespected by those who study this region. In spite of the extraordinarily abundant and multifarious forms of expression that exist, a gender-based analysis of Latin American and Caribbean folk art is a task whose foundations have yet to be established. The present anthology aims to begin performing this task.

Folk art includes the visual and plastic arts and refers to the cultural production of the world's poorest inhabitants. The poorest among the poor are most often women, and, not surprisingly, women are the most common practitioners of this art. Folk art, in general, relies on the use of traditional techniques and simple tools, and it is always handmade. Rarely is folk art utilitarian. In that sense, it differs from handicrafts, which also comprise handmade objects but are produced to satisfy practical needs, exhibit less artistic quality, and tend to be extremely repetitive, both in terms of the products themselves and of the production process. When wrestling with the question of how to evaluate artistic quality, one cannot avoid returning to the aesthetic values of so-called Western cultures, the same cultures that invented the labels for folk art that I mentioned above.

Marion Oettinger divides folk art into three classifications: utilitarian, ceremonial, and recreational. The folk art I find most interesting has no function other than an artistic one; it is mainly "recreational." Oettinger concludes that Mexican pottery is predominantly utilitarian: "Pottery is perhaps the most common folk expression in Mexico, whether it be strictly utilitarian, figural, or both. It comes in every shape, color, and size. . . . No matter what other use [ceramic pieces] may have, they are primarily containers" (1986, 34). A telling exception to this rule can be found in Mata Ortiz, a pottery-making community that is the focus of my article in this anthology. Mata Ortiz pottery is strictly decorative and not at all utilitarian. Reversing Oettinger's conception of pottery's primarily functional nature, the Mata Ortiz ceramic pieces only serve a utilitarian purpose if their artistic qualities have somehow fallen short. For example, a badly thrown pot may end up as a container for paintbrushes. Another testament to the principally ornamental nature of the Mata Ortiz pottery is that it is not designed to hold liquids. Even though ceramic pots were originally produced, ages ago, to contain any liquid or solid used in cooking, purely decorative pieces are increasingly common.

How does one begin to define folk art in Latin America and the Caribbean? Is there an authentic folk art? Which would it be? The question of authenticity is not resolved by proposals such as Oettinger's, which argues that Latin American folk art must be created *by* and *for* Latin Americans (1992, xiii, 3). It has been a commonplace to think that folk art was created by the people for the people, but a significant portion of the folk art created in Latin America is consumed outside of its community of origin and, even more often, in another country altogether. For me, *authentic* does not mean *pure,* and this concept may not prove useful to understand folk art at all. James Clifford proposes that "we need exhibitions that question the boundaries of art and of the art world, an influx of truly indigestible 'outside' artifacts [and] shows that feature the impure, 'inauthentic' productions of past and present tribal life . . . [representing] affinities of the tribal and the postmodern" (1988, 213). Although he makes an important effort to break with traditional conceptions about art, he nonetheless continues to perceive the world from a Eurocentric, although postmodern, perspective.

For too long, folk art has been considered a minor art form, inferior to "great art." The fine arts, or so the story goes, represent the pinnacle of artistic creation in Latin America and the Caribbean. Only the poor make folk art, and thus it seems less deserving of serious consideration. Folk art, a derivative and deviant expression of the common people (Weekley 1988, 10–11), has been consistently ignored by scholars of aesthetics and art history, especially when compared to the attention that the "high" art created by white men from the developed world has received. Scholars of "high" art have studied individuals and artistic movements ad nauseam; they have constructed an Art History and innumerous theories to explain it. However, no such history of folk art has been developed, nor have studies been made of the different styles, and even less attention has been paid to the aesthetic theories of this art. In the so-called Western nations, a feminist art theory is in the process of construction; we cannot say the same about the existence of a feminist theory of folk art. Gene Blocker, who uses the term *primitive art,* emphasizes the extent to which folk art has been overlooked, stating that "primitive art has not been investigated as art, at all" (1994, 2). Folk art, or "exotic art," as anthropologist Raymond Firth (1992) chooses to call it, has been studied almost exclusively by specialists on the anthropology of art or aesthetics — who number only a handful and who tend to be women. James Clifford asserts that "non-Western objects have generally been classified as either primitive art *or* ethnographic specimens" (1988, 198). I would like to know where the West begins and ends. Are Mexican ceramics from Puebla considered

"non-Western objects"? Is all folk art made in Latin America automatically non-Western?

Ruth Barnes's impressive research stands out as a model of what we need vis-á-vis folk art. Two aspects of Barnes's work, which focuses on Indonesian textile art, exemplify her rich perspective: she evaluates textiles as artistic creations that emerge from a specific sociocultural context, and she focuses on the women who make the textiles—identifying the connections between their lives and the entire process of their artistic production (Coote and Shelton 1992).

Studying folk art from a gendered perspective—which enables one to see the often overlooked artistic creation of women—continues to be a challenging task, especially in the Latin American context. A gendered perspective is absolutely fundamental for reasons often ignored because of their obvious importance. First, a focused study on the processes of women's artistic creation today and in the past helps us develop our general understanding of women as a social group and can aid us in appreciating how their roles in the production of art compare and contrast to those of men. In turn, this understanding helps establish a more integral identity for women and leads to improved conditions of existence by recuperating a history often ignored and recognizing women's roles in producing culture. Finally, a focus on gender promotes a broader understanding of the production, distribution, consumption, and iconography of folk art in general, whether it is created by women or men. Knowing if a piece was produced by a woman is just as important as recognizing that it was created by a specific cultural group, such as the Huicholes, Purépechas, Mayas, Chamulas, or a mestizo community. It is no longer acceptable to assume that folk art constitutes the artistic creation of "the people," a general, abstract, and gender-neutral term. The articles published in this anthology, which focus on issues of gender and cultural production, aim to address the weaknesses of earlier studies of folk art in order to enrich the knowledge we have about women's artistic production and about artistic production in general. As Evelyne Hatcher observes: "Esthetic systems are not isolated constructs. They arise from and are expressions of the way life is conceived and what enhances the quality of life. Therefore, the more one can learn of the lives of the makers and users, the more one can see in what ways the art forms are or were meaningful in their original contexts, and the deeper our esthetic perception" (1999, 205).

Our focus on women's artistic production also works against a twofold process of marginalization: folk art clearly remains on the periphery of intellectual consideration, but women's folk art is practically invisible. This margin-

alization demands a feminist investigation of women's folk art, a study whose methodology is grounded in a political philosophy that strives to transform the subaltern position in which so many women find themselves. Such a study foregrounds the gender of those who produce folk art and investigates particular pieces' iconography in order to delineate and interpret representations of the feminine and the masculine. The existing contributions to and foundations of a feminist perspective on Latin American social reality and folk art must be acknowledged. For example, Betty LaDuke's *Compañeras: Women, Art, and Social Change in Latin America* (1985) constitutes an important, pioneering text. While LaDuke's study indeed focuses on the artistic production of Latin American and Caribbean women, it does not distinguish between handicraft, folk art, and elite visual arts.

There is, of course, another genre altogether: the coffee-table book. In recent years, a number of impressive, full-color, and costly volumes designed as living-room furniture have emerged—luxurious celebrations of art that comes from the world's poorest regions. These books tend to feature excellent photography, but they lack serious commentary on the artists and the meaning of what they produce, a problem endemic to most books on Latin American folk art. It is not surprising that a significant number of these books are catalogs from expositions.

Not every catalog ignores the artists. For example, *Ocumicho: Arrebato del encuentro* (1993) features women artists, giving them faces, bodies, and names. The *Ocumicho* exposition was organized as an interesting "experiment" by Mercedes Iturbe, a well-known promoter of Mexican cultural production. Iturbe visited the small town of Ocumicho, Michoacán, famous for its ceramics, and distributed reproductions of paintings to women potters. The images included the work of twentieth-century Mexican artists like José Clemente Orozco, seventeenth-century European engravings, eighteenth-century oil paintings and prints, and codices depicting the conquest of Mexico. Iturbe suggested that the potters of Ocumicho recreate these images in clay. The resulting book is elegantly made, contains superb photographs, and contributes significantly to the goal of making women artists and their work more visible.[2] Still, the book's text pales in comparison to the images, presenting only a superficial analysis of the creative process and the pieces portrayed.

Most scholarly work on Latin American folk art that approaches the topic from a gendered perspective has emerged from Europe and the United States. Less frequently have European and U.S. scholars considered the folk art of their own nations from that perspective. This imbalance may arise from the

fact that this Latin American art has often been considered "primitive," "native," or "savage," labels which intellectuals from developed countries would scarcely use to refer to people of their own nations, excepting "Native Americans" or other nonwhite people. But their art would be considered an "outsider art" anyway. In order to study the folk art of white women from developed countries, one must broaden the category of artistic production to include tasks traditionally considered nothing more than "women's work" or domestic labor. For example, an excellent history of embroidery in Great Britain stands out because it expands the definition of what constitutes art. A knowledge of embroidery's history constitutes a knowledge of women's history, the book's author, Rozsika Parker, tells us (1996). *Women and Craft* (1987), edited by Gillian Elinor et al., proves another exemplary volume. It analyzes various forms of domestic labor, including embroidery, weaving, crocheting, knitting, and quilting. These tasks represent folk art par excellence in developed countries, and have, for the most part, remained hidden in the scholar's closet, next to the broom and the feather duster.

When a pluriethnic country attempts to consolidate its cultural identity, aspects of each ethnic group, especially folk art if it exists, are often integrated into a purportedly unified national imaginary. After the Mexican Revolution of 1910, this phenomenon produced the glorification of folk art, promoting it as a fundamental element of the modern nation-state. Applauding the art of the people was seen as a necessary step toward unifying a radically diverse country. These efforts are represented by *Las artes populares en México,* Dr. Atl's classic text, published immediately following the revolutionary decade in 1922, and by the work of Daniel Rubín de la Borbolla, which appeared a few decades later, in 1963.

The case of Australia offers a more recent example of how folk art is edified as a nation's unifying force. Many institutions collaborated to establish a strong cultural identity in light of the one-hundred-year anniversary of the nation's birth. *Everyday Art: Australian Folk Art* (1998) resulted from this search. It is a brief but very well-done text that considers, surprisingly, the gender of Australian folk artists. Another recent text that deserves mention is the volume edited by Paola Gianturco and Toby Tuttle, *In Her Hands: Craftswomen Changing the World* (2000). Gianturco and Tuttle's well-produced book, complete with full-color illustrations, stands apart from most of the other books on folk art similar in appearance. It focuses more on the artists than the art they create. *In Her Hands* provides less of a dense, academic investigation than a broadly appealing ethnographic-aesthetic exposition. Based on a series of interviews, the volume identifies each artist's ethnic

origin, gender, and artistic medium. Perhaps most interesting is the fact that the women in this book are photographed laughing and smiling, actively working and creating. Such portrayals stand in contrast to the typical images of people living in impoverished regions, which depict the static, artificial poses of a serious, sad, and defeated community. The photographs in Gianturco and Tuttle's book also avoid picturesque representations of their subjects, and many of the women have their backs to the camera. For the editors of *In Her Hands,* it was clear that "these invisible women with their world-altering dreams deserved the spotlight" (10).

In Her Hands stands as an exception that proves the rule. All too often, books on folk art provide pages and pages of analysis that do not mention artists at all. Worse are the cases where the focus on artists leaves women in the margins, with no apparent justification other than crass chauvinism, which has proven a pervasive tendency. Even Carlos Monsiváis, a Mexican intellectual renowned for his solidarity with feminist struggles, committed this error in an essay that appeared in the book, *Arte popular mexicano: Cinco siglos* (1996). Monsiváis's piece mentioned sixteen artists; only two were women. *Oficios de México* (1993), another book devoted to folk art, depicts a male artist on the cover and contains ninety photographs. Nineteen of them portray female artists. A stark example of how women artists are frequently condemned to exist without faces or names appears in Kathleen Trenchard's 1998 study of Mexican paper cutting. All the book's portraits are of men. The only hands photographed for the book belong to women.

Better studies include excellent analyses of how the socioeconomic conditions of female folk artists shape their working conditions and artistic production. Patricia Moctezuma's investigation of the glazed pottery of Patamban, in the Purépecha region of Michoacán, stands out in this regard (Mummert and Ramírez Carrillo 1998, 73–101). Still, problems persist. Moctezuma's and similar studies typically describe folk art in the same way they might describe home-baked cookies or handmade shoes:[3] as just another form of artisanship, ignoring its artistic value. Of course, Moctezuma's work indeed proves groundbreaking in its combined emphasis on questions of gender and working conditions. What must be done now in order to understand folk art more completely is to combine the following, essential concerns: social class, race and ethnicity, gender, and art, art thereby interpreted as a process and not a collection of lifeless objects.

I consider studies of women folk artists (whether from indigenous communities or not) emphasizing the entire creative process and analyzing iconography from a feminist perspective to offer the most outstanding scholarship

on Latin American folk art. Such studies are extremely rare.[4] Lois Wasserspring, who recently published a book on six of the most famous women potters of Oaxaca, contains all the necessary elements for a potentially exceptional study. Based on interviews, *Oaxacan Ceramics: Traditional Folk Art by Oaxacan Women* (2000) outlines the entire creative process, describes the women's lives in detail, and analyzes specific works and their imagery as the products of a particular social context. It is beautifully illustrated and features color photographs by Vicki Ragan. However, it lacks scholarly rigor and a critical framework. It also presents a frankly picturesque outlook, which reinforces a romanticized, paternalistic conception of the artists, their work, Oaxacan culture, and Mexico as a whole.

In Spanish, references to artisans are generally made using the masculine form, *los artesanos*. I often ask myself whether mentioning artisans in the masculine is a way of legitimizing it. Does the use of the feminine automatically devalue what it describes? Women, for example, often speak about themselves with masculine language for fear of otherwise irrevocably devaluing their status. Linguistic bias emerges in studies of folk art such as Cecile Gouy-Gilbert's investigation of the artistic production in Ocumicho and Patamban (1987). Almost 100 percent of the artists in these communities are women, and still Gouy-Gilbert only describes *artesanos* (using the Spanish masculine plural noun ending), and when she does focus on particular people, she only provides accounts of the scarce male artists who reside in those villages. To the author's credit, her study does investigate the artists' socioeconomic conditions and describes the iconography of their work. Unfortunately, it lacks analysis from a specifically aesthetic viewpoint.

The absence of aesthetic analysis constitutes a common problem. Additional cases in point include the work of Les Field about gender relations and artisans in Nicaragua (1999) and Lynn Stephen's analysis of Oaxacan Zapotec women (1991). Field's research is extraordinary for its focus on Nicaragua, where folk art traditions are not as developed as in other countries, and for its focus on women artists. Like Field's work, Stephen's is an ethnographic study that combines interests in folk art, social class, ethnicity, gender, and feminism. Her study of Zapotec artists adopts a strongly anthropological approach, but her treatment of artistic creation portrays it fundamentally as labor. Stephen researches relations of production, division of labor, and commercialization, but any discussion of artistic value remains hidden behind her emphasis on the art's socioeconomic context.

At the other extreme we find texts, generally exposition catalogs, that provide minutely detailed aesthetic examinations of particular pieces, tech-

niques, and styles, mentioning as well the pieces' place of origin, but that neglect artists entirely (Lechuga et al. 1997; Martínez Massa 1992). If such catalogs identified the artists, they would prove useful to an analysis of creative production from a gendered perspective, thereby expanding our understanding of women's—and by extension men's—folk art. Due to the absence of names in these catalogs, folk art's process of production appears as completely abstract, neutral: "the people" weave, paint, and embroider. And any time the artists do appear, they are masculine *artesanos* (Tarazona and Tommasi de Magrelli 1987).

Semiological investigations of folk art tend to be more conscious of gender concerns. Verónica Cereceda's study of the aesthetic aspects of Aymaran textile production in Isluga, Chile (1987), focuses on female artists. Peter Gow's work (1999), which pays special attention to the Piro women of the Amazonian region in Peru, also focuses on the iconography, symbolism, and technical aspects of these artists' designs. Although both Gow and Cereceda develop a gendered perspective for framing their analyses of folk art, their research could ask more about the general social, economic, and working conditions of the artists. Of specific value would be a more thorough discussion of their art's processes of production, distribution, and consumption.

The investigations of Janet Catherine Berlo (1991) and Cathy Winkler (1993) are exemplary for their rare ability to combine several analytical approaches. They consider history, anthropology, art history, and the ethnography of art, also taking into account the artists' gender, social class, and ethnicity. Berlo's work on Latin American textiles attests to the author's remarkable knowledge of and concern for aesthetics and sociohistorical factors. Winkler's meticulous study of the artists of Olinalá is primarily anthropological, but it does not ignore entirely the question of artistic value.

When considering the overall scarcity of scholarly work on folk art that foregrounds gender, it is important to note that, in general, folklore has lent itself to feminist analysis more often than folk art has. In developed countries, folklore has received more attention than folk art, probably because it has traditionally been considered more fundamental to cultural identity. I would argue that folk art is extremely richly developed in many cultures of Asia, Africa, and Latin America but, in general, it does not enjoy such an elaborate tradition in the United States, Canada, Europe, or even Australia (in spite of the recent renaissance of aboriginal art mentioned above). Folk art exists in almost every culture of the world, but it is more developed in some places than in others.

Focusing on folklore in their own countries, feminist scholars from devel-

oped regions find folk art in the developing world. Significantly, it is much less common for Latin American and Caribbean scholars to look at the folk art of their own regions. When they do, art, as I mentioned earlier, appears as labor and not as a primarily aesthetic, creative process. For example, Loreto Rebolledo's work on pottery and textiles in Chile (n.d.) describes the commercialization of and social relations that shape artisanal industries; but she says nothing about art. In short, it is necessary to develop a structured theoretical framework for analyzing folk art from a gendered perspective, especially in Latin America, where existing contributions to such a framework remain particularly scarce.

Although developing a gendered perspective is essential, it is also necessary to examine closely the entire process of producing folk art. It is certainly true that not all artistic production clamors for a gender-based analysis. As opposed to bold displays of conceptions of the masculine and the feminine, pieces often raise such concerns in a barely audible whisper, warning scholars against jumping immediately from description and analysis to establishing broad-based theories about gender in Latin American folk art.

The need to combine different scholarly tendencies in order to understand folk art more completely is reinforced by a glance at how others have addressed this issue. For example, Marion Oettinger (1992, 2) contends that there are two clearly differentiated schools of thought: on one hand, studying folk art as art; on the other, emphasizing socioeconomic context and ignoring the question of aesthetics. Blocker argues that scholars must unite these divergent tendencies: "You can approach primitive art from an aesthetic point of view but subjectively, or you can approach primitive art from a more objective basis, but not aesthetically. What has not occurred in the case of primitive art, as has occurred with practically every other art form is an approach which is both aesthetic and objective" (1994, 2–3). I believe that the present anthology begins to achieve this goal. All of its contributors combine Oettinger's schools of thought: they analyze folk art as artistic creation emerging from a complex web of social relations that in turn help shape and are determined by relations of production, distribution, and consumption.

This collection includes ten studies of the visual folk arts in seven different Latin American and Caribbean countries. I should clarify that the anthology does not attempt to be representative of the entire region. There are four pieces about Mexico, for example, and mostly for rather arbitrary reasons. I am Mexican, and I live in Mexico. Perhaps it would have been good to cover each country. However, adhering to this criterion would make different indigenous groups invisible by privileging the nation-state form. This

concern also illustrates why it is deceptive to say that there are four essays about Mexico. Each focuses on different ethnic groups and different regions of that heterogeneous country. Of course, I must acknowledge that the anthology still exhibits serious absences, the most important of which is Brazil. I simply could not find anyone who works on Brazilian folk art and gender. Many other absences are merely due to limitations of space. In a book of this scale, it is impossible to provide exhaustive coverage of the entire region of Latin America and the Caribbean.

The texts included have been chosen for their effectiveness in providing and developing interesting comparative perspectives. For example, readers can better understand the similarities and differences between the indigenous pottery-making communities of the Amazon and the mestiza potters of Mexico and Colombia (Whitten, LaDuke, Bartra, Duncan). Though the creative and technical processes of pottery making are remarkably similar in all of these groups, the function of ceramics and the meaning of its design and iconography vary widely from place to place.

Another aspect of the anthology important to mention is that five of the articles have been written by Anglos, while Latin American and Caribbean scholars wrote the other five. Thus, aside from considering how the creative process is shaped by geographical, linguistic, ethnic, social, political, and economic factors, this anthology presents another complexity by including perspectives from inside and outside of the Latin American and Caribbean region. Aside from this difference, all of the pieces included here share the trait of analyzing communities that are not the authors' own. But even this commonality manifests itself along a broad range. Sally Price's article on the Maroon women of Suriname speaks of a culture that she perhaps knows better than her own, even though she remains an outsider. The same complex relationship describes the positions of Dorothea Scott Whitten, Ronald J. Duncan, and Mari Lyn Salvador, all of whom have spent decades researching the communities they discuss here. Betty LaDuke, an artist-academic, has spent a great deal of time immersing herself in artists' communities in Latin America and Africa, and she focuses consistently and insightfully on questions of gender. To varying degrees, the articles by Dolores Juliano, María J. Rodríguez-Shadow, Norma Valle, Lourdes Rejón Patrón, and myself represent studies of communities with strong cultural connections to the scholars in question. Simply put, this collection approaches different cultural traditions from a variety of cultural perspectives, granting credence to Blocker's observation that "the study of primitive art is necessarily and unavoidably cross-cultural in nature, judging their art in our terms" (1994, 21). All of the

anthology's essays acknowledge the combination of change and continuity inherent to folk art. Though in many aspects traditional, folk art is a very dynamic form, and the collection's authors recognize its responsiveness to change.

Women create art in Latin America and the Caribbean, and, as far as anyone can tell, they always have. This anthology strives to develop a clear, systematic framework for better understanding exactly what and how women folk artists create. For too long, their artistic production has remained hidden, either confused with domestic labor or concealed behind an abstract notion of the pueblo that is almost always assumed to consist solely of men.

Half of the pieces assembled here focus on indigenous communities (Price, Whitten, Salvador, Juliano, Rejón Patrón), while the other half focuses on groups of women artists who do not identify themselves as indigenous and who do not speak indigenous languages (LaDuke, Duncan, Bartra, Valle, Rodríguez-Shadow). Women of this latter group form part of mestiza society, or at least that is how it appears.

Each essay in the anthology—with the exception of the article by Rodríguez-Shadow, whose subjects remain anonymous—focuses on women artists. Every piece also elaborates on the creative process of producing art, and on its distribution and consumption. Most important, each essay considers folk art as *art;* every contributor made a concerted effort to address this fundamental point.

This anthology is one of the first of its kind. It is our hope that many more will follow, helping to illuminate what for too long has remained as invisible as if it resided on the dark side of the moon: the creative wealth of poor women from the multiethnic and pluricultural communities of Latin America and the Caribbean.[5]

Notes

This introduction was translated by Ryan Long.

1 For an interesting discussion about primitive art, see Price (1989).
2 This is also true of film and video. See, for example, Julia Kellman and Phil Miller's video, *The Moon Woman's Sister* (Conejo Productions, USA, 1993), which focuses on the Mayan weavers of the Guatemalan high plains.
3 For a similar tendency in the scholarly work on other parts of the world, see Michel (1999).
4 Of particular interest are the studies published by the Centro de Estudios para

el Desarrollo de la Mujer (CEDEM) in Santiago de Chile, within the Colección Artes y Oficios. See, for example, Loreto Rebolledo, *Artesanas de Rari: Tramas en crin* (Santiago de Chile: CEDEM, 1990), number 2 in the series; Ximena Valdés, *Loceras de Pilén* (Santiago de Chile: CEDEM, 1991); and Angélica Willson, *Textilería mapuche: Arte de mujeres* (Santiago de Chile: CEDEM, 1992), number 3 in the series.

5 I prefer advancing the term *pluricultural* to adhering to the term *multicultural* because of the latter's associations with a dominant sexist and racist ideology that persists most strongly in the United States. See Sartori (2001) for an interesting study of pluriculturalism.

Reference List

Agosin, Marjorie. *Scraps of Life: Chilean Arpilleras: Chilean Women and the Pinochet Dictatorship.* Trans. Cola Franzen. Trenton, N.J.: The Red Sea Press, 1987.

Atl, Dr. *Las artes populares en México.* 2 vols. Mexico City: Secretaría de Industria y Comercio-Ed. Cultura, 1922.

Barnes, Ruth. *Dress and Gender: Making and Meaning in Cultural Contexts.* New York: Berg, 1992.

Berlo, Janet Catherine. "Beyond *Bricolage:* Women and Aesthetic Strategies in Latin American Textiles." In *Textile Traditions of Mesoamerica and the Andes: An Anthology,* ed. Margot Schevill Blum, Berlo, and Edward B. Dwyer, 437–79. New York: Garland, 1991.

Blocker, H. Gene. *The Aesthetics of Primitive Art.* Lanham, Md.: University Press of America, 1994.

Cereceda, Verónica. "Aproximacions a una estética andina: De la belleza al *tinku.*" In *Tres reflexiones sobre el pensamiento andino,* ed. Thérèse Bouysse-Casagne et al., 133–231. La Paz: Hisbol, 1987.

Clifford, James. *The Predicament of Culture: Twentieth-Century Ethnography, Literature, and Art.* Cambridge: Harvard University Press, 1988.

Coote, Jeremy, and Anthony Shelton, eds. *Anthropology, Art, and Aesthetics.* Oxford: Oxford University Press, 1992.

Elinor, Gillian, et al., eds. *Women and Craft.* London: Virago, 1987.

Everyday Art: Australian Folk Art. Canberra: National Gallery of Australia, 1998.

Field, Les W. *The Grimace of Macho Ratón: Artisans, Identity, and Nation in Late-Twentieth-Century Western Nicaragua.* Durham, N.C.: Duke University Press, 1999.

Firth, Raymond. "Art and Anthropology." In *Anthropology, Art, and Aesthetics,* ed. Jeremy Coote and Anthony Shelton, 15–39. Oxford: Oxford University Press, 1992.

Frank, Isabelle, ed. *The Theory of Decorative Art: An Anthology of European and*

American Writings, 1750–1940. Trans. David Britt. New Haven, Conn.: Yale University Press, 2000.

Gianturco, Paola, and Toby Tuttle. *In Her Hands: Craftswomen Changing the World.* New York: Monacelli, 2000.

Gouy-Gilbert, Cecile. *Ocumicho y Patamban, dos maneras de ser artesano.* Mexico City: Centre d'etudes Mexicaines et Centroamericaines, 1987.

Gow, Peter. "Piro Designs: Painting as Meaningful Action in an Amazonian Lived World." *Journal of the Royal Anthropological Institute* 5, no. 2 (1999): 229.

Hatcher, Evelyne Payne. *Art as Culture: An Introduction to the Anthropology of Art.* 2d ed. Westport, Conn.: Bergin and Garvey, 1999.

Hendry, Jean Clare. *Atzompa: A Pottery Producing Village of Southern Mexico in the Mid-1950's.* Nashville, Tenn.: Vanderbilt University Press, 1992.

Hutcherson, Gillian. *Gong-Wapitja: Women and Art from Yirrkala.* Canberra: Aboriginal Studies Press, 1998.

LaDuke, Betty. *Compañeras: Women, Art, and Social Change in Latin America.* San Francisco: City Lights Books, 1985.

Layton, Robert. *The Anthropology of Art.* 2d ed. Cambridge: Cambridge University Press, 1991.

Lechuga, Ruth, et al. *Lacas mexicanas.* Mexico City: Museo Franz Meyer/Artes de México, 1997.

Martínez Massa, Pedro. *Artesanía ibero-americana: Un solo mundo.* Barcelona: Quinto Centenario/Miniserio de Industria, 1992.

Michel, Maskiel. "Embroidering the Past: Phulkari Textiles and Gendered Work as 'Tradition' and 'Heritage' in Colonial and Contemporary Punjab." *Journal of Asian Studies* 58, no. 2 (1999).

Monsiváis, Carlos. "Las artes populares hacia una historia del canon." In *Arte popular mexicano: Cinco siglos,* ed. Olga Sáenz González. Mexico City: Antiguo Colegio de San Ildefonso, 1996.

Mummert, Gail, and Luis Alfonso Ramírez Carrillo, eds. *Rehaciendo las diferencias: Identidades de género en Michoacán y Yucatán.* Zamora: Colegio de Michoacán, 1998.

Ocumicho: Arrebato del encuentro. Mexico City: Museo de Arte Moderno/Museo de Arte Contemporáneo, 1993.

Oettinger, Marion, Jr. *Con Cariño, Mexican Folk Art: From the Collection of San Antonio Museum Association.* San Antonio: The Association, 1986.

———. *The Folk Art of Latin America: Visiones del Pueblo.* New York: Dutton Studio Books/Museum of American Folk Art, 1992.

Oficios de México. Mexico City: Nafinsa, 1993.

Parker, Rozsika. *The Subversive Stitch: Embroidery and the Making of the Feminine.* London: Women's Press, 1996.

Price, Sally. *Primitive Art in Civilized Places.* Chicago: University of Chicago Press, 1989.

Rebolledo, Loreto. *Fragmentos: Oficios y percepciones de las mujeres en el campo.* Santiago de Chile: CEDEM, n.d.

Rubín de la Borbolla, Daniel. "Arte popular mexicano." *Artes de México* 11, no. 43/44 (1963).

Sartori, Giovanni. *La sociedad multiétnica.* Madrid: Taurus, 2001.

Stephen, Lynn. *Zapotec Women.* Austin: University of Texas Press, 1991.

Tarazona Zermeño, Amanda, and Wanda Tommasi de Magrelli. *Atlas cultural de México.* Vol. 3, *Artesanías.* Mexico City: Grupo Editorial Planeta, 1987.

Tice, Karin E. *Kuna Crafts, Gender, and the Global Economy.* Austin: University of Texas Press, 1995.

Trenchard, Kathleen. *Mexican Paper Cutting: Simple Techniques for Creating Colorful Cut-Paper Projects.* Ashville, Ore.: Lark Books, 1998.

Wasserspring, Lois. *Oaxacan Ceramics: Traditional Folk Art by Oaxacan Women.* San Francisco: Chronicle, 1999.

Weekley, Carolyn J. "Introduction: Defining American Folk Art." In *American Folk Art Paintings.* New York: Little, Brown, 1988.

Winkler, Cathy. *Changing Power and Authority in Gender Roles: Women in Authority in a Mexican Artisan Community.* Bloomington: Indiana University Microfilms International, 1993.

Always Something New

Changing Fashions in a "Traditional Culture"

The hard part—for me as much as for other students of African diaspora arts—is to fully grasp the pace and persistence of innovations. Even after arguing in countless books and articles for the dynamism of art in the Suriname Maroon society where I've done my most long-term fieldwork, I was inclined to view the women's cross-stitch craze of the 1970s—introduced by European missionaries, learned in mission-run schools, and slavishly copied from diagrams in foreign women's magazines—as the end of the (authentically Maroon) road. A decline of artistic creativity. An irreversible sellout to the West.

So when, in 1997, I happened on Norma Amania putting the finishing touches on a brilliantly colored shoulder cape in a flowing pattern of reverse appliqué, something in the style of a Panamanian *mola* (fig. 1), I expressed surprise.[1] Never had I seen anything like it. Norma looked up from her sewing, furrowed her brow, and set me straight. "Hey," she said, "you're supposed to know us better than that! You can't expect to go away for a matter of years and come back to find us just doing the same old thing!"

Of course she was right: I shouldn't have been surprised that cross-stitch embroidery had passed from the height of fashion to a kind of second-best leftover during my several-year absence—nor that new crazes had taken its place. Nothing I had learned about Maroon art and attitudes toward change suggested that a given fashion, no matter how popular, would settle in for the long term. Maroon art tended to lean more in the direction of what Leroi

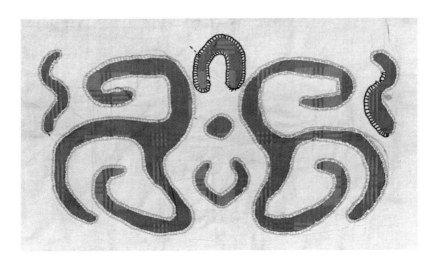

1. A reverse appliqué textile in progress. Cutouts in a white cloth expose an orange-and-green cloth underneath. The seamstress has begun decorating the edges of the design with yellow and black embroidery. *Photograph by Pierre Buirette.*

Jones (Amiri Baraka), writing in 1967 about black music in the United States, called "the changing same." The overall aesthetic of Norma's composition seemed comfortably in line with Maroon preferences that I was familiar with concerning color, form, and balance, but the cloth on her lap was a completely new one in the specifics of its materials, layout, and technique of execution. "We call it abena kamísa koósu," she told me. The sewing style known as *abena kamísa koósu* was first executed by a woman from the village of Abena [sitonu] who incorporated it in the cloth (*koósu*) she used to make a loincloth (*kamísa*) for her husband.

I'll attempt in this essay to follow up on Norma's wisdom, updating the picture of Maroon women and their arts as reported in my 1984 book, *Co-wives and Calabashes*.[2] It has, after all, been almost twenty years, and as Norma reminded me, a lot can happen, artwise, in that amount of time. As I write this article in 2001, even the reverse appliqué of the late 1990s has been upstaged by a new art, which I will discuss below. I start with a baseline sketch of the arts in question and their place within the society of their makers, descendants of Africans who escaped from slavery in the Dutch colony of Suriname (on the northeastern shoulder of South America), fought a century-long war of liberation, and have maintained relatively independent societies since the conclusion of peace treaties in the 1760s. The Maroon population

divides into six groups, of which the Saramaka—Norma's people—are one. Readers unfamiliar with the history and culture of the Suriname Maroons are referred to Sally and Richard Price, *Maroon Arts,* for general background, and to Richard and Sally Price, *Maroons under Assault,* for a picture of current threats to the group's culture and society.[3]

Maroon Women as Artists

Western visitors to the interior of Suriname, from eighteenth-century explorers and colonial officers to twentieth-century anthropologists and missionaries, have rarely failed to include descriptions of Maroon men's wood carving in their accounts, but women's artistic efforts are often passed over with barely a mention. And while the living room of nearly every tourist to Suriname boasts some piece of carved wood fashioned by a Maroon (most commonly a comb, a coffee table, or a folding stool), women's textiles and calabashes are not generally considered marketable items. In the context of the culture they're made for, however, women's arts play crucial aesthetic and social roles. During the 1960s and 1970s, Saramaka women and men helped me piece together the history of these less well-known arts, and later I was able to complement the information and insights they provided by working in museums, libraries, and archives elsewhere—principally in Suriname and the Netherlands, but also in France, Germany, and the United States. I must begin, then, by expressing gratitude to all the Saramakas, Norma included, who shared their artistic knowledge with me.

Saramaka daily life is strongly shaped by cultural ideas about men and women. Almost every social or religious role, every subsistence activity, every ritual involvement is more strongly associated with (in many cases assigned to) one rather than the other. It seems more "natural," from a Saramaka perspective, for men to be the ones to fell trees, make combs and canoes, drive outboard motors, live in their natal village, work on the coast, learn foreign languages, earn money, interrogate oracles, maintain historical knowledge, run council meetings, dig graves, and play drums. Similarly, it seems more "natural" for the gathering of firewood, the sewing of clothes, the planting and harvesting of rice, the cooking of meals, and the maintenance of dual residences (in natal and conjugal villages) to be the stuff of a woman's life. In the realm of artistic expression, Saramakas generally consider it more "natural" for men to produce geometric designs with well-executed symmetry and for women to produce free-form designs with imperfectly realized symme-

try; for men to work with manufactured tools and for women to execute their carvings with pieces of broken glass and their crochet work with recycled umbrella spokes.

In the literature on Maroon culture, the word *têmbe* has often been translated as "woodcarving," effectively limiting most discussions of art to the male domain. But *têmbe* also functions as an adjective, a compliment for any kind of artistic production or even a person's overall giftedness as an artist. The kinds of objects that are complimented by this term are most frequently intended for use in the ongoing courtships that figure so prominently in Saramaka life, both between spouses and between lovers. I therefore start my exploration of the dynamics of Saramaka creativity by sketching in the main lines of the gendered division of labor and cultural notions about the material interdependence of men and women. Although women assume primary responsibility for supplying and processing food from gardens (rice, tubers, bananas, peanuts, okra, etc.) and the forest (most importantly, the palm nuts used to make cooking oil), it is the men who do the hunting and fishing, purchase imported goods (including pots and pans, cloth and soap, sugar and salt, guns and machetes, radios and tape recorders) with their earnings from wage labor, and who fashion wooden objects such as houses, canoes, paddles, stools, combs, and cooking utensils. With marriage serving as the main institution through which these foods and goods pass from male to female hands, a woman without a husband is at a significant disadvantage in terms of material comfort. For various demographic reasons, including earlier first marriages for women and, since the 1870s, heavy out-migration by men, there have been, for about the past hundred years, many more women of marriageable age than men. Both because and in spite of the fact that most men have more than one wife, there is vigorous competition among women for the available pool of husbands. These (and a number of other) demographic and economic factors come together to produce a cultural environment in which women spend a great deal of energy trying to please men. In this setting, their artistic production plays an important role.

In terms of textile arts, the great bulk of patchwork and decorative sewing has, until very recently, appeared on the vibrantly designed shoulder capes that represent the most prominent item of men's formal dress; second in importance have been men's breechcloths. Even when women decorate their own skirts and capes, there has been (again, until very recently) a general understanding that it would be inappropriate to devote as much aesthetic attention to this kind of sewing as to that on a man's garment.[4] In the 1970s, for example, when narrow-strip patchwork capes were declining in popularity

but women still had large accumulations of strips (edge pieces trimmed from the cloths they had hemmed to make their own wrap skirts), they sometimes used the strips to make patchwork skirts for themselves. They were quick to explain, however, that they simply threw together, with an explicit avoidance of preplanning, whatever scraps they had on hand.

Similarly, while the handsomely carved calabash bowls that women produce belong to them and not to the men, the most important use of these bowls is at men's meals, a highly charged site for competition among each man's several wives. The calabash forms destined for men's meals (water-drinking and hand-washing bowls) are embellished with more elaborate and carefully executed designs than those destined for use by women (spoons, spatulas, ladles, and rice-rinsing bowls), where the carvings are sparse and simple. (Calabashes intended for use in rituals remain completely undecorated.)

Textile Arts

The earliest mentions of Suriname Maroon clothing and textiles are frustratingly sparse in their descriptive detail. Missionaries who lived for many years among the Saramaka during the second half of the eighteenth century, for example, wrote that their hosts had "no clothing except a small covering over the abdomen," and a drawing in one of their books supports this description.[5] John Gabriel Stedman described the clothing and accessories of two Maroons he encountered in eastern Suriname in the 1770s, but he neither mentioned nor illustrated any kind of patchwork or decorative sewing.[6] Although other early accounts go into some detail about costume, including both ritual accessories and coastal imports such as shirts and trousers,[7] they do not document Maroon patchwork or decorative sewing. Indeed, despite clear evidence that earlier Maroons had women's wrap skirts, two styles of men's loincloths (wider and narrower), an impressive range of jewelry and accessories (much of it intended for ritual protection), and Western-style clothing purchased in coastal Suriname, shoulder capes (a standard item of men's dress throughout the twentieth century) are notable for their absence from accounts from before the second half of the nineteenth century. An eighteenth-century Saramaka dictionary gives no word for cape; an observer reports in 1866 that among the Maroons of eastern Suriname, both men and women wear multiple cloths over the shoulders, but his illustration—which shows eight men in loincloths, chest sashes, neckerchiefs, hats, leg bands,

jewelry, and more—does not depict capes; another observer's description and numerous illustrations of Aluku Maroons ten years later confirms this picture; and a book on the Ndyukas and Saramakas brought to Amsterdam for the colonial exposition of 1883, systematically photographed in native garb, shows all of them barechested.[8]

It seems likely that men's capes and decorative sewing made their first appearance in Maroon costume at roughly the same time. It is in the late nineteenth century that both of them began appearing in museum collections and written documentation. And Maroon ideas about dress might well reflect their simultaneous introduction since, as we will see below, men's shoulder capes have traditionally been the most consistently and most elaborately decorated of any type of garment.

The oldest type of textile art that present-day Maroons remember, and that photographs and museum collections document, consists of embroidered figures on a monochrome or subtly striped cotton backing. The shapes tend to be curvilinear, their placement roughly symmetrical around a vertical axis, and they are executed as linear outlines, often filled in with dense stitching in a contrastive color.[9] The absence of vibrantly colorful patchwork textiles during this early period does not mean, however, that Maroons would not already have developed both the aesthetic principles and the cutting-and-piecing technique that were to go into its creation. Not only is color contrast already present in the nineteenth-century embroidery designs but many other domains of daily life attest to its importance as a central feature of Maroon aesthetics. Gardens are laid out in patchworklike alternations of "red" and "white" rice varieties, even though the different kinds look and taste the same once they get to the cooking pot. Dress reflects an explicit preference for wearing colors that contrast rather than blend with each other (for example, a red waistkerchief on top of a yellow-and-green wrap skirt). Ideals of physical beauty include admiration for bright white teeth against jet-black skin and dark ("green") cicatrizations on an albino woman. And the inlays of men's woodcarving introduce tonal contrast into an otherwise monochrome art.

In terms of the technical dimension, there exist Maroon garments made by cutting cloth into pieces, repositioning them, and seaming them back together without incorporating any of the vibrant color contrasts that later came to dominate the art of patchwork. In a cape construction popular in the 1920s, for example, a length of striped cloth was cut into five pieces that were then repositioned and sewn back together in three vertical panels.[10] Here, no pattern of contrastive colors or cross-cutting stripes results; both

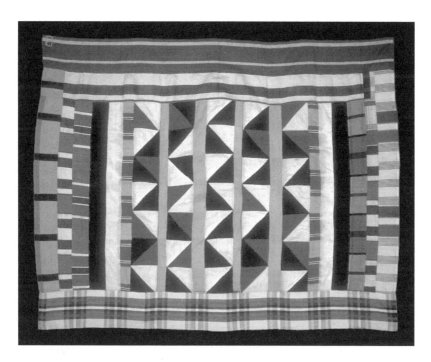

2. An embroidered cape with patchwork/appliqué borders, sewn about 1900–1910. *Photograph by Richard Price.*

the initial cloth and its pieced-together follow-up are characterized by uniform stripes running in a single direction. But while a cape made from the uncut cloth either would have displayed horizontal stripes (which Saramakas say they don't like on capes) or would have been too long and narrow, the cut-and-pieced version forms a cape of the preferred orientation and appropriate proportions. Similarly, close examination of clothing often reveals seams discreetly joining two pieces of a single color, reflecting the fact that the seamstress did not have a single piece of cloth large enough for the garment.

A cape in the early embroidery style, made for the late Agbago Aboikoni, paramount chief of the Saramakas, illustrates both this type of patching and other characteristic features of Maroon textile arts (fig. 2). First, the design spread over its center serves as an excellent illustration of a very common color scheme in which the basic threesome of red, white, and navy or black predominates but is complemented by yellow, blue, and orange. Second, it displays the imperfectly realized bilateral symmetry that characterizes the bulk of women's art—calabashes as much as textiles. Saramakas explicitly

esteem symmetry more than off-balance visual effects, but are quite unanimous in the belief that women are less skilled at producing it than men. A layout of motifs such as the one on this cape seems almost designed to prove their point, since it is clearly conceptualized in terms of a vertical axis but has been executed with its elements a bit off center. Third, the central embroidered composition is framed on the sides and bottom by an entirely different technique of decorative sewing—strips of red, white, and black patchwork appliquéd onto the white cloth.

The steps of production lend clues to the reading of such a textile's aesthetic features. Having been present countless times as Saramaka women plan out capes, I have been struck by the way they always begin planning them at the center and then work progressively out to the edges. Furthermore, when adjustments are made on a cape that has already been worn, they are introduced at the edges, which means that a cape's borders sometimes postdate its center by many years. It is not unusual, for example, for a cape to be enlarged in response to changing fashion by extra strips sewn onto the sides and bottom.[11] So whether or not the patchwork strips framing Chief Aboikoni's embroidered cape were present the first time he wore it, they would not in any case have been sewn on until after the embroidery design's completion. This means that the masterful realization of an established embroidery art filling the center of the cape was complemented by a three-sided border in which the seamstress experimented with something new. Over the years, as both the makers and the wearers of capes began to get tired of the same old thing, the once fashionable embroidery style faded out and the newer technique and aesthetic represented in its edge strips moved center stage.

Although the new style, which made its debut in the early years of the twentieth century, showed up on the same garments with the earlier curvilinear embroidery, it was constructed by a completely different process, used different raw materials, and produced a different aesthetic effect. Small strips, squares, and triangles were cut with a knife from monochrome red, white, and black or navy cloth, and sewn together to produce a patchwork strip, which was then appliquéd onto the backing cloth. This technique/style eventually became known variably as *bè-ku-baáka* (red-and-black), *pèndê koósu* (striped/patterned cloth), or *píspísi* ("pieced-together" or "bits and pieces") sewing (fig. 3).

Over time, the new bits-and-pieces strips began to upstage the older curvilinear embroidery as women became more proficient at designing and producing them and as men acquired a taste for clothes that featured them.

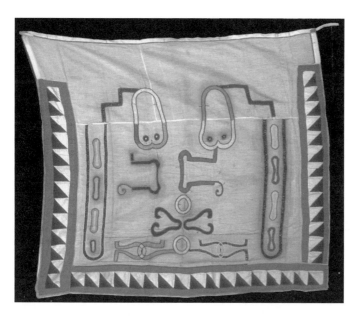

3. A "bits-and-pieces" cape sewn about 1920–40 by Peepina,
village of Totikampu. Gift of the late Saramaka paramount chief,
Agbago Aboikoni, to Richard and Sally Price, 1979.
Photograph by Antonia Graeber.

With embroidery falling in the popularity charts of Maroon fashion, bits-and-pieces patchwork literally took the center. On breechcloths, this meant a patchwork composition covering the broad rear flap — the most noticeable portion since the front flap is small in comparison, and the rest of the garment simply passes between the wearer's legs. This rear panel receives special attention because of the swinging motion it makes when its wearer walks. As Saramakas explained to me, the design itself is colorfully spread out, *wangaa!* on the breechcloth, and it swings jauntily, *lioliolio* . . . as the man moves — hence their term for a breechcloth sewn in this style: *awangalió*.[12] For shoulder capes (which, unlike breechcloths, have no nonvisible parts), the construction in which a solid piece of cloth served as a backing for decorative patchwork dropped out, and the entire garment came to be formed exclusively of "bits and pieces," the seams of which were tucked under with a needle and meticulously hemmed to hide the raw, cut edges. At the same time, the standard red, white, and navy color scheme of earlier textiles was embellished with accents of yellow.

The production of a cape in this style began with the construction of patch-work strips. One of these (often of a unique pattern—in the cape illustrated above, for example, the central patchwork strip is black-and-white, while all the others are black, white, and red) was chosen for the garment's "spine" (*báka míndi*), thus defining its vertical center. The spine was then flanked by a pair of matching strips, one to the right and one to the left, followed by another and another until the center of the composition achieved the proper size. The strips were laid out on the ground without being sewn, so that changes could be made at any point. Often, once the patchwork strips were in place, the seamstress continued the process with strips of the multicolored cotton sold in coastal stores, beginning with patterns she had in duplicate in an attempt to continue the symmetry, and then finishing with a more ran-dom sequence. She would then select one or two warp strips (strips running in the same direction as the cloth's selvage) for the lower edge and attach a final warp strip, to be tied at the man's shoulder, on the top. A single stitch or two would fix the chosen order of strips, and the time-consuming process of seaming and hemming could begin.

Readers following the argument will already be turning their attention to the edges again and find themselves in a position to predict the next rage. By the mid-1960s, capes composed exclusively of narrow strips cut from multi-colored, striped cotton had completely driven out the bits-and-pieces style. Despite their visual resemblance to non-Maroon eyes, to West African tradi-tions of edge-sewn textiles, this style of narrow-strip composition emerged directly from experimentation by Maroon seamstresses who, tiring of the older form of sewing, discovered the properties of raw materials recently made available in coastal stores and elaborated in novel ways an aesthetic preference for contrasts and interruptive patterning that already ran through many dimensions of their daily lives.

We now follow these multicolor strips as they migrate from the edges to the center of fashion (fig. 4). It is worth noting that in this new textile art the raw materials themselves are "marginal" in the most literal sense, since the strips are the leftover trimmings from women's wrap skirts, made by cutting the ends and sides off two-ell lengths of trade cotton, and even the sewing thread was sometimes salvaged from such scraps when store-bought thread was in short supply. The earlier bits-and-pieces construction has by this time dropped out completely, and the entire composition consists of multichrome narrow strips, though the procedure of establishing a vertical spine and flank-ing it, from the center out, with matching strips remains constant.

Meanwhile, around the same time that the narrow-strip capes were domi-

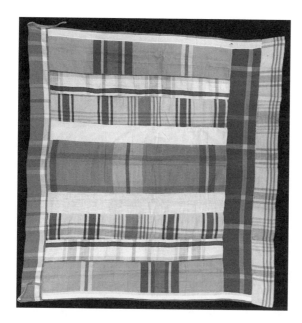

4. A Saramaka narrow-strip cape, probably sewn in the 1960s or early 1970s. Collected 1978 in the Saramaka village of Dangogo. *From the Photograph and Illustrations Department of the Johns Hopkins University.*

nating men's fashion in the villages of Suriname interior, young Maroon women in the villages closest to the city, where Moravian missionaries had set up churches, medical clinics, and schools, were learning the refined art of cross-stitch embroidery, conscientiously following diagrams in the women's magazines provided by the missionaries. Saramaka men from upstream villages, who traveled the river frequently on wage-labor trips and developed romantic ties with downstream women, were often presented with gifts of capes and breechcloths decorated in this cross-stitch embroidery—and they wore them with pride at community events in their home villages upriver, where their wives were not insensitive to the admiration they inspired. And although the upriver women, who had never had an opportunity to go to school, were at first profoundly intimidated by this competition from their more formally educated rivals, they realized they would have to learn to embroider cross-stitch if that's what their men wanted.

So they did. For the first several years, women worked on thin trade cotton like that their mothers and grandmothers had used for embroidery, first setting up a grid of horizontal and vertical guidelines for the crosses by pulling threads out of the cloth with a pin. The designs on these early "pull-the-thread" capes were linear motifs, and they were executed at the very edges of the cape.[13] Both because the thread pulling was labor-intensive and because

the women didn't yet feel confident in the medium, these early cross-stitch designs remained rather minimal. Later on, women discovered that a heavier weave of commercial cotton, which they called *lapu,* allowed them to skip the time-consuming preparation since its knobbier texture supplied a ready-made grid. And with time, they mastered the new embroidery technique at least as well as the downstream women had. By the mid-1970s, when men had packed almost all of their narrow-strip capes away in trunks or started using them for rags, the cross-stitch art had broken out of the edges and taken over the centers of capes, and sometimes breechcloths.[14]

Norma Amania, who as a child had attended a school run by Moravian missionaries, was among the first generation of Saramaka women to master the technique of cross-stitch embroidery. By the early 1990s, she had turned her talents to the new art of reverse appliqué. But less than a decade later, she was faced with yet another technical/aesthetic challenge, for the textile art that was by then making waves was fashioned from heavy commercial yarn, the kind long used for tassels on men's calf bands and decorative pompons for their hunting sacks. It had also begun to be used for embroidered designs, in place of thinner threads. Now, however, women were beginning to work the yarn with a crochet hook, creating openwork ribbons that provided decorative edging on tablecloths (framing the central design in cross-stitch embroidery) or hammocks (framing lavish designs in reverse appliqué). And soon this new style, known variably as *tatai koósu* (very roughly meaning "cloth with yarn") or *haki* (from the Dutch *haken,* "to crochet"), made its appearance on women's skirts (fig. 5). As of this writing, all the examples of crochet work that I have seen are edgings. But in July 2001, women living in a Saramaka settlement in French Guiana told me about a cloth they had seen, back in Suriname, in which a circle had been cut out in the middle and filled in with a separately constructed inset in crochet. The migration from margin to center appears to be continuing.

The dynamism of Maroon artistic life is not limited to styles and techniques. The vocabulary of artistic criticism is treated with playful innovation, as we have seen, and even the role of art in social life can evolve significantly. Over the entire twentieth century, for example, women's textile arts were focused virtually exclusively on the men's garments that they presented to husbands and lovers as gifts of affection. Although they used aesthetic criteria in choosing their own outfits, their skirts and capes never displayed the elaborate decorative touches that embellished the men's clothing. Over the past few years, however, men's move toward Western dress has accelerated dramatically, while women have continued the custom of wearing wrap skirts,

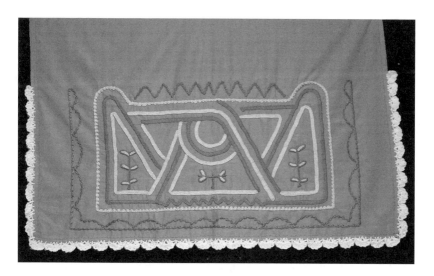

5. Skirt with yarn embroidery and crocheted edging, sewn ca. 2000. Pink cloth with yellow and green embroidery and white edging. Gift from the seamstress, Ozlène Jewani, to Sally Price, July 2001. *Photograph by Sally Price.*

simply adding a bra or blouse in deference to Western notions of personal modesty. In this changed environment, women have shifted their artistic talents in favor of their own clothing and made their skirts into a site of aesthetic creativity fully as explosive as the best of their twentieth-century production on men's capes.

Calabash Carving

One question is whether the progression of artistic experimentation from edges to centers characterizes other arts as well. The second major medium exploited by Maroon women is calabash carving, an art form having neither warp nor weft, neither selvages nor raw edges. Where, then, are the "marginal areas," and what do we see happening in them?

The earliest Maroon calabashes—as represented in historical documents, museum collections, and the memories of late-twentieth-century Maroons—were decorated in a technique and style that followed the general model of carvings done by their ancestors in many parts of Africa. In spite of the fact that the fruits utilized by the Maroons came from the American cala-

bash tree and the fruits known as calabashes in Africa were picked from vines in the botanical family of pumpkins and squashes, the bowls made out of the two fruits looked a lot alike.[15] That is, the raw materials were totally unrelated, but the objects made from them, and the artistic style of their decoration, were at first strikingly similar. Early Maroon calabash carvings were, like many of their African precedents, composed entirely of intricate designs carved on the exterior surfaces of bowls and covered containers. In early Maroon communities, it was the men who made these carvings, using manufactured metal tools imported from the coast.

The history of women's calabash carving begins with a discreet takeover of this traditionally male artistic domain. While the innovative styles that young women developed in textile arts eventually replaced those of their mothers and grandmothers, the artistic territory that their calabash experimentation invaded was that of their fathers and grandfathers. If, in examining early examples of Maroon calabash carving in museum collections, we look beyond the published photographs, if we pick the bowls up off the shelf and turn them over, we notice markings in their "leftover" spaces. We see crude incisions clearly not made by a knife or chisel or gouge, clearly not designed with rigorous attention to symmetry or geometry, clearly not products of a coherent artistic style, clearly not executed with full manual control, and clearly not carved by the same artist who worked the bowl's exterior.[16] The authorship of these irregular, off-center, bas-relief markings is not identified in publications or museum records, but by following them through time, we can see them evolving into a highly refined carving style. As the women gradually redefined their artistic terrain, abandoning bowls that had already been carved by men and taking over control of the entire object, their designs spread over the bowl's whole interior surface, and their art became a pervasive presence in the material culture of the Maroons. In short, both the carvings themselves and the role of the art in daily life moved out of the wings and into center stage—just like each style and technique in the series of textile arts that we saw earlier.[17]

It may be worth noting that the tools for the calabash carvings also emerged from the "margins" of Maroon material culture, in much the same sense as the edge trimmings that women used to make narrow-strip textiles. Maroon men had long been working on calabashes with manufactured instruments they bought in the city. But women (who had no personal access to money or city stores) discovered that by setting a bottle on the ground and breaking it with a rock, they could produce small, very sharply pointed pieces of glass, some of which, with a little experimentation and a lot of practice, served as

effective tools for the carving of their bowls. This tendency to exploit the margins of material culture with artistic innovativeness can be seen in other domains as well. The colorful calf bands that men, women, and children wear as an accessory, are crocheted by women using the sharpened spokes of old umbrellas. And the smoothly graduated stacks of shiny aluminum anklets that women literally build onto their lower legs are made from the insides of cables appropriated by Saramaka men from the Alcoa subsidiary in coastal Suriname.

Visiting with Maroons in French Guiana in 2000, I caught my first glimpse of what promises to be the next move in calabash arts—delicately pierced designs reminiscent of the kind of filigree openwork that men sometimes produce in their wood carvings. The examples I saw were at the edges—more practical than holes in the center of a bowl, of course, but also consistent with the general pattern of artistic experimentation in this society (fig. 6). It seemed to me that the test, several years down the road, would be to see whether women allow aesthetics to win out over function on some of their calabash bowls by filling them more expansively with the new openwork technique. The answer came during a return to French Guiana in February 2002—a new fad in which delicately pierced calabashes were being made as decorations to hang on the wall of a woman's house (fig. 7).

Given the particular configuration of gender roles in Saramaka culture, it does not seem incongruous for women to construct their vibrant textile compositions from scraps, to carve their handsome calabashes with bits of broken glass, to craft their jewelry from the detritus of an aluminum factory, or to crochet their tasseled calf bands with the spokes of discarded umbrellas. This is, after all, a society in which women eat their meals out of cooking pots with the children, while men are served smoothly molded rice in a handsome bowl carefully covered with an attractive embroidered cloth; where a man can tell his wife to heat water for his evening bath, though she must never drop a hint that she would like him to go hunting; where women, like men, serve as mediums for individual spirits, but men are the priests of the major oracles; and where women are the seamstresses, but men own the sewing machines. In this context, there's a certain logic to the idea that women do not allow themselves to be diminished by working at the edges, that they create works of remarkable beauty in the margins.

But Maroon women have begun, over the past several decades, to challenge the traditional gender constructs of their societies. The loosening of lineage control over their forays beyond the villages of the rain forest marked an important first step. In the 1960s, a woman's trip to the coast to join a

6. Calabash drinking bowls made ca. 2000 with notches and holes on the edge. Bought from commercial stands in French Guiana, carvers undocumented. *Photograph by Sally Price.*

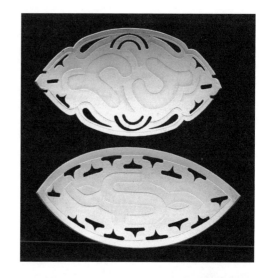

7. Decorative calabashes carved 2002. Bought from relatives of the carver, Yowensia Ngwete, village of Soola. *Photograph by Sally Price.*

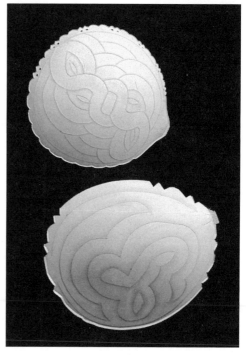

husband was subject to approval by lineage elders (in formal meetings) and ancestors (in oracle sessions), and it was not rare for permission to be denied. But women now travel to the coast on their own, a shift that carries both new freedoms and new responsibilities. While men's wood carving always represented *the* marketable artistic medium of the Maroons (and virtually the only art considered worthy of treatment in the literature), women now participate in cooperatives that offer their textiles for sale and manage to get their carved calabashes into coastal shops. More stunningly, at least one woman has bucked the long-standing Maroon understanding that men, and only men, possess an aptitude for wood carving and has tried her hand at purpleheart figurines with quiet success.[18] Slipping her carved animals in among those of her male relatives, she earns her share of the roadside stand's profits . . . and ultimately nudges their daughters' artistic options into more open terrain.

Notes

Parts of this paper draw on materials and ideas developed in previous publications — see Sally Price (1999) and Sally and Richard Price (1999).

1 *Mola:* brightly-colored appliqué textile made by Kuna women. See the chapter in this volume by Mari Lyn Salvador.
2 Sally Price (1984).
3 Richard Price and Sally Price (2001) and Sally Price and Richard Price (1999).
4 This observation applies specifically to Upper River Saramakas. Even in the past, eastern Maroons and Saramakas living in the villages closest to Paramaribo sometimes decorated their skirts.
5 Staehelin (1913–19, 3.2:141) and Richard Price (1990, esp. 161).
6 Stedman (1988, 390–92, 405, frontispiece, plate 53).
7 See Sally Price (1984, 125–29).
8 Schumann (1778), Coster (1866), Crevaux (1879), and Bonaparte (1884).
9 See Sally and Richard Price (1999, figs. 4.30–4.31).
10 See Sally and Richard Price (1999, fig. 4.34) and, for a similarly pieced breech-cloth construction, Sally Price (1984, fig. 46).
11 See, for example, Sally and Richard Price (1999, fig. 4.32).
12 See, for example, Sally and Richard Price (1999, figs. 4.61–4.63).
13 Sally Price and Richard Price (1999, fig. 4.49).
14 Sally Price and Richard Price (1999, figs. 4.51, 4.82).
15 For a discussion of the these two botanical species (*Crescentia cujete* and *Lage-*

naria siceraria) and the implications of differences between them for Maroon art history, see Sally Price (1982).

16 See Sally Price (1984, figs. 15–19).

17 Examples of the impressive variety of designs this produced are illustrated in Sally Price and Richard Price (1999, figs. 6.28–6.31).

18 Sally Price and Richard Price (1999, fig. 1.1).

Reference List

Bonaparte, Prince Roland. *Les habitants de Suriname: Notes recueillies à l'exposition coloniale d'Amsterdam en 1883.* Paris: A. Quantin, 1884.

Coster, A. M. "De Boschnegers in de kolonie Suriname, hun leven, zeden, en gewoonten." *Bijdragen tot de Taa-, Land- en Volkenkunde* 13 (1866): 1–36.

Crevaux, Jules. "Voyage d'exploration dans l'intérieur des Guyanes, 1876–77." *Le tour du monde* 20 (1879): 337–416.

Price, Richard. *Alabi's World.* Baltimore: Johns Hopkins University Press, 1990.

Price, Richard, and Sally Price. "Maroons under Assault in Suriname and French Guiana." *Cultural Survival Quarterly* 25, no. 4 (2001): 38–45.

Price, Sally. "When Is a Calabash Not a Calabash?" *New West Indian Guide* 56 (1982): 69–82.

———. *Co-wives and Calabashes.* Ann Arbor: University of Michigan Press, 1984.

———. "The Centrality of Margins: Art, Gender, and African American Creativity." In *The African Diaspora: African Origins and New World Identities,* ed. Isidore Okpewho, Carole Boyce Davies, and Ali A. Mazrui, 204–26. Bloomington: University of Indiana Press, 1999.

Price, Sally, and Richard Price. *Maroon Arts: Cultural Diversity in the African Diaspora.* Boston: Beacon, 1999.

Schumann, C. L. "Saramaccanisch Deutsches Wörter-Buch." In Hugo Schuchardt, "Die Sprache der Saramakkaneger in Surinam," *Verhandelingen der Koninklijke Akademie van Wetenschappen te Amsterdam* 14[6], 1778, 46–116, 1914.

Staehelin, F. *Die Mission der Brüdergemeine in Suriname und Berbice im achtzehnten Jahrhundert.* Herrnhut: Vereins für Brüdergeschichte in Kommission der Unitätsbuchhandlung in Gnadau, 1913–19.

Stedman, John Gabriel. *Narrative of a Five Years Expedition against the Revolted Negroes of Surinam: Transcribed for the First Time from the Original 1790 Manuscript.* Ed. Richard Price and Sally Price. Baltimore, Md.: Johns Hopkins University Press, 1988.

The Emergence of the Santeras

Renewed Strength for Traditional Puerto Rican Art

She made five pieces of *Las Tres Reinas Magas* [The three wise queens] for the Fourth Folkloric Fair of Women Saint Makers held in April 2001 in Old San Juan, Puerto Rico. She made them as an experiment to see if her devotees liked them. They did. The queens were sold, and she received several more orders for her carvings. Thus, Raquel Pagani, one of Puerto Rico's best-known *santeras,* has created at the beginning of the twenty-first century an original wooden santo. The white cedar sculpture is seven and one-quarter inches tall from base to crown and six and one-half inches wide, with three slim figures of women, one of them black, painted in acrylic basic colors. Its style is described by Pagani as "contemporary," but when the beholder observes the carving of *Las Tres Reinas Magas,* one sees definitely a Puerto Rican santo that holds within the fibers of its noble wood at least five centuries of cultural tradition. It is important to acknowledge the Pagani's ingenuity, since the sculpture of *Los Tres Reyes Magos* [The three wise kings] has proven the most popular Puerto Rican santo for several centuries. Pagani got the idea from artist Lizzette Lugo, who made an engraving called *Las Tres Reinas Magas.* Pagani's daughter saw the work of art and fell in love with it: "Mother, you have to do a carving like that." The *santera* then spoke with the engraver, and they made a verbal pact—when Pagani had made her first *talla* (wooden carving) of the three wise queens, she would exchange it for one of Lugo's prints. And so they did.

1. *Las Tres Reinas Magas.*
Original santo by Raquel
Pagani, Puerto Rico, 2001.
*Photograph by Alana
Alvarez-Valle.*

Below
2. *Santera* Raquel Pagani
in her workshop, Dorado,
Puerto Rico. *Photograph by
Adriana Mangual.*

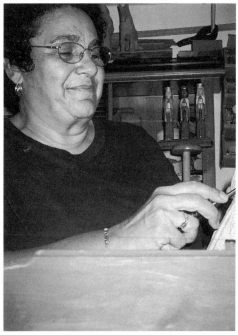

In colonial days in Puerto Rico, Catholic churches were few and far between. Few and poor roads made it difficult for the faithful to get to daily, even to weekly, mass. That is probably the main reason for the flowering of religious art in Puerto Rico from the 1500s on. In almost every home, from that of the more humble peasant families to that of the rich *hacenda-dos* (hacienda owners), there stood a small altar for family worship. It usually had one or more santos, votive candles, and flowers, especially white lilies since their perfume would impregnate the room. Wealthy families imported their religious figures from Spain, but the majority of Puerto Ricans bought them on the island or had them made by the *santeros,* artisans who learned their trade from Spanish priests, from the very few sculptors who visited the colony, or who taught themselves. Of humble birth, the native *santeros* had their own workshops in their homes as did, centuries before them, the medieval artisans who developed their art. *Santeros* led holy lives, and they were distinguished in their communities. With the advent of modern times, in the first half of the twentieth century, the *santos de palo* (wooden saints) apparently lost their appeal as part of religious worship, but the art developed new meaning, now becoming a symbol of Hispanic tradition in a country struggling to keep its Puerto Rican identity in spite of U.S. invasion (1898) and rule. Later on, in the fifties and sixties, with the renaissance of many aspects of Puerto Rican national culture, the *santeros* regained their place in society and the santos became treasured art objects.

In fact, the three kings santo, or *parranda,* as the public calls it, has evolved in history, or as many critics have stated, it has been *criollizado,* that is, become Puerto Rican. The carving of the three kings is made with the three male figures standing on the base or riding on horseback, the latter a local variation from the kings riding on camels. The greatest variations of the santo occur in what the kings carry in their hands: it could be the traditional chest as a symbol of its holding gold, incense, and myrrh; it could be the typical Puerto Rican musical instruments, the *cuatro,* the *güiro,* and the *maracas;*[1] or the national flag;[2] or even machetes and rifles, as in a landmark exhibit held in 1972 in the Museo de Santos del Instituto de Cultura Puertorriqueña, *The Revolution of the Santos.* This exhibit presented to the public a collection of santos carved by poet and sculptor José Manuel Torres Santiago. His kings carry rifles, grenades, and machetes as a symbol of a Puerto Rican revolution for national independence.

Torres Santiago, now a full professor of Puerto Rican studies at the City University of New York's Hunter College, wanted to make a political statement with his santos by taking a traditional national icon and turning it into

a revolutionary symbol. His work was completely sold out during the exhibit, so that these pieces now form parts of different private collections.[3] Other popular santos are Saint Anthony, patron of those looking for girlfriends or boyfriends, and the so-called *Miracle of Hormigueros,* which portrays a Puerto Rican legend in which a campesino was saved by the Virgen de la Monserrate, a black virgin, when a bull was about to charge.

Women *santeras,* especially a fair grouping at least forty women artists, is something recent in the cultural world of Puerto Rico, for it has been the *santeros,* or male saint makers, that have kept the tradition thriving for centuries. Experts in folkloric Puerto Rican art have estimated that presently there are in Puerto Rico—in museums, private collections, or simply in households—approximately ten thousand wooden santos, carved between the end of the eighteenth and the first half of the twentieth century.[4] In 1947, Dr. Ricardo Alegría, researcher, writer, and former director of the Institute of Puerto Rican Culture, organized the first important museum exhibit of wooden santos at the University of Puerto Rico. Since then, local and international collectors, art scholars, and critics have given attention to this tradition claiming to provide not only aesthetic pleasure to the art lover but also an inspiration to spiritual devotion in those that believe in the intercession of the religious saints with the Almighty.

Scholar Irene Curbelo de Díaz González has made a chronology of the Puerto Rican santo, which dates the first known *santeros* to the period of 1770–1830. These are considered colonial-style *santeros* since they worked the wood as trained by Spanish priests and their sculptures, placed on church altars, were bigger in size and more sophisticated in style than present-day specimens. The autochthonous style pertaining to families of carvers can be traced to the 1800s and many of their pieces—from the Rivera group or the Cabán group—are presently on view in museums such as the Museo de las Américas in San Juan and the Smithsonian Institution in Washington, D.C. The latter boasts one of the biggest collections of Puerto Rican santos in the world, donated by private collector and scholar Teodoro Vidal.[5] The primitive style can be identified in the families of Don Zoilo Cajigas y Sotomayor (1854–1962) and several other *santeros.* In 1956, Ricardo Alegría made a beautiful dramatic documentary about the story of Zoilo Cajigas, the *santero* who lived to be 110 years old. Partially fictionalized, the documentary shows how the traditional wooden saint maker faces progress. In the film, progress is symbolized by plastic figures of saints made in a factory with modern machinery, while the *santero,* who lived an ascetic life in the countryside spent day after day carving his small *santos de palo* inspired by the holiness of God

through nature and prayer. The film, however, has a happy ending. The *santero* in the story cannot sell his santos in front of the town church, but he marches on to the University of Puerto Rico, Río Piedras campus, where the newly educated Puerto Rican scholars buy his santos to be exhibited as an authentic expression of Puerto Rican art.[6]

The traditional Puerto Rican santo is a sculpture "in the round," that is, the head, body, and clothing were usually carved in one piece. According to Curbelo, although large santos were made for churches, most existing carvings are of a size appropriate for worship in the home, that is from eight to twenty inches in height. In general, the santo was entirely made of wood. Artisans gave preference to native woods durable and easily workable, such as capa, lignumvitae, balata, podocarp, mahogany, cedar, and white cedar. Scholars suspect that most *santeros* used primitive tools, sometimes just a pocket knife, more often improvised. "The technically more sophisticated pieces, however, reveal that chisels, burins and gouges were used."[7] Today women *santeras* mostly use the same woods as did the *santeros* centuries before, especially mahogany, cedar, white cedar, ebony, and lignumvitae or guaiacum.[8]

However, the tools have truly changed. In the past decades, the Artisan's Administration that works under the government's Puerto Rico Industrial Development Company (PRIDCO) has distributed thousands of dollars in equipment to Puerto Rican *santeros* and *santeras*. In fact, Raquel Pagani has several technologically advanced machines to cut wood. "Don't think that because I have this machinery this is not a real handmade piece," she is fast to explain. Pagani uses the equipment to cut the pieces of wood on which she carves her santos. Also, she makes the bases for the sculptures with the machine. This is a long way from the times when Don Zoilo Cajigas went to his patio, cut down a tree or made an incision in the trunk with his machete, and then went on with his carving. But then, of course, times have changed. Back then, there were no women *santeras* . . . or were there some women working in the family workshop?

Professor Myriam D. Vargas affirms that women *santeras* have been recognized only during the last decade; before, their work went "ignored or undervalued." She does mention several *santeras* whose names have come up in the research about this popular art tradition, such as Justina Torres de Ramos from the town of Aguada, Virginia Cajigas from Camuy, and Juana "Pichona" from Cataño.[9]

Most of the women saint makers on the island have been working intensively for the past ten years, although it is known that some women from the families of *santeros* or popular artists worked in the shops along with their

husbands and parents. Such is the case of Santia Rivera Martínez, wife of famous Domingo Orta from Ponce, who started attending the family *taller* (workshop) as a hobby and gradually became a *santera* in her own right. She is very shy but assertive about her family and her art. Santia became Domingo Orta's wife when she was fourteen years old, and since then she has worked tirelessly at raising her six children (four sons and two daughters) and at helping her husband in the workshop. "She started painting all the santos that I carved, and then about 25 years ago she started carving herself," says Don Domingo, interviewed in his workshop amid santos half-carved or finished by himself and Santia, "she is a better artisan than I am." He seems very unassuming, even though his santos have a place of honor in several museums in Puerto Rico and the United States, including the Museo de las Américas and the Smithsonian Institution. "I think she is good because she doesn't only carve. She is able to mix the colors well and use them effectively," he adds. Santia Orta was honored as one of the best in her field in 1995 at the First Folkloric Fair of Women Saint Makers.

She carves miniature three kings on foot and on horseback, and she also makes the regular size carvings that range from seven to twenty inches in height. Her favorite carvings, however, are the *Once Mil Vírgenes* [Eleven thousand Virgins] and *La Virgen de los Reyes* [The Virgin of the kings], a rare and beautiful rendering of the Virgin Mary sitting on a throne, while the three kings stand in front of her base. Santia is the oldest, at sixty-four, but all the women in her family, both her daughters and her daughters-in-law, carve santos or work on some other kind of handicraft. "Everyone that comes into the Orta family becomes an artisan; they must have something special," says Walter Murray Chiesa, an expert in folkloric art and a collector who has worked for years with the Institute of Puerto Rican Culture.

Iris Torres, to whom the Fourth Folkloric Fair of Women Saint Makers was dedicated, is another example of a woman working in the family shop. From the mountain town of Orocovis, Iris Torres is married to Rafael Avilés of the Avilés family, known for their artisanry and their Museo del Santo, located in their hometown. "Once you are married to one of them, you just follow them into the shop. If my husband went out to look for materials, especially wood, I would go with him. I followed him around and told him I was interested in carving, which was not considered feminine. Who would think that women could carve?" she explains, then adding, "I was taught to sew, embroider, and hemstitch as a child, to help my mother who was a seamstress." Iris was born one of thirteen children to a very poor family, who thought she would be just a good housewife. Now she has won prizes and has sold

hundreds of religious figures. She was invited to Islas Canarias, Spain, and to Chicago, Illinois, to exhibit her work.[10] She works in very simple surroundings, in a wooden shack in the back of her house, where there's a hammock, a fire, and many trees—grapefruit, orange, guava, mahogany. Iris learned to use the knife from her husband, but then she was on her own, learning by doing her art.

Zaida Isern's life differs greatly from that of the rural *santeras*. She is a college graduate who majored in elementary school education. Her husband is a medical doctor, and when her children were small, she decided to quit her teaching job and stay at home. "We started going to folkloric fairs, we traveled the island visiting the town fairs, we gathered a collection of *santos de palo*. Then I saw the ad announcing a short carving course (*talla de santos*) at the University of Puerto Rico's extension program. I took the five month course, and my life changed. Since then, four years ago, I carve every day. It's like an addiction. I need to be involved with wood every day," Zaida explains. The artisan opines that once you start carving a figure "the saint leads your hands." She follows the inspiration that the Virgin or saint she is carving at the moment demands. She has taken courses with carving masters Luis González and José Rosado. She carves, as all the other *santeras* do, many different saints, but she loves carving Mother Theresa and has sold about fifty pieces. Every time she goes to a fair and people see her carving of Mother Theresa, they order more pieces from her. She also makes the Virgen de los Reyes, Virgen Milagrosa, and San Judas Tadeo.

Awilda Anguita, an artisan from the western coastal town of Mayagüez, was one of the several women saint makers who exhibited their *santos de palo* in the landmark exhibition *Santos 2000* at the Museo de Arte de Ponce, from 25 June to 31 August 2000.[11] The exhibition is a biennial art affair held to promote the carving of wooden santos by Puerto Rican artisans, while at the same time encouraging the public to appreciate this artistic tradition. Anguita exhibited two works: the *Virgen de la Candelaria,* patron saint of her hometown, and *La Adoración de los Reyes Magos* [The adoration of the three kings]. Anguita works as the manager of a hospice for the elderly, but she is involved in several cultural activities in her native town.[12]

Besides the biennial exhibit of santos at the Museo de Arte de Ponce, the Museo de las Américas, the Museo de Arte de la Universidad de Puerto Rico, and the new Museo de Arte de Puerto Rico all have permanent collections of Puerto Rican santos, many dating as far back as the eighteenth century. The tradition of the *santos de palo* has influenced other areas of plastic art. It has, for example, been portrayed in hundreds of posters,[13] prints, intaglios,

3. Archangel Saint Raphael, patron of good health. Santo by Norma Sierra, Puerto Rico, 2001. *Photograph by Alana Alvarez-Valle.*

oil paintings, and installations. Since the 1940s, when Dr. Ricardo Alegría founded the Museo de Arte de la Universidad de Puerto Rico and developed there a permanent collection of santos, artists like Lorenzo Homar, Rafael Tufiño, José Rosa, Lissette Rosado, and many others have found inspiration in these religious wood carvings. There are posters depicting exhibits of santos, but also the santo is used as an icon of Puerto Rican culture to enhance a painting. There are probably hundreds of works of graphic art on the island that portray a santo in a protagonist or subordinate role.

Norma Sierra has designed a room of her own for her workshop—it is located on the house's balcony.[14] She remembers that her grandmother had an altar with santos, so she grew up familiar with the religious wooden figures. About a decade ago, when she and her husband were visiting different fairs and collecting santos, they decided to take a carving course at the Institute of Puerto Rican Culture. Since then they have been carving santos, but their workshops are located in different parts of the house. "I carve every single day, I just love it," she says excitedly as she exhibits her Archangel Saint Raphael (fig. 3) and her Virgins and saints. She estimates that she has pro-

duced about 150 carvings in her short career as a *santera,* and she exhibits and sells at most of the fairs she is invited to.

In centuries past it was expected of *santeros* that they be devout Catholics, but that is no longer the case. Although Zaida Isern and Norma Sierra are practicing Catholics, Raquel Pagani belongs to the Lutheran church. "I do have a profound respect for saints," she says and gets several volumes of the book *Vidas de santos* [Lives of saints], which she enjoys reading to learn the features of the santos she carves. "I also look now on the Internet for information on the saints," she adds.[15]

The *santeras* identify some differences between their carvings and those of their male colleagues. "I think we spend more time on details," says Isern, and Pagani explains that "we carve more delicate features on the faces." They also share a feeling of solidarity, a sense of togetherness at the fairs as they learn from each other by exchanging tips about their everyday work. These contemporary religious artists learn not only from experienced professors who teach carving at vocational schools, the Institute of Puerto Rican Culture's workshop, and the University of Puerto Rico Continuing Education Program, but also by visiting the carefully curated collections of santos at several museums in Puerto Rico.

This chronology of events is not unique to Puerto Rican culture. Folk art experts Chuck and Jan Rosenak have meticulously traced the Hispanic tradition of the saint makers of northern New Mexico and southern Colorado.

> The people of this region, surrounded by temptation and a harsh and sometimes hostile environment, are united by their inner devotional strength. The *santeros*— and more recently, the *santeras*—have helped the faithful; attempted to lead saintly lives; expressed simple truths and virtues in their art; looked to saints and angels for intercession and protection. They have stepped into the breach and have given us opportunity for joy in introspection and an art of universal importance in our daily lives—not just abstract ideas.[16]

I have traveled through many Central and South American countries, and in many I have found the noble tradition of saint making, although each country's santos have special characteristics. Known are the wooden santos of Mexico, Guatemala, Venezuela, and Paraguay, and, of course, those in the United States from New Mexico and Colorado, all of which have been researched and documented. In many of these countries the *santos de palo* were made for small town and village churches. In Puerto Rico, one of the poorest of our poor countries, the santos, as we have seen, were mainly carved for home altars.

Author Marie Romero Cash explains the art of the *santero* in southern Colorado: "The folk art of the santero experienced the same evolutionary development as the other arts. It was based on prototype—one artist influenced by another's work. The surviving examples are links in a chain of artistic production that derives from the past and contributes to the future." When describing the role of women in the carving of santos, she says, "although the role of the village women in santero art has been largely neglected, it is evident that these hardy Hispanic women assisted their santero husbands or fathers in numerous ways. In addition, women may have assisted santeros in the application of color to the body and faces of the *bultos* (*santos*) or other similar tasks."[17] Learning about the santos art and tradition in other parts of Hispanic America, we find that it has similar origins and development through time. Yet at the same time, each tradition exhibits individual characteristics giving it uniqueness and cultural identity. Thus we may say that Puerto Rican santos are definitely Puerto Rican.

The *santeras* attend many of the folk fairs held in the country during the year, and at the same time these fairs form part of a new Puerto Rican tradition—that of looking at, appreciating, and buying folk art, mainly santos, and working on a private collection. A college professor showed me with pride her growing collection of *vírgenes* (Virgins); others collect carvings only of the three kings. Some of the most famous and well-attended fairs (drawing thousands of people) are the Feria Bacardi, Fiestas de la Calle San Sebastián, and Feria de Artesanías de Barranquitas. The Institute of Puerto Rican Culture also sponsors annual competitions of saint makers, sometimes to commemorate a national or religious holiday. Once the *santero* wins a contest, he or she is honored by the Instituto de Cultura Puertorriqueña (ICP) and community groups and is recognized by the media. Newspapers and the electronic media have also played a role in spreading the knowledge and appreciation of this popular art.

While Pagani claims that most of her clients are collectors, Sierra has sold the *Anima Sola* to several jealous women wanting to solve their problems, a Santa Lucía to a girl whose boyfriend had problems with his eyesight, and a Virgin to a woman suffering kidney disease. "They come looking for a saint in particular. For example, Saint Raphael is the patron saint of health, so it is always good to have him in the house so the whole family is kept healthy," a smiling Sierra says of some of her clients.[18]

Whether for religious worship, aesthetic pleasure, or even a good investment in art, the truth is that the *santeras* love carving santos. Thus this loving spirit keeps alive the tradition of the Puerto Rican saint makers.

Notes

1 The *cuatro* is a small, four-stringed guitar, the *güiro* a percussion instrument made of a dry gourd, and the *maracas* is another percussion instrument made of a dry gourd.

2 The symbol of the Puerto Rican nation has five red-and-white stripes and a star within a blue triangle.

3 José Manuel Torres Santiago has published several poetry books, among them *La paloma asesinada* (San Juan: Cooperativa de Antes Gráficas Romualdo Real, 1967) and *En las manos del pueblo* (Barcelona: Gráficas Estilo, 1972).

4 Traba (1972, 77).

5 The Smithsonian Institution received the gift in the late 1990s and has since partially exhibited the collection.

6 *El santero,* dir. Amilcar Tirado, wr. Ricardo Alegría, 1956, División de Educación a la Comunidad. Film Archives, San Juan, Puerto Rico.

7 Irene Curbelo de Díaz González in Traba (1972, Appendix C).

8 Translated into English as lignumvitae, the *guayacán* wood comes from the guaco tree, recognized and quoted by Shakespeare as a medicinal plant. Its wood is very hard and of a light color. The Puerto Ricans rhetorically consider their national identity as that of a *guayacán,* that is, strong and everlasting.

9 González (2001).

10 Cantres Correa (2001, 54).

11 "Haz tu aparición" (2000, 26).

12 "Expone tallas en Santos 2000" (2000, 39–40).

13 The poster or *cartel* is another ingrained Puerto Rican artistic tradition, an art cultivated by the best painters and graphic artists of the country.

14 During interviews done by this author for an article included in the special edition of the Latin American magazine *fempress,* Puerto Rican women chose the balcony as their favorite place in the house since they considered it their window to the outside world, the street. The article can be read on the magazine's Web site at www.fempress.cl.

15 I did these interviews in 2001 and 2002.

16 Rosenak and Rosenak (1998, 2).

17 Cash (1999, 15–17).

18 Interview with the *santera* in 2002.

Reference List

Canino, Marcelino. "El folklore en Puerto Rico." In *La gran enciclopedia de Puerto Rico,* vol. 12. San Juan: 1976.

Cantres Correa, Asunción. "Homenaje a una orocoveña." *El Nuevo Día* (San Juan), 28 April 2001.

Cash, Marie Romero. *Santos: Enduring Images of Northern New Mexican Village Churches.* Niwot: University Press of Colorado, 1999.

"Expone tallas en *Santos 2000.*" *La Estrella de Puerto Rico,* 16 August 2000.

González, Carmen E. *Mujeres artesanas talladoras de santos.* Leaflet for the IV Encuentro de Talladoras de Santos, held in Old San Juan, Puerto Rico, April 2001.

"Haz tu apararición: *Santos 2000:* Bienal de santos tallados en madera por artesanos puertorriqueños." Advertisement for the Museo de Arte de Ponce. *El Nuevo Día,* 22 June 2000.

Quintero Rivera, Angel G., ed. *Vírgenes, magos y escapularios: Imaginería, etnicidad y religiosidad popular en Puerto Rico.* San Juan: Fundación Puertorriqueña de las Humanidades, 1998.

Rosenak, Chuck, and Jan Rosenak. *The Saint Makers: Contemporary Santeras and Santeros.* Flagstaff, Ariz.: Northland, 1998.

Traba, Marta. *The Rebellion of the Santos.* San Juan: Ediciones Puerto, 1972.

Valle, Norma. "Irrumpen las talladoras: Las mujeres comienzan a cultivar el arte centenario de la talla de santos." *Fempress* (May 1998): 16.

Kuna Women's Arts

Molas, Meaning, and Markets

The Kuna of Panama live in a land of remarkable beauty, a beauty expressed and celebrated in their verbal and visual arts. They have created an aesthetic system that crosscuts all aspects of their culture and is linked to their worldview. To the Kuna, each part of the natural world—rain forest, rivers, and mountains, birds and other animals, their own farms and coconut groves, the islands on which they live, the sea and its fish—is a gift from their deities, Great Father and Great Mother. Through the verbal arts, Kuna men and women express their feelings of admiration and appreciation for the natural environment, as well their responsibility to protect the earth. Expressive culture enriches all aspects of Kuna life, reflects ideology and worldview, communicates with the spirit world, and provides the context for demonstrating skill and distinguishing personal achievement. The Kuna have created a remarkable range of verbal, visual, and performance arts that provide insights into what they value, what they think, and how they feel.

Visual and verbal artistry is integrated into language, ritual, politics, everyday dress, adornment, and housing; each element has its spiritual dimension, and each task is carried out with expressive creativity and aesthetic discernment. In the Kuna cosmos, everything in the world, whether natural, cultural, or spiritual, is divided by gender, and almost every specific kind of verbal or visual art belongs either to males or females, but not to both. Moreover, although women sing and men produce objects, verbal art is predominantly associated with men and visual arts with women (Howe 1997).

The Kuna enjoy speaking in the artful language of everyday life and take pleasure in joking and playful conversation. The primary verbal arts of the men include singing and eloquent political oratory, as well as the chanting that animates and guides activities in the spirit world (Chapin 1997; Howe 1986; Sherzer 1983, 1997). Kuna women sew elaborate *mola* blouses and have created a unique dress style that is an art form in and of itself. The performance arts, music and dance, which bring verbal and visual elements together and involve the participation of both men and women, are generally associated with girls' puberty ceremonies. Recently established interisland dance festivals offer opportunities for men and women to celebrate and publicly demonstrate their musical ability and finesse (Smith 1997).

Both men and women contribute to Kuna economy. In addition to raising coconuts for the international market, men dive for lobsters and octopuses and work for wages outside Kuna Yala. Women have developed a brisk business of selling molas and mola products to tourists and outside buyers.

Kuna Yala

The Kuna in Panama live on thirty-eight islands and eleven villages along the Caribbean coast from Mandiga Bay to Puerto Obaldia at the Colombian border. Every village has at least two public buildings, both of them enlarged versions of a traditional dwelling. These are the gathering house, where the community manages its affairs and assembles as a religious congregation, and a *chicha* house, where the community celebrates the coming-of-age of its young girls. Today all but one or two villages also have elementary schools; many have Baptist, Catholic, or Mormon missions; and all of them construct public docks for trading boats. Even the most crowded villages reserve space for a basketball court. Stores are plentiful; they range from tiny operations run out of a home — where neighbors can buy sugar and salt, dry goods, soft drinks, and kerosene — to much larger shops in concrete buildings stocked with clothing, fabric, canned foods, sundries, and an occasional restaurant. Many of these stores are owned and staffed by members of co-operative societies.

Kuna villages are made of dozens of matrilocal households, each with an extended family group of two or three generations of women living along with their husbands and children. Traditionally, older family members arranged marriages. The husband moved to the wife's home where he was ex-

pected to work for her parents. Although the senior man is often called the owner of the house, the structure itself passes from mother to eldest resident daughter. Both men and women inherit fields and coconut groves, and though men predominate in the public spheres of politics and ritual, relations at home are based on balance and equilibrium.

Generally, men are responsible for providing food and women for food preparation. Kuna men travel each day to the mainland for slash-and-burn agriculture, in which staples—bananas, plantains, and root crops—are supplemented by corn, rice, and seasonal fruits. Some men hunt, but game is scarce near the coast, and most animal protein in the Kuna diet comes from the sea. In the morning, when children are in school and men are off-island fishing or working on mainland farms, most villages are quiet, with only a scattering of individuals passing through the streets. Groups of women paddle to nearby rivers to fill water bottles and wash clothes, except on islands that now have aqueducts to bring fresh water from the mainland. By midday or early afternoon, fishermen begin returning, and as the day wears on, agriculturists sail and paddle home with canoe loads of bananas, coconuts, and firewood.

Women in the family share household responsibilities by allocating duties according to age. The oldest women take care of most of the heavy work, including cooking, a smoky and time-consuming job. Younger women spend some time taking care of the children, hauling water, washing clothes, and hulling rice. Women of this age may also take turns working in small stores. Young girls assume much of the responsibility for the care of the younger children in the household. This arrangement—the combination of matrilocality and the division of responsibilities by age—enables women from their late teenage years through middle age to spend many hours each day making molas.

This essay focuses on the artistic life of Kuna women within the context of Kuna society. Each sphere of Kuna life has its associated art forms, even the domestic sphere. Kuna men make household implements, cooking utensils, baskets, and canoes, and they work in cooperative groups to build traditional houses. Basketry is treated as an explicit marker of Kuna identity and is a skill expected of all grown males. Canoe making, the ability to shape a tree trunk into the graceful form of a seagoing dugout, is a rare talent of high prestige.

Omegana Yer Dailege: Beautiful Women

Kuna women take pride in the way they look and have developed a distinctive style unlike that of their neighbors or visitors now or at any time in the past. Beauty and fastidiousness, attributes the Kuna associate with being a woman, are common topics of discussion in the gathering house as well as in the home. For Kuna women, beauty is based as much in artistic expression as on physical attributes. Family wealth is often expressed through the women's dress and jewelry, and beautiful women bring prestige to the whole family. Contemporary women use clothing as a mode of personal expression, taking great care with decisions about combinations of skirts and scarves, as well as with the creation of their mola blouses. Although mola panels are often framed or made into pillows by outsiders, they actually constitute the front and back panels of a traditional mola blouse.

In the late nineteenth century, Kuna women started experimenting with ways to transfer body-painting designs onto handwoven cloth. The new process eventually developed into the creation of designs that were cut out and sewn onto imported fabric. This innovation combined the creative use of new materials—manufactured trade cloth, scissors, and needles—and new processes—cutting and sewing. Over the years, the women have intensified the process and have developed hundreds of mola designs, as well as more creative ways of executing them. At this time, the art form is going in the direction of heightened complexity, refined designs, smaller and smaller filler elements, and an increasingly elaborate system of aesthetic judgment. These women have created an art form uniquely Kuna and have established corresponding criteria for artistic criticism.

Through the study of Kuna aesthetics and concepts of beauty, it has become clear that the Kuna value talent, learning, competence, and productivity, and have an interest in both continuity and change. Kuna criteria for fine-quality molas are based on the skillful manipulation of the technical process, proper organization, design visibility, appropriate subject matter, and the use of acceptable color combinations. At this time, when the women have so mastered this process that they are able to execute almost any contemporary design they wish, many are looking to molas from the past for inspiration. They experiment with old designs by combining various types of mola work and techniques, adding elements and changing color combinations to create blouses conforming to contemporary standards of taste.

The women's unique clothing style figures prominently in Kuna narratives and has captured the attention of explorers, visitors, and photographers for

centuries. Lionel Wafer, a seventeenth-century buccaneer doctor, wrote a vivid account of the native people he lived with while stranded in the Darién jungle in 1681. Illustrations in his book, published in 1699, show men with loincloths, necklaces, and feather headpieces and the women with wraparound skirts, nose rings, and beads. He writes enthusiastically about body painting and jewelry (Wafer 1970).

By the late 1800s, we begin to find descriptions of women wearing skirts and head coverings, as they do to this day. The early 1900s bring more detailed descriptions of the women and their extraordinary dress style, accompanied by photographic images as early as 1912. Women at this time were wearing long chemiselike blouses, with a large yoke and small, short sleeves, made of plain or print fabric. Some blouses have mola work as a border along the bottom of the blouse, while others have broad panels of mola work that hang from the wide yoke. During this period, women began wearing wraparound skirts of printed trade cloth reaching almost to the ankle and covering a shorter underskirt that had painted designs. As in the past, they wore large nose rings, necklaces, and strands of beads wrapped around their arms and legs.

Reporting to the Smithsonian Institution about her visit to Kuna Yala in 1909, Eleanor Bell offers a brief description of the mola work: "Their garments consist of a short skirt and sort of chemise of colored cotton, composed of various layers of appliqué work neatly sewed together forming very curious designs" (1910, 630). The writings of a tourist and adventurer give information about traditional women's appearance in 1922. Lady Richmond Brown, an adventurous British woman who visited the Darién area with her companion, Mr. Frederick Mitchell Hedges, wrote about their experiences and described the women and their molas: "The woman had her head and most of her face covered with a brilliant figured scarf, while her dress consisted of a remarkable looking top, rather like a jumper, with another piece of cloth wrapped around her waist" (Brown 1925, 56).

Over the next fifty years, the overall dress style changed gradually, becoming more formfitting. Smaller blouses and shorter, more tightly wrapped skirts replaced the large blouses and long, loose skirts of the 1920s and 1930s. The mid-1920s were a time of transition in Kuna women's dress. While some women chose to change to Panamanian-style clothing, the general response to efforts by the Panamanian police to suppress traditional dress and force women to change was intensely negative. Tension rose to the breaking point as descriptions of police ripping out nose rings, tearing molas, and obliging women to dance with them spread throughout Kuna Yala, and in 1925

1. Kuna women in traditional dress at dance practice, 1967. The young man playing panpipes is an albino. *Photograph by Mari Lyn Salvador.*

a group of Kuna rebelled. To this day, men as well as women refer to the beauty of traditional women's dress as an important aspect of Kuna identity.

Kuna women feel that they are more beautiful now than at any time in the past. Contemporary women put a great deal of effort into being attractive and indicate, in a general way, their interest in increased options and flexibility. Changes in dress style reflect changes in Kuna women's concepts of beauty. Traditional dress now, as in the past, is structurally much like a uniform in that, until recently, all women wore the same general outfit — mola blouse with skirt, scarf, distinctive jewelry, and short haircut. The basic elements of the outfit have stayed the same since the early 1900s, but the shape and style of each component have been altered significantly (fig. 1).

The mola blouses themselves have been modified over time. As mentioned, in the 1920s, they were large and loose-fitting, with tight sleeves. Through the years, they have become smaller and more tightly fitted, with the mola work filling all but the yoke and sleeves. In the early 1980s several significant changes were made that heightened emphasis on individuality and personal style within the acceptable boundaries of tradition. All the pieces remained there, the dress still being distinctly Kuna; nevertheless several subtle, new

options surfaced. Many women began to wear fitted mola blouses with huge, puffy sleeves, and they speak enthusiastically about these refinements, explaining that the new top draws attention to the face. They continue to experiment with fancy new fabrics and with the size and shape of the blouse, adding more and more elaborate trim on the seam between the bodice and the yoke and on the sleeves.

Skirts and scarves made of imported print fabrics have been popular since the 1800s. While the skirt has changed very little, it is now being wrapped more tightly. For decades, the women used the head scarves to protect themselves from the sun and as an expressive device to hide or accentuate the face. Some women still use them when they travel or when they dress up, but they no longer wear them every day. The scarf is now worn less often by young women, or worn in nontraditional ways—twisted behind the neck, or rolled and wrapped around the head.

Recent changes in personal adornment have centered on the upper portion of the body. The large gold nose rings of the past are no longer widespread, although having a long, striking nose is considered to be beautiful. Many women still feel that it is important to highlight the nose. Some have chosen to wear smaller and less noticeable rings, while others no longer wear them at all. Nose painting—a cosmetic option that does not permanently alter the body—continues to flourish. The huge gold earrings, breastplates, and coin necklaces seen in the photographs from the 1940s to the 1960s continue to be used for special occasions.

Until the 1970s, women either wore the complete traditional outfit or had abandoned it entirely. By 1974, some women who had previously worn Panamanian dress began to wear mola blouses with skirts or pants, and many young girls now alternate between the two styles. At this time, there is more flexibility, which allows for both continuity and change. Some women wear Panamanian-style dress in the daytime and traditional dress in the evening. Other women use Panamanian clothing for everyday wear and traditional dress when visiting, attending meetings in the gathering house, or representing the Kuna in the city or abroad. Schoolgirls now shift with ease, wearing sundresses or shorts one day, and traditional dress the next. Regardless of which type of clothing they choose to wear, they maintain the same sense of finesse and personal style.

Molas over Time

Although the origins of dress and the designs women used for body painting, and later for their molas, are richly represented in traditional Kuna narratives, creating these patterns in trade fabric constitutes a relatively new art form. In his book, Wafer describes body painting: "They make figures of Birds, Beasts, Men, Trees, or the like, up and down every part of the Body, more especially the Face, but the Figures are not extraordinarily like what they represent, and are of differing Dimensions, as their Fancies lead them. The Women are the Painters, and take a great delight in it. The Colours they like and use most are Red, Yellow and Blue, very bright and lovely" (1970, 83). These designs, first painted onto the body, then onto cloth, were later sewn onto the borders of the blouses. Women to this day make molas using birds, beasts, people, and other figures as designs, and they still prefer the same basic color combinations: red, yellow, and dark blue or black.

Underskirts made of heavy cotton and painted with repeated patterns like those on baskets and leg bands were worn at least through the 1920s. Some women still wear underskirts, but they are now made from commercial fabric and are no longer painted. Many molas from the 1920s have designs similar to those used on the underskirts. Some of these early mola blouses were long and displayed mola work only along the bottom, like those described in the late 1800s. These tend to have simple, repeated geometric patterns. By 1918, women were using machines for putting the blouse together and sometimes even experimented with machine stitching for the actual mola panels. To this day some women use sewing machines for the mola work; however, most women find it inefficient and consider it unacceptable because the stitches show.

By the late 1920s, women were making all of the types of molas that remain popular today. The style, complexity, and quality of the mola work varied greatly in the past, as it does in the present. Early molas often had abstract designs inspired by nature or based on household objects. Women created these molas by reducing an object to its basic lines to make a geometric pattern and then replicating it. These designs often have specific names that identify the original source, such as the frog mola shown in figure 5.

Blouses with more obvious figurative designs from outside Kuna culture are seen in collections from the 1920s as well. Molas based on foreign objects, package labels, books, and cards, the type of molas that most people associate with the Kuna, became very popular by the 1940s and flourish to this day. At that time, women began creating central, representational designs in the

foreground with repeated geometric filler patterns in the background. They represented a wide range of visual images that interested them, often based on new products in stores in Kuna Yala or things they might have seen in Panama City or Colón. As they copied labels and product trademarks, they began to use letters on their molas. In the early 1980s, there was renewed interest in creating contemporary molas based on past designs.

Mor Maynamaloe: "Go Make Molas"

Despite its relatively recent development, the art of making molas is considered an integral part of their culture and important to their ethnic identity by the Kuna. Women sew while visiting, traveling, participating in village meetings, or sitting by themselves. Young girls are encouraged to learn to sew as early as they seem interested, which may be at the age of three or four. By the time they are five, they usually play at sewing each day. Girls begin by sewing small scraps of material together or by cutting pieces of cloth to place in molas that women in the household are working on. By the time they are seven or eight, they may sew small designs on a piece of cloth for practice or even begin to do some stitching in small areas on "real" molas. As the women sew, they talk, share designs, and scrutinize each other's work, but no one takes on a formal mentor or apprentice (fig. 2).

The process of mola making, often described as appliqué, is actually a distinct technique in its own right. The basic sequence is to draw, baste, cut, and sew. To make a mola, the woman draws the design onto the top layer. Next she bastes carefully along the line and cuts about one-eighth of an inch on both sides of the basted line. She then folds under about one-sixteenth of inch along the cut edge of the top layer and sews the folded edge to the base layer with fine, hidden stitches using matching thread. For a mola with more overall layers, the process is repeated. Molas with lots of colors, and complicated filler motifs require additional steps, including appliqué, embroidery, and a wide range of finishing touches.

Women name molas in various ways. They use classificatory terms that identify the type of mola based on its number of layers or how it was made, such as one color (*mor gwinagwad*), two interlocking colors (*obogaled*), and many colors (*mor gonikat*). They also identify certain kinds of design elements, like long lines with teeth (*suigandamakaled*), or identify the content of the design, such as bird mola (*sikwi mor*) or hanger mola (*ake mor*).

Mor gwinagwad are called "one color" because Kuna women only count the

color above the base layer. This earliest type of mola, also called grandmother style (*mugan*), continues to be popular today. It generally displays repeated, abstract geometric patterns or pictorial designs with integrated geometric filler as in figure 3. *Obogaled* molas are those that have two interlocking colors in one layer over the base as in figure 6. This complicated technique requires careful planning before the first cut. They tend to be geometric or have highly stylized, abstract designs. *Mor gonikat,* "many colors," are the most complex and currently the most popular type of mola (see figs. 5, 7, and 8). The basic process is the same as that previously described, merely repeated. The principal difference lies in the treatment of filler areas and finishing details. *Mor gonikat* usually have at least two full layers above the base, but they also have small areas of color placed under the top layer with small areas cut out to reveal the color below. These may also have embroidery, small areas of built-up motifs, or other kinds of surface decoration.

When the panels are completed, they are sewn onto the piece of fabric that will form the front and back of the yoke. The seams are covered with a strip of material often decorated with rickrack, or *dientes,* a handmade sawtooth outline. A slit is made in the center of the yoke for the neck opening, and the edge is finished with a contrasting color. The sleeves are gathered or pleated and attached at the shoulder. The sleeve opening is bound with a different color fabric and may be decorated with mola work, rickrack, or other precious trim. Even though many women use sewing machines to put their blouses together, it is not common to use the machine for stitching the actual mola panels.

Kuna Aesthetics

The evaluation of expressive activities forms a part of everyday life in Kuna Yala. Subtle judgments are made on the basis of a person's skill and finesse. Chanting and verbal abilities are taken into consideration in the selection and evaluation of traditional political leaders. The quality of the music and costumes as well as the dance performance is considered in judging dance groups in interisland festivals. Women distinguish themselves through their traditional clothing; talented mola makers are esteemed and bring prestige to their families and communities. Although there exists an explicit emphasis on egalitarian principles and relative sameness, the Kuna have developed an implicit system of subtle differentiation. Prestige is generated by high-level performance and is evaluated, at least in part, using aesthetic criteria. Gener-

2. Young girls learn to make molas by watching women in the family as they sew, 1994. *Photograph by Mari Lyn Salvador.*

Below
3. This one-color (*mor gwinagwad*) bird mola is an example of fine, even lines and an integrated design. *Photograph by Mari Lyn Salvador, 1968.*

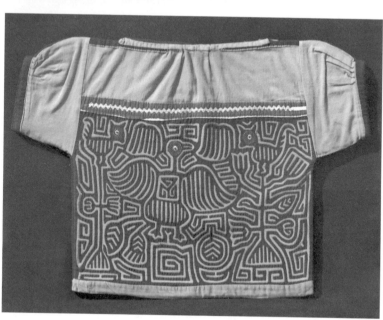

ally, the arena for women's performance is visual art—mola making—while the arena for the men is verbal art—chanting and political oratory. Kuna society combines egalitarianism and hierarchy in an uneasy combination. Villages have ranked chiefs and other leaders, as does Kuna Yala as a whole, but no one lets those leaders put on airs or order their followers around. Similarly, men compete for recognition by what they learn and how they perform it: rivals assess and quietly criticize each other's proficiency, and everyone knows who the great teachers and performers are (Howe 1986).

The home marks the primary context for evaluating as well as creating molas. Conversation and mola making go together, and friends often sit and sew and talk. Most of their commentary focuses on the subtleties of technical process in their own work as well as in the work of others. Mola making represents a series of carefully considered decisions reflecting women's thoughts, and it provides access to a better understanding of Kuna thought and concepts of beauty. Which type to make? What style? What subject? Which designs to use—traditional or new? What type of fabric? Which colors? All have to be thought out before investing time, energy, and money in a new mola. Discussion about these decisions, commentary on the progress of current work, the evaluation of the young girls' work in the family, and sharing opinions about other women's molas constitute a part of everyday conversation. Visiting from house to house on one's own island, as well as visiting other islands, Panama City, Colón, or even the National Museum of the American Indian in New York, provides intensified contexts for presenting one's own blouses and for scrutinizing other women's molas.

The concept of rank ordering is not foreign to the Kuna. Women make molas of varying quality for themselves for different occasions and designate some as better than others. They compare their molas to those of their peers. For sale purposes, the Kuna have a consistent system of ranking molas by quality into price classes, ranging from five to two hundred dollars (Salvador 1976). The sophistication of the Kuna women's aesthetic system, and the fact that Kuna women are very articulate about artistic criteria and indeed enjoy talking about molas, became clear in 1966 when I came to Panama with the Peace Corps. Kuna women taught me to buy molas for Artesanía Panameña, the Mola Co-op's retail store in Panama City, because they felt it was essential that I learn to pay the "proper" price for the appropriate quality mola, and they insisted that I grasp the smallest details of evaluation.

In 1974, as part of my dissertation research, I began a long-term ethno-aesthetic study designed to gain an understanding of the principles guiding Kuna women's arts from the perspective of the artists themselves. I worked

with women considered fine mola makers and started by talking with them about their own mola blouses regarding type, design, content, sewing, color combinations, and overall quality. I used a set of eleven molas to elicit specific information about artistic criticism and aesthetic preference. After a discussion of general impressions of overall qualities and drawbacks of molas, the women ranked them, often hanging them on a clothesline or on the edge of a boat. Research in 1986 centered on changes in artistic criteria, and three molas were added to the standard set. Photographs of molas collected in 1927 by Baron Erland Nordenskiöld, as well as those from the collections of the National Museum of the American Indian and the Smithsonian Institution, were used to learn more about the names, sources, and interpretation of *sergan* (old) designs and to gain an understanding of contemporary Kuna women's views about the history of the art form. In 1994, Kuna representatives Cacique Leonidas Cantule Valdéz, Nicanor González, Serafina López, and Rodolfina Andreve visited the collection of the Smithsonian in Washington, D.C. In 1996, four Kuna cultural specialists knowledgeable about *sergan* designs visited the National Museum of the American Indian in New York: Cacique Carlos López, Balbina Denis, Elvira Torres, and Nicanor González traveled from Kuna Yala to see the original molas and document the collections. It is their interpretation that informs and guides the material presented in this essay.

Ethnoaesthetics, the study of artistic criteria from the perspective of the artist, offers an opportunity to understand Kuna expressive culture and leads to a better understanding of the ideology behind it. Through the analysis of their arts, it has become clear that the Kuna value talent, learning, competence, productivity, and eclecticism. Furthermore, similarities exist in the structural principles guiding the verbal and performance arts and the visual arts. Parallelism and repetition with minor variation, subtle asymmetry, filled space, embellishment, and appropriate content—basic criteria for evaluating molas—are similar to those documented for Kuna speech, chants, lullabies, and flute music (Kramer 1970; Sherzer 1983, 1997; Sherzer and Sherzer 1976; Smith 1997).

Basic to Kuna ideology is the concept of *gurgin,* roughly translated as "talent." The Kuna believe that *gurgin* is distributed in varying degrees to all people by Muu, the spirit grandmother-midwife. One can have *gurgin* for any skill: hunting, political oratory, learning a foreign language, or making beautiful molas. Although endowed before birth by Muu, *gurgin* can be enhanced by the use of various medicines. Women who wish to improve their skill for sewing, soak plant leaves with interesting geometric designs in fresh

water. They bathe their eyes in this water to enhance their ability to see and create pleasing forms in their own work. They also soak leaves with geometric patterns and mold them into rounded shapes, burn them, and pass their hands through the rising smoke to improve their skills for cutting and sewing.

Artistic Criteria

The Kuna aesthetic system is based on the skillful manipulation of the technical process and the amount of work involved, together with design considerations, which include filled space, repetition with subtle variation, subtle asymmetry, visibility, complexity, and interesting subject matter. Kuna concepts of visual organization prescribe that designs should be generally balanced bilaterally and that all space requires filling. Both the right and left sides of a mola panel are more or less symmetrical. Main figures tend to be centered and balanced, and the filler elements in the background create a unified pattern. Mola panels are usually divided bilaterally along the vertical axis or into quarters. Motifs often occur in clusters of fours or eights, ritual numbers for the Kuna. Even though molas often appear symmetrical at first glance, the women actually emphasize subtle asymmetry in either the shape of the pattern, the color of the outlines, or the variation in the filler motifs.

Repetition constitutes an important element of mola design. Abstract patterns and space fillers—geometric designs, slits, triangles, or circles—are repeated over and over. However, the repetition undergoes conscious variation—either the shapes, the colors, or both, differ. Front and back panels are always of the same type, having similar color combinations and related subject matter, but rarely are they exact duplicates. Women often mention the importance of careful cutting and sewing as essential to creating fine molas. "Good" molas meet the basic rules of cutting and sewing, "Beautiful" molas are well cut and sewn, involve a great deal of work, are difficult to make, and prove pleasing to the eye. Skilled cutting creates good design. Molas are considered most beautiful if the lines are straight and have distinct, clear-cut edges, parallel sides, and even spacing throughout. The line on the top layer should be about one-quarter inch, the layer below even thinner, forming an even outline. The space on the base is usually a bit wider. The width of the line and the spaces between them should be even as in the boat mola shown in figure 6. Each time a woman cuts the fabric, she must sew it down. Women criticize broad, uneven lines, and careful sewing proves essential. Large, uneven stitches using unmatched thread evoke strong criticism. The stitches

should be small, evenly spaced, as hidden as possible, and made with thread matching the top layer.

What the Kuna refer to as seeing the design or visibility has mainly to do with contrast and color. Women explain that designs should stand out and that it does little good to go to the trouble of cutting and sewing several layers together if a viewer cannot see the design. Several factors contribute to the sense of contrast, including hard edges between colors, regular spacing, and the use of closed figures such as circles. The edges between the layers are as sharp as possible given the cloth medium. Women select fabric carefully to get a hard edge and choose high-quality cotton poplin with a tight, even weave.

Sergan Designs

Molas in collections from the 1920s to the present show innovative ways to create designs in fabric and a remarkable range of motifs, from the simplest geometric patters to complex pictorial designs with a concern for movement, realism, and perspective. As indicated, most types of molas made today are also represented in early collections. The answer to the question "What is this design?" is often simply "sergan" or "mugan." *Sergan* refers to the pattern and means "old" or "from the past," while *mugan* means "grandmother" and seems to refer more to the overall style and to carry the connotation of "old-fashioned" in a general sense. There are very few really old molas in Kuna Yala, in part because cotton fabric deteriorates quickly in the tropics and be-cause a woman's molas were generally buried with her. Furthermore, women have been selling their blouses to outsiders since the 1920s. Young women look to the grandmothers and their molas for inspiration. Many women are interested in photographs of old molas from museum collections and often trace the designs onto paper or fabric.

Some *sergan* designs are simple geometric patterns, while others are in-spired by patterns on baskets, beaded leg bands, and body painting, or from abstract designs based on images in nature or common household objects such as gourds, leaves, snakes, or wooden hangers used in the home. Some are easy to recognize, but others are so abstract that they require explanation. To create this type of abstract design, women scrutinize an object, often turn-ing it to view it from all angles, and reduce it to what they consider the basic components of its form, then repeating the design over and over (fig. 4).

Balbina Denis and Elvira Torres used this same technique to interpret the

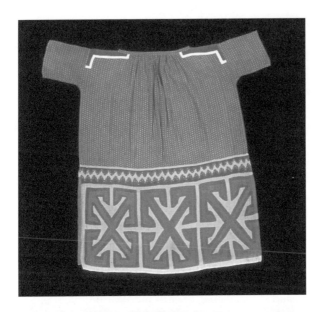

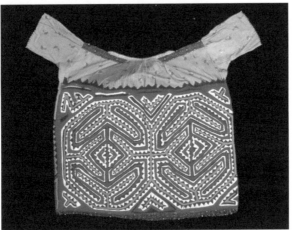

Top: 4. Mola blouse collected by Erland Nordenskiold,
c. 1927. A wide border with geometric patterns was sewn
along the bottom of a long, full blouse. *Photograph by
Mari Lyn Salvador, 1986.*

Bottom: 5. This multicolored (*mor gonikat*) frog-leg mola
was collected by Lady Richmond Brown in 1922. It is now
at the National Museum of the American Indian, Smith-
sonian Institution. *Photograph by Gina Fuentes, 1997.*

molas they saw at the National Museum of the American Indian in New York. They rotated the blouse to see it from all angles and focused on tiny details as well as the overall image in order to discern what the design represented. In some cases they figured out the design after exploring the molas carefully, tracing small areas with their finger and discussing the possibilities. They interacted with the blouse in the same way they interact with objects they depict in their mola panels. They quickly discovered that the design shown in figure 5 was based on a specific type of frog found in a particular part of the river. They explained that these frogs are used for medicinal purposes in Kuna Yala. Often Kuna women depict only selected parts of animals, not the entire body. Here only the stylized back legs are repeated four times in a design presenting them in opposing pairs. The mola panel is balanced bilaterally with the space divided into quarters, a common design technique. They also pointed out the use of *dientes,* teethlike edges. *Dientes* are considered a prestigious technique because it is difficult to cut and sew such small points. This mola, made in 1929, is a fine example of attention to detail in both content and technique (fig. 5).

Contemporary women say that they make better molas today than their grandmothers did in the past. They go on to explain that the grandmothers figured out how to make molas, experimenting little by little as they went, and that women now are improving the technique. Women who are fine mola makers have such a command of the process that they can make whatever they please.

Beginning in the 1980s, many women began to take a greater interest in grandmother molas. They enjoy looking at photographs of *sergan* designs from the 1920s and 1930s and have a keen interest in copying them. Nevertheless, they make it clear that they modify the motifs by refining the spacing and using different colors if they so desire. These changes reflect contemporary aesthetic taste. At a more general level, the interest in *sergan* designs reflects a widespread interest in the ways the Kuna have lived in the past at a time of introspection and rapid change in Kuna Yala.

An example of such a mola is shown in figure 6. This "boat mola" was considered a beautiful mola in all regards. The bodice and sleeves are made of precious, expensive fabric. The blouse itself has elaborate, handmade trim, a quality greatly appreciated by mola makers. It is an example of a *sergan* design done in a contemporary style. The design is an abstraction based on the outline of a canoe viewed from the side, combined with the outline of the prow viewed from inside the boat. Women are shown wearing molas with the same design in photographs from as early as 1908. Molas of this type, with inter-

locking designs (*obogaled*), tend to have a high level of preciseness and are particularly prestigious. Most of the *obogaled* molas the author has seen have been well made, perhaps because they require such a high level of skill that only expert women attempt to make them. Similarly, designs with thin lines that change direction radically, particularly in forty-five-degree angles, are difficult to cut and sew (fig. 6).

Traditional ritual and social activities also provide inspiration for molas. Girls' puberty ceremonies, curing rituals, and events in the gathering house are common themes. The mola in figure 7 illustrates activities associated with girls' coming-of-age ceremonies. The central figure on the left panel, the "keeper of braziers," wears a feather hat and necktie, a sign that he is an official, and holds two ceramic braziers used for burning cocoa bean incense. The other figures also form part of the festivities—two men play panpipes, others dance, and two play gourd rattles that accompany the chanting. Four and eight are ritual numbers for the Kuna—note that many design elements in this example are repeated either four or eight times. The two main figures on the right panel wear feather hats identifying them in their official roles during the ritual. They are smoking cigars with the lighted end in their mouths, the traditional fashion described by Lionel Wafer in 1699. The form placed between the figures with the cigars is based on the stool the ritual specialist sits on and probably stands as a kenning, a type of metaphor for the official himself (fig. 7).

Motifs from the Outside

The Kuna are protective of their traditional lifestyle, showing exceptional cultural resilience and continuity. Nevertheless, they are eclectic and do not oppose the incorporation of foreign elements into their expressive arts as long as they can be made to fit within their cultural criteria. Missionaries, anthropologists, doctors, military personnel, Peace Corps volunteers, and, more recently, shiploads of tourists have brought a wide range of new ideas and material goods to Kuna Yala. For the Kuna themselves, travel outside the *comarca* (territory) and long stays in urban centers have become common among many families. Elements such as scissors, elevators, and swivel chairs have now entered into the traditional narratives; helicopters, Santa Claus, Mickey Mouse, and product labels often appear as designs in molas as well. These outside elements are integrated in "Kuna ways." Women select the design elements they like and add to or rearrange the original composition.

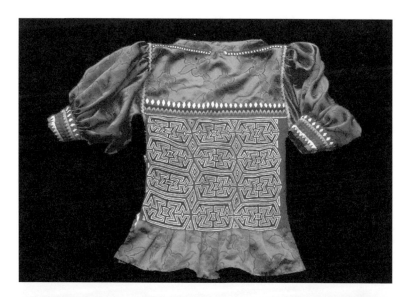

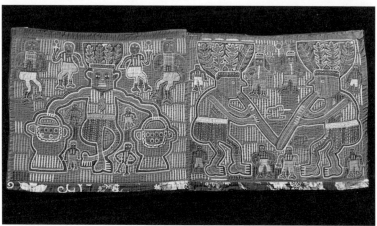

Top: 6. Canoe mola with interlocking design, *obogaled,* by Doralinda Denis. Kuna women took interest in this blouse and used it to explain what they meant by *yer dailege*—beautiful—and to show how designs from the grandmothers have been refined. *Photograph by Don Cole, 1997.*

Bottom: 7. *Chicha* mola, which illustrates a girl's puberty ceremony. It is a multicolored (*mor gonikat*) piece. *Photograph by Don Cole, 1997.*

Boats loaded with trade goods have been coming to Kuna Yala for decades. Colombian boats bring hammocks, household goods, coffee, sugar, cookies, and so on to trade for coconuts. Kuna cargo boats travel from Colón through Kuna Yala carrying clothing, canned foods, soft drinks, and sometimes even ice cream. Panamanian and imported products fill the stores and serve as a popular source of designs. Labels on cereal boxes, milk cartons, or matchboxes and needle cases, and graphics from soft drink bottles and tobacco cans are copied to appear on molas. The abundant supply of books, magazines, comics, and posters in Kuna Yala serve as inspiration as well. There are small libraries on several islands; missions have Bibles, catechism books, and religious pictures. Around election time political posters abound. Although Kuna Yala is an autonomous region, the Kuna vote in Panamanian elections. Mainland politicians come with flags and posters to campaign and Kuna women use these images and the symbols of their political parties in the molas they create. The mola in figure 8 shows a worker breaking the chains that enslave him. The main figure is represented quite realistically: his muscles are bulging, his hands are strong, and his eyes are cast upward. The chains are circles of fabric actually linked together, with the last one broken. The details from the poster on which it was based are realistic, but the subordinate figures are stylized (fig. 8).

Letters and phrases, such as "MOVIMIENTO NACIONAL LIBERACION" seen in figure 8, have been popular since the 1940s. Embroidered or cut out of fabric, they can identify the artist, the occasion for which the mola was made, or the subject of the design. Women take letters from the images they copy. Beyond the intention to communicate information, they use letters as decorative features and playfully fit them into the overall design, sometimes turning the cutout forms upside down or backwards.

Women and the Economy

Over the past thirty years, the Kuna economy has shifted from a system based mainly on subsistence and exchange to one based, at least in part, on cash. Well into the 1970s, coconuts were used for trade—products from the Colombian boats were traded for coconuts, which could also be used to purchase things in the Kuna stores. In recent years, as the need for cash has increased and coconut production has suffered from endemic blight and a weakening market, alternative pursuits have intensified. Men earn cash from

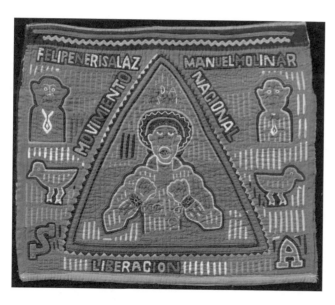

8. Political mola, multicolored (*mor gonikat*).
Photograph by Don Cole, 1997.

wage labor and the sale of lobster and octopus, while women make molas for sale.

For many years, Kuna men have left home in small numbers for months or years of wage labor, working in the plantations in Bocos del Toro, in the Canal Zone, or in Colón or Panama City. Since the 1970s, the flow of migrants has greatly increased, encompassing whole families drawn by the greater educational opportunities of the city as well as by paid employment. With the turnover of the canal to Panama, the number of jobs for Kuna men has been reduced. Furthermore, as foreign personnel left, a major source of clientele for molas diminished. With the challenge of general economic difficulties, Kuna women have expanded their strategies for marketing their artwork.

To this day, women mainly create traditional mola blouses to wear. Although they sew blouses for their young daughters and nieces and occasionally make a blouse for another woman who might not be able to sew her own, only rarely does a woman sell a mola to another Kuna woman to wear. Mola makers aim first to please themselves, along with their friends and family, taking pleasure in combining skirts and scarves as well as in designing the

mola panels themselves. After wearing blouses for some time, or when they are out of style, some women cut out the panels and sell them to tourists or merchants; thus foreigners constitute a significant second audience. Lady Richmond Brown, for example, mentions in her book that she bought sixteen hundred mola blouses during her travels in 1924. Scientists, missionaries, researchers, commercial buyers, and, more recently, hundreds of tourists have over the years bought thousands of molas and taken them back to their countries throughout the world.

Every year, January brings crystal blue skies, relatively calm seas, and cruise ships with thousands of tourists to the Carti area. Tours range from huge luxury liners, which dock just outside the reef and send tourists zipping around in speedboats, to smaller vessels that pull right up to the islands. As word spreads that a ship is due to arrive, women from nearby islands take molas, dresses, T-shirts, and a wide range of toys, beads, and small items to hang, in open-market–style, along the street or clustered in an open space designated for the purpose. Visitors stroll through the streets, buying products and taking pictures. Most transactions require cash, except on some islands with high tourist activity like Porvenir, where credit cards can be used (Swain 1977).

For decades, Kuna women have been sending molas to the city with the men in their families, who sell them to the doctors and military personnel, or market them to retail stores. Men often carry a few molas to sell when they travel abroad as well. Recently, with so many women living outside Kuna Yala, they market their own molas at street fairs or to retail stores. The Mola Co-op and other Kuna-owned mola production enterprises market a wide range of mola products locally and internationally. Over the past thirty years, a small group of Kuna women have become brokers or intermediaries. Some work for the Mola Co-op, while others have developed independent commercial businesses. These women travel between Kuna Yala and the city, buying molas, commissioning products, and bringing information regarding marketing to the islands. As mola makers themselves, they are familiar with the process; they make an effort to understand what the consumers like and to communicate to the producers a sense of outsiders' current taste. They design products they think will be appealing and marketable.

Over the decades, a vibrant commercial line of mola products, often made in nontraditional forms, has been developed to sell to outsiders. Rectangular panels reminiscent of those taken from traditional mola blouses are made with simple figures and simple background filler. Called *turista molas,* these are made, sometimes rapidly, especially to sell, with simple designs and wide

9. Stuffed fish made for the Mola Co-op, 1997. The design is based on scientific illustrations of fish in Kuna Yala. *Photograph by Don Cole*

spacing, at the expense of good quality. Well-made tourist molas with fine stitching look more like traditional molas, except for the slightly more open space and pastel colors. T-shirts with all kinds of mola designs or mola trim are available for tourists, as are mola headbands, purses, jackets, vests, dresses, and swimsuits.

The pastels and distinct color combinations found in these products have not been integrated into women's own mola blouses. Some women who wear Panamanian-style clothing put mola pockets or trim on their dresses, and they sometimes make sundresses with mola work for young girls, but they do not use the mola products that they make for tourists.

The Mola Co-op

Clothing, pillows, stuffed animals, Christmas ornaments, and many other novelties using mola work, designed and made by members of the Mola Co-op, are marketed in Latin America, Canada, Europe, and the United States, as well as in Panama (fig. 9). The Mola Co-op, La Cooperativa Productores de Molas, R.L., which started as a Peace Corps project in 1966, now has twelve hundred members in Kuna Yala and in Panama City. The co-op has fifteen co-op houses in Kuna Yala, owns one store on the island of Porvenir, and a workshop and two retail stores in Panama City (Tice 1995).

Co-op members elect officers and the president; an accountant, the manager, and other staff work for the co-op in Panama City. The workshop always exhibits a flurry of activity. Women cut up bolts of brightly colored fabric

and trim stacks of material with an electric cutter into the shapes of birds, fish, turtles, and lions, pillows, handbags, and items of clothing. The cut fabric is sent to Kuna Yala, where co-op members select the pieces they want to work on. They create the mola work and attach a tag with their name and co-op number on it. The pieces are then returned to the co-op house on their island, where the products are checked for quality, placed on the inventory list, packed, and sent back to the workshop in Panama City to be made into the finished products. Sewing machines are used to sew the seams of dresses, handbags, and many other objects, but the mola work itself is always done by hand. The co-op does not accept mola work with machine stitching. The staff takes and fulfills wholesale orders, maintains inventory, and travels abroad to represent Kuna women and market co-op products. The co-op is now working with Peoplink to market their products internationally at www.catgen.com/home/coopmola.

The Mola Co-op has become a significant economic institution and a unifying social context for Kuna women living in the city, as well as for those living in Kuna Yala. The administrative staff works with international development specialists to create seminars on the principles of cooperativism, leadership, production, quality control, management, and accounting. Women in the co-op stress the value of the companionship between members and are clear about the importance of the institution. Rosa Angela Martínez, the past staff accountant, speaking of the importance of the co-op, explained, "Cooperativisim — you need to understand the term, what it means . . . to teach and to help one another. You help me and I help you. If you don't know how to do this, I'll teach you."

Over the past twenty years, women have developed a strong business in the sale of molas and mola artwork, and they play an ever intensifying role in the economy. Beyond purchasing fabric to make new mola blouses and buying jewelry for themselves, these women now provide cash to purchase food, medicine, household commodities, uniforms, and school supplies, to send their children away to school, and to support family members living outside Kuna Yala. Given their contribution to the economy, many Kuna women are currently raising issues regarding an increased participation in the decision-making process and are expressing their desire to gain a stronger voice in politics.

Although the primary mode of artistic expression for women is visual, while it is verbal for men, the visual and verbal arts are not strictly gender exclusive. Some men make molas, while some women engage in verbal arts. Lullabies sung to children by their mothers, sisters, or female relatives pro-

vide children with their earliest exposure to language, song, and the ways of Kuna life. Women occasionally give speeches at the Mola Co-op and the village gathering house when the subject is of interest to them. Likewise, men create visual arts, such as carved wooden figures, authority canes, baskets, and decorated canoes. Anthropologists have noted several dominant principles of Kuna aesthetics over the years. Perhaps the most apparent principle is balance, especially balance between pairs, of which the prime example is man and woman. This principle emerged strongly in discussion with Kuna experts who came to the National Museum of the American Indian in October 1996. Balbina Denis noted, "Iberogun nos dijo que no vivan solos, ni hombres ni mujeres, siempre en pares, y por eso todo viene en pares" [Iberogun told us not to live alone, neither man nor woman, and for that reason everything comes in pairs].

Reference List

Bell, Eleanor Yorke. "The Republic of Panama and Its People." In *Smithsonian Institution Annual Report for 1909*, 607–37. Washington, D.C.: Smithsonian Institution, 1910.

Brown, Lady Richmond. *Unknown Tribes, Uncharted Seas*. London: Duckworth and Co., 1925.

Chapin, Mac. "The World of Spirit, Disease, and Curing." In *The Art of Being Kuna: Layers of Meaning among the Kuna of Panama*, ed. Mari Lyn Salvador, 219–44. Los Angeles: UCLA Fowler Museum of Cultural History, 1997.

Howe, James. *The Kuna Gathering: Contemporary Village Politics in Panama*. Austin: University of Texas Press, 1986.

———."The Kuna and the World: Five Centuries of Struggle." In *The Art of Being Kuna: Layers of Meaning among the Kuna of Panama*, ed. Mari Lyn Salvador, 137–45. Los Angeles: UCLA Fowler Museum of Cultural History, 1997.

Kramer, F. *Literature among the Cuna Indians*. Göteborg, Sweden: Göteborg Ethnografiska Museum, 1970.

Salvador, Mari Lyn. *Yer Dailege! Kuna Women's Art*. Albuquerque, N.M.: The Maxwell Museum of Anthropology, 1976.

———. "Looking Back: Contemporary Kuna Women's Arts." In *The Art of Being Kuna: Layers of Meaning among the Kuna of Panama*, ed. Mari Lyn Salvador, 151–211. Los Angeles: UCLA Fowler Museum of Cultural History, 1997.

———, ed. *The Art of Being Kuna: Layers of Meaning among the Kuna of Panama*. Los Angeles: UCLA Fowler Museum of Cultural History, 1997.

Sherzer, Dina, and Joel Sherzer. "Mormaknamaloe: The Cuna Mola." In *Ritual and*

Symbol in Native Central America, ed. Philip Young and James Howe. Eugene: Department of Anthropology, 1976.

Sherzer, Joel. *Kuna Ways of Speaking: An Ethnographic Perspective.* Austin: University of Texas Press, 1983.

———. "Kuna Language and Literature." In *The Art of Being Kuna: Layers of Meaning among the Kuna of Panama,* ed. Mari Lyn Salvador, 103–36. Los Angeles: UCLA Fowler Museum of Cultural History, 1997.

Smith, Sandra. "The Musical Arts of the Kuna." In *The Art of Being Kuna: Layers of Meaning among the Kuna of Panama,* ed. Mari Lyn Salvador, 293–310. Los Angeles: UCLA Fowler Museum of Cultural History, 1997.

Swain, Margaret. "Cuna Women and Ethnic Tourism: A Way to Persist and an Avenue to Change." In *Hosts and Guests: The Anthropology of Tourism,* ed. Valene L. Smith. Philadelphia: University of Pennsylvania Press, 1977.

Tice, Karin E. *Kuna Crafts, Gender, and the Global Economy.* Austin: University of Texas Press, 1995.

Wafer, Lionel. *A New Voyage and Description of the Isthmus of America.* 1699. Ed. George Parker Winship. New York: Burt Franklin, 1970.

Connections

Creative Expressions of Canelos Quichua Women

On a hot, humid September day in southern Illinois, Estela Dagua and Mirian Vargas, a mother-and-daughter team from Puyo, Pastaza province, Amazonian Ecuador, were giving pottery demonstrations to forty-two high school art students from Pinkneyville. They were teaching traditional Amazonian techniques of hand coiling, burnishing, and decorating thin-walled bowls and jars. The next day they continued to show methods of painting and firing to more art classes from Bellevelle College and Sesser High School; about one hundred students traveled to the Southern Illinois Arts and Crafts Market Place, Rend Lake, to learn from the Amazonian potters.[1]

These demonstrations, as well as five previous ones at Southern Illinois University, Carbondale, and John A. Logan College, Cartersville, used materials shipped from Ecuador: nearly four hundred pounds of pottery clay from three different mines, chunks of rock-hard clays for paint pigments, big slabs of resins to lacquer and waterproof, smooth special stones for burnishing, dried bottle gourd and calabash scrapers and paddles, and tiny hairbrushes to paint fine lines. The potters were bilingual in Quichua and Spanish. They gave their explanations and answered questions in Spanish, translated by Norman Whitten Jr. Camcorders and flashing cameras did not appear to faze them, although neither had ever experienced such public scrutiny. Before they came to Illinois, they had only flown in a single-engine Cessna once or twice, yet they thoroughly enjoyed the jet ride to the United States, the onboard breakfasts and lunches, and the movie *The Babe* about

Babe Ruth. Traveling with our party—Estela Dagua, Mirian Vargas, and Norman and Dorothea (Sibby) Whitten—was a young man, Sergio Gua-linga, from Sarayacu, Pastaza province. This is the region where Estela was born and where she spent her formative years. Sergio was on his way to assist Dr. Janis Nuckolls in her translation of Quichua material and in her Quichua classes at Indiana University, Bloomington (Nuckolls 1996, viii).

Both mother and daughter were sporting newly permed hairdos and traveled with sensible wardrobes of jeans and T-shirts. Far from the popularized images of feathered and painted Amazonian indigenous people, they in many ways resembled and blended with their student audiences. After they answered questions about what they liked about the United States, particularly Southern Illinois—seeing deer emerge at dusk from the Shawnee National Forest was a high point—one Pinkneyville student exclaimed, "Why, they're just like us!"

During their two-day sojourn at Rend Lake, they met the regional director of tourism for Southern Illinois; were taken on a tour of a nearby fish hatchery, open after hours just for them; visited a new tourist facility, where the gift shop interested them greatly; and received VIP treatment at the local coal mine. After the tour, the manager presented a specimen of Illinois coal to each of them. The remnants of the only gift they left behind in Urbana are still visible below my office window as I write. On the way to the coal mine, our hostess (manager of the Arts and Crafts Market Place) stopped by a Sesser High School football practice to introduce the potters to her son and other players, including a Norwegian exchange student. Mirian learned to throw a forward pass, but more important, they got an up-close look at football uniforms. They had been intrigued by this gear, particularly the heavy padding and the strange helmets, ever since they attended the University of Illinois football opening game against Northern Illinois University, four days after their arrival in Urbana. The next day, Sunday, they studied the Chicago Bears' televised game and by Monday (Labor Day) they were sitting on our back porch watching the birds and squirrels, busily creating the first known pair of Amazonian pottery football players.

Estela and Mirian were accompanied on their southern Illinois tour by Norman and Sibby Whitten and their arthritic black cocker spaniel, Charger, all traveling in a University of Illinois van packed to the ceiling with buckets of clay, a huge pile of bamboo that had been trucked to Urbana from Miami, other pottery paraphernalia, clothing, and picnic supplies. After meeting the director of the department of ceramics, Southern Illinois University–Carbondale, and unloading bamboo and clay, we visited the university mu-

seum. The current exhibition, *Causáunchimi! "We are Living!" Ceramics from the Canelos Quichua* (1 March–18 December 1992), contained around one hundred pieces of ceramics, traditional and innovative, made by a number of women from Pastaza province, home of Canelos Quichua culture.[2] Works by Canelos Quichua men were also featured: decorative bead and feather headdresses and necklaces; musical instruments; and wood carvings—traditional hardwood stools, large flat bowls and pestles for pounding cooked manioc, shaped boards for rolling pottery coils—and recently carved balsa birds, a commercial enterprise that draws on the vibrant imagery of the rain forest.

The potters first studied their own contributions before moving on to examine and discuss every other item on display. Ceramics by Estela included an elaborately decorated *tinaja aswa churana manga*, a large, round-bellied jar in which cooked manioc pulp is fermented and stored before being mixed with preboiled water and served in delicate painted bowls, called *mucawa*. Her contributions also included two glistening smoke-blackened cooking pots, one made to cook manioc roots, the other to brew *Banisteriopsis caapi*, the hallucinogenic drink known to Quichua speakers and others as *ayahuasca*. Additionally, she had created over the past several years a number of figurines designed explicitly to teach us and the outside world about mythical and spirit beings significant in Canelos Quichua cosmology. Among them were the mean monkey person, the embodiment of outside disruption; water spirit people and fish representing the power of the hydrosphere; *cachi amu*, overseer of salt, and a bracket fungus, which respectively portray symbolic elements of the myths of the origin of salt, sun, and seed beads, and of soul restoration and resurrection of man. A segment of the exhibition, labeled "Control of Power," displayed shamanic paraphernalia and items that symbolically depict facets of shamanic power. One was Estela's figurine Wanduj Warmi, feminine spirit master of the hallucinogen datura (*Brugmansia suaveolens*). A shaman's ability to send deadly spirit darts to enemies was represented by a ceramic scorpion, its stinging tail arched high over its back, made by Denise Curipallo (Apacha) Vargas, Estela's *comadre* (the godmother, seen from the point of view of the child's godfather or parent) from whom she first learned her pottery skills in the hamlet of Unión Base. I will return to design motifs and symbolism later.

Mirian lingered over her shaman's set, a group of small figurines depicting a patient and his supplicant or intercessor, the shaman's assistant, and the shaman, sitting on his seat of power, surrounded by his cleansing and curing tools: a leaf bundle, a rolled-up cigar of native tobacco, several spirit stones,

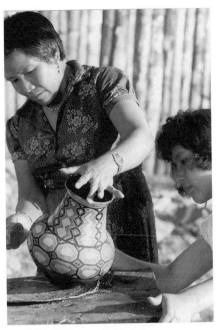

1. Estela Dagua and Marian Vargas apply resin to a small storage jar, 1993. *Photograph by Norman E. Whitten Jr.*

Below

2. Apacha Vargas and Estela Dagua preparing to visit the exhibition *Causáunchimi* in Quito, 1987. *Photograph by Norman E. Whitten Jr.*

and a gourd bowl for drinking *ayahuasca*. She created her shaman's set to instruct others about Canelos Quichua peoples' abiding belief in the powers of shamanism, just as Alfonso Chango intended when he wrote and illustrated his book *Yachaj sami yachachina* [Shaman's class knowledge] (Chango 1984).

By the end of the eleven-day tour, the women had given six eight-hour-long demonstrations in five locations, and they produced some thirty to forty pieces of pottery in spite of having to adjust to faster drying conditions, improvising with local woods to supplement the thin Florida bamboo, and packing up everything, including greenware, unpacking and repacking repeatedly. We were all tired and relieved to get home to Urbana, but after a day's rest, the potters graciously accepted invitations to give a few demonstrations at the Ceramics Studio and the department of anthropology, both on the campus of the University of Illinois at Urbana-Champaign. Before these sessions were completed, however, a friend and buyer from California came to Urbana and flew them back to Berkeley to give a lecture and demonstration at her mother's gallery. A quick tour of San Francisco, a moonlight champagne dinner cruise on the San Francisco Bay, and they were back in Urbana within three days, bringing with them their champagne flutes. The prairie winds of late September were getting stronger and colder, practically ruining their last two attempts at outdoor firing, but strengthening their feeling that it was time to return to their tropical Pastaza homes.

Pastaza province, comparable in size to Guanajuato state in Mexico, the Republic of Haiti, or the North American state of Maryland, is the second largest province in Ecuador but one of the least populated.[3] It is bordered on the west by the Pastaza River, gushing from its sources near the Andean Cordillera de los Llanganatis to its juncture with the Marañón in Amazonian Peru. From its western backdrop of Andean foothills, the territory gradually descends to the low-lying true Amazonian rain forest in the areas of Montalvo (on the Bobonaza River) and Curaray (on the Curaray River), and other sites further east. The province is home to six indigenous cultural groups—Shuar, Achuar, Shiwiar, Canelos Quichua, Záparo, and Guaraní—who identify themselves as separate *nacionalidades* (nationalities). Canelos Quichua constitute the largest population; there are probably only a handful of Zaparoan speakers, but more people are reclaiming this heritage and they are recognized nationally.[4] A few dedicated Shiwiar are undergoing a sort of cultural revival and struggling for recognition as their own people, distinct from Shuar and Achuar. All indigenous and nonindigenous populations maintain a strong identity as residents of Pastaza.

The major indigenous language of Ecuador, Quichua, is spoken through-out the Sierra and the Oriente, as the Amazonian region is often called. It comprises many Ecuadorian variants of Quichua, the language of the im-perial Inca, which is spoken by millions of people in Peru and Bolivia, and by some people in Colombia and Argentina. Canelos Quichua take their name from their supposed heartland, Canelos, and the speakers also identify them-selves by the place-names of their *quiquin llacta,* the place of origin of their ancestors. Hence people from riverine sites such as Puyo, Pacayacu, Sara-yacu, Villano, or Moretecocha could call themselves Puyo Runa (*runa* means "human, human being," and their language is called *runa shimi,* "human speech"), Sarayacu Runa, and so on. Quichua speakers live in hamlets and dispersed settlements in these and numerous other sites scattered through-out much of the province, but the majority live in an arc surrounding Puyo, capital of the province, and within the city and its ever-growing outskirts.

Puyo, according to the official history publicized by the municipality, was established on 12 May 1899 as a Dominican mission to Christianize indige-nous people living along the eastern banks of the Pinduc (also Pinduj, now Pindo) River and to offer them refuge from marauding, bellicose peoples who invaded from the southern and western areas.[5] Because of its location, Puyo provided a convenient midpoint stopover for missionaries traveling from Andean Baños via the Pastaza Valley to Canelos, the Dominican base mission east of Puyo, and from Canelos to Baños: two or more rugged days of riding on mules (for the missionaries) and walking (for the native cargo-bearers), a rest, then two more days of harsh travel in either direction.

Although there are different versions and interpretations of the data and circumstances of the founding of Puyo, there seems to be general agreement that the original hamlet consisted of a cluster of indigenous homes and the mission building (or buildings). Alfonso Chango has drawn a map, based pri-marily on the recollections of his mother, Clara Santi Simbaña, that shows eighteen or nineteen indigenous families living in earliest Puyo.[6] Puyo, by the way, derives from *puyu,* which means "fog" in Quichua. Colonists from the Sierra began arriving in the early 1900s, and by 1931 the population of Puyo reportedly included seventy-eight indigenous and thirty-one colonist families.[7] The trickle of colonists became a flow as a road inched its way from Baños to Puyo, following the old foot and mule trail high over the Pas-taza gorge. Begun in the late 1920s, the road reached Puyo in 1947, the same year that president José María Velasco Ibarra established the Comuna San Jacinto del Pindo several miles south of Puyo. He did so in response to a peti-tion from indigenous leaders who expressed their constituents' need for their

own territory in which to live their own lives free of the now overwhelming colonist presence.

Clara Santi and Apacha Vargas, both master potters and daughters of two well-known men who were among the original founders of Puyo, have shown the Whittens the locations of their own and other families' homes around what is now the central plaza of Puyo. They have done this repeatedly over the years; their histories are complementary and unchanging. Apacha poignantly recalled, in a 1982 interview for a local publication, how she lived in Puyo as a child, when there were no roads, no cars, people worked with machetes, and missionaries knew how to walk from Baños. Then came white colonists, gradually taking over the land with the help of government decrees and agencies (Ruiz et al. 1984–98, 25–26).

Having survived progressive waves of intrusions that came and left, indigenous people finally succumbed to permanent colonization: by 1955 virtually all of them had relocated to the Comuna San Jacinto del Pindo. By 1990 a reverse process was underway due to two major factors. With every ensuing generation, pressure for land in the comuna became more intense as each family's designated area eventually had to be divided among its children (frequently six, eight, or more) and then subdivided among their heirs. As tensions and conflicts over scarce land in the comuna increased, the Dominican mission in Puyo started selling lots, parcel by parcel, within a largely uninhabited territory between a Dominican school and the Pindo River. Indigenous families soon moved in, obtaining lots by whatever means they could, building small houses, but still maintaining their swidden gardens in the comuna for sustenance. A number of them were engaged in the popular ethnic-tourist art industry of carving and painting balsa birds.[8] There eventually appeared a pattern of an ongoing collective enterprise. As more family members joined the wood-carving industry, their increased (if slight) prosperity allowed them to secure adjoining lots, build houses, and bring in still more relatives. Within six to eight years, a number of extended families had recreated a small-scale version of their traditional *ayllu* and *llacta* systems.[9] This area on the edge of Puyo continues to expand and in 2002 is home to an estimated several hundred indigenous people, from both the comuna and other parts of Pastaza, and scattered mestizo families.

Puyo today probably has the most dependable supply of electricity in the country; its source is the Agoyán hydroelectric dam, located just east of Baños, and it is powered by the Pastaza River. Telephone, television, and electronic communications link Puyo to the rest of the nation and hence to most of the world. The steadily increasing infrastructure of roadways and air strips

has greatly increased the mobility of people from outlying areas: Canelos is now two hours from Puyo by car, three by bus, and an hour's flight from Shell in a one-engine plane will take one to the farthest reaches of the province.

Four months before Estela Dagua and Mirian Vargas traveled to the United States, a different sort of journey was launched from Puyo. This was the Caminata of 1992, a peaceful march from Puyo to the national capital, Quito, by Pastaza Runa (used here to refer to the collective *nacionalidades* of the province, including Achuar and Shiwiar) to petition the president, Dr. Rodrigo Borja Cevallos, for the rights to their own lands and hence the right to control their own livelihood (Whitten, Whitten, and Chango 1997). The march was propelled by Antonio Vargas Guatatuca and OPIP (Organización de Pueblos de Pastaza, Organization of Indigenous Peoples of Pastaza), of which Vargas was president. It was supported by CONFENIAE (Confederación de Nacionalidades Indígenas de la Amazonía Ecuatoriana, Confederation of Indigenous Nationalities of Amazonian Ecuador) and CONAIE (Confederación de los Pueblos Indígenas de Ecuador, Confederation of Indigenous Peoples of Ecuador) with funding in part by the Rainforest Action Group. The OPIP office was located in the center of Puyo; the headquarters of CONFENIAE were located south of Puyo, on a hill overlooking the hamlet of Unión Base, home to Antonio Vargas. The overarching national organization CONAIE was housed in Quito. The logistics of the march obviously demanded careful planning and coordination by the organizations: support groups provided food, blankets, medical care, and other necessities along the entire route.

On the rainy morning of 11 April, roads were jammed with people walking from Unión Base into Puyo to join many others who swarmed into the central plaza. When nearly all were assembled, a pottery trumpet was blown from somewhere in the crowd. People stood in the downpour to listen to leaders from provincial, regional, and national organizations give speeches. The most moving of these came from Dr. Luis Macas, president of CONAIE. After they had spoken Macas, Valerio Grefa (president of CONFENIAE), and other leaders joined the serpentine mass of people, which the feathered headdresses, bead and bone necklaces, and black and red face paints worn by marchers rendered colorful (Kipu 1992a, 5). People crowded into the cathedral for a special mass celebrated by Monseñor Victor Corral, bishop of the Andean city of Riobamba and head of the indigenous ministry of the Catholic church. The bishop blessed the march as a sacrifice "worthy of being justly examined by the Government and by the Ecuadorian people" (Kipu 1992a, 5). The people reciprocated by presenting a feather headdress to the bishop.

3. Clara Santi Simbaña and José Abraham Chango reenact their performance during the Caminata of 1992. *Photograph by Dorothea Scott Whitten.*

According to *El Comercio* (23 April 1992), reprinted in Kipu (1992a, 79), representatives of 148 indigenous communities of Pastaza province took part in the so-called March for Land and Life. Among them were Apacha Vargas, Clara Santi and her husband, José Abraham Chango, an older brother, Camilo Santi Simbaña, and a younger brother, Marcelo Santi Simbaña, and his wife, Faviola Vargas Aranda. Children accompanied their parents, many of whom have shared their lives with the Whittens since 1968 and the early 1970s. Once they safely reached Quito, mayor Rodrigo Paz allowed them to settle into El Ejido park, where they camped for twenty days, awaiting results from the drawn-out negotiations with government officials. During this period, a number of marchers engaged in dialogues with curious onlookers from all walks of life. They talked a great deal about their environment, which they hoped to bring under indigenous control once again through nationalist legal commitment, action, and compliance. They tried to communicate the meaning of mythic time-space (*unai*) and its transformation (*tucuna*) into beginning times-places (*callarirucuguna*) through times of destruction and ancestral times into the future (*caya*) — that future, which they were now trying to take into their own hands, bound through these transformations to enduring indigenous history. Speakers patiently explained male shamanic power and female visionary power, the latter manifest in women's creation of songs and fine hand-coiled Upper Amazonian ceramics.[10] Clara composed songs about the march, and she and other women even gave demonstrations of their pottery-making skills, using clay and mineral paints brought from Amazonia by leaders of CONFENIAE.

The marchers returned to their homes on 14 May, having gained titles to well over a million hectares of land, divided evenly among OPIP and two opposing indigenous organizations, FEDECAP (Federación de Desarrollo Campesino de Pastaza, Federation of the Development for Small Farmers of Pastaza) and AIEPRA (Asociación de Pueblos Indígenas Evangélicos de Pastaza, Association of Protestant Indigenous People of Pastaza). The resale and subsurface exploration of minerals and petroleum were prohibited, and the rights of colonists living on previously occupied or allocated land remained protected. Pastaza Runa had established themselves as an active force in the national political scene, but some, particularly Clara Santi, felt that other people did not understand the message she and her brothers had tried to convey about their culture and about the very nature of indigenous concepts of territoriality.

To understand Clara's concerns, we must turn to the pottery tradition, because it embodies the symbols and knowledge that link environment to people and people to cosmos. Today Canelos Quichua potters continue to demonstrate their remarkable adaptability to modern life on the one hand, and a strikingly apt reference to their enduring traditions on the other. The integration of tradition and modernity, of continuity and change, is graphically represented by their thin-walled, coil-built ceramics. We return to the power of music, also of major significance, later.

The production of *aswa* is basic to the creation of Canelos Quichua decorated vessels. *Aswa* is a mildly fermented food beverage fundamental to the group's diet. Women cultivate and carefully prepare the manioc from which they make *aswa* by boiling cleaned, peeled roots of this earth vegetable also known as cassava, or yuca. Cooked roots are pounded into a pulp in a large, flat wooden bowl. Some of the pulp is then gently chewed to provide the proper yeasts for fermentation, which is necessary for storage in the moist tropics. An enzyme in the saliva, ptyalin, converts starch into dextrine and maltose. Yeasts that cause fermentation also supplement the scant vegetable protein of the starchy root.

Both spheres of activity—making ceramics and making *aswa*—are the exclusive domain of women. Their array of polychrome vessels include large jars in which manioc pulp ferments and is stored, bowls to serve *aswa* every day to household members and guests, and special bowls and figures to serve *aswa* during periodic ceremonies and festivals. In addition, they make blackware pots to cook manioc, other foods, spices, or drinks, and blackware bowls to serve cooked food.[11] Kelly and Orr (1976), Norman E. Whitten (1976, 1985),

and Whitten and Whitten (1978, 1988, 1989, 1993b) describe the technology of ceramic production.

Three spirit masters serve as dominant symbols to the Canelos Quichua and in one or another transformation come to be represented in ceramic art. These include Sungui, spirit master of the water domain; Amasanga, spirit master of the rain forest; and Nungüi, the spirit master of garden soil and of pottery clay. The first two may be male or female or androgynous, but Nungüi is strictly feminine.

Peak creativity occurs when a woman prepares an array of pottery for a festival. She draws on her cultural heritage, her ecological knowledge, and her personal observations to recreate ancient images. The festival offers a time of conceptual expansion, when everything—animals, plants, spirits, and souls—is regarded as existing in the contemporary, living, sentient, indigenous world. Many life forces are represented by special effigy jars made with spouts to serve *aswa*. Music is integral to the festival, for it is through music that people transcend everyday life to communicate with the spirit world. Men play flutes and beat drums; the tremolo of their nearly synchronized drumming represents the thunder of Amasanga, just as the buzz of the snares signifies the spirit bee-helpers that come to a shaman entering séance. Frequently, a woman makes a ceramic trumpet and fills it with *aswa* to serve to a prominent man. After he finishes drinking all of the contents of the trumpet, he blows it, replicating the echoing sound of *yami*, the tropical bird known as trumpeter, *Psophia crepitans*. While other men continue to drum and play flutes, he again blows the trumpet—creating a long, honking sound—as he leads a procession of the festival crowd from one main host house to the other, then back to the first, and so on throughout the ceremony, which may last three days. People tell myths and exchange songs, evoking imagery of the past while incorporating their experiences of the present. Sometimes, people sing silently to themselves, just as women often do when making pottery.

In addition to the household and ceremonial uses of pottery, I have mentioned several instances of women who want to communicate their cultural values to an outside world by making ceramics for museum display. There is also an important commercial value involved. Potters and/or their husbands have long sold bowls, figurines, and even jars left over after a ceremony. Any number of women currently produce items to sell in the ethnic-tourist market, either sporadically or regularly, to supplement the family income. Quite a few women sell or trade their ceramics to obtain modern medical care for

themselves and their families, especially for their children. Their trust in contemporary Western medical care coexists with their belief in shamanic practice.[12] Unfortunately, certain commercial pressures emanating from Quito are forcing some pottery production into a mold. This results in crudely made items that sell for low prices and in economic exploitation of the potters who are not fully paid until their work is sold. Potters placed in this predicament must make two or more trips to Quito, at their own expense, to receive their pay.

Until fairly recently, all women of Canelos Quichua culture were expected to make pottery for their families' needs, but this is no longer the case. Some young women are extending their education beyond the mandatory six primary years and are going on to complete secondary school, technical and professional courses, and college programs which qualify them to work as secretaries or teachers or to take active leadership roles in indigenous organizations. Others may spend a few years in domestic service for nonindigenous families, both locally and in the Andes, before returning home to marry and rear their own children. Pressures to migrate—economic need, internal conflict within kin groups, shamanic feuds, to mention only a few—may place a woman far from a source of good pottery clay. This constitutes an incomplete list of factors that have contributed to the gradual decline in basic pottery skills of some women. To remedy this perceived problem, OPIP has attempted to hire a few master potters to give courses in areas it deemed lacking in pottery-making knowledge. How successful such courses were, and are, remains to be seen. If the production of ceramics seemed to be disappearing in some places, it has remained vibrant in Puyo and its immediate environs for about twenty years. The rest of this essay deals with women who have maintained their skills and who balance traditional knowledge with modern experience to create outstanding ceramics.

A girl may learn to make pottery at her mother's knee, or she may learn later from her mother-in-law or another close female relative. The actual production of pottery varies according to immediate circumstances, which change as a woman moves through her life cycle. Creative ability is different for each woman; the highest level of skill is achieved by those whose mastery of knowledge allows them to control and project the symbolism of their universe. Potters of this stature are generally regarded as *sinchi muscuj warmi,* a woman of strong vision or images. Women who express powerful images through their songs are also called *sinchi muscuj warmi.*

Amazonian pottery impressed early European explorers, particularly Fran-

cisco de Orellana and Hans Staden, in the 1500s. Some three hundred years later, the British naturalist Richard Spruce traveled through the heartland of the Canelos Quichua people and noted the constant use of delicate ceramics, even during canoe trips. On the basis of his field research in Upper Amazonia during 1916–19 and 1928–29 and additional museum research, Rafael Karsten (1935) identified the various ceramic styles of indigenous people in this region of Peru and Ecuador. He noted the fragility of the clay and added that "certain magical or animistic ideas seem to be associated with the very material used." He thought that the Canelos people in particular brought their ceramic art "to a remarkable degree of perfection" (99–100).

Estela Dagua, one of the *sinchi muscuj warmiguna* who have brought their ceramic art "to a remarkable degree of perfection," has survived a difficult early life to become the best known Canelos Quichua potter to date. Her ceramics are sold, among other places, at several prestigious galleries in Quito and at a few locations in the United States. One of the Quito shops has a second gallery in Cuzco, Peru, and in both sites Estela's creations sit next to elaborately decorated Shipibo-Conibo pottery. In her home, she has received numerous visitors from the United States, Germany, Switzerland, England, and France. Often attracted to her and her work through the publication of *From Myth to Creation* (Whitten and Whitten 1988), they come to study with her for a few days, to place special orders, or just to watch and purchase two or three pieces. A guide from Baños periodically stops at her house, unleashing a vanload of curious, gawking, questioning tourists. She takes all this in stride, just as she has done with more serious trials in her life.

When Estela was quite young, probably in her early teens, her ailing father died, leaving the family without a strong kin network or solid territorial base. After several years of unsettled living, trekking from place to place, her mother remarried a Shuar, and Estela and one brother moved to Unión Base, a hamlet of the Comuna San Jacinto del Pindo, in about 1970. Shortly thereafter she married Luis Vargas, who had recently returned from working in Ambato to reside with his uncle, Severo Vargas (the second). His sister, Apacha, was currently living there and became Estela's first mentor in ceramics. Another master potter, the late Pastora Guatatuca, was also a strong influence in Estela's acquisition of knowledge and skill. Pastora, whose photographs were featured in an article in *Natural History* (Whitten and Whitten 1978), decorated her bowls and jars with strong anaconda designs. While working on her swidden garden in 1988, she was struck in the neck by a huge fer-de-lance and died before she could receive medical attention. She did not

live to see her son, Antonio Vargas Guatatuca, rise to political prominence as president of OPIP, leader of the Caminata, later president of CONAIE, and for a couple of hours in 2000 member of the governing junta of Ecuador.[13]

Within four years, Estela and Luis found themselves in the same situation that she, her mother, and siblings had suffered through, with no land and no strong kindred support in Unión Base. They trekked through the rugged, hilly rain forest to Canelos, then to Villano where they eked out an existence for two more years. When Luis took a job with a petroleum exploration company in 1976, Estela returned to Puyo to live and work. Unable to find a residence, she went to live with her mother in the Shuar hamlet of Kunguki, on the Sigüín Range south of Puyo. In 1980 she obtained a five-year "loan" of a tiny plot of land in Puyo in exchange for Luis's free, part-time labor. They built a small wood house, he continued to take contract jobs, usually to cut lumber in the rain forest, and she dedicated herself to making and selling pottery to feed, clothe, and educate their five children.

In the spring of 1987, the landlady sent a bulldozer to knock down the house. She claimed it was to make way for a new street, but Estela firmly believed that the woman was jealous of her because she was successful in selling pottery and "had too many visitors," some indigenous, some foreign. As the bulldozer roared closer and closer to the house, Estela tried desperately to finish firing a large *tinaja* in spite of a drizzly rain; from the radio still playing inside the house came the strains of the sign-on tune of the Catholic radio station's classical music hour—"Ode to Joy." To interfere or intervene in the conflict would only have heightened the tension between Estela and the landlady; we, who were visiting, had to leave the scene and help later, in other ways. On our way home, we stopped by the house of Rebeca Gualinga, another master potter from Sarayacu noted for her vast repertoire of myths and for figurines representing the spirit world.[14] We intended to tell her about Estela's misfortune, but she already knew; she just looked at us and said "Tractor wá!"—the equivalent of "the tractor cometh." After Estela and the children had temporarily settled into Apacha's cramped Puyo quarters, she told us "wasi wañui, Estela wañui" [when my house died, Estela died].

Within days Luis returned from a logging job, and he and Estela obtained permission to build on another small lot, quickly constructing a small wood house with a zinc roof. Estela had already entered the domain of *sinchi muscuj warmi* by creating representations of dangerous spirits such as *wamaj supai,* a fierce female spirit who lives deep in the thicket of giant bamboo (*wamaj*) and jealously guards it from robbers who try to steal her spiny stalks.

Now, more determined than ever to succeed in her pottery-making endeavors, Estela turned out arrays of blackware, small effigies of nuts from forest trees, sets of figurines representing shamanic practice (the forerunner of her daughter Mirian's specialty), and large models of toucans, giant anteaters, deer, and tapir, accurately portrayed and embellished with the symbols of iguanid, anaconda, tortoise, and turtle.

Estela constantly strives to innovate, to incorporate something new into her basically traditional designs. On the body (*wicsa,* "belly") of one large storage jar she painted a horizontal, symmetrical anaconda motif embedded in two rows of symmetrical turtle motifs which, in turn, encapsulate asymmetrical representations of spirit stones (*supai rumi*). She painted the neck (*cunga*) with vertical, alternating rows of anaconda and zigzag patterns. She also produced a series of what she called her *ollas fantásticas,* fantastic jars. This is an apt description of their decoration. The design painted around the belly of one jar is completely composed of horizontal, stylized segments of various motifs, all floating on a soft coral pink background. The segments combine basic symbolism of the rain forest with references to Estela's personal experiences. While she was in Urbana, Estela made a large blackened cooking pot with a rippled or corrugated exterior surface that suggested a woman's long, flowing hair; the pot was adorned with the face of Manga Allpa Mama, master spirit of garden soil and pottery clay. She has also innovated technologically and now uses an old oil drum, cut lengthwise, to fire bowls and figurines; this pseudokiln burns less firewood than aboveground firing, and it gives some protection against shifting winds.

For a number of years a Quito gallery specializing in Latin American art has placed orders with Estela for her ceramics; a request might be for twenty very large bowls, perhaps eighteen inches in diameter, or for a set number of figurines or *tinajas.* Estela hires assistants to help fill these orders. She may have from one to four helpers, young indigenous women who come to Puyo from Canelos, Pacayacu, Sarayacu, Montalvo, and other sites to look for employment. Estela does all the basic work for each and every piece. She coils and shapes the form, brushes on the slip and burnishes it, and then lays on the *mama churana,* the guiding lines of the predominant motif. The assistants elaborate this, filling in the design with smaller lines, called *paiba aisana,* "its decoration," adding contrasting colors and details with tiny brushes made of a strand of a woman's hair tied to a sliver of wood.

Since 1988, Estela and her family have lived on a sloping lot near the center of Puyo; from the highest spot one can look south to see the hills and small mountains rising from the Comuna San Jacinto del Pindo. On a clear day,

the permanently snow-covered volcanoes Sangay and Altar stand out against the Andean cordillera to the west. As some of the ten children have grown up and married, they have settled on land adjoining the parents' indigenous-style house. Mirian Vargas lives just to the north, her younger sister Marta to the south. Both Mirian and Marta make pottery to sell in the tourist market, but Mirian must do her work on weekends and during vacations from her full-time job as secretary in an indigenous-run school within the comuna. Their sister-in-law, Gloria Machoa, is following in the footsteps of her mother, Alegría Canelos, who in her prime was a recognized master potter from Curaray.

Another very well-known master potter, Apacha Vargas, learned to make ceramics primarily from her mother, Andrea Canelos. Her father, Severo Vargas, was a strong *curaga,* a church-appointed leader who could rally his own people as well as mediate between church-state authority and indigenous dissidence. He was a legendary traveler throughout the Ecuadorian and Peruvian Oriente, and he acquired a vast knowledge of the flora, fauna, and indigenous peoples of the rain forest. He was a noted guide for other travelers, including the Swedish anthropologist Rafael Karsten and the German anthropologist Udo Oberem.[15] The knowledge Apacha gleaned from her father was amplified by her own experiences in the Amazonian rain forest, particularly in the Comuna San Jacinto del Pindo, where she and her husband, Dario Vargas, established their home and reared their many children. As a witness to Puyo's transformation, where her father had two houses, from an indigenous hamlet to a colonist settlement, Apacha experienced the pain of the newcomers' ridicule of her people as being dumb and illiterate. "Even the priest turned against us," she said, "while the colonists could all write and through writing got what they wanted from church and state" (qtd. in Ruiz et al. 1984–98, 25–26). These early impressions surfaced later in her ceramic expressions.

Her creative powers are grounded in her deep knowledge of history, mythology, and natural and supernatural beings, and in her existential experiences. She has made figurative representations of powerful forces of the cosmos, such as Amasanga and Sungui, and Sungui's soul. Her ceramic images include every conceivable life force of the rain forest, from jaguars to rattlesnakes, from tapir to turtles. During the 1970s she made a series of insects —rhinoceros beetles, mole crickets, various larvae, and many others—so accurate they could be identified by an entomologist from the Smithsonian Institution doing research in the area. Her pottery statements about contemporary life are compelling: a worker's hard hat, decorated with the flower of

a large rain forest tree; two ticks, on thin, one fat from engorging the blood of cattle now pastured on land cleared of the forest; and Godzilla, Apacha's interpretation of the monster that arises from the Sea of Japan to combat the destructive forces of "civilization."

Apacha's self confidence as a powerful woman became apparent in a brief, significant event that occurred during the Caminata of 1992. After reaching Quito, thousands of marchers assembled at the Plaza de San Francisco, in the colonial center, where president Borja was to meet them and invite their leaders to talk with him in the Presidential Palace. As a delegation of indigenous leaders and government officials escorted the president from the palace, he hesitated before the multitude. Apacha took him by the arm and, speaking in Spanish and Quichua said, "Don't be afraid of us, we are all your *churis* [sons] and *ushis* [daughters]."[16] By acting as a mediator between cultures, as her father had done before, she confirmed her identity as a bona fide indigenous person and a proud citizen of the Republic of Ecuador.

The life history of Clara Santi is in many ways similar to that of Apacha Vargas. Clara spent her early years in the tiny village of Puyo and often accompanied her parents on periodic treks to dispersed settlements along the Conambo, Curaray, and Copataza Rivers. Her father, Virgilio Santi, originally from the Copataza River region, acquired shamanic powers that increased as he gleaned more knowledge of the worlds of other people through his own travels and from strangers who came to him seeking treatment. He became a widely known *sinchi yachaj,* a strong shaman, one who could "see" the cause of an illness and remove it from the patient's body. Clara learned by listening to his shamanic music and his telling of mythic and historic episodes and of his own shamanic travels. She incorporated this knowledge of distant worlds into her increasing familiarity with her rain forest environment and her everyday experiences. From her mother, Antonia Simbaña, her grandmother, and the mother of her close sister-in-law, Soledad, she learned the art of pottery making and about the heritage of women's songs.

When Clara was about fifteen, Virgilio moved his family from Puyo to the newly established Comuna San Jacinto del Pindo, and he also contracted her marriage to an Achuar youth, José Abraham Chango, better known as Paushi, Currassow. They settled in the comuna and moved periodically from one location to another. Their most stable residence was in the hamlet of Río Chico, where Virgilio and four of Clara's brothers lived. Here they reared many of their ten children as well as Clara's niece, whose mother died in childbirth. Later, after the death of their eighteen-year-old daughter, they "adopted" and reared her two daughters. They currently live on the edge of

Puyo, in the recently settled territory formerly owned by the Dominicans, where they are surrounded by many of their adult children, grandchildren, and great-grandchildren.

Living among his wife's kindred, in their territory, Paushi mastered the Quichua language while retaining his own native Achuar. Clara's knowledge grew as she learned more of her husband's language, customs, and myths from him and through visits with his relatives from Capahuari, a dispersed settlement midway between the headwaters and the mouth of the Capahuari River. Clara's experiences bridge three cultures—those of the indigenous Quichua and Achuar peoples, and of the nonindigenous colonists. The expansiveness of her knowledge and the depth of her observations over time inform her status as *sinchi muscuj warmi*. She has the rare ability to express her visions in ceramics and songs. Her repertoire of songs includes some she learned from older female relatives and others she composes herself. Many of them merge poetic descriptions of nature with ancient mythology and her own, personal experiences. In almost all of her songs, Clara reveals a multivocalic reflexivity through which she takes the role of actor while observing his or her behavior, with references to herself and comments to other family members who may or may not be present. Clara sings a lesson in ecology when she enacts the role of the wife of the mythic toucan person: "I'm toucan woman, eating only nuts . . . I don't kill in eating this way . . . don't eat my flesh."

In "Yacu Lubu" (river otter, *lubu,* is lobo), Clara sings "I'm river otter woman, I'm river otter woman," who travels the fast currents, dives deep for fish, and defends herself against threats. Clara takes the role of big black amarun (anaconda) woman in another song: "I lie in the river, deep in the river. . . . I seem to be watching people. I shall make the river swell, I shall lose the people. . . . I'm an existing woman, very angry amarun." She goes on to sing "Don't you just know how to lose everything? Everything seems to be lost. Losing half the *llacta,* I won't say it wasn't lost, you remember, you remember . . . it seems to be lost." On a descriptive level, this song delivers an accurate report of anaconda behavior; it does lie below the water surface, watching and waiting to capture its victim. Symbolically, the song alludes to the Canelos Quichua belief that the anaconda is a corporeal representative of the master spirit of the hydrosphere, Sungui, and when this mighty power is unleashed, chaos and destruction follow. On a personal level, Clara is referring to terrible conflicts over her father's land after his death, disputes that troubled her greatly as she saw her brothers and sisters pitted against one another.

Over her lifetime, Clara has made enumerable pieces of pottery ranging from very large storage jars to a tiny bowl from which her brother drank datura during a vision quest.[17] During a disruptive period in the 1970s, when economic pressures forced Paushi and many other indigenous men to take jobs with petroleum exploration companies, Clara composed a song about the big monkey person, Jatun Machinmi, and she made two figurines that reflect the dual meaning of *machin* as "monkey" and "stranger." One is a straightforward representation of a woolly monkey, with his face blackened and his tail resting casually on his shoulder. A spout protrudes from his back, for this *machin* was designed to serve *aswa* at a traditional kinship festival. The other figure has a round head placed on a body shaped like an edible gourd. One hand is raised to the baseball cap shoved back on his head, and his mouth stands wide open. This monkey is the epitome of *machin* as stranger. He is the oil boss shouting orders to his indigenous workers, orders that they must understand emotionally if not literally. To Clara, the oil boss represented entrapment. His ceramic image was made to sell to tourists for much-needed money.

As previously stated, Clara and Paushi participated in the Caminata of 1992. Clara composed the following song which she sang in El Ejido park:

> I am puma woman, I am black jaguar woman,
> walking through the mountains, walking through the rain.
> From my territory, I am just walking, walking to Quito.
> Puma woman, standing here in Quito, singing *¡hoo hoo, jijiji, meeoow!*
> Standing here before the palace, I am not afraid.

Clara's father, Virgilio, was such a powerful shaman that he could transform himself into a jaguar and travel as one. According to Canelos Quichua cosmology, jaguars are corporeal representatives of Amasanga, and they are sometimes known to be the mascots of Sungui. Clara sings here as black jaguar woman, Amasanga *warmi,* feminine counterpart of the master spirit of the rain forest, not afraid to confront the national government for her land and her life.

The changes taking place in the lives of Canelos Quichua people, other Ecuadorians, and South Americans in general are part of the worldwide process known as globalization. In his analysis of the contemporary transformations of "traditional" creative expressions of Australian indigenous people, Robert Layton states that he wishes to make a distinction between creative action and its consequences in the world:

On one hand, those who are competent in a cultural tradition use its intellectual resources to build outwards into the world. They construct metaphors, similes and other tropes that play on congruences between different orders of experience, and they construct causal hypotheses about how the world "works." Deployed in practical settings, these become assertions about the social order. On the other hand, such creative actions are produced into a world beyond their creator's control, which determines their fate as others take them up or reject them according to what is desirable or possible in particular social circumstances. . . . In a connected world, the social and natural environments promote or inhibit the effects of creativity but do not determine what the creative urge will produce. (Layton 2000, 49–50)

The Canelos Quichua language has no word for art, yet Canelos Quichua people recognize beauty in the objects they create. Regardless of how others may label their creations, they have widespread aesthetic appeal. Women and men, guided by a deep-rooted cosmology that integrates shamanic beliefs, mythology, legend, history, ecological knowledge, and personal experiences, make ceramic, wood, feather, and bead objects imbued with meaning. When a man carves a hardwood stool, it is not merely something to sit on; its shape and decoration signal that it represents the *charapa,* water turtle, seat of power of the first shaman and ultimate source of shamanic power. Likewise, a woman forms a thin-walled serving bowl and paints a small face on it to represent the master spirit of pottery clay and garden soil. Belief in the transition from mythic time-space to beginning times-places rests on the concept of transformation, *tucuna.* Through transformational processes, mythic time-space and beginning times-places, which span mythology, lore, and history, are projected into contemporary life. Virtual travel, through dreams, hallucinogenic experiences, and shamanic séance is as essential to transformational processes as physical travel is to contemporary life.

The potters described in this chapter, and many others, have proved their ability to animate their beliefs and integrate them with their knowledge and experiences as they participate in an ever changing modern world. Some ceramists travel abroad as goodwill ambassadors and give demonstrations of pottery making, as did Estela Dagua and Mirian Vargas on their trip to Illinois and California. Others tour the United States, Canada, and Europe to raise funds for their indigenous organizations, and there is a strong feminine presence in indigenous associations and in conferences dealing with indigenous rights on local, national, and international levels. Through their creation of songs and ceramics, women reflect the multiple, connected, and interconnected worlds of the Canelos Quichua people. They participate in many

versions of modernity on their own terms and by their own choices. As they do so, they contribute a sense of enduring aesthetics to the world in which we dwell.

Notes

I am indebted to all of the ceramic artists mentioned in this chapter. They have shared their knowledge and time with the Whittens over the years, as have many others, including Faviola Vargas, Delicia Dagua, Balvina Santi, Olympia Santi, Elsa Vargas Santi, Santa Gualinga, Amadora Aranda, Alicia Canelos, Theresa Santi, Juana Catalina Chango, and Rosaura Gualinga. Marcelo Santi Simbaña, Camilo Santi Simbaña, José Abraham Chango, Alfonso and his wife Luzmila Salazar Guatatuca, the late Gonzalo Vargas, and the late Virgilio Santi have explicated many facets of their culture. Absalom Guevara has added to our knowledge of both indigenous and non-indigenous peoples of Pastaza. I wish to thank don Felipe Balcázar R. for his gift of the book *Pastaza: Manifestaciones culturales,* a valuable source of information exceedingly difficult to obtain. As always, I am most grateful to Norman E. Whitten Jr., for his advice, critical commentary, and editorial assistance.

Portions of research between 1972 and 1974 were funded by a National Science Foundation grant (GS-2999). Research has been conducted under the auspices of the Casa de la Cultural Ecuatoriana, the Instituto Nacional de Antropología e Historia, the Instituto Nacional de Patrimonio Cultural del Ecuador, the Museos del Banco Central del Ecuador, and the Universidad San Francisco de Quito.

All translations are by the author.

1 The potters' trip to the United States to give demonstrations in five facilities in southern and south-central Illinois was supported through the Illinois Humanities Council, grant number 11273–1492, "Culture and Ceramic Art." Supplementary funds and in-kind assistance were provided by the following units of the University of Illinois at Urbana-Champaign: the Center for Latin American and Caribbean Studies, the Program on Ancient Technologies and Archaeological Materials (ATAM), the Department of Anthropology, and the School of Art and Design. Additional support was provided by the Sacha Runa Research Foundation, a not-for-profit corporation.

2 The terms *pottery* and *ceramics* are used interchangeably throughout this essay. Only women make pottery, although designs may be derived from male shamanic visions and knowledge.

3 Areas are given first in square kilometers and in parentheses in square miles: Pastaza, 29, 520 (11, 398); Guanajuato 30, 439 (11, 753); Haiti 27, 749 (10, 714); Maryland 27, 394 (10, 577).

4 The most comprehensive data about the Canelos Quichua is presented in Nor-

man E. Whitten Jr. (1976) and expanded in Norman E. Whitten Jr. (1985). See also Reeve (1985, 1988) and Whitten and Whitten (1988).

5 In addition to Norman E. Whitten Jr. (1976), see Ruiz et al. (1984–98) and Ledesma Zamora (n.d.a, n.d.b).

6 Chango's original map drawing and its explication are in the Whittens' files. The map is reproduced in Ledesma Zamora (n.d.b, 195).

7 Ledesma Zamora (n.d.a, 74).

8 The term *ethnic art–tourist art market* is derived from Graburn's (1976) definitions and refers to arts based in ethnic cultures and sold in the ethnic-tourist market.

9 Basically, *ayllu* is a kindred-based social organization and *llacta* constitutes the territorial base of the *ayllu* organization. For an elaboration of these concepts, see Norman E. Whitten Jr. (1976, 1985).

10 Shamanic music has been recorded and documented by Crawford and Whitten (1979); the importance of women's songs among various Quechua/Quichua cultural systems is demonstrated by Harrison (1989).

11 Unlike the polychrome ware, blackware came to be replaced by aluminum cooking pots and enamel plates and cups. By the early 1970s, it was made and used only in some fiestas. One woman in particular undertook the task of teaching the Whittens about the old ways, about the black vessels her mother and grandmother used to make—the late Soledad Vargas, daughter of the famous territorial founder Javier Vargas (Nayapi), and wife of Camilo Santi Simbaña. She patiently created one after another form and explained its purpose: larger pots for cooking manioc (*yanuna manga*) and the traditional Amazonian "pepper pot" stew (*uchu manga*); *huayusa* (or *huaisa*) *manga,* a small bowl with an extremely wide flaring wall and rim to brew a tea called *huayusa*, which is an Ilex species similar to maté in Argentina. She also made different styles of *callana,* eating bowls for serving cooked food; tiny bowls to hold salt and cooked hot pepper sauce; and even a *cachi manga,* a salt jar. Soledad's ancestors trekked to salt mines on the Huallaga and Marañón Rivers, filled these jars with the slushy, semiliquid brine, boiled it down, and then broke the jar to obtain a molded chunk of solid salt. In 2000, people began to insist on the use of traditional blackware at their festivals and for their own participation in national festivals. Women responded by remembering how their mothers had made such ware, and older women joined the movement of cultural restoration by teaching their daughters and granddaughters these techniques.

12 The participation of men and women in a medical care delivery program is described in Whitten and Whitten (1985) and Dorothea S. Whitten (1996).

13 On 1 January 2000, an indigenous, a military-and-civilian-backed coalition took control of the national legislative building in Quito. Congressional members were actually meeting in Guayaquil at the time. The junta then took over the Presidential Palace, forcing elected president Jamil Mahuad to abandon office.

Antonio Vargas was part of that junta. After three hours, under pressure from the Organization of American States and the United States Department of State, the junta conceded to a constitutional arrangement for the elected vice president, Gustavo Noboa, to become the new president.

14 An autobiographical statement by Rebeca Gualinga, as well as an inventory of her spirit myths and figurines, is presented in Paymal and Sosa (1993, 153–57). A number of her figurines are illustrated in Whitten and Whitten (1988).

15 In preparation for his 1928–29 expedition to the Aguaruna in Peru, Karsten paid Acevedo (Severo) Vargas one hundred U.S. dollars to obtain a canoe and crew and to guide him along the Pastaza to the Marañón, through the territory of the hostile Muratos (Candoshi) (Karsten 1935, 72).

16 A photograph of this event was published on the front page of the prominent Quito newspaper *Hoy,* 24 April 1992.

17 For an in-depth description of a vision quest and shamanism and hallucinogenic use, see Norman E. Whitten Jr. (1985, 105–63).

Reference List

Carvajal, Gaspar de. *The Discovery of the Amazon: According to the Account of Friar Gaspar de Carvajal and Other Documents.* Ca. 1541. Comp. José Toribio Medina. Ed. H. C. Heaton. Trans. Bertram T. Lee. New York: American Geographical Society, 1934.

Chango, Alfonso. *Yachaj sami yachachina.* Quito: Abya-Yala, 1984.

Crawford, Neelon, and Norman E. Whitten Jr. *Soul Vine Shaman.* New York: Sacha Runa Research Foundation, 1979.

Graburn, Nelson H. H. "Introduction: The Arts of the Fourth World." In *Ethnic and Tourist Arts: Cultural Expressions from the Fourth World,* ed. Graburn, 1–32. Berkeley: University of California Press, 1976.

Harrison, Regina. *Signs, Songs, and Memory in the Andes: Translating Quechua Language and Culture.* Austin: University of Texas Press, 1989.

Karsten, Rafael. *The Head-Hunters of Western Amazonas: The Life and Culture of the Jibaro Indians of Eastern Ecuador and Peru.* Helsinki: Societas Scientiarum Fennica, 1935.

Kelly, Patricia, and Carolyn Orr. *Sarayacu Quichua Pottery.* Dallas: Summer Institute of Linguistics, 1976.

Kipu. *Marcha indígena de los pueblos amazónicos Puyo-Quito.* Special supplement 18 (1992a).

———. *El mundo indígena en la prensa ecuatoriana* 18 (1992b).

Layton, Robert. "From Clan Symbol to Ethnic Emblem: Indigenous Creativity in a Connected World." In *Indigenous Cultures in an Interconnected World,* ed.

Claire Smith and Graeme K. Ward, 49–66. Vancouver: University of British Columbia Press, 2000.

Ledesma Zamora, Oscar. *El pasado en el presente de Puyo: 1930.* Puyo: Municipio de Pastaza, 1992–96. n.d.a.

———. *El pasado en el presente de Puyo: 1930–1960.* Puyo: Administración Municipal, 1996–2000. n.d.b.

Nuckolls, Janis B. *Sounds Like Life: Sound-Symbolic Grammar, Performance, and Cognition in Pastaza Quechua.* New York: Oxford University Press, 1996.

Oberem, Udo. "Trade and Trade Goods in the Ecuadorian Montaña." In *Native South Americans: Ethnology of the Least Known Continent,* ed. Patricia J. Lyon, 347–57. Boston: Little, Brown, 1974.

Paymal, Noemi, and Catalina Sosa, eds. *Amazon Worlds: Peoples and Cultures of Ecuador's Amazon Region.* Quito: Sinchi Sacha Foundation, 1993.

Reeve, Mary-Elizabeth. *Identity as Process: The Meaning of "Runapura" for Quichua Speakers of the Curaray River, Eastern Ecuador.* Ann Arbor, Mich.: University Microfilms, 1985.

———. "Cauchu Uras: Lowland Quichua Histories of the Amazon Rubber Boom." In *Rethinking History and Myth: Indigenous South American Perspectives on the Past,* ed. Jonathan D. Hill, 19–34. Urbana: University of Illinois Press, 1988.

Ruiz, Silvana et al. *Pastaza: Manifestaciones culturales en la región de el Puyo.* Pastaza: Consejo Provincial, 1984–98, n.d.

Spruce, Richard. *Notes of a Botanist on the Amazon and Andes.* Ed. Alfred Russell Wallace. London: Macmillan, 1908.

Staden, Juan [Hans]. *Vera historia y descripción de un país de las salvages desnudas feroces gentes devoradoras de hombre situado en el nuevo mundo América.* 1557. Ed. and trans. Edmundo Wernicke. Buenos Aires: Universidad de Buenos Aires, Museo Etnográfico, 1944.

Whitten, Dorothea S. "Ancient Tradition in a Contemporary Context: Canelos Quichua Ceramics and Symbolism." In *Cultural Transformations and Ethnicity in Modern Ecuador,* ed. Norman E. Whitten Jr., 749–75. Urbana: University of Illinois Press, 1981.

———. "License to Practice? A View from the Rain Forest." *Anthropological Quarterly* 69, no. 3 (1996): 115–19.

Whitten, Dorothea S., and Norman E. Whitten Jr. "Ceramics of the Canelos Quichua." *Natural History* 87, no. 8 (1978): 91–99.

———. *Art, Knowledge, and Health.* Cambridge, Mass.: Cultural Survival, 1985.

———. *From Myth to Creation: Art from Amazonian Ecuador.* Urbana: University of Illinois Press, 1988.

———. "Potters of the Upper Amazon." *Ceramics Monthly* 37, no. 10 (1989): 53–56.

———. "Development and the Competitive Edge: Canelos Quichua Arts and

Artisans in a Modern World." In *Redefining the Artisan: Traditional Technicians in Changing Societies,* ed. Paul Greenough, 149–68. Iowa City: Center for International and Comparative Studies, University of Iowa, 1992.

———. Introduction to *Imagery and Creativity: Ethnoaesthetics and Art Worlds in the Americas,* 3–44. Tucson: University of Arizona Press, 1993a.

———. "Creativity and Continuity: Communications and Clay." In *Imagery and Creativity: Ethnoaesthetics and Art Worlds in the Americas,* ed. Whitten and Whitten, 309–56. Tucson: University of Arizona Press, 1993b.

———, eds. *Imagery and Creativity: Ethnoaesthetics and Art Worlds in the Americas.* Tucson: University of Arizona Press, 1993c.

Whitten, Norman E., Jr. *Sacha Runa: Ethnicity and Adaptation of Ecuadorian Jungle Quichua.* Urbana: University of Illinois Press, 1976.

———. *Sicuanga Runa: The Other Side of Development in Amazonian Ecuador.* Urbana: University of Illinois Press, 1985.

Whitten, Norman E., Jr., Dorothea Scott Whitten, and Alfonso Chango. "Return of the Yumbo: The Indigenous Caminata from Amazonia to Andean Quito." *American Ethnologist* 24, no. 2 (1997): 355–91.

Engendering Clay

Las Ceramistas of Mata Ortiz

One doesn't have to search far and wide to find the *ceramistas* (female pot-ters) of Mata Ortiz.[1] The simple desire to see them is more than enough. There they are, by the dozens. Although the *ceramistas'* work is as extraordi-nary as the artisans are numerous, describing it in detail is not the purpose of the present essay. Instead, I propose to explain *why* and *how* the women of Mata Ortiz make pottery. Throughout the essay, I will also point out several ironies of their experience, ironies that I began to notice as I became familiar with this community of artists.

Most published work on ceramics focuses on production, making it easy to forget the people behind the clay. This bias persists in the extensive bibliog-raphy on Mata Ortiz. Many of these texts—almost all of which appear only in English—provide minute descriptions of ceramic techniques, and most resemble catalogs that include advice for tourists alongside tips for more seri-ous collectors. Thus they also constitute travel narratives of a sort, tending to present an exoticized view of Mata Ortiz, casting it as a marvelous, magical primitive world.

The publishing market that caters to collectors, buyers, and distributors of popular art is indeed vibrant and growing (Davies and Fini 1994). Prominent books on Mata Ortiz include the work of Walter Parks (1993); the collective efforts of Bill Gilbert et al. (1995) and Susan Lowell et al. (1999); Gilbert's more recent book (1999); and an entire issue of the magazine *Kiva* (1994). A special edition of the Mexican periodical *Artes de México* (1999) represents

one of the scarce publications in Spanish about this village of potters. Aside from books, countless exhibits (predominantly in the United States), at least four videotapes, one CD-ROM, several academic theses, and numerous Internet sites feature Mata Ortiz.[2] The Web sites appear to be set up exclusively by galleries and distributors, since not one is run by the potters themselves. This is indicative of the fact that the active interest in Mata Ortiz is guided almost exclusively by the desire to possess its artistic production and the view that its ceramics are a valuable investment guaranteed to appreciate over time. Galleries throughout the United States, Mexico, and even Japan are banking on it.

Already familiar with the superb quality and high monetary value of its pottery, many of those who travel to Mata Ortiz express shock on discovering that such exquisite pieces come from what seems to them a remote and simple community. Furthermore, visitors have difficulty comprehending that the inhabitants of this rustic hamlet could also be artists, and prolific ones at that.[3] From the outsider's perspective, this ironic contrast fosters romanticized portraits of Mata Ortiz that callously disregard the realities of rural poverty. Rhoda Lurie's *Discovering the Magic Pots of Mata Ortiz* (1997) is a case in point and includes the following description of the author's lodgings: "I am staying in a typical, rectangular adobe mud brick house, sans electricity, sans running water and sans toilet. What a charming place!" (15). The visitor from a highly industrialized nation does not see the poverty that produces this charm because she is blinded by the apparent need to get away from it all in the remoteness and simplicity of an isolated Mexican town.

Of course, not all portrayals of Mata Ortiz are as shamelessly exoticizing as Lurie's. For example, Michael Williams's "La lucha del barro: Two Pottery-making Families of Mata Ortiz" (1991) is the result of a careful anthropological investigation of the aesthetic and sociohistorical developments that have shaped the ceramics industry. Thus the firsthand accounts that comprise the written history of Mata Ortiz and its pottery establish a spectrum with Lurie and Williams at opposite extremes.

Once upon a Time . . .

Travelers to communities in underdeveloped regions find it tempting to describe their encounter with a different culture and its people as, at best, a fictional narrative, or, at worst, a picturesque moment of contact with an altogether exotic presence. Spencer MacCallum, who began his own "personal

adventure" in Mata Ortiz in 1976, thinks that many tell the story of Mata Ortiz as if it were a fairy tale (1994a). That was a feeling I'd been having as I read different texts, and I was moved to construct this tongue-in-cheek fantasy narrative: Once upon a time in a faraway land of magnificent, golden sunsets and simple, honest people, there lived a young woodsman named Juan Quezada. Although very poor, Juan was also very talented. Little by little, he taught himself to craft beautiful pots of painted clay in the tradition of his ancient, indigenous ancestors. For years he worked in humble anonymity, until one day, a blond wise man from the north discovered Juan and his work and was generous enough to help the solitary potter become a wealthy artist, known throughout the world.

Juan Quezada (born 1939) indeed exists, and he has revolutionized pottery making. He spent years studying pre-Hispanic earthenware until, fascinated and intrigued by its designs, he began to make his own pieces. Quezada freely copied from designs he came across, such as the Ramos Polychrome pattern, "distinguished by its scalloped border and macaw motif" (Braniff 1999, 17). In 1976, MacCallum saw three of Quezada's pots in New Mexico. Impressed, he set off to find the artist. Since the best potters of the southwestern United States are women, MacCallum was surprised to discover that Quezada was in fact a man (Parks 1993, 2; Di Peso and MacCallum 1979, 32). From their initial meeting, MacCallum and Quezada formed a lasting friendship and a commercial relationship that boosted the entire Quezada family's production (Di Peso and MacCallum 1979, 1).

Almost everything written about the pottery boom in Mata Ortiz centers around the figure of Juan Quezada, who is responsible for initiating the ceramics industry there in the 1960s and for its subsequent commercialization in the 1970s. It seems that any discussion about Mata Ortiz must praise this master, patriarch, artist, and innovator. As Norbert Turek puts it, "Juan Quezada is the internationally known patriarch of a pottery revolution that has revitalized the village of Mata Ortiz" (1999, 59). Not unlike Frida Kahlo, Quezada carefully cultivates his own image—cowboy boots, a hand-tooled leather belt, and a wide-brimmed hat—conveying a presence of authority that complements his affable and even somewhat shy nature. In a word, he is charming. Although he does not speak English, the sign in front of his house reads, "Pottery. Juan Quezada," and everything inside his gallery is also written in English.

The attention that Quezada and his family receive is more than deserved. As the creator of what is widely known as the Mata Ortiz "miracle," his story is as unique as his art. In 1999, Quezada's exceptional skills were soundly ac-

knowledged when he received the National Prize of the Arts. In addition to revolutionizing Mexican art, Quezada and his family have also transformed their local and regional economies.

An interesting fact about Quezada reveals a history of pottery making in his family. His mother's hometown, San Lorenzo, Chihuahua, was once an important site for the manufacture of clay pots, a task women tradition- ally performed. Quezada's grandmother, great-aunts, and great-grandmother were potters. His grandmother's early death—when his mother was only six—interrupted the generational transfer of the family skill and coincided with the decline of pottery making in San Lorenzo. By the 1950s, the ceram- ics industry had disappeared from the community. Fortunately, the artis- tic tradition also runs through Quezada's paternal family, and all his uncles on his father's side—who also reside in Chihuahua, but in the town of Tu- tuaca—are artisans (Di Peso and MacCallum 1979, 68–74). This suggests an innate disposition toward artistic labor, or at least the influence of sociohis- torical conditions on Quezada's trade.

. . . in a Faraway Land

It always strikes me as a little odd whenever anyone says that a place is far away. Far from where? For the people that live there, surely it is not remote. Juan Mata Ortiz has 308 houses, a total population of about 1,140, six hun- dred men and five-hundred and forty women, and though a bit dilapidated, it is a fascinating community. It forms part of the municipality of Casas Grandes, Chihuahua, in northwestern Mexico. A little more than ten thou- sand people reside in the municipality, 5,140 men and 4,887 women.[4] Mata Ortiz, 130 miles to the southeast of Ciudad Juárez, lies in a fertile valley at the foothills of the western Sierra Madre. Accessible only by a dirt road, it is situated about twenty miles to the southwest of Casas Grandes and the ruins of Paquimé, which date back to the reign of the so-called Gran Chi- chimeca, that is, from the beginning of the thirteenth to the end of the fif- teenth centuries (Ravesloot, Dean, and Foster 1995, 247). The buildings of Paquimé are believed to have once stood four or five stories tall (hence the name Casas Grandes, "Big Houses"). Ruins of these impressive structures are concentrated near the present-day community of Mata Ortiz, but human remains, ceramic artifacts, and other material signs of the region's ancient culture can be found throughout the vast perimeter that includes Paquimé and Mata Ortiz as well as the surrounding hills and mountains. Although

Paquimé disappeared six hundred years ago, its vestiges constitute an omnipresent backdrop to contemporary life. This particular corner of Chihuahua is layered with history, its land occasionally yielding other vestiges' harvests: bullets fired during the battles between Francisco I. Madero and the federal garrison of Casas Grandes, which defended the interests of oligarchs Luis Terrazas and Enrique Creel under the dictatorship of Porfirio Diaz (Romero Flores 1959, 158–61); or the military souvenirs left behind after Pancho Villa's clashes with various armies during the revolution of 1910–17.

Mata Ortiz was founded around 1905. The oldest headstone in its cemetery, which rests on a hill north of the community, dates from 1916. The town was originally known as Pearson Station, a railroad encampment on the Chihuahua line that connected Ciudad Juárez and the Pacific.[5] Pearson Station's industrial activity centered around a company that processed timber from the nearby mountains and then sold it in the United States. Though successful, the sawmill was a short-lived venture, in ruins by 1920: "The Pearson lumber mills were at a standstill. Pearson was now but a station for the Mexico North Western railroad and a terminus for the mail. Trains limping around burned bridges on 'shoo-flys' found it difficult to carry on. The huge planers, drying sheds and floating log service were idle. A million-dollar industry was deteriorating from disuse" (Hatch 1954, 240).

In 1923, the town's out-of-place foreign name was changed in honor of a nineteenth-century Apache fighter. During the latter decades of that century, Don Luis Terrazas, Chihuahua's principal landowner, asked his nephew, Colonel Joaquin Terrazas, to help organize raids against the Apache tribes of the region. Major Juan Mata Ortiz was second in command of Terrazas's three hundred–man "army"—which included Tarahumaras—and defeated the Apaches in 1880 (Felsted 1998, 4). The town of Mata Ortiz is predominantly mestizo, not indigenous, and Spanish is the dominant language. Ironically, a village renowned for maintaining indigenous traditions in ceramics is not populated by descendents of pre-Columbian peoples. Of course, traces of indigenous culture have persisted, as was the case with Juan Quezada's father, who spoke Tarahumara (Di Peso and MacCallum 1979, 74).

Juan Mata Ortiz became an *ejido* in 1925, with communal land dedicated to farming and raising livestock.[6] Potters even today extract their clay from collectively owned land and seldom have to buy it. They only purchase clay, in the nearby community of Anchondo, when they make white pieces. In Mata Ortiz, the potters do not even pay for clay when they get it from private property. Some landowners have tried to charge them, but in the land of Juan Quezada that is an idea whose time has not yet come (Wisner 1999, 188).

Free access to prime material distinguishes Mata Ortiz from other pottery-making communities, where artists always have to purchase clay. Notable examples of communities where clay must be bought include Ocumicho, Michoacán, renowned for its variety of clay figurines, particularly the famous smiling devils; Ocotlán de Morelos, Oaxaca, the home of the Aguilar sisters, who make incredible three-dimensional reproductions of Frida Kahlo paintings; and Santa María Atzompa, also in Oaxaca, the origin of Teodora Blanco's astounding unpainted and oversized clay market women.

Mata Ortiz suffered a severe economic blow in the 1960s, when the Mexican railroad company transferred its switchyard to Nuevo Casas Grandes. Until then, Mata Ortiz's economy was sustained by its timber industry, the railroad, farming, and raising livestock. The loss of the switchyard increased emigration to the United States. Many of those who stayed—and these were mostly men—could only find work in the orchards of Colonia Juárez, the nearby Mormon community. There is no timber left in Mata Ortiz, let alone a sawmill or railroad to process and export it. The trains stopped passing through in 1996, but a lovely station remains. The dark green wooden structure was recently converted into a museum dedicated to the region's history and ceramics, testifying to the importance of the newest industry: tourism. Current plans to revive the town's abandoned railway include constructing a small-scale train to transport visitors who come to admire and buy the creations of more than four hundred potters. Two hotels have also contributed to the tourist economy, employing some residents. For fifty years, Mata Ortiz was a timber and railroad community. By the 1980s, it had become economically dependent on pottery and the tourists this activity attracts.

Unlike the vast majority of Mexican towns, which seem to stay the same for years on end, Mata Ortiz is undergoing change too rapidly for scholars to keep up. For example, as recently as 1991, the train continued to run, carrying passengers and cargo. Some residents still followed the traditional custom of living in abandoned freight cars. Agriculture was the primary occupation, and hardly anyone owned a car. But by this same year, more than one hundred potters had already set up shop (Williams 1991, 38–39, 147).

Mata Ortiz is divided into five different neighborhoods: El Porvenir, Centro, Iglesia, Americano, and López. Adobe houses with sheet-metal roofs and cement floors line the town's unpaved streets. Signs of prosperity shine through this humble facade. For example, at each mass in Mata Ortiz's tiny church—which overlooks the majestic red iron bridge that spans the Palanganas River—expensive cars and pickups fill the field in front of the church. This produces the strange feeling that one is spending Sunday morning in

a U.S. town, not a small Mexican village. Satellite dishes are now a common sight in Mata Ortiz, and many houses boast such luxuries as big-screen color TVs, washing machines, and premanufactured furniture sets. Overall buying power varies from family to family, but it is generally far superior to other villages whose economies center around the production and sale of popular arts. Even though droughts frequently afflict the region, Mata Ortiz has plenty of water. Alcohol, however, is scarce. It is prohibited to sell, consume, or even import it. Organizers of local festivals must obtain a special permit from the municipal officials in order to serve alcohol. Shops that sell only nonalcoholic beverages are a rarity in a country where beer, wine, and hard liquor are readily available in almost any corner store. This strict control (subverted by a highly inflated black market) could be the result of the puritanical Mormon influence that extends from the neighboring communities of Colonia Juárez and Colonia Dublán. As Nelle Hatch writes, the region's Mormon settlers "kept their covenants, and permitted no saloon to operate within town limits, and profanity was ever held to be an infraction bordering on crime. It was seldom heard in Colonia Juárez" (1954, 38).

If tourists want to avoid the arduous trip to Mata Ortiz—a journey notorious among scholars—they can stay in Casas Grandes, where an enormous sign proclaims, in English, "We make Mata Ortiz Pottery." The ceramics industry has outgrown the borders of Mata Ortiz, either because its potters have moved or because people throughout the area have been infected by the pottery bug.

Pre-Hispanic and Contemporary Indigenous Pottery

Mata Ortiz pottery bears an uncanny resemblance to ceramics from San Ildefonso, New Mexico. Pueblo Indians of the southwestern United States and the potters of Mata Ortiz maintain pre-Hispanic traditions through their work. Still, while the Pueblos have been working clay practically uninterrupted for centuries, Mata Ortiz produced no pottery for nearly six hundred years. Pre-Hispanic pottery known to pertain to the three major indigenous groups of the southwestern United States and northeastern Mexico—the Anasazi, the Hohokam, and the Mogollon—was used almost exclusively for practical purposes (Covarrubias 1961, 209; Brody, Scott, and LeBlanc 1983, 69). In contrast, all of the ceramic pieces produced today by the Pueblos and in Mata Ortiz are ornamental.

Miguel Covarrubias describes the Mogollon culture as "flourishing in the

magnificent classical period of the Mimbres Valley, and persisting into the Casas Grandes period" (1961, 209). This region lies to the south of present-day New Mexico, and Covarrubias situates the classical period between 900 and 1200 A.D., noting that the Mogollon culture's disappearance leaves unanswered the question as to "the destiny of the Mimbres Valley's exceptional artists" (223). In the Spanish text, Covarrubias refers to the valley's artists with a feminine pronoun because, analogous to the division of labor among twentieth-century U.S. indigenous groups, pre-Hispanic potters in what is now northeastern Mexico were women (Brody 1977).[7]

The Paquimé culture began to thrive after the classical Mogollon period. Although the case of the Pueblos indicates that contemporary potters are women because their pre-Hispanic counterparts also were, I do not believe that this analogy applies to Paquimé and Mata Ortiz. Because men and women are involved in ceramics today in Mata Ortiz, one would imagine that the ancient culture of Paquimé exhibited a similar division of labor. Numerous archaeological studies invalidate this comparison and support the hypothesis that only women worked the clay in pre-Hispanic Mexico.

In New Mexico and Mata Ortiz, artists have adopted figurative and more directly representational Mimbres designs. Julian and Maria Martinez of San Ildefonso were the first modern indigenous ceramics painters to incorporate Mimbres designs into their own art. J. J. Brody emphasizes the importance of this homage to their ancestral cultures: "All Mimbres motifs have current symbolic value for all of the Pueblos as a sign of legitimacy and antiquity" (Brody 1977, 221). In present-day Mata Ortiz, no potter considers him- or herself a direct inheritor of pre-Hispanic tradition. However, the artists render tribute to that past by adopting and adapting ancient designs, a practice that endows contemporary motifs and styles with cultural authority, revealing iconographic roots traceable to Mimbres and Casas Grandes: "In its resurrected state, then, Mimbres painting has been used mostly as an emblem, valued for what it represents rather than for what it is. In that respect its reentry has not been too dissimilar from that of other exotic arts that have become a part of the visual inventory of the industrial world during the last century" (Brody 1977, 227).

Mata Ortiz pottery undoubtedly shares many traits with ceramics from the U.S. Southwest. Its smooth, glossy texture and geometrical designs are reminiscent of Hopi pottery; black geometrical patterns over a white or brown background recall Acoma Pueblo handiwork. Additional commonplaces include animals sculpted in relief, a Navajo design, and the seed jars of the Nambe and Pojoaque. Although Mata Ortiz pottery exhibits characteristics

similar to contemporary U.S. and pre-Hispanic designs, it is easily distinguishable. First of all, it is of exceptional quality, remarkably fine, delicate, and smooth. Many pieces stand out as works as individual as the artists who made them (Williams 1991, 156), in contrast to the mass-produced products of anonymous artisans typical to other locations. The variety of Mata Ortiz designs is surprisingly rich, and although they incorporate Mimbres and Paquimé patterns, potters use these as starting points for an impressive array of contemporary creations. This has led Susan Lowell to ask, "Why does [Mata Ortiz pottery] look pre-Columbian and postmodern at the same time?" (Lowell et al. 1999, 16). Her question is important and interesting, and I do not think it can be applied to any pottery from the U.S. Southwest. MacCallum echoes Lowell's observation when he describes Mata Ortiz pottery as "peculiarly modern in feeling" (1994b, 90). He further testifies to the pottery's singularity by noting that "both the pottery shapes and the designs executed in matte slip are unmistakably Mata Ortiz" (78).

In what was to become the state of New Mexico, during the first decade of the twentieth century, anthropologist Edgar Lee Hewett and his research team excavated several sites where shards of pottery had been found. Dr. Hewett became fascinated by the idea of reconstructing clay pots based on fragments he had come across, so he set out to find the best potter he could, which eventually led him to Maria Martinez. Hewett showed Martinez the recovered portions of an ancient pot and asked her to recreate it the way she thought it would have been originally. Thus was the beginning of the renowned San Ildefonso pottery, with its distinctive black color. Since then, it has enjoyed nearly a century of uninterrupted production and is strongly associated with its most famous artist, Maria Martinez, who, by 1925, was considered the best potter in San Ildefonso (Guthe 1925; Peterson 1977, 89). During the 1950s, ethnologist and archaeologist Kenneth Chapman introduced Mimbres and Mogollon designs to the potters of Acoma, New Mexico (Coe 1986, 206). Hewett's and Chapman's influences on New Mexican potters are similar to MacCallum's on Juan Quezada in Mata Ortiz, which became another town famous for renovating and adapting pre-Hispanic traditions for the contemporary age.

In addition to aspects of design, San Ildefonso and Mata Ortiz pottery share techniques. Practitioners of both traditions insist on a completely handmade process and never use a pottery wheel. Artists from both places employ the "rolling technique": they begin by forming the base—a sort of clay tortilla—on top of a plaster bowl that works as a mold for the base, and then they gradually build up the sides by adding a number of clay rings, one

on top of the other. In New Mexico as in Mata Ortiz, potters fire their pieces using cow manure and wood as fuel. Furthermore, they both polish the finished pots with stones instead of cloth, this latter material common in other places, such as San Bartolo Coyotepec, Oaxaca (Peterson 1977, 93). While most prefer stones, some artists in Mata Ortiz use leather and deer bones for polishing (Wisner 1999, 192). Another technical aspect of pottery making is the position of the artist's body, which has changed over time. Photographs from the first thirty years of the twentieth century portray women in New Mexico modeling clay while kneeling on the floor. Josefina Aguilar, a famous potter from Oaxaca, continues to work in this position, but the *ceramistas* of Mata Ortiz and San Ildefonso prefer to sit or stand. The use of different paintbrushes distinguishes Mata Ortiz from San Ildefonso pottery. When it comes to the most precise brushes reserved for detail work, in New Mexico the artists typically take fibers from yucca plants, while in Mata Ortiz potters tend to cut fine, straight hairs from a child's head. Still, MacCallum notes that Quezada also makes the thicker brushes with human hair (1981, 74).

Aside from distinct, individual qualities each artist brings to his or her work, the process is more or less the same in San Ildefonso as it is in Mata Ortiz.[8] Mata Ortiz potters follow a uniform series of steps: they mix their clay with water, form the pot by hand over a plaster mold, and with a hacksaw blade or a knife shape the sides, spreading the clay until it is extremely thin. While the piece is still wet, they use sandpaper to smooth its surface while rubbing oil or soap into the clay. Then they let it dry. After polishing it with stones, potters paint the pot with natural pigments. Sometimes they polish a second time after painting, but other times they fire the pot with manure and/or wood. Typically done one pot at a time, firing is a process that varies depending on the desired color. For white, red, or brown, the potter covers the piece with a metal bucket or clay casserole dish, leaving just enough space to let air in. If a potter wants a black pot, its firing cover must be sealed. Each finished piece perfectly combines the four fundamental elements: earth, water, air, and fire. This has led Claudia Cancino to describe the process as magical, and the potters as modern-day alchemists (2000, 40).

Mata Ortiz pots, inspired predominantly by the Casas Grandes tradition, come in a range of sizes, from miniature pieces to some over a foot tall. Seed jars and serving platters are also common. Some potters make animal-shaped figurines, which often very much resemble pre-Hispanic designs, but are just as often the products of the artist's imagination. Ironically, outside of Mexico, Mata Ortiz pottery is always considered an "Indian" or ethnic craft.

Originally, Native Americans and the people of Mata Ortiz did not sign their work (Coe 1986, 90–91). Even Juan Quezada and his family produced unsigned pieces. Buyers explicitly asked potters not to put their signatures, because anonymous works could be artificially aged and sold as "authentic" pre-Hispanic pieces from Casas Grandes. Artisans began to sign as a reaction to this practice, making it impossible for buyers to sell "ancient" pottery. Always adapting buyers used the signatures to their advantage, no longer selling artifacts but instead the unique creations of contemporary artists. Nevertheless buyers exercise a strong influence over artists and the nature of their work.

I believe that the practice of signing pieces proves especially relevant to the history of women in art, and particularly folk art. Anonymous works are frequently attributed to men. For example, an unsigned sixteenth-century painting would automatically be considered the work of a male artist. Thus it would seem that the relatively recent, market-driven trend of acquiring signed folk art is most important, in the end, as a means of studying more effectively the artistic production of women. Yet another irony.

Gender in Mata Ortiz

J. J. Brody points out that "for several generations Pueblo men have been observed decorating pottery, gathering and preparing clay and tempering materials, building kilns, firing, and doing everything else except fabricating the pots" (1977, 116). In Mata Ortiz, the men make pots and everything else.

Almost all the texts written about Mata Ortiz in the wake of its pottery boom assign women a secondary role. This proves a particularly meaningful irony considering that ceramics in general are held to be "that quintessentially female domain," as Sherry Chayat puts it (2000, 48). Even glances at exhibition catalogs and books about Mata Ortiz reveal that women potters are generally deemed less important than their male counterparts. The catalog that accompanied an exhibition organized by Bill Gilbert, *The Potters of Mata Ortiz* (1995), includes eighteen interviews, nine of which are with men, eight with couples, and only one with a woman by herself. Out of seventeen men and nine women, only two women appear as protagonists of their craft. The same disproportionate representation occurs in the issue of *Artes de México* dedicated to Mata Ortiz, where women occupy an absurdly small minority: of twenty-five potters mentioned, five are women, four of whom

are married and therefore form part of a couple. In Walter Parks's *The Miracle of Mata Ortiz* (1993), women constitute less than half of the artists listed in the index. A more recent book by Susan Lowell et al., *The Many Faces of Mata Ortiz* (1999), lists 170 women from a total of 364 potters. Comparing this index to the catalog by the Pearson Group, which I will discuss later, reveals twenty-eight *ceramistas* in Mata Ortiz not even mentioned in Lowell's book. The discrepancy is even greater when it comes to the photographs that appear in *The Many Faces:* eighty-six men and only twenty-seven women have themselves or their work pictured. These numbers highlight a stubborn bias that persists within and beyond the artistic realm, namely, that men's accomplishments are almost always treated as more important than women's.

Exceptions exist. Rick Cahill published one of the first books about Mata Ortiz, and he emphasizes the role women play, concluding that the women of the Casas Grandes region produce some of the most beautiful pottery (1991, 65).[9] Before the pottery boom, women in Mata Ortiz had little or no chance of obtaining a paying job outside their community. They were responsible for domestic tasks: laundry, ironing, shopping, child care, and cooking, and they were also expected to care for farm animals if they had them. In the past, many women emigrated in order to find work, but today fewer leave Mata Ortiz because of the opportunities created by the ceramics industry. Nevertheless, they perform the same daily chores as always. Since pottery is made at home, it has become, ironically, yet another domestic responsibility. The difference is that it pays, and quite well. Initially a means to shore up the family budget, pottery making has produced a situation where, as Williams notes, "women are able to supplement or often surpass the family's income while still performing their accepted household duties" (1991, 163, 175). Williams stresses the gendered division of labor in Mata Ortiz, and he is the only writer to tabulate the number of hours women invest in both domestic work and ceramics (80–83). When aspects of daily life are enumerated in such a way, they *seem* more clearly identifiable, more important, and even more "real." In this case, Williams is trying to *see* better how the *ceramistas* spend their working days. Even though he writes more about women and gender relations than anyone else who studies Mata Ortiz, Williams insists that "the role of gender should be explored in greater detail" (178).

The Pearson Group

It was 1996 and the ceramics industry was thriving when Guillermo Lozano arrived. Don Memo, as most people call him, came to Mata Ortiz to buy ceramic goods and suggested that the village's potters organize in order to obtain state-sponsored loans and to increase their selling power.[10] Lozano recommended that women organize first, then men; a men's group has yet to be established. Verónica Ramírez, a twenty-five-year-old *ceramista,* presides over the Pearson Group, and she believes that women have organized more successfully than men because "women are more decisive, they cooperate more, and they attend meetings more often."[11] Fifty-two women founded the Pearson Group in 1997, but by 2000 only thirty-two members remained. Those that no longer belong argue that they wasted time attending meetings, and that they prefer to dedicate time to their pottery. In addition, they see no advantages to belonging to the group, which requires paying fifty pesos, which is the equivalent of a five-dollar monthly fee.[12] The group spends these dues on collective needs, the most important of which is maintaining its *Centro de Acopio,* which serves mainly as a store. The women who remain active in the group find that they are happier with its reduced size, which facilitates decision making and increases overall efficiency. Members meet once a month, and attendance is obligatory. After three unexcused absences, a member faces expulsion. The group holds elections annually and fills administrative positions on a rotating basis.

Although none of the most famous *ceramistas* belongs to a group, organizing enables many others to market their products more effectively. The *Centro de Acopio* provides Pearson Group members with a centralized space to sell pottery; and, as a group, they are invited to exhibits in other cities and regions of Mexico. In the past few years, they have organized trips to Guadalajara, Chihuahua, and Mexico City. Some have traveled elsewhere on their own. A collective identity is also advantageous because pottery associated with a group name is more easily recognized and becomes actively sought by purchasers and distributors. A promotional catalog, published in 1997, commemorates the Pearson Group's identity, reputation, and efforts (see Lozano 1997).

The prosperous Verónica Ramírez household lives in the El Porvenir neighborhood, on the southern side of Mata Ortiz. This family has just recently entered the ceramics profession, and Ernesto, her youngest brother, learned first. He began making pottery at thirteen and was producing quality work only two years later. In 1996 he taught his mother, Doña Paz Silva, and his

1. Paz Silva de Ramírez shaping a pot, 2000. *Photograph by Eli Bartra.*

older brother Alonso. The division of labor within the family is unusual: Doña Paz dedicates her time exclusively to forming pots, while Verónica sands, polishes, and paints them—on an ironing board, with the television on. Verónica neither forms the pots at all nor fires them by herself; the two boys collect and prepare clay, and also take turns polishing, sanding, and painting. The family fires their pots in a metal washtub, using manure for fuel. Whoever paints the pot signs it, and Verónica is the only woman in the Ramírez family who paints. Mr. Ramírez, the father, is responsible for farming and raising livestock, and he does not contribute to the family's pottery work. Theirs is an atypical family because domestic chores are distributed relatively equally, with the exception of Doña Paz's canning, which she does by herself, filling jar on jar with preserved fruits and vegetables.

The Ramírez women belong to the Pearson Group and find it worth their while, especially as a means to sell the family's wares. Their pottery is notable for its thin, fine surfaces, original crosshatch designs, and exceptional quality. Verónica and her family originally copied designs from books or other Mata Ortiz potters, but now they invent their own. Aside from their shapes, which

sometimes reveal a Paquimé influence, the pieces have little or nothing in common with their pre-Hispanic predecessors. According to Verónica, her brothers produce the family's best and most innovative work. Ernesto and Alonso are indeed excellent potters, but Verónica tends to exaggerate the quality of their work at the expense of undervaluing her own. This tendency to overvalue men's work over women's can be seen in both the studies on Mata Ortiz as well as among the women themselves. For example, one *ceramista* told me, "I only paint, my husband is the one who really knows what he's doing." Ironically, painting is generally considered the most innovative and artistic aspect of pottery making, which is why the painter signs the finished pot.

The most successful pottery-making families have the means to hire domestic help, in some cases live-in servants. The extra help gives *ceramistas* more time to make pottery, which in turn increases their income (Williams 1991, 99). This idea led me to believe that the most famous *ceramistas,* such as Consolación or Lydia Quezada, would have domestic workers, but it seems they do not. Instead, they invest in washing machines, refrigerators, and modern kitchen appliances.

Lucy Mora, secretary of the Pearson Group, says that only women joined because "they are a little slow"; apparently, she accepts the widespread belief that women are not as intelligent as men. Perhaps it is easier to take advantage of women, which is precisely what Guillermo Lozano did. The group's original promoter between Mata Ortiz and FONAES (Fondo Nacional a Empresas Sociales [The National Foundation of Collective Enterprise]), Lozano acquired a 300,000 peso loan, but only contributed 250,000 to the Pearson Group.

Lucy, who works in the municipal government, has no time to form pots. Instead, she buys them already shaped and paints them herself with Mimbres designs she copied from an illustration of pre-Hispanic pottery given to her by a North American. She signs all of her family's pots and sells the large pieces for eighty dollars. Like Lucy, most of the women in the group are married. In fact, only three are single.

Members of a group or not, all Mata Ortiz potters use simple tools. In the first place, they do not use a wheel, just their hands. Secondly, the handles of their child's hair brushes are either sticks or empty ballpoint pens. The artists fasten the hair to the brushes with string or tape. Their rudimentary utensils and working styles contrast dramatically with their houses' loud curtains, made from synthetic fabrics, and brand-new, ostentatious furniture, exces-

sively varnished and usually trimmed in a gaudy golden color. One more irony.

Thus the *ceramistas'* interior decorating tastes have nothing in common with the aesthetic that comes across in their pottery, to which they dedicate hours each and every day. Numerous houses in Mata Ortiz exhibit two utterly conflicting senses of taste. Since women are generally responsible for selecting curtains, furniture, and purely decorative items, this notable duality is most likely the result of their efforts. Such a contrast raises interesting questions. How is it that the same person capable of creating a precious work of art, complete with original designs hand-painted with natural pigments, would also buy kitschy window drapes, a horrendous porcelain horse, a statuette of a ballerina, or any other bibelot that invariably comes in an anemic shade of pastel pink or baby blue? This phenomenon occurs not only in Mata Ortiz, but also in other Mexican villages that produce folk art, especially in even more prosperous locales such as Ocotlán de Morelos and Teotitlán del Valle, in the state of Oaxaca, or even in Mexico City. Artisanry and handicrafts connote primitive cultures and backwardness, while premanufactured objects of plastic, porcelain, or synthetic fabrics symbolize modernity and progress. Mass-produced commodities acquire a magical value that somehow exceeds what potters can make with their own hands.

This contradiction has not escaped the attention of other observers, such as Parks, who notes without being judgmental that "The living room where we sat was decorated with a print of the Last Supper, a large wedding photo . . . and highly-glazed ceramic animals, a decorative style typical of the homes in Mata Ortiz" (1993, 45). Gilbert openly wonders why the *ceramistas'* pottery is not incorporated more into their daily lives, and asks, "Why is this aesthetic not reflected in the furnishing of their houses?" (Gilbert et al. 1995, 56). But potters in Mata Ortiz seldom use the pieces they make. Curiously, Olivia Rodríguez stores her paintbrushes in a cracked pot. Lupe Soto keeps her handmade pots in the window, as decoration or possibly as an advertisement. Lydia Quezada's house has a special glass showcase reserved for pottery. The art works that spring from these women's hands change hands quickly in the demanding ceramics market.

Lupe Soto, a member of the Pearson Group, is especially adept at crafting very thin, smooth, and beautiful pots, painted almost exclusively with Mimbres designs. She works with her husband, who signs some of the pieces, depending on where they are sold. For example, Lupe signs the pots they sell in the *Centro de Acopio,* even if both she and her husband worked on

them. Their prosperity self-evident, Lupe and her husband live in a comfortable house with a tiled floor, new furniture and, of course, the requisite knickknacks that clash garishly with their exquisite pottery.

From the potter's perspective, market conditions vary widely, depending principally on the demand for a particular artist's work. Prices range from between five and ten dollars to three or four thousand.[13] Some potters have extensive client lists, while others struggle to make a single sale. For example, Juan Quezada can easily charge over three thousand dollars for a pot. Macario and Chevo Ortiz have a six-month waiting list, and a new customer of Nicolás Ortiz will have to wait two years to purchase a piece. However, the *ceramistas* whose work is unexceptional sell their wares in local exhibitions, organized periodically, or in their houses. Lucy Mora has a gallery in the El Porvenir neighborhood, where she sells her family's and other local potters' pieces. Pearson Group members have access to the *Centro de Acopio* as a place to exhibit and sell their work. Some artists buy already formed pots and then sell them after painting, signing, and firing them. Signing establishes ownership over a design and helps an artist gain recognition. Poorest quality pieces are typically sold in the streets to any passerby willing to make a deal. Wholesalers and distributors are the most important purchasers, and they come predominantly from the United States. Mexican distributors account for a fraction of the sales, while tourists buy the remaining portion. Raymond Firth sums up the impacts of the Mata Ortiz ceramics trade when he writes, "Industrial society has not only offered a new market for indigenous art work, it has also given new opportunities for artistic enterprise" (1992, 32).

The Paquimé Group

In 1997, the Pearson Group already closed to new members, a number of *ceramistas* organized to found the Paquimé Group. As with the Pearson Group, Guillermo Lozano was the go-between acquiring funds from FONAES, securing a loan in 1998. This time, however, the quantity of 104,000 pesos was paid directly, therefore in full, to the potters.

Carolina Marín, the association's secretary, informed me that fifty-one women joined the group at its inception, but that since then four have left, having married or emigrated to the United States. Nine members share family ties. The group has no fixed meeting dates, and each *ceramista* sets the prices for her own work. Marín emphasizes that the Paquimé Group helps members display their pottery at exhibitions and raise money in order to pub-

2. Sara Corona
painting, 2000.
*Photograph by
Eli Bartra.*

lish a catalog, which, according to Marín, is sorely needed. In 1999, Paquimé
Group members went to three exhibitions, and by the middle of 2000, they
had already attended one. The group elects administrative officers every two
years, and even though members would like to establish a system of rules and
regulations, this remains an uncompleted project. Not all participants are
native to Mata Ortiz. Instead, they come from a variety of nearby commu-
nities including Nuevo Casas Grandes, Santa Rosa, and Colonia Anchondo.

Ana Trillo, the social director and treasurer, joined the Paquimé Group
after returning to Mata Ortiz from Ciudad Juárez, where she had worked
for a time in a *maquiladora* (assembly plant). Like most of the women in
the Paquimé and Pearson Groups, Ana is married. About twelve years ago,
a friend taught her the skills needed to begin making pots, and now Ana is
serving as a mentor to her sister-in-law, Sara Corona, another member of the
Paquimé Group. They often work together in Sara's house, and both par-
ticularly enjoy painting, especially in comparison to polishing and sanding,
activities which most women I interviewed liked the least. *Ceramistas* tend
to prefer painting and forming pots, the most creative aspects of the process.
Sara, who is single, is responsible for a variety of tasks. Not only does she
gather, wash, and prepare clay but she also farms and cares for her chickens
and pigs.

Ana works with her husband Mónico. She forms the piece, usually a small
one, and Mónico sands it with sandpaper. Once it has been formed and its
sides are smooth, Ana paints the outlines of her design with a brush made
from strands of her youngest son's hair. Of her four children, his is the finest
and straightest. Mónico fills in the design and then polishes the pot with one

of a number of possible substances: cooking oil, oil used for curing leather, or flakes of Zote, a laundry soap, which he cuts from the bar with a Gillette razor. The whole family helps fire the pots, and they polish the pieces with Brazilian river rocks, gifts provided by "Americans." Ana signs all the pots. Concerning household responsibilities, Mónico raises livestock and farms their twenty hectares of irrigated land. Ana performs all of the domestic tasks.

At one point, FONAES suggested that the Paquimé Group build a central workshop and a large gas oven, capable of firing many pieces simultaneously. The group members decided against the idea because they preferred to work in their individual houses, which allows them to make pottery and care for their children at the same time. In addition, firing pots in a gas oven would mean sacrificing a significant degree of what they consider authentic. The *ceramistas*' ability to attend to a number of tasks at once, and their insistence on maintaining traditional methods of firing pottery, support Ana's explanation as to why only women joined the Paquimé Group. Simply put, she says, "We work harder!"

Ana and Sara are conscious of the widely shared opinion that the quality of the *ceramistas*' work varies a great deal. Ana notes that some women are capable of "very refined work," while others "produce coarser pieces." She continues by explaining that "some started out badly, but have since improved. That is why our prices vary so much." Paquimé Group potters do not use manure to fire their pieces but instead prefer burning wood from poplar trees. Although it is generally easier to use wood than manure chips (one potter commented in passing that manure was inconvenient because it attracted spiders), the latter are much better for crafting white pottery because they burn at a higher temperature.

Sara's designs often incorporate representations of chickens and corn, which she explains by noting that for many years she was a farmer. Regarding her economic success, she happily proclaims, "Many Mexicans dream of going to the United States to earn dollars. I earn them right here, and don't even have to work that hard!" Her family is upper middle class within the community, and it always has been. Even before the ceramics boom, her father had ample land, livestock, and even a *troca*, the local term for a pickup truck.

Lilia Rentería, widow and ex-member of the Pearson Group, lives in the town's center near the train station and has the reputation of being a rather unscrupulous merchant. Potters strapped for cash sometimes sell her a piece below market value only to have her resell it at a considerably higher price.

The citizens of Mata Ortiz tend to frown on Rentería's questionable ethics. By the same token, potters find themselves trapped in a similarly unfair predicament when it comes to their business dealings with distributors. For example, *ceramistas* in the Paquimé Group bitterly recount the common experience of selling a pot to an American wholesaler for 300 dollars, which he or she then sells to a gallery for 600, where its final purchase price easily approaches 1,000 dollars.

Williams argues that while "there are no implicit rules regarding gender roles in pottery manufacture," that they may exist is a hypothesis that "needs to be tested" (1991, 178). Although certain aspects of pottery making do not follow gender-based rules—such as who begins the trade in a family, and who teaches whom—clear tendencies persist. For example, women shape pots more often than they paint them. Frequently, they fill in the designs that men paint. Both men and women perform the heavier, less creative tasks, like sanding and polishing, but it is clear that women tend to do them more frequently, thereby playing a merely supportive role. There are exceptions, but it is uncommon for a man to shape pots that a woman paints. The converse is remarkably commonplace, a fact that contradicts Williams when he proposes that there is no consistency regarding who shapes and who paints (170). Membership in the Pearson or Paquimé Group alters gender rules. *Ceramistas* in the group are leaders; they take initiative and make decisions about the design and sale of their pottery. Though the *ceramistas* remain enmeshed in a familial production process, the pieces that groups sell are generally made and signed by women. Some women, and men, make the entire pot, working it through every step of the process. Most artisans work as a team. Even Juan Quezada works with his wife, Guillermina Olivas, who helps him polish and sand.

From purely geometric line work to figurative representations, the *ceramistas* of Mata Ortiz display an enormous range of designs on the surface of their pottery. Some clearly recall pre-Hispanic motifs, while others are only vaguely reminiscent of the Mimbres and Casas Grandes traditions. Heavily stylized or more realistic representations of animals are frequently incorporated into the designs, including rabbits, tortoises, birds, fish, sheep, ants, lizards, butterflies, and ladybugs. Women tend to make small pots with round bases which require a special stand to keep them upright.[14] The stands, or *aros*, are typically made from clay whose color matches that of the pot. Some women, generally the oldest and the youngest, specialize in making *aros*. *Ceramistas* often make them on their own, or paint prefabricated *aros* to fit with the design and color of finished pieces. Although some craft figurines,

the vast majority of *ceramistas* make pots. This is due to the simple fact that pots sell better. Market forces aside, *ceramistas* are free to exercise their own tastes, preferences, and imagination, exploring a broad range of colors and a seemingly limitless number of designs.

Seeking Perfection

That famous room of one's own, a space providing silence and solitude, fertile ground for the imagination . . . such a place is little more than the stuff of dreams for most Mata Ortiz potters. Only a handful—most of them men—have achieved sufficient privilege and wealth to transform fantasy into reality and acquire a studio. These lucky few include members of the Quezada, Ortiz, and Gallegos families. The rest must content themselves with the kitchen or dining-room table, or even the bedroom, surrounded by children and constantly interrupted by the comings and goings of other family members, ceaselessly nagged by domestic chores. Describing her experiences in Mata Ortiz, Claudia Cancino writes that she "was pleased to confirm that no studio is needed for creation" (2000, 40). Of course, if a studio were a prerequisite, humanity's artistic heritage would indeed be a poor one. This still does not discredit the fact that a room of one's own remains the ideal space for artistic creation.

The first generation of potters in Mata Ortiz was one of innovation and rapid change, shaping the town's art and daily life. A second generation implies tradition and continuity, and its progeny, in turn, will grow up within a community defined by the ceramics industry, its destiny already written, like line work on a ceramic vase.

In general, Mata Ortiz pottery can be divided into three categories pertaining to quality: excellent, good, and fair. Imagining this schema in the form of a vase, a small quantity of very good work, considered equivalent to "fine art," constitutes its mouth. The vase's body, its widest section, corresponds to the greatest number of pieces, of the typically high quality of Mata Ortiz. Finally, the base represents work of the lowest quality (see fig. 3).

Although such differences are self-evident, all of the potters in Mata Ortiz strive for excellence. Their collective drive to improve, relentlessly, the work they produce has resulted in some of the finest, if not *the* finest, ceramics in Mexico. To continue with a metaphor similar to the one outlined above, throughout Mexico the quality of folk art tends to conform to the shape of

EXCELLENT _____

GOOD _____

FAIR _____

3. Quality of Mata Ortiz pottery.

EXCELLENT _____

GOOD _____

FAIR _____

4. Quality of Mexican folk art.

an isosceles triangle: at its peak stand a small number of exceptional artists, and descending from there the quantity increases as the quality of the art decreases (see fig. 4). Along with Mata Ortiz pottery, the apex of Mexican art includes the *sarapes* (blankets) of Teotitlán del Valle, the clay figurines of Santa María Atzompa, the paintings on *amate* (fig tree bark) from Xalitla, and the earthenware crockery of Metepec.

Juan Quezada, who embodies the village's drive for perfection, is partly responsible for the excellence that defines Mata Ortiz. However, it is likely that the extraordinary quality of Mata Ortiz pottery has more to do with the volatile combination of two factors: the historically and culturally determined capacity of the Mexican people to create exquisite works of art; and the opportunity for lucrative remuneration that such an ability provides. Mata Ortiz will become an even more significant place on the artistic map if the promise of a paved freeway is fulfilled. At that point, perhaps it will no longer appear as such a remote place, and its isolation will cease to be an obsessive leitmotif for those who write about this community and its art.

In contrast to most of the visual arts, pottery, and especially Mata Ortiz pottery, is a veritable feast for two of our five senses: sight and touch. Attracted by the lovely colors, marvelous designs, and seductive shapes, one cannot resist reaching out to enjoy the experience of feeling the fragile elegance of a piece's silken surfaces and eggshell-thin sides. This delicacy is deceptive, given the force with which Mata Ortiz pottery has emerged onto the stage of Mexican folk art. Although it seems guaranteed, only time will tell if these ceramic wonders obtain lasting legitimacy in the canon of national art.

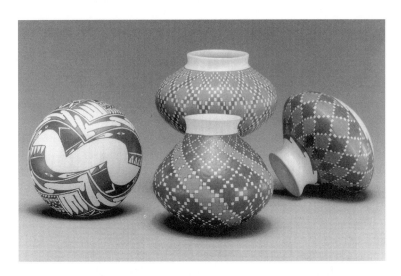

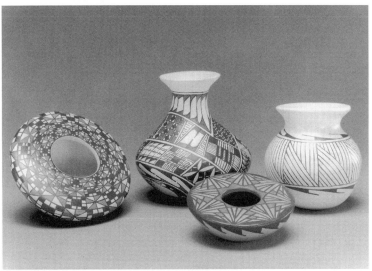

5. and 6. Mata Ortiz pottery, 2002. *Photographs by Jesús Sánchez Uribe.*

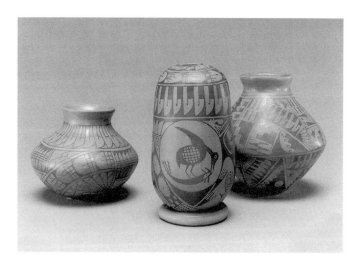

7. Mata Ortiz pottery, 2002. *Photograph by Jesús Sánchez Uribe.*

After all, they sing in English and speak in dollars. Will it become necessary, some day, to nationalize them?

Notes

First I would like to thank Mary Goldsmith for her helpful suggestions and for accompanying me during my fieldwork. Many thanks also to Javier Soto, whose invaluable knowledge of Mata Ortiz and its potters made what could have been a slow and difficult process much easier and enjoyable. I am especially grateful to the potters themselves, and I cannot thank them enough for their generosity, both with their time and their knowledge. Thanks to Ryan Long, who did an excellent job translating the Spanish text of this essay, and who also opened doors for my research at Duke University. Special thanks to my daughter Maiala Meza for her careful reading and astute observations. Finally, to John Mraz, for his meticulous revisions of the manuscript and, as always, for his love.

1 Translator's note: For stylistic reasons I have preserved the Spanish term, which, with the article that accompanies it in the Spanish original, is gender-marked as female. Throughout the essay, *ceramista* denotes a woman potter.

2 The videotapes and CD-ROM known to me are *Mata Ortiz Pottery: An Inside Look,* dir. Ron Goebel and Nancy Andrews, 1997, 35 minutes; *The Potters of Mata Ortiz,* dir. Barbara Goffin, 1994, 47 minuntes; *Juan Quezada,* dir. William F. Price, La Luz Productions, 1992, 15 minutes; *Mata Ortiz,* dir. Gerardo Lara,

Sep/Ilce, n.d., 27 minutes; "Mata Ortiz Pottery," David George Lucas, CD-ROM for Windows or Macintosh, 2001.

3 See, for example, Cahill (1991), Donnelly (2000), Felsted (1998), Gilbert (1995, 1999), Johnson (1999), Lowell et al. (1999), Lurie (1997), Parks (1993, 1995), Smith (1997), William (1995), Willams (1991), and Wisner (1999).

4 Censo Nacional de Población Vivienda 2000: www.inegi.gob.mx.

5 Frederick Star Pearson was a Canadian entrepreneur and inventor who found the funds necessary to construct the railroad and the sawmill at Pearson Station. He suffered an untimely death in 1915 when he drowned during the sinking of the *Lusitania*. See Lowell et al. (1999, 56).

6 An *ejido* is a collectively owned portion of land used for harvest or grazing. According to Barbara Goffin's video (see note 2), in 1994 there were 270 co-owners of the Mata Ortiz *ejido*.

7 Translator's note: Covarrubias's text in Spanish reads, "se desconoce la suerte que corrieron las excelentes dibujantes mimbreñas."

8 The pottery-making process has been described in great detail elsewhere, so the present essay only discusses it in general terms. For more developed descriptions, see Gilbert (1995, 1999), MacCallum (1981, 1994b), Parks (1993, 1995), and Williams (1991).

9 The translation of this work into Spanish is, as usual, very poor.

10 The first organization of this kind in Mata Ortiz, the Cooperative Society of Potters, was founded by the government and directed by Juan Quezada around 1979. See Di Peso and MacCallum (1979, 80–83) and Fournier and Freeman (1991, 113).

11 Personal interview. All of the interviews with *ceramistas* were conducted by the author between June and July 2000.

12 The minimum wage in Chihuahua is 40.35 pesos per day (Comisión Nacional de Salarios Mínimos, 2001: www.conasani.gob.mx/indice.htm).

13 A Juan Quezada pot is offered in an Internet advertisement for 2,950 dollars. This is said to be a half-price sale because of the work's imperfections.

14 This is a clear vestige of the pre-Hispanic shape. In Mexico, and other places such as the United States, the bottom of old pots is round rather than flat, much like that of modern pots.

Reference List

Braniff, Beatriz. "Paquimé: Origen de una tradición cerámica." *Artes de México* no. 45 (1999): 10–18.

Brody, J. J. *Mimbres Painted Pottery.* Santa Fe, N.M.: School of American Research, 1977.

Brody, J. J., Catherine J. Scott, and Steven A. LeBlanc. *Mimbres Pottery: Ancient Art of the American Southwest: Essays.* New York: Hudson Hills, 1983.

Buckley, Cheryl. *Potters and Paintresses: Women Designers in the Pottery Industry, 1870–1955.* London: Women's Press, 1990.

Cahill, Rick. *The Story of Casas Grandes Pottery.* Tucson, Ariz.: Boojum Books, 1991.

Cancino, Claudia. "Juan Quezada: Mexican Potter." *Ceramics: Art and Perception* no. 41 (2000): 39–41.

"Cerámica de Mata Ortiz." *Artes de México* no. 45 (1999).

Chayat, Sherry. "In the Margins: Women in Ceramics." *American Ceramics* 13, no. 3 (2000): 46–48.

Coe, Ralph T. *Lost and Found Tradition: Native American Art, 1965–1985.* New York: American Federation of Arts, 1986.

Coote, Jeremy, and Anthony Shelton, eds. *Anthropology, Art, and Aesthetics.* Oxford: Oxford University Press, 1992.

Covarrubias, Miguel. *El águila, el jaguar y la serpiente: Arte indígena americano.* Mexico City: Universidad Nacional Autónoma de México, 1961.

Davies, Lucy, and Mo Fini. *Arts and Crafts of South America.* London: Thames and Hudson, 1994.

Di Peso, Charles C., and Spencer Heath MacCallum. *Juan Quezada and the New Tradition/Y la Nueva Tradición.* Fullerton: The Art Gallery/Visual Arts Center, California State University, 1979.

Donnelly, Karen. "The Art of Innovation." *World and I* 15, no. 4 (2000): 112+.

Felsted, H. Herb, and Carla H. "Juan Mata Ortiz." *Mexican Meanderings,* March-April 1998, 4–6.

Firth, Raymond. "Art and Anthropology." In *Anthropology, Art, and Aesthetics,* ed. Jeremy Coote and Anthony Sheldon, 15–39. Oxford: Oxford University Press, 1992.

Fournier, Patricia, and Andrea K. L. Freeman. "El razonamiento analógico en etnoarqueología: El caso de la tradición alfarera de Mata Ortiz, Chihuahua, México." *Boletín de antropología americana* no. 23 (1991): 109–18.

Gilbert, Bill. "Mata Ortiz: Traditions and Innovations." *Ceramics Monthly,* December 1995, 51–56.

———. *The Potters of Mata Ortiz/Los ceramistas de Mata Ortiz: Five Barrios, Seven Families/Cinco barrios, siete familias.* Albuquerque: University of New Mexico Art Museum, 1999.

Gilbert, Bill et al. *The Potters of Mata Ortiz/Los ceramistas de Mata Ortiz: Transforming a Tradition.* Albuquerque: University of New Mexico Art Museum, 1995.

Guthe, Carl E. *Pueblo Pottery Making: A Study at the Village of San Ildefonso.* New Haven, Conn.: Yale University Press, 1925.

Hatch, Nelle Spilsbury. *Colonia Juárez: A Mormon Village.* Salt Lake City, Utah: Desert Book Company, 1954.

Hayes, Allan, and John Blom. *Southwestern Pottery: Anasazi to Zuni.* Flagstaff, Ariz.: Northland, 1996.

Johnson, Mark M. "The Potters of Mata Ortiz: Transforming a Tradition." *Arts and Activities,* February 1999, 29–32.

Kaplan, Flora S. *A Mexican Folk Pottery Tradition: Cognition and Style in Material Culture in the Valley of Puebla.* Rev. and enl. ed. Carbondale: Southern Illinois University Press, 1994.

Kiva: The Journal of Southwestern Anthropology and History 60, no. 1 (1994).

Lowell, Susan, et al. *The Many Faces of Mata Ortiz.* Tucson, Ariz.: Treasure Chest Books, 1999.

Lozano, Guilermo. *Paquimé: Grupo Pearson: Artesanía viva: Cincuenta y dos mujeres alfareras.* Mexico City: FONAES/Sedesol, 1997.

Lurie, Rhoda. *Discovering the Magic Pots of Mata Ortiz.* Santa Monica, Calif.: Rhoda Lurie, 1997.

MacCallum, Spencer Heath. "A Story of Three Pots: Juan Quezada and the New Palanganas Pottery Tradition." *NCECA Journal* 2, no.1 (1981): 71–75.

———. "Introduction: Chronology and Perspective on Mata Ortiz Phenomenon." *Kiva* 60, no. 1 (1994a): 5–23.

———. "Pioneering an Art Movement in Northern Mexico: The Potters of Mata Ortiz." *Kiva* 60, no. 1 (1994b): 71–91.

Oettinger, Marion. *Con Cariño: Mexican Folk Art: From the Collection of the San Antonio Museum Association.* San Antonio, Tex.: San Antonio Museum Association, 1986.

Parks, Walter P. *The Miracle of Mata Ortiz: Juan Quezada and the Potters of Northern Chihuahua.* Riverside, Calif.: Coulter, 1993.

———. "The Pottery of Mata Ortiz: A Modern Form Rooted in a Prehistoric Tradition." *Bulletin of Primitive Technology* 1, no. 10 (1995): 58–62.

Peterson, Susan. *The Living Tradition of Maria Martinez.* Tokyo: Kodansha International, 1977.

Ravesloot, John C., Jeffrey S. Dean, and Michael S. Foster. "A New Perspective on the Casas Grandes Tree-Ring Dates." In *The Gran Chichimeca: Essays on the Archaeology and Ethnohistory of Northern Mesoamerica,* ed. Jonathan E. Reyman, 241–51. Aldershot, U.K.: Avebury, 1995.

Romero Flores, Jesús. *Del porfiriato a la revolución.* Mexico City: Costa Amic, 1959.

Smith, Sandra S. *Portraits of Clay: Potters of Mata Ortiz.* Tucson, Ariz.: Sandra Smith, 1997.

Turek, Norbert. "The Spirit to Learn, the Spirit to Teach." *Ceramics Monthly,* November 1999, 59–66.

William, Gilbert. "Juan Quezada: Mexican Potter." *Studio Potter,* December 1995, 51–59.

Williams, Michael Allan. "La lucha del barro: Two Potterymaking Families of Mata Ortiz." Master's thesis, Arizona State University, 1991.

Wisner, Michael. "The Ceramic Technology of Mata Ortiz." In *The Many Faces of Mata Ortiz,* ed. Susan Lowell et al., 187–97. Tucson, Ariz.: Treasure Chest Books, 1999.

RONALD J. DUNCAN ✪

Women's Folk Art in

La Chamba, Colombia

As Colombia has been torn in recent decades by its internal war between the government, drug traffickers, leftist guerrilla groups, and right-wing militias, the folk artists of the country have provided a sense of humanity and stability in the face of massacres and battles. The women potters of La Chamba stand out among the most important of these folk artists. They are heirs to the indigenous craft traditions in the Andes, where "crafting is viewed as a fundamental attribute of socially mature adults; part of what constitutes genuine adulthood, genuine humanness" (Helms 1993, 58). Art and craft are considered defining characteristics of humanity, culture, and civilization in this indigenous tradition. Today, the folk artists and artisans of Colombia maintain this heritage even during the current period of civil violence challenging the country's foundations.

La Chamba is a village located in the Magdalena River Valley of south-central Colombia, and the ancestry of its 2,000 inhabitants is linked to the indigenous people living in the region before the Spanish conquest. The valley constitutes a subtropical area where the temperatures rise into the nineties (thirties Celsius) all year long. People dress in light clothing, and the houses remain open to permit breezes to enter. Shade trees tower about the houses, and the fruit trees produce throughout the year. A few large landowners control the best agricultural land, and most men work as day laborers on the big farms. Houses are strung out along the one dirt road that runs through the village and ends at the Magdalena River, one kilometer from the plaza and the

church. Older houses have adobe walls, dirt floors, and thatched roofs, but newer ones are constructed of commercially made blocks and have metal or composition roofs and cement floors. Most houses have three or four rooms, and the average household has five people.

Early in the day, the footpaths throughout the village are busy as men go to their jobs in the surrounding fields, children walk to school, and women leave to mine clay. By eight or nine o'clock, women have returned home with their bags of clay, and during the heat of the day they work on ceramics inside. In the meantime they prepare lunch for the children who come home from school at noon. After lunch, children assist the mother in some of the basic tasks of ceramics making: the older children burnish pieces she made earlier, and the younger ones go out to gather dried donkey dung for use in later firings. Boys may be asked to pulverize the recently mined clay, and girls will have the job of soaking it in old pots to prepare it for use. After the heat of the afternoon passes, people are outside visiting while children play. This is the peaceful face of La Chamba, but the social conflicts in this region of Colombia have deep roots (Duncan 2000, 44–48).

La Chamba is located in Tolima, a region known for its history of social and political tensions. A primary cause for the tensions in this agricultural economy lies in the ownership of most of the fertile land by a few wealthy landlords. The structure of the feudal economy dating from the Spanish colonial period has changed little, leading to conflict. Tolima played an important role in the 1950s in the formation of the FARC (Fuerzas Armadas Revolucionarias Colombianas or Colombian Revolutionary Armed Forces), the largest guerrilla group in the country. In the 1970s, the landless poor from villages near La Chamba invaded large farms in the area, demanding land reform, but their movement failed when they were driven out by the police. Although the area has known conflict, La Chamba is a peaceful village of farmers and potters where women make folk art to support their families.

La Chamba Women and Their Art

The gender ideology with which La Chamba women view themselves defines them first as mothers and sisters, secondly as housewives, and thirdly as potters and folk artists. It is common in La Chamba for women to live in matrilocal residential clusters near their own mothers, aunts, sisters, and female cousins. Frequently women live almost entirely within the sisterhood of this matrilocal family, sharing food, clothes, child rearing, and ceram-

ics tasks. As mothers, they closely supervise daughters, giving special attention to the development of their domestic and pottery skills, which they will need when they become adults. Grown daughters commonly live close to the mother, sometimes in the same house, contributing to the family production of ceramics.

More important than their role as potters are women's tasks as household managers, obtaining and preparing the daily food, caring for the house itself, and attending to the everyday needs of the husband and children. Women are ultimately responsible for food, clothing, and health care, and they manage the money to provide those necessities. Since men have irregular incomes as day laborers in agriculture, women make ceramics to even out the flow of income for the family.

Children of both sexes learn from their mothers to mine and prepare clay, burnish pots, and fire them, but in adolescence this equality ends. Then young men limit their involvement to mining clay and firing the work, just as young women begin to specialize and learn all the steps of pottery making. As adults, women are the potters, and men assist them in firings. By the time women are mature adults, they have created support networks around themselves to organize their work, and the matrifocal extended family serves as the most obvious example of these networks.

The Prada Matrifocal Extended Family

The Prada family shows how the matrilocal extended family functions in La Chamba. Just off the plaza near the church live two older sisters with several of their own daughters clustered around them in separate houses. Wenseslada Prada, the older of the sisters, owns the larger house, and she has two daughters in their twenties, Clara and Aura, who continue living with her as well as an unmarried son. Next door lives her older daughter, Anatilde, with her husband and children. On the other side lives Wenseslada's younger sister along with two of her married daughters, each with their own family. In total seven adult women live in this cluster, and all are active potters. Each of the older sisters owns a kiln, so the seven women divide their firings between the two kilns.

The matrilocal extended family gives a social support network for the women, which extends beyond the nuclear family. Sisters, daughters, granddaughters, aunts, and cousins borrow, exchange, and share between them-

selves on a daily basis. This social security network means that women are less dependent on men than is the case in the larger Colombian society. In this particular extended family under consideration here, only three of the seven adult women had husbands. La Chamba has an extraordinarily high incidence (30 percent) of female-headed households for Colombia (Duncan 2000, 100–101; Montoya de la Cruz 1990, 46). Most rural areas have much lower rates of women heads of household, closer to the less than 5 percent recorded for the highland ceramics community of Ráquira (Duncan 1998, 58). The matrilocal extended family gives women social independence, and their craft skills give them an economic independence that few rural women have in other parts of the country. In keeping with indigenous patterns in the Andes (Hamilton 1998, 182–83), marriages tend to be more symmetrical and less male-dominated than is the case in the Spanish tradition.

Women and the Indigenous Heritage

Ceramics have been made in this area since the pre-Hispanic period. Following the indigenous tradition, pottery making is considered a woman's occupation, and there are almost two hundred women potters in La Chamba (Duncan 2000, 59). Their techniques of handwork for making vessel ceramics remain completely indigenous, with no significant Spanish influence (Duncan, 198–99). During the nineteenth century and the first half of the twentieth century, La Chamba potters almost exclusively made food and water vessels. The practice of making figurative ceramics in La Chamba dates only from the last few decades, a period of market expansion for village crafts in Colombia.

La Chamba figures portray the single issue most important to agricultural communities: fertility. They celebrate the luxuriousness and fertility of nature by showing a canoe full of plantains, a bowl full of fruits, a surging fish, and the epitome of fertility, the hen. The La Chamba potters show the fertility of the tropical environment of the Magdalena River Valley where they live, finding the positive aspects of life. They do not portray the violence and civil strife in the larger world surrounding them, and in so doing they remind people that violence is not all that defines Colombia at this point in its history.

Gender and Ceramics across Cultures

Cross-cultural studies of gender and work reveal women, as they are in La Chamba, as the potters in most societies. The broadest survey of the subject was made by George P. Murdock and Caterina Provost (1973), comparing 185 societies from various regions of the world. They found that ceramics were made in 105 of the societies surveyed and that women were the potters in 76 percent of the cases. Men were the potters in 18 percent of the cases, and women and men both made pottery in 6 percent of the societies. In total, women make ceramics in 82 percent of the pottery-making societies, making it one of the most gender-specific crafts in the world (Murdock and Provost, 207). In South America, the gender identity in ceramics making is even more pronounced, with women being the potters in 89 percent of the communities surveyed. This ranks pottery among the tasks most identified as women's work in the Murdock-Provost survey along with spinning (90 percent), laundering (91 percent), cooking (92 percent), bringing water (95 percent), and preparing vegetables (96 percent) (209).

Murdock and Provost studied fifty common human tasks, correlating gender and work characteristics for each. They concluded four rules for determining the gender identification of a task:

1. Gender and the nature of the raw materials used in the task. Women work primarily with soft, supple materials such as leather, textiles, plant material, and clay. In contrast, men usually work with hard materials like wood, stone, bone, horn, shell, or metal.
2. The gender that uses the end product tends to make it. Since women are the primary users of pottery for cooking and storing food and water, they tend to make it.
3. Innovative technology is usually assigned to men's tasks, while women tend to use older and less complex technology. This holds true in La Chamba ceramics where women continue to use techniques largely pre-Columbian in origin.
4. Women tend to work more in task sharing and men more in task specialization. In women's work organization, each person tends to know all of the steps and people interchange tasks. In contrast, men tend to organize their work into separate specialized processes. (211–16)

According to the Murdock-Provost study, women are usually responsible for work closer to the residence, not dangerous, and congruent with child care. Women's work is commonly repetitive so that it can be easily resumed after interruptions, and it usually requires continued attention day after day. In contrast, men tend to work in tasks requiring greater physical strength,

short, concentrated physical exertion, and greater distances traveled from the residence (211). Given the characteristics of work according to gender, pottery making is consistent with the usual work pattern for women as identified by Murdock and Provost.

Dean Arnold (1985, 101–102) added an economic dimension to the original Murdock and Provost explanations based on his ethnographic studies on the role of women in ceramics making in Mexico and Peru. He suggests that women's involvement in pottery results primarily from the need to supplement household income when agricultural production is marginal. Arnold named six factors rendering it more appropriate for women, rather than men, to make ceramics in a subsistence agricultural economy: (1) Ceramics making is compatible with child care, for which women tend to be responsible. (2) The work can be done at home, where most other women's tasks are also located. (3) Since no dangerous materials or machinery are required, no danger is introduced to the household. (4) Its repetitive nature allows tasks to be stopped and resumed after the frequent interruptions required in child-care. (5) Ceramics work can be scheduled around other household duties. (6) The day-to-day rhythm of ceramics making follows a similar schedule to domestic work. To these explanations offered by Murdock, Provost, and Arnold (211–16), we should add the increasing necessity for cash in rural economies in Latin America today, which pushes women into household-based craft work. As rural families move from subsistence to cash-based economies, there is pressure for women to contribute to the family income. The subcontracting chains of the global economy systematically target these rural women for low-wage contracts in household manufacturing. Marketable crafts, such as ceramics, basketry, and weaving, are subcontracted through these chains to rural women who have no other source of income and who are economically vulnerable. The household economics of rural families make it imperative for many women to accept these low-wage contracts.

Gender and Work Culture

Although each woman in La Chamba works independently with her own children, they also, as described above, collaborate within the matrilocal residential group. The women organize their pottery making primarily as a household team effort, incorporating their children and husbands or brothers into the process. Women are the lead workers in these household work teams, and other family members help them complete their orders on time. In this

domestic economy of women's groups, work is not a commodity to be paid for, but a form of collaboration. Women share information, orders, tools, tasks, and kilns between each other. If a woman cannot complete an order in the time required, she asks a relative to help her do so. In the art ceramics of recent decades, mother and daughter may collaborate in making the same piece, with the mother creating the basic form and the daughter modeling in the figurative elements to finish the piece. Although women take pride in the quality of their individual pieces, most are not egotistical about being the sole authors of the work. Rather, they readily collaborate and combine skills to complete it.

Among mountain potters in the central Andes of Colombia, cooperative family work groups also exist among women (Duncan 1998, 73). June Nash recorded a similar phenomenon among indigenous potters in Chiapas, Mexico, where she observed women working in interdependent stages, with each woman doing the tasks she performed the best (1985, 70). Borrowing Durkheim's terminology, Nash called this an "organic" pattern of interdependent cooperation, in contrast to the "mechanical" pattern followed by men. In the latter, each man worked independently in separate tasks, also in keeping with the pattern described by Murdock and Provost (Murdock and Provost 1973, 213).

Lynn Stephen (1993, 44) also documented Zapotec women weavers organizing family work teams in Mexico, where husbands and children assisted them. In the Zapotec case, women were responsible for production decisions such as the time allocation of their children's work, the volume of the production, and the negotiation of the selling price. This widespread documentation of cooperative women's work groups among artisans of indigenous descent in Latin America suggests it as a cultural pattern characteristic of this region of the world.

In La Chamba, women are responsible for each stage of production, from mining and preparing the clay, to making and burnishing pieces, supervising firings, and selling the finished product. The independence of La Chamba women in doing their own work and selling it, combined with the support they receive from their matrilocal extended families, gives them more independence within the nuclear family than most rural women in Colombia have. They have used this freedom to become the most innovative women potters in the country, creating new figurative and design styles.

Although women have more relative independence in La Chamba, men continue to play a crucial role in their lives—as husbands, collaborators, and middlemen for sales. As mentioned earlier, men are especially involved in

firing ceramics. In part, this results from traditional beliefs about the balance of hot and cold elements in maintaining health.

Humoral Theory and Gender

The classic statement of humoral theory comes from Hippocrates' theory of pathology, stating that matter consists of the four essences heat, cold, wetness, dryness (Mathews 1983, 827). Health is believed to derive from a balance of the humoral (hot and cold) elements in life, a belief affecting women working in ceramics. The concepts of *hot* and *cold* are not simply matters of temperature, and for example, the gender dimension of this theory suggests that women are cold and men hot (Duncan 2000, 196). Coldness and dampness are associated, so women who are "cold" can work with damp clay (which is also cold) without harm, but men cannot. Since women are cold, they should have minimal contact with "hot" elements like a kiln.

Men, who are hot by definition, can mine dry clay and fire the kiln, but they rarely touch clay in the moist or cold stages. There exists one exception to this rule, tending to confirm it. In certain cases, males do assist their female relatives by burnishing leatherhard pots, but we only observed younger adolescent boys or older retired men doing this. The older men were clearly embarrassed by being observed burnishing pots, and no mature male of a sexually active age was ever observed burnishing. There seems to be a belief that the cold experience of working with damp clay can drain away the heat of the male's sexuality. This suggestion is further confirmed by the sexual joking that goes on around the kiln during firings, which I will discuss below.

According to George Foster (1988, 121), the improper balance of heat and cold for an individual leads to illness, so people try to maintain a proper balance between hot and cold elements as preventive medicine. Since women are cold, they keep some distance from the kiln during the firing. Women carry pieces to the kiln and put them in saggers (large pots in which smaller ones are fired), but they rarely do the hot work of loading and unloading these saggers from the kiln itself because of the belief that excessive heat can "dry up the blood" or make them infertile. Loading and unloading the heavy saggers from the kiln requires considerable strength, also rendering it more appropriate for men for that reason. After experiencing the heat of the firing, people of both sexes are supposed to avoid cool experiences, such as getting caught in the rain, standing in the wind, or taking a bath, until their bodies have had time to return to normal temperatures.

Firing the kiln is one of the most important instances of collaboration be-
tween women and men in the community, and occasionally they turn to
jokes with sexual overtones. Men usually start the joking by suggesting that
the heat of the kiln invigorates them sexually. They compare the long poles
used to drag hot pots from the kiln to their own sexual organs, while the pots
are compared to women. Not to be outdone, the women disparage the men's
strength and question whether they really have the strength to carry out their
claims. This joking occurs as the man works at the door of the kiln and the
woman observes the process from ten to twenty feet away. By working at the
hot mouth of the kiln, men claim or perhaps assert their masculinity.

Although humoral theory was originally a Mediterranean concept, it
blended with existing herbal beliefs in the Americas to produce the belief
system found in La Chamba and other areas of Latin America today. One
of the end results of this belief system is that women depend on men to fire
their work for them. La Chamba women will fire their own kiln as a last re-
sort if no man is available to do it for them. As women pass menopause, it is
no longer as critical to avoid the fire of the kiln. So the stage of the life cycle
affects how a woman works in ceramics.

The Life Cycle and Women's Art

The life cycle of women potters in La Chamba is divided into four stages,
and those stages also conform to design cycles in ceramics. The folk artists
are to be found in the younger age groups, while the older women work in
traditional pottery. La Chamba potters tend to work throughout their lives
in ceramics, from fourteen or so until they die or until they are incapacitated
to work. The differences between folk art and traditional pottery reflect gen-
erational changes between grandmothers, mothers, and daughters, with the
former making cooking pots, the mothers making tableware, and the latter
making one-off figurative pieces reflecting their interests in art. This change
also represents a change in the urban markets, where an interest in folk art
has grown remarkably in recent decades.

Apprenticeship constitutes the first stage for the potter (approximately
fourteen to twenty years of age). During this stage, young women work with
their mothers or maybe with an aunt or grandmother to learn basic tech-
niques of the craft. The apprenticeship lasts until the young woman is mar-
ried, usually in her early twenties. During the apprenticeship, the young

woman assists the older potter in completing the orders, and the older woman corrects the less skillful work of the one learning.

Early adulthood (twenty-one to thirty-nine years) constitutes the second stage, which begins when a woman marries and sets up her own household. During this stage, women begin to work more independently from their mothers, but many continue to share orders with them. Some young potters have to leave their production on consignment in the local stores at this stage until they have developed a reputation among buyers for the figures or designs they make. The folk artists in La Chamba are concentrated in this stage because these are the women who have learned to do modeling and make figurative pieces.

By the mature adulthood stage (forty to sixty years), potters have established reputations among buyers, making tableware, especially bowls, which are very popular in the urban markets. By this time their children are also older, so women have more free time for their craft work, and they enter the most productive stage of their lives. Children help their mothers doing various supportive tasks.

Elder potters (older than sixty years) represent the last stage of the life cycle, and they make mostly traditional pottery such as cooking pots and serving bowls. The oldest potters continue to work as long as possible, and in some cases the adult daughters will assume responsibility for the mother and her work. Even in their late sixties and well into their seventies, La Chamba women commonly continue to work on a daily basis.

This evolution of styles between the generations in La Chamba reflects the social change that remains ongoing in the country. Over the last fifty years, the market for pots and bowls has changed dramatically, and today people can easily buy metal pots and plastic bowls more functional than traditional ceramic utensils. At the same time, urban populations have grown dramatically in Colombia, and many city dwellers look to traditional ceramics or folk art as icons of the country's cultural roots. Gradually the women ceramists of La Chamba have changed from being traditional potters to folk artists creating the figures that represent the rural and small-town values of the country. During this process, La Chamba ceramics have emerged as a folk art.

Ceramics as Art or Craft

Art ceramists metamorphose the inert material of clay into a statement of creativity, converting raw material into an expression of aesthetic concepts and values. Pottery constitutes an art medium accessible to all members of society because it has its roots in everyday life and function. This constant relationship with daily life has shaped many of the visual qualities of ceramics, especially form and texture. Philip Rawson (1971, 9) suggests that this connection with daily life and experience gives ceramics its special aesthetic attractiveness. Not only is pottery one of the oldest media of visual expression, but the various stages of its evolution have reflected important social, economic, technological, and aesthetic aspects of society (Cooper 1981, 7).

In Colombian ceramics, folk art finds expression primarily as human and animal figures (Duncan 1998, 91–107; 2000, 166–80) since the painting of surface designs is virtually nonexistent. Folk art differs from gallery art in the cultural information it provides. Traditionally, folk art has been more narrative of common, everyday experiences, with little or no reference to the conceptual history of art, although this severe line is beginning to blur today. Folk art potters, such as those from La Chamba, make figurative ceramics in which they link narrative intentions with aesthetic ones. A potter makes the nativity scene, a hen, a jumping fish, or a dove because she thinks it will sell. But as she models the nativity figures or the hen, she takes care to give them the form, color, and surface qualities that she believes are the best ones. In doing so, she is making aesthetic choices about composition and perspective. The international market has recognized the aesthetic value of La Chamba ceramics, and they are offered today in fashionable boutiques and design stores from New York to London. Terence Conran, a leading British designer, has prominently included La Chamba ceramics in his design stores.

As the concept of fine arts has emerged over the last two centuries in European and American thought, it has been largely used to refer to the traditional European media of figure making, including painting, drawing, and sculpture. Some art theorists have even questioned whether non-European art qualifies as art because it does not comply with European definitions (Zolberg 1990, 5–8). Other theorists adopted the idea of so-called primitivism to explain art that came from non-European cultures (Barasch 1998, 191). However, the emergence of the art crafts movement and the anthropological studies of art in the last century have pointed to the ethnocentricity of limiting *art* to European media and definitions. Even with that, ceramics has

been defined as a craft or a minor art at best in the Euro-American scheme of fine arts, however.

When can we consider the medium of ceramics art and when craft? Since both art and craft require visual skill in the use of materials and techniques, we should regard both approaches to creating images and objects as inherently related. The artist and artisan differ in their intent and in the way of resolving the problems of producing their work. Jean Clare Hendry (1992, 2) suggests that we distinguish between the artist's emphasis on the abstract qualities of a piece (i.e., history or idea of the form, texture, color, etc.) as opposed to the artisan's emphasis on the concrete, technical qualities of those same aspects. The artisan may work as a production potter making pottery in volume, or she may work with the intention of a designer or artist emphasizing the aesthetic quality of the craftsmanship. A La Chamba artisan creates art when she chooses visual elements, such as shape (open or closed spheres), texture (satin or rough), or color (iron-oxide red or black) to make a composition that is aesthetically appealing. A painter or sculptor, as much as a potter, may be an artist or an artisan, depending on the quality of the work process.

Urban Colombians tend to derive their aesthetic standards from Euro-American models. They distinguish between art and craft in terms of social class (high equals art, low equals craft), ethnicity (European equals art, indigenous equals craft), and residence (urban equals art, rural equals craft). This distinction between art and craft holds true throughout much of Latin America (García Canclini 1990, 224–25). It is a view that contrasts the perception of the artist as creating sophisticated one-of-a-kind works in thoughtful isolation with that of the artisan as doing collective, anonymous, repetitive, and uncreative production work. In this view of the aesthetics, art has a high social status, and crafts are relegated to a lower status associated with indigenous and mestizo peoples. In Colombia, the ceramist's social class provides the critical indicator that distinguishes whether the person's work is considered art or craft.

Caste, Residence, and Eurocentrism

The separation between urban professional and village folk artists in Colombia is a castelike one based on difference of social status and cultural origin. The social distance between university-trained ceramist and the traditional folk ceramist is graphically portrayed in the way each makes and sells ceram-

ics. Professional or university ceramists use Eurocentric designs and sell them at high prices in upscale design stores or galleries in Bogotá, but in contrast the village folk ceramists work in indigenous methods and sell their pieces at low prices in stores of *artesanías* or crafts.

In the census of craftspeople made by Artesanías de Colombia (1998, 3), only 1.94 percent of the craftspeople in the country had university-level training, and few of those had taken courses in their craft at a university. Of the various craft media, only textile design/weaving (Universidad de los Andes) and ceramics (Universidad Nacional de Colombia and Universidad de los Andes) are taught in the major university art departments of the country. Half of the artisans in the census (51 percent) had little or no formal education at all. The gulf between this majority of uneducated craftspeople, most of them rural and mestizo, and the two percent of university-educated craftspeople, most of them urban, is so great that it appears castelike and virtually unavoidable.

Since the urban art community remains Eurocentric, it does not encourage looking at local traditions. Although there is an appreciation of pre-Hispanic and rural/village ceramics, there has been a traditional taboo against university-trained ceramists incorporating ideas from those sources into their own work. The social gap is such that indigenous aesthetics historically have not been considered an acceptable subject in the "high" art of urban galleries and museums. As Dean Arnold (1985, 127) says, ceramics are a means by which ideological and social structural information is communicated within a society, and in Colombia, folk ceramics communicates ruralness with its associated burden of indigenous roots and poverty.

Ceramics as Art, Craft, or Manufacturing

Ceramics may be considered a fine art, folk art, industrial production, or craft, depending on whether the primary purpose is expression or production and whether the ceramist is using professional or folk reference systems to produce the work (see table 1). As discussed earlier, older potters in La Chamba are craftspeople making large numbers of repetitive forms, while the younger generation of potters makes folk art figures, so that in La Chamba folk art and craft coexist.

If potters create work with the intention of expressing aesthetic choices, they are working as artists rather than as artisans even though they live in a village. On the other hand, craftspeople tend to produce domestic material

TABLE I. Art or Manufacturing

	MODE OF WORK	
LOCATION	Art	Production
City	Professional Art	Industry
Rural	Folk Art	Craft

goods, such as cooking pots, required to sustain life in subsistence econo-mies. Craft is rooted in place, time, and tradition, and it is characterized by handwork. In contrast to industrial workers, craftspeople are independent workers who own their means of production, have their own distinctive style, and control the disposition of their work.

However, traditional rural craftspeople, who historically have been subsis-tence-oriented artisans producing baskets, pottery, and weavings for their families, are rarities today, if they exist at all. Although La Chamba potters work with the techniques and organization of traditional handicrafts, they now work on contract and sell their products to national markets. So are they doing craft work or engaged in manufacture?

Mary Helms (1993, 16) distinguishes between crafting and manufacturing by saying that the former emphasizes the qualitative process of transforming materials while the latter emphasizes the quantitative process of production. She suggests that craft becomes industry when the production goals become more important than the act of transforming raw material into an artifact. She also points out the necessity of distinguishing between skillfully crafted material objects with aesthetic qualities and ordinary crafted objects in which the utilitarian qualities dominate (148).

In La Chamba, the makers of traditional vessels and tableware are crafts-women interested primarily in production. In contrast, the makers of figures and figurative vessels focus more on the quality of the image and whether it will pique the interest of people who see it.

Art and Political Violence

La Chamba folk art represents a nonviolent and almost bucolic life at a time in Colombia's history when social conflict and civil war are tearing at the fiber holding the country together. That makes for part of this figurative style's ap-

peal. It portrays a life rooted in the security of nature, which has become an important reference point for a society threatened daily by the insecurity of violence. Increasingly in the 1980s and 1990s, the government has been unable to guarantee social order, and in the maelstrom of violence, government troops battle with guerrilla armies, paramilitary groups, drug traffickers, and common criminals. Civilians find themselves caught in the crossfire between these groups. Kidnappings and extortion have become daily events, and over the last decade Colombia has experienced more than ten times the number of violent deaths suffered by Israel and Northern Ireland combined. Massacres are commonplace. Lines of corpses from the latest firefight or massacre and weeping family members at funerals are scenes seen regularly on television and in the newspapers.

How do folk artists deal with such terrible events in society? By and large, they have ignored it, providing a traditional vision of the world that acts as a counterweight to the violence of contemporary daily life. The fact that potters and artists continue work in such an environment makes for one point of stability in the society, and the folk quality of their work rooted in the earth and nature has proven important in Colombia. La Chamba artists, along with the other folk artists in the country, provide a ray of hope for normalcy and trust to a beleaguered society.

One Family of Folk Artists

The Sandoval-Valdés family has emerged as one of the most important in developing folk art in La Chamba. The mother and father (María Isabel Valdés de Sandoval and Juan Sandoval) live along the Magdalena River near the Chapetón landing. Their adult daughter, Lidia Inés, lives with them, and both the mother and daughter work as potters. The mother, now older, is no longer active, but Lidia Inés makes figurative pieces and tableware. Her brother Eduardo is also one of the most important figure makers from La Chamba, but he no longer lives in the community, and he continues to work in the local style even though he moved to Bogotá several years ago. He travels to La Chamba regularly to get clay and to fire his pieces in the family kiln.

Lidia Inés Sandoval makes striking fish platters in the curved form of a jumping fish, as well as modeled figures of donkeys complete with miniature pots on their backs. Her pieces are known for their excellent detailing, which includes carefully modeled fins and the tail swooping up into the air. The eyes and mouth of the fish are incised. Most noticeable is a finish com-

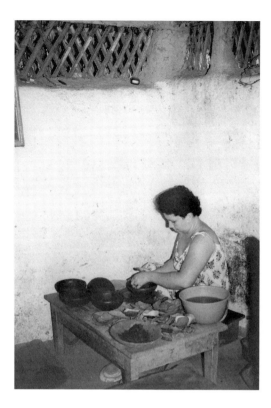

1. Lidia Inés Sandoval working in her house. Ms. Sandoval works in one corner of her house, on a short table almost at floor level. Here she makes fish platters, donkey figures, and small serving bowls. *Reprinted courtesy of the University Press of Florida.*

pletely smooth in texture which has the reflectiveness of a satin gleam and a red iron oxide color.

Like most ceramists in La Chamba, Lidia Inés is modest about her work, and although she makes some of the most beautiful pieces in the community, she thinks of herself more as an artisan than an artist. She works in the corner of a room in her parents' house on a small table (two feet by three feet) less than knee-high (see fig. 1). She sits on a low, ankle-high stool, which permits her to spread out the pieces that she makes on the floor around her. Like all the potters in La Chamba, she creates pieces completely by hand, needing only simple tools like a scrapper and a burnishing stone. This reliance on hand building and simple tools means little interruption in the ongoing household activities. Enough clay for a few days of work only is collected at a time, and there are no machines to process anything. Pieces waiting for firing or for delivery to the middleman are stored compactly in corners of the house.

The Sandoval house is placed high on the western bank of the Magda-

lena River, and tall tropical trees tower above the house, keeping it in the shade. Behind the house stands a long bamboo table for drying the ceramics pieces before they are stored for firing. Although ceramics are ever present in and around the house, the house is immaculately clean, and the making of ceramics does not dirty or clutter it. Lidia Inés works in harmony with her surroundings, and the figures she and the other women of La Chamba make reflect the tranquility of their everyday lives.

La Chamba Figures

Colombian potters, including the ancestors of the people of La Chamba, abandoned the pre-Hispanic figurative traditions after the Spanish conquest because the conquerors prohibited iconographic references to indigenous belief systems. During the subsequent colonial period, indigenous potters largely confined themselves to making vessels (mainly cooking pots, water jars, and eating bowls). The art of the colonial elite during that period was largely Christian, and it was drawn from European art and craft traditions. Polychromed wood made for the most popular medium, and indigenous artisans in the Americas learned to make figures of Christian saints for the churches and the houses of the wealthy. Since ceramic figures held little importance during the colonial and republican periods of Colombian history, the rich pre-Columbian traditions of figurative arts were largely lost.

The expansion of markets and the urban demand for display ceramics since the 1950s has allowed La Chamba potters to explore figuration as an expressive style for the first time since the Spanish conquest. They have responded by developing vessel-based figures as well as stand-alone ones. Since most of the ceramics made in this region for the past five hundred years have been vessels, it is not surprising that La Chamba potters create their best figures when they are incorporated into vessel forms. Few make sophisticated stand-alone figures like those from other Colombian ceramics centers, such as Ráquira (Duncan 1998, 91–107) and Pitalito (Villegas and Villegas 1992, 78–79).

When village potters in Colombia began making figures again in the twentieth century, the figurative models they knew were mostly Spanish ones. They reinitiated the pre-Columbian practice of making figures of local animals and religious images, but now most of those are Spanish in origin. So the Spanish influences in the ceramics of La Chamba surface primarily in the figurative pieces. In contrast, vessels are made still basically following pre-Columbian models.

Since the La Chamba potters did not have a preexisting style for figures, they borrowed from other ceramics communities in Colombia and even Mexico, and they also developed ideas from pre-Columbian sources. Competitions organized by various state and national institutions have encouraged La Chamba potters to create figures. Potters have responded by portraying their surroundings in ceramics, including domestic animals and fruits. One institution that has organized figure-making competitions has been the Museo de Artes y Tradiciones Populares (Museum of Popular Arts and Traditions) in Bogotá. For many years, this museum held an annual competition for nativity scenes, and the museum's personnel has also invited other figurative themes. These competitions combined with the growing market for figures have encouraged La Chamba women to produce figurative ceramics.

Stephen Gudeman (1992, 58) suggests that "art and material culture are brought together in trade and domestic use, in identity formation, in constructing social relations . . . in securing power and adjusting political processes." In other words, art provides an avenue to understanding thought systems, identity, and social relations in human societies. The recent change in the figurative art styles in La Chamba shows how the folk arts reflect new trends in Colombian society, as urban customers seek the solace of folk art in the face of city life's insecurities.

Human Figures

La Chamba potters represent the human figure in religious scenes, such as the nativity and the indigenous shaman, and in work scenes, such as the man with a canoe load of plantains. Although the nativity scene has become a standard subject for figure making in Colombian folk ceramics in recent decades, it was not a subject historically important in village Colombia. Its popularity among potters today stems more from its commercial possibilities than from religious values. A potter who makes figures can sell eighty to one hundred nativity sets per year for the Christmas season. So, in some cases, figure making can provide an important source of income.

The nativity scenes include the standard set of figures, Joseph, Mary, the Christ child, the three kings, a cow, and a donkey or other domestic animal. The figures are shown in worshipful poses looking at the Christ child, while the three kings wear crowns and hold the gifts they are presenting to the child. Since these figures are hand-modeled rather than cast, they include details of hair and clothes texture not found in the mass-produced nativity

figures from other Colombian communities, such as Ráquira (Duncan 1998, 102).

Over the last couple of decades, a few potters have experimented with the figure of the *mohán,* the shaman of this area's indigenous tradition. Potters have made this figure as a part of their exploration of their culture's pre-Columbian roots. They portray the *mohán* as a figure in a squatting position smoking a cigar. The static squatting position emphasizes the shaman's use of spiritual powers rather than physical ones, and the smoking of a cigar is associated with the power of nature represented in tobacco. According to the legend, if someone is in a canoe on the river and sees a *mohán* sitting on the river bank, they should not try to approach the shaman because they will be caught in a whirlpool and sucked down by the river and drowned. The story teaches the greatness of the shaman's spiritual powers, powers to be respected by regular humans.

Animal Figures

Animal figures are more important than human figures in La Chamba art, especially the domestic animals that the women potters usually tend, such as donkeys, cows, pigs, and chickens. The Spanish introduced all of these animals, and that constitutes their primary influence on La Chamba folk art. In part, these figures represent what women observe in their daily lives, but they are also figures successful in the urban markets. Like the human figures, they usually remain small in scale, measuring under twenty centimeters in height and length.

Donkey figures, much like the real donkeys seen in the community, have become popular from time to time. They may be shown carrying pots similar to the "pony" figures from Ráquira (Duncan 1998, 99–101), suggesting that La Chamba potters may have borrowed the idea from that community. The donkey was a Spanish introduction to the Americas, and potters portray it with the Spanish/Moroccan–style side carriers for loads, which emphasizes its Iberian origin. Sacks of clay, bunches of plantains, and other heavy loads can be carried that way. So women portray the donkey as it helps them and their neighbors as a beast of burden.

Chickens, more specifically hens, make for another popular topic for ceramic figures created by women, and usually they are made as casseroles. Many households have chickens, which are usually left to range freely around the house, so they represent common figures in the domestic world of women

and children. One popular version of the hen is a small toy one (ten centimeters in circumference), with miniature pots and baby chicks inside. It looks like a diminutive hen casserole. The top half of the toy hen has the head, wings, and tail feathers, and it can be lifted off, although it is attached by a plant fiber hinge to the bottom half. This is a popular gift item for children, and adults as well as children love the miniature pots and baby chicks that they discover hidden inside the hen's interior.

The pig is another ceramic figure that women potters make, usually as a piggy bank, which I will discuss in greater detail in the next section. In the households that have a pig, the women usually feed and care for it, so they have the opportunity to observe it closely. They usually represent the pig as voluminous and round, emphasizing the idea of fullness, an attractive idea in a community in which many people live close to the edge economically. Another representation of the pig is a sow nursing piglets, a good image because it means prosperity. A woman who has a sow can sell the piglets, providing an additional source of income for her household.

Potters also portray common wild animals in La Chamba, such as birds and turtles. Some figurative potters have made monochrome ceramic doves which are similar in shape to the polychrome painted Mexican versions. Water animals are also important here since La Chamba is located at the confluence of small waterways and the Magdalena River. The water animals include fish, turtles, and serpents, with the first being the most popular and the latter two made only occasionally. Turtles and serpents are modeled as stand-alone figures, but fish are made as vessel-based figures.

Vessel-Based Figures

As mentioned, the best figures in La Chamba are animal shapes incorporated into vessels, and these are most commonly hens, fish, or piggy banks. As creative people frequently do, La Chamba artists have borrowed extensively from other art and craft traditions in Colombia, Mexico, Europe, and perhaps even China for their figurative pieces. Yet even if the idea for a form is borrowed, it is always adapted to make it fit the La Chamba style of careful hand-finishing, burnished satin surfaces, and saturated iron red or black colors.

Potters make the hen casserole from the undecorated round casserole by adding a head, wings, and tail feathers. These skilled modelers have incorporated the figurative elements of the hen into the casserole so well that it has

become one of the best figures produced in La Chamba. Although details like the comb, beak, and eyes are apparent, all of the features are highly stylized. Potters represent the wings as raised featherlike parallel patterns and the tail as a fan with lines representing clumps of feathers. The hen bulges out into the full body of the casserole intended to hold a good volume of food. The back is a lid, and the knob on the lid is commonly represented as a baby chick. The potter makes the bottom half of the casserole from a slab on a hump mold, and the lid comes from another slab. A variation on this form is the hen-shaped water container shown in figure 2.

Another popular figure is the long fish-shaped bowl or platter. Mother-daughter teams frequently collaborate in creating this shape, with the mother making the slab and building up the walls and the daughter modeling the features of the fish into place. The mothers usually explain that they do not have the modeling skills their daughters do, so they collaborate with them to make these forms. There exists a wide range of fish forms, with the most dynamic ones made in the form of a surging or jumping fish, its head and tail raised high to create a curved form (fig. 3). Observers who have watched fish and understand their movements have created these forms. In contrast, other fish-shaped bowls emphasize the horizontal line, with the head and tail on the same plane as the rest of the body, suggesting a stillness and inactivity uncharacteristic of fish. Platters can be made with or without lids, and with a lid, the dorsal fin becomes the knob for it. This fish platter resembles in shape ones made in China in the eighteenth century for the Compañía de Indias (Indies Company), the Spanish trading company (Duncan 2000, 159–60). Did some potter from La Chamba see one of these Chinese fish platters, or a picture of one, and create her own version of it, or is this a case of parallel invention?

The piggy bank has become a popular form in recent decades, and it has simultaneously also become important in many other pottery-making communities in Colombia (Duncan 1998, 102). In a process similar to that used in other vessel-based figures, the potter first makes the body in the form of a pot on a small hump mold. When the bottom has firmed up to the leather-hard stage, the potter turns it upside down and places it on a bowl to facilitate turning it while she completes the top part with coils. She adds the coils in such a fashion as to gradually enclose the body until it becomes a closed sphere. After it firms up, she models the ears and snout on one end, the tail on the other, and cuts a coin slot in the back of the animal. Gertrude Litto (1976, 149) has documented this process well. Although there have been other experiments with vessel-based figures, such as the Indian motif planters that

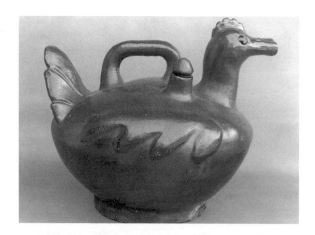

Top: 2. Hen-shaped water container. The hen is a popular figure made by La Chamba women, and it may be variously made as a water container, casserole, or play hen for children. This one is blackware, and it is fifteen inches long, eleven inches wide, and ten inches high.

Bottom: 3. Fish-shaped bowl and donkey figures on drying stand. Lidia Inés Sandoval made these pieces, which are drying on the bamboo rack at the back of her house. The "fine ceramic" fish-shaped bowl has been made in redware. The fins and head are modeled to communicate the idea of the jumping fish. This piece is sixteen inches long, eight inches wide, and six inches high. The small pots will be carried by the donkey figures. *Both reprinted courtesy of the University Press of Florida.*

some people borrowed from Ráquira potters in the 1970s, the hen, fish, and piggy bank are the figures associated with La Chamba.

The Visual Qualities of Figures

Figurative pieces are hand-modeled so that each one becomes a one-off piece, meaning that it is individually crafted although it may be one of a series of similar pieces. Occasionally a ceramist even makes one-of-a-kind pieces, unique in their composition. The modeling style in most pieces is rustic, with stylized features and only minimal details for hands, feet, and even facial features such as eyes, ears, noses, and mouths. The overall figure is important, but the individualizing details are not.

Figure makers use both the natural clay finish and burnished surfaces. Women potters employ the natural clay surface when they make stand-alone animal figures, such as the pigs, donkeys, and turtles. The naturally occurring temper in the clay body contributes to a gritty surface close to the actual textures of these animals' skins. This surface may even be scrapped to emphasize its gritty, almost furlike quality. Such pieces range among the rare ones made in La Chamba that are not painted with slip.

The burnished surface is used for all of the vessel-based figures, including hens, fish, and piggy banks, and also for human figures and birds. These pieces are painted with the best slip obtainable in the community, and they are carefully burnished, producing the satin-luster surface identified with La Chamba ceramics. The vessel-based figures in fine ceramics are functional (i.e., hen casseroles or fish-shaped platters), and they are used as fine tableware in the houses of the urban customers. Both stand-alone figures and vessel-based ones usually have the naturally occurring iron-oxide red color of the slip. In contrast, much of the common tableware in La Chamba is made in blackware, produced by a postfiring reduction process. The popular black color used for tableware has been considered inappropriate for figures, except for the small hen with play pots and baby chicks inside.

The potters of La Chamba have been successful with experiments modeling figures onto vessel forms, but their attempts to make stand-alone figures remain more rustic and frequently lack the attention to detailed finishing found in their pots and bowls. Since potters have borrowed most of the ideas for stand-alone figures from other pottery-making communities, their work has a hesitant and tentative nature to it. However, the younger generation makes vessel-based figures with confidence, giving them a creative integrity

appropriate to their cultural imagination. The vessel-based figures (especially hens and fish) are consistently compelling in their composition and finishing, and in these pieces La Chamba women have achieved the union of art and commerce that they have not been able to achieve with stand-alone figures.

Commerce and the Art of Symbolic Goods

The determinants of value in a market economy are supply and demand, social status, and symbolic value. Since the 1950s, there has been a sustained, continuing market demand for La Chamba ceramics, which the growing number of women potters has supplied. Although the demand for their ceramics has been strong, it has not sufficed to alter the role of La Chamba pottery as an inexpensive craft. The status of potters at the bottom of the socioeconomic system results in little social value being assigned to their work. However, the market value of symbolic goods is established not only by the social status of the makers but also by the symbolic value of the commodity in addition to the cost of materials, labor, and transportation. Curiously, the symbolism of La Chamba ceramics is important to urban consumers even though potters have low social status. Helms (1993, 60) observed that "the social worth and esoteric understanding of the artisan are often expressed in personal moral terms which infuse the products of crafting with inalienable value." This holds true for La Chamba, but it has done little to improve the potters' social or economic status.

Many urban consumers buy La Chamba figures because they symbolize the local roots of Colombian culture. Although the purchase of ceramics constitutes an economic transaction, many urban buyers actually rather desire to possess the cultural memory and heritage of a rural Colombia that seems to be in danger of disappearing from the combined threats of social change and civil war. So in purchasing a La Chamba figure, the customer acquires an object of Colombian cultural identity that represents something authentic and stable during a threatening period in the country's history. The clientele for folk art tends to come from the professional and educated classes whose families have rural or small-town backgrounds, and La Chamba folk art represents the cultural memory of an idyllic rural past to them. Since art by definition has value in a market economy for its symbolic and aesthetic values rather than any functional value, it may be said that La Chamba ceramics are becoming more art than craft.

In the terms of Pierre Bourdieu (1993, 115), folk art works are symbolic

goods of large-scale cultural production oriented toward the general public. Following Bourdieu's thought, La Chamba folk art communicates symbolic information about cultural memory, and today's consumers are increasingly buying it for its messages about nature and the security of rural life. In recent decades, craft has survived in many countries of the world on its symbolic value rather than its functionality.

Women, Work, and Wages

In interviews, the women of La Chamba repeatedly mentioned the problem of low compensation for their work. One reason they are underpaid is that no one generally views their pieces as professional work but rather as an extension of their domestic labor. As such, urban Colombians interpret it more as a "hobby" craft than a professional one. This conception of women's craft work as nonprofessional is widespread in Latin America, and it leads to lower remuneration for their work, even when it is comparable to men's work.

Research on men and women potters in Ráquira found that men earned up to three times more than women (Duncan 1998, 185), stemming from gender differences in work organization. Carmen Deere (1990, 286) found among tailors and seamstresses in Peru that men charged twice as much as women for similar work, and this was explained by men's alleged higher skills. Tracy Ehlers (1990, 111) has pointed out that women's work in household crafts is based on domestic skills and does not prepare them to compete with male workers who have more experience in the market economy and subsequently earn more for their work. The home-based work of women in folk art tends to be compensated at minimal levels, which locks them into perpetual cycles of hard work and poverty-level remuneration. Although La Chamba potters who make art pieces receive higher pay for their work than do the local production potters, their incomes are still commonly below the minimum wage standards for Colombia.

Mies (1982, 180) introduced the concept of "housewifization" to explain how the work of women is undervalued. According to her explanation, a society that sees women primarily as housewives will fail to give their economic production the same value as labor performed in a specialized work setting such as a workshop or factory. Elisabeth Prügl (1996b, 115–16) suggests that defining women primarily as housewives makes the exploitation of their labor less visible. The mask of housewifization makes a morally intolerable situation seem acceptable to middlemen and even to some women.

Rural women working as home-based artists or artisans are vulnerable to undervaluation and underpayment for their labor.

The "Putting-Out" System and Underpayment of Work

Folk arts in La Chamba are marketed primarily through a so-called putting-out system by middlemen, who may be urban-based merchants or buyers reselling the work to merchants in cities. Mies (1982) described this system for India, and it works essentially the same in Colombia. The middleman has a circle of craftswomen with whom he places orders for pieces, returning at a specified time to pick up the order. In the meantime, women may be making nativity scenes for the Christmas market, fish-shaped platters, or hen-shaped casseroles according to their specialization. The craft artist assumes all the risks of production and supplying materials, and she is paid when the middleman picks up the order.

The putting-out system has existed in Latin America since the Spanish colonial period when indigenous women were required to produce tributary goods for the government. Laurel Bossen (1984, 324–25) described this process for Mayan women weavers. Spanish officials delivered raw cotton to the weavers to be spun into thread at little or no cost, a practice called *el repartimiento de hilazas* (distribution of the yarn). The weaver's work would partially satisfy the family's tributary tax obligation. Bossen goes on to say that a similar system is still used today, but now in a commercial framework as merchants distribute the yarn to women weavers in a subcontracting system. Prügl (1996a, 43) and Scott Cook (1990, 113) have documented similar systems among weavers in Oaxaca, Yucatán, and Chiapas, and among knitters in Ecuador.

Since women folk artists in La Chamba work as independent contractors in the putting-out system, the minimum wage laws of the country do not apply to them. The remuneration they are offered under the system of subcontracting work commonly falls below the level of the legal minimum wage. Some women work full time to earn as little as 50 percent of the minimum wage, and that includes the unpaid labor of their children (Duncan 2000, 208–11). Although La Chamba women are angered by the substandard compensation they receive, they continue to accept it because they have no other alternatives for earning income in the village. Some young women abandon ceramics and migrate to the city to become maids or manual workers, but it is at the cost of isolation from the family. Like folk artists in small towns

and villages throughout Latin America, La Chamba women have difficulty obtaining fair prices for their work, and many consider this the most onerous aspect of their occupation. Frustrations like these multiplied throughout hundreds of villages in Colombia have fed the long social unrest that has torn this country.

Conclusions

The folk art from La Chamba opens a window for us onto the world of rural Colombia, specifically Tolima, and it communicates to us the fertility of that rural life. To the person who will listen, La Chamba women protest the social and economic injustice that pushes them and their children to work long hours for half the pay they should receive. At the same time, they have the creativity to offset these limitations by organizing themselves into matrifocal support groups. Work in ceramics constitutes the economic glue that holds these groups together and permits the women of this community more independence than most women in rural Colombia have. In spite of low social status and pay, the women of La Chamba have made a major contribution to cultural identity and memory in Colombia with their folk art. They have played an important symbolic role during this time of civil war, demonstrating that folk art can symbolize peace and cultural stability, counterbalancing the threat of violence in today's world.

Notes

I have made use of material adapted from the book by Ronald J. Duncan entitled *Crafts, Capitalism, and Women: The Potters of La Chamba, Colombia* (Gainesville: University Press of Florida, 2000) with the permission of the University Press of Florida.

Reference List

Arnold, Dean E. *Ceramic Theory and Cultural Process*. Cambridge: Cambridge University Press, 1985.
Artesanías de Colombia. *Censo económico nacional del sector artesanal*. Santafé de Bogotá: Ministerio de Desarrollo Económico, 1998.

Barasch, Moshe. *Modern Theories of Art.* Vol. 2, *From Impressionism to Kandinsky.* New York: New York University Press, 1998.

Bossen, Laurel. *The Redivision of Labor: Women and Economic Choice in Four Guatemalan Communities.* Albany: State University of New York Press, 1984.

Bourdieu, Pierre. *The Field of Cultural Production: Essays on Art and Literature.* Ed. Randal Johnson. New York: Columbia University Press, 1993.

Cook, Scott. "Female Labor, Commodity Production, and Ideology in Mexican Peasant-Artisan Households." In *Work without Wages: Comparative Studies of Domestic Labor and Self-Employment,* ed. Jane L. Collins and Martha Gimenez, 89–115. Albany: State University of New York Press, 1990.

Cooper, Emmanuel. *A History of World Pottery.* New York: Larousse, 1981.

Deere, Carmen Diana. *Household and Class Relations: Peasants and Landlords in Northern Peru.* Berkeley: University of California Press, 1990.

Duncan, Ronald J. *The Ceramics of Ráquira, Colombia: Gender, Work, and Economic Change.* Gainesville: University Press of Florida, 1998.

———. *Crafts, Capitalism, and Women: The Potters of La Chamba, Colombia.* Gainesville: University Press of Florida, 2000.

Ehlers, Tracy Bachrach. *Silent Looms: Women and Production in a Guatemalan Town.* Boulder, Colo.: Westview, 1990.

Foster, George. "The Validating Role of Humoral Theory in Traditional Spanish-American Therapeutics." *American Ethnologist* 15, no. 1 (1988): 120–35.

García Canclini, Nestor. *Culturas híbridas: Estrategias para entrar y salir de la modernidad.* Mexico City: Editorial Grijalbo, 1990.

Gudeman, Stephen. "Epilogue: Art and Material Culture." *Museum Anthropology* 16, no. 3 (1992): 58–61.

Hamilton, Sarah. *The Two-Headed Household: Gender and Rural Development in the Ecuadorean Andes.* Pittsburgh, Pa.: University of Pittsburgh Press, 1998.

Helms, Mary W. *Craft and the Kingly Ideal: Art, Trade, and Power.* Austin: University of Texas Press, 1993.

Hendry, Jean Clare. *Atzompa: A Pottery-Producing Village of Southern Mexico in the Mid-1950's.* Nashville, Tenn.: Vanderbilt University Publications in Anthropology, 1992.

Litto, Gertrude. *South American Folk Pottery.* New York: Watson-Guptill, 1976.

Mathews, Holly F. "Context Specific Variation in Humoral Classification," *American Anthropologist* 85, no. 4 (1983): 826–47.

Mies, Maria. *The Lace Makers of Narsapur: Indian Housewives Produce for the World Market.* London: Zed, 1982.

———. *Indian Women in Subsistence and Agricultural Labour.* Geneva: International Labour Office, 1986.

Montoya de la Cruz, Gerardo. *Comunidad artesanal de La Chamba: Aproximación a los componentes socioculturales* (brochure). Bogotá: Artesanías de Colombia, 1990.

Murdock, George P. and Caterina Provost. "Factors in the Division of Labor by Sex: A Cross-cultural Analysis." *Ethnology* no. 12 (1973): 203–25.

Nash, June C. *In the Eyes of the Ancestors: Belief and Behavior in a Maya Community.* Prospect Heights, Ill.: Waveland, 1985.

Prügl, Elisabeth. "Home-Based Producers in Development Discourse." In *Home-workers in Global Perspective: Invisible No More,* Ed. Eileen Boris and Prügl, 39–59. New York: Routledge, 1996a.

———. "Home-Based Workers: A Comparative Exploration of Mies' Theory of Housewifization." *Frontiers* 17, no. 1 (1996b): 114–36.

Rawson, Philip. *Ceramics.* London: Oxford University Press, 1971.

Stephen, Lynn. "Weaving in the Fast Lane: Class, Ethnicity, and Gender in Zapotec Craft Commercialization." In *Crafts in the World Market: The Impact of Global Exchange on Middle American Artisans,* ed. June Nash, 25–57. Albany: State University of New York Press, 1993.

Villegas, Liliana, and Benjamin Villegas. *Artifactos: Colombian Crafts from the Andes to the Amazon.* New York: Rizzoli International, 1992.

Zolberg, Vera L. *Constructing a Sociology of the Arts.* Cambridge: Cambridge University Press, 1990.

The Mapuche Craftswomen

Between Self-Subsistence and the Marketplace

The manufacture and commercialization of handicrafts falls somewhere between the domestic and industrialized levels of production. Crafts generate economic resources through the implementation of traditional techniques on the open marketplace. This process can articulate native, indigenous groups to the macro society, while transforming the survival strategies of entire communities. As the preferred holders of specific skills, Indian women have employed this strategy widely, generating autonomous resources that have produced changes in gender relations and, in some cases, been at the heart of their reformulation. Thus the Indian women from the highlands of the state of Chiapas in Mexico have found that the production of crafts, particularly ceramics and embroidery, for the tourist market has allowed them to organize in cooperatives, to handle the most important source of income for their domestic units, and to acquire an increasingly active political role. In an earlier article (Juliano 1998), I have argued that this phenomenon may well have nourished women's participation in the neo-Zapatista revolts and many of the issues posed by the so-called Laws of Women.

However, be it or be it not reflected in specific political grievances, researchers have certainly noted the economic relevance acquired by Indian craftswomen. In an Aymara tribe studied by Benton (1987), for example, the importance of crafts sales is such that it has motivated an increased educational level among daughters seeking to acquire better business skills. This, in turn, has promoted certain margins of autonomy unavailable for their ancestors. Mapuche society has not escaped such processes where the com-

munal prestige of women is founded on their condition as crafts producers. Cattaneo (2000) has argued that the acknowledgment of female status in the nineteenth century was already related to their domestic, ritual, and crafts-oriented activities. Women who crafted textiles, of both symbolical and economic importance, were especially valued: their produce found admirers and buyers both within the immediate community and without it.

The Mapuche People

In the extreme south of the American continent, the Mapuche people are particularly interesting due to the plasticity of their adaptation in diverse circumstances, linked with a tenacious defense of their specific cultural features. Between 1546, when they first faced off with the Spanish invaders, and 1879, when they were finally defeated by the Chilean and Argentinean armies, the Mapuches sought to maintain their autonomy, way of life, and organization—in brief, their culture. They employed armed struggle as their main defensive strategy, but they also used—according to circumstances and events—political negotiations, commercial interchange, and a range of diverse transactions. In reality, defense against the processes of colonization tests a people's capacity both for innovation and resistance. There exists a neoromantic current in the social sciences, termed ethnopopulism by Díaz Polanco, which holds that Indian peoples have in certain circumstances maintained the values of their primitive cultures intact (though concealed), despite five centuries of contact and confrontation. A different current of thought, related to the theoreticians of so-called acculturation, emphasizes the processes of social disintegration, anomie, and loss of identity resulting from the conquest. Both tendencies pivot around a functionalist and static concept of culture, which can only view change as a loss. However, in theoretical terms, the most interesting aspect of research into the native peoples of the Americas, and the Mapuches in particular, concerns their social creativity and capacity for cultural innovation. Confrontation with the Europeans entailed important transformations for the Mapuche people, not only due to the loss of population that ensued from open warfare and its consequences of death or slavery,[1] from impoverishment, or from forced relocation but also due to the fact that these processes culminated in the theft of their lands and in the implementation of systematic campaigns for cultural imposition carried out initially by missionaries and later by the educational system. To this we must add the symbolic violence of being negatively conceptualized as

the savage pole of the civilization-barbarism dichotomy and of being denied an acknowledgment of autochthony on their own territory (in this regard, see Lázzari and Lenton 2000). They also suffered under the impact caused by the mass production of alcohol and by the spread of European-borne diseases. The Mapuches related these catastrophes to the invaders, whom they viewed as unclean and malign beings, incapable of any form of loyalty. The term *huincas,* used to designate Europeans and their descendants, still reflects all of these meanings. This devalued image of the enemy was transformed into an element of self-affirmation (and in this respect they differ from other Indian peoples). Thus, despite a long period of contact and trade between the two cultures, the Mapuches did not massively interiorize elements of self-devaluation and were consequently able to maintain a community ethic, based on a specific worldview and a peculiar aesthetics, until the late nineteenth century.

When they were finally defeated, the Mapuches who remained in their zones of origin were forced to settle in reduced areas unsuited to traditional forms of agriculture or cattle raising, and extremely vulnerable to degradation through excess use. An important part, estimated at some 50 percent of the population, was forced to abandon their lands and search for employment among the *huinca* population. This situation nourished a tendency that first appeared in the nineteenth century, where the production of crafts for self-consumption was transformed, while generating both a need—born of poverty—and a potential market due to enforced contact with the white population. However, the production of crafts was but one (and not the most frequent) of the survival strategies employed by the Mapuches. The majority of the population remained in place, opting to continue a tradition of recollection and farming,[2] combined with some agriculture, and supplementing incomes through salaried labor in neighboring fields. Others emigrated to urban centers, where the men found employment as policemen, bakers, or construction workers,[3] and the women preferably in domestic service. The production of crafts is commonly perceived as a complement to such tasks, and there consequently exist few full-time artisans. These usually live and work in the cities, which allows them to cut out middlemen while maximizing potential profits. However, they can also be found in areas where there are Mapuche communities, provincial trading centers (as is the case of Neuquén), and local cooperatives. Weaving cooperatives can be found in the neighboring province of Río Negro. In Los Toldos (province of Buenos Aires), we also find weaving and spinning cooperatives; the latter are mostly related to Catholic organizations.

The Prestige of Gender Roles

If we accept Latchman's hypothesis, according to which the traditional form of Mapuche filiation until 1860 was matrilineal (which is to say, belonging to the group, and its associated rights and obligations, was maternally transmitted), and link this datum to the inclusion of daughters in inheritances, the prematrimonial sexual freedom of women, and the existence of *curenguequel* ceremonies of female initiation, which implied their acknowledgment as full members of the group, we begin to outline a portrayal of traditional society in which the status of women was not wholly unfavorable.

This status, however, was later eroded by the militarization of society that ensued from resistance, the rapid spread of alcoholism, and the influence of white conceptual schemes (which included patriarchal religious practices) that devalued women. Furthermore, a state of permanent warfare drastically reduced the proportion of men, which increased polygamy. This meant that widows or separated women could obtain a new husband, allowing them to maintain the support of a male laborer. In any case, the fact that male bachelors were frowned on, while single women—including pregnant women— were not, allows us to see that polygamy was not based on a devaluation of women but rather on a peculiar form of division of labor. Although social militarization enhanced the prestige of warriors while decreasing that of other roles, women did not entirely lose their social acknowledgment. Divorce and remarriage are always accessible to Mapuche women, who can aspire to prestigious posts within their communities regardless of married status. Today, due to a process of predominantly female emigration, demographic conditions have shifted once again, providing these communities with an elevated index of masculinity (108.2 in the case studied by Balazote and Radovich 1993), which has again raised the status of female skills.

Clearly, after its defeat in the nineteenth century, and its later inclusion as discriminated populations within Chile and Argentina, Mapuche society was forced to carry out certain restrictive adaptations in terms of gender. Nonetheless, men and women retain the ability to acquire respected, though different, positions in society. In traditional society, such positions were more often linked to age than gender, although in actuality we frequently find young men and women acting as representatives for their communities. Such prestige is an acknowledgment of their political abilities, essential in the defense of Mapuche interests against *huinca* society.

In traditional Mapuche communities, and even today, the two most im-

portant figures are the *machi* and the *lonco*. The *lonco* (lit. head, or, in a broader sense, cacique or leader) coordinates the group's political activities, serving as arbiter and counselor in case of conflict. This post is normally reserved for older males, but it can also be filled by either young men or women (during the 1980s, this latter option represented 10 percent of all cases). The *machi,* or shaman, is almost always female, for the Mapuches believe that only female sensibilities can achieve the necessary levels of communication with nature. It is also held that men rarely make effective *machis,* except when homosexuality allows them to approach the female ideal.[4] The *machi* is someone with an acknowledged level of wisdom who is in charge of the community's general health (by celebrating the *machitun*) or survival (by officiating the *nguillatún*). No religious ceremony can be held without her; only she may bear the *kultrum,* or sacred drum, and she is the group's preferred mediator with superior forces. Although both *machis* and *loncos* are highly respected, neither post is remunerated in monetary terms. In actuality, traditional shamanistic medical practices, particularly those involving surgery, have almost vanished: firstly, because Western medical legislation has outlawed them, and secondly, because Catholic dogma frowns on them. However, they are gradually reappearing, fostered by a renewed appreciation of alternative medicine and by tendencies of ethnic reactivation.

Textiles and Silverware

The Mapuches are skilled in a wide range of crafts—including spinning, weaving, wood carving, leather work, pottery,[5] and silverware—but the analysis of their work can be centered on the internal production and circulation of the two most prestigious crafts within their communities: textile work and silverware. Although the Mapuches do not tend to divide tasks along gender lines, this element does surface in labor options, materializing forms of social organization, systems of belief, and scales of prestige. Mandrini (1991) has argued that traditional economic life was based on two circuits: one, male, pivoted around the breeding and sale of livestock and prestigious crafts, such as silver- or leather ware; a second, female, was centered on the tasks of self-subsistence and the production of textiles for self-consumption and trade. Weavers also had to provide the requisite animals. Thus weaving was viewed as an appropriate occupation for women, who were responsible for all stages of production, from the raising of the sheep to the preparation and dyeing of

the thread, to the choice of motifs and final manufacture. Today, they wash and weave wool from sheep (as they would have done previously with wool from vicunas or guanacos); the thread is dyed in colors obtained from herbs or industrial dyes, and it is finally hand-woven on vertical looms. The most elaborate garments are ponchos, sashes, or blankets, which usually combine complex designs with an enormous wealth of color. Patternless blankets and ponchos are also woven, but while the latter are for domestic purposes or women's attire, the former, that is to say, the elaborate and colorful items, are exclusively for the use of men. Thus, the *lonco*'s ponchos boast special patterns and colors, while the girdle and the male *trari-lonco* ribbons (head ornaments) are the most elaborate. Consequently, women employ both their labor and their artistic sensibilities in the manufacture of garments that they do not normally wear. These items, which remain a male Mapuche's most prized ornament, have also become an important source of income in the form of crafts to be sold outside the community.

As a counterpart, Mapuche women will adorn themselves, if possible, with silver objects. The *trapelacucha* (a silver pectoral symbolizing the force of the eagle and the wind), *trari-loncos* of flat slabs and hanging medals, *quipus* (pins) with large circular heads and enormous, trapezoidal pendants—these manifest a Mapuche woman's traditional wealth, her pride and ornament. However, silver work constitutes a predominantly male craft. It is an ancient tradition, and although some researchers have suggested that it was incorporated after the conquest, with the silver coinage circulated by the Spaniards as the raw material, it may well also be a pre-Hispanic craft. De Rosales has noted that the Araucanos paid their tribute to the Incas in silver, stamping each ingot with the symbol of a woman's breast. Interchange with the European population provided them with an ample supply of the silver coins they used as ornaments.

Furthermore, the originality of their designs, more related with a Quichua than a European aesthetic sense, and the very fact that they worked exclusively in silver—a metal related, in Mapuche mythology, to the moon and other favorable forces—and not in gold or bronze—suggest that this practice is deeply rooted in Mapuche culture. It also seems likely that as a consequence of territorial displacements produced firstly by the Spanish invasion and later by pressure from Chile and Argentina, this group was separated from its pre-Hispanic silver mines and deposits,[6] forcing it to rely exclusively on silver obtained through barter. They may also have obtained part of their silver by this means prior to the Spaniards' arrival, but whatever the case, it is clear that the main goal of this activity, undertaken even by caciques (see

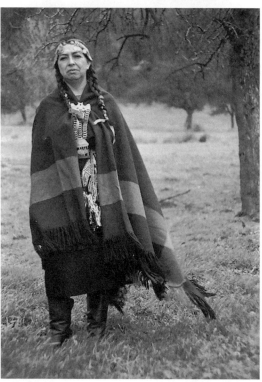

Above
1. Mapuche woman in the traditional dress (*trarilonco* and *trapela-cucha*). Postcard produced by the Association of Chilean Mapuches, Ad Mapu (Splendor of the Earth) as part of a solidarity campaign in the 1990s. *Drawing by Carmen Fraquela. Reproduction by Jordi Canyameres.*

Left
2. Rayén (Rosa Zurita), c. 1994. *Photograph by Dolores Juliano.*

Mansilla 1964) and reaching a peak between the eighteenth and nineteenth centuries (Aldunate 1984), was to produce ornaments for women.

Today, this craft appears to be dying out, and silver workers are scarce, particularly in Argentina. So much so that in a recent interview with silver worker Silvia Rilque, she commented that she knew of no more than two remaining silver workers who still employed traditional techniques and designs. However, this is not to say that the objects themselves have lost any of their symbolic value. These items, so prized that they were frequently laid to rest along with their owners, are not traded or sold; rather, they circulate as gifts, tightening family and social links (Zurita 1988). Thus when a girl becomes a woman, although she no longer undergoes the feast of female initiation discovered last century by Housse and D'Obigny, she does receive from her grandmother, father, boyfriend, or other relatives some pieces from the prized family collection of silverware, which she will wear at feasts or religious ceremonies.

When a man ascends to *lonco,* on the other hand, the production of the distinctive poncho which will identify him is usually commissioned to the most skillful weaver available. In exchange for her labors, she will receive a silver *trari-lonco* and *trapelacucha.* However, because not all men are silver workers, and not all women know how to produced patterned weaves, the circulation of such resources is usually mediatized by intermediate steps, where the silver worker will receive a gift of seeds or foodstuffs from a family that hopes to acquire a pendant or silver chain, which in turn will become a present. Similarly, weavers receive a range of presents in exchange for the items that they produce.

It should be noted that both silverware and patterned textiles play a second role in Mapuche culture. Small, richly ornamented blankets are used at each *ruca* (hut) to indicate the place of honor for invited guests. A log, a cow's head, a stone, or a rustic chair is consequently transformed into a place of privilege, a throne in a certain sense, within the elaborate Mapuche rituals of courtesy and hospitality. Occasionally, these blankets are replaced by particularly attractive animal skins, but textiles are the preferred choice.[7] A similar situation exists with silverware, although its second role is related to horses rather than to the household. After the introduction of horses by the Spaniards during the seventeenth century, they became one of the Mapuche's most precious possessions. Horses were not only auxiliaries in warfare or assistants in the vital work of ranching and cattle breeding; they also became deeply embedded in the Mapuche system of beliefs, to the extent that the canoe-shaped coffin, in which the souls of the departed could sail into the

3. Mapuche woman weaving. Postcard produced by the Association of Chilean Mapuches, Ad Mapu (Splendor of the Earth) as part of a solidarity campaign in the 1990s. *Drawing by Carmen Fraquela. Reproduction by Jordi Canyameres.*

Below
4. Mapuche rug, Chile. Postcard produced by the Unidad y organización por la cultura mapuche, 1974. *Reproduction by Jordi Canyameres.*

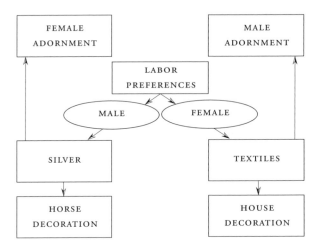

5. The circulation of crafts within the Mapuche community.

setting sun, was gradually replaced by the custom of burying warriors along with their horses so that the latter could bear their owners into the next world. Consequently, horses are treated with great care, and ornamented with leather and silver.

Thus, while Mapuche women can proudly provide their guests with richly decorated blankets, for the men an equal source of pride can be a horse exquisitely attired in silver (fig.5). This division in the production and usage of crafts along gender lines is amply documented in historical terms, as can be seen in multiple nineteenth-century citations compiled by Cattaneo (2000).

Given the pervasive poverty afflicting Mapuche communities today, silver has become increasingly difficult to acquire, and many of the traditional Mapuche silversmiths have vanished. Ponchos, on the other hand, particularly those with complex patterns requiring months of constant labor to produce, tend to be considered as a possible source of income if sold to tourists. Despite such distortions, the system works (on a symbolic level) as a model of symmetrical and compensated endowments. Within their specific cultural milieu, they remain relevant, and the exterior signs of prestige and ornamentation for each gender still depend largely on the activities and tastes of the opposite sex.

Crafts play a wholly different role within the lives of Mapuches who live outside of their communities. Here, their value in terms of merchandise is emphasized, although the manufactured items retain their traditional de-

signs and techniques. The recovery of abilities such as artisanry is also linked to the reconstruction of ethnic identity and the airing of gender grievances.

Tradition and Resignification

Silvia Rilque, a silver craftswoman from the community of Los Toldos, re-affirms the links between silver and women by suggesting that the production of silver was originally a female craft, supported by the mythical union between the moon (a central axis in the Mapuche cosmology), silver, and women. Legend has it that silver is formed by the tears of the Moon, Kishen, as she wept after her husband the Sun betrayed her: a present for all her Mapuche sisters. This myth inverts the most frequent assignation of specialities by gender, arguing that men were initially weavers, not silversmiths, and that these roles became inverted under *huinca* influence. Thus the recovery of silversmithing as a female activity is simultaneously a gender replevy, which repositions women within the center of the Mapuche worldview, and an ethnic replevy, which restores a custom to its original condition. The sacred character of silversmithing is reflected in the fact that women begin this activity as an interpretation of their dreams. The use of dreams as a means to recover lost sacred teachings is coherent with the importance that Mapuches have traditionally assigned to this state of semiconsciousness as a route toward diverse fields of knowledge. It has been documented by Robertson (1991) in respect to the apprenticeships of *machis,* and by Briones de Lanata and Olivera (1984) concerning the clarification of social conflicts. The silver pieces used in these rituals are largely manufactured from flat surfaces, folded to make links for chains, and then assembled into necklaces and *trari-loncos* with a large number of hanging medals representing *pillanes* (spirits, or the souls of the departed), *canelo* flowers (the sacred tree), moons (round and flat), and tears of the moon (drop-shaped).

The continuity of traditional motifs proves significant: the Mapuches have developed a pantheistic cosmology where natural phenomenons (sunrise, sunset, the cycle of seasons, storms), the elements (water, fire, and stone), plants, and animals, are all viewed as linked aspects of a complex and inter-related system also including humans and their social actions. Positive and negative superior forces are reflected in this system through nature before they act on humans. A whirlwind can be the incarnation of a *huecuvu* (evil spirit); a soaring eagle, on the other hand, can be a positive omen. To a certain extent, this is a "culturalization" of nature, in which the latter apparently

responds to human demands and forms part of social crises. It is also, however, a "naturalization" of culture, which explains internal conflicts in terms of the surrounding environment.

In this context, where nature is perceived as a set of messages to be deciphered, the code of nature is also used to transmit social information. The designs of weavers and silversmiths are neither capricious nor related to individual aspirations; rather, they constitute deeply rooted depictions of cosmological systems that form an important part of ethnic identity, even if in many cases, and particularly in textiles, the meanings of these patterns have been lost to the artisans. Thus, as crafts producers, women handle and perpetuate the symbolic universe, using it to define the elements that condition gender, so that we can postulate, in accordance with Arnold (1994), that women play a primordial role in the design of social relations.

Notes

This essay was translated by Julián Brody.

1 Mapuche prisoners were used locally as servile labor in ranches or encomiendas, or else sold as slaves in High Peru.
2 The recollection and consumption of *pehuén* pines and wild apples makes for an important survival strategy for many of the Indian communities in Neuquén.
3 The preference for such activities, which is fairly widespread among the Chilean Mapuches, is related to the fact that this form of employment provides lodgings.
4 In actuality, traditional religions survive in a state of some conflict with Christianity. While the Protestants tend to forbid traditional religious practices, the Catholic church has attempted to assimilate them. However, it is not unusual for Pentecostal communities to maintain traditional religious figures as well. In many cases, nonetheless, the chain of transmission for such sacred learnings has been broken, and neophytes who aspire to become *machis* must invent techniques for self-teaching (such as the interpretation of dreams) or travel long distances in search of adequate tutoring (see Robertson 1991).
5 For a good analysis of pottery, see Montecino (1995b).
6 Ancient Mapuche mines have recently been discovered in Chile. They had been sealed by the Mapuches themselves, as a means of keeping them from the Spaniards.
7 This tradition was documented in 1870 by Armaignac (quoted by Cattaneo 2000) as part of the welcoming ceremonies for illustrious visitors.

Reference List

Aldunate del S., Carlos. "Reflexiones acerca de la platería mapuche." *Cultura, hombre, sociedad: Revista de ciencias sociales y humanas* (1984).

Alvarez, Gabriel Omar. "Los mapuches, el parentesco, la mujer y el poder: Visión de la sociedad mapuche durante el período anterior a la Conquista del Desierto." Unpublished paper, 1991.

Arnold, Denisse. "Hacer el hombre a imagen de ella: Aspectos de género en los textiles de Qaqachaka." *Chungara* 26, no. 1 (1994).

Balazote Oliver, Alejandro O., and Juan Carlos Radovich. *Gran obra e impacto social en Pilquiniyeu.* Buenos Aires: Centro Editor de América Latina, 1993.

Bartra, Eli. *En busca de las diablas: Sobre arte popular y género.* Mexico City: Tava/ Universidad Autónoma Metropolitana-X, 1994.

Bengoa, José. *Historia del pueblo mapuche.* Santiago de Chile: Ediciones Sur, 1985.

Benton, Jane. "A Decade of Change in the Lake Titicaca Region." In *Geography of Gender in the Third World,* ed. Janet Henshall Momsen and Janet G. Townsend, 215–23. Albany: State University of New York Press, 1987.

Briones de Lanata, Claudia. "La identidad imaginaria. Puro winka parece la gente." Paper read at the "II Congreso Argentino de Antropología Social," Buenos Aires, 1986.

Briones de Lanata, C., and M. A. Olivera. "Che Kimin: Una cosmo-lógica mapuche." Unpublished paper, 1984.

———. "Estructuras cognitivas e interacción social: El caso de la brujería entre los mapuches argentinos." In *Actas del 45 Congreso Internacional de Americanistas,* Bogotá, 1985.

Cattaneo, María del Carmen. "Etnocentrismo y género: Las mujeres indígenas en el siglo XIX." Paper presented in the "VI Congreso Argentino de Antropología," Mar del Plata, 2000.

De Rosales, Diego. *Historia del reyno de Chil.* Santiago de Chile: n.p., n.d.

Díaz Polanco, Héctor. *La cuestión étnico-nacional.* Mexico City: Línea, 1985.

D'Orbigny, Alcides. *Voyage dans l'Amérique méridionale.* Paris: n.p., 1835.

Housse, Rafael Emilio. *Une epopéye indienne.* Santiago de Chile: Zig-Zag, 1940.

Juliano, María Dolores. "Algunas consideraciones sobre el ordenamiento temporo—espacial entre los mapuches." *Boletín Americanista* 34 (1984).

———. "Los mapuches: La cultura y la naturaleza" and "Los movimientos indios." In *Situació actual de la població indígena a l'América Llatina,* ed., 113–56. Barcelona: Ajuntament de Barcelona, 1989.

———. "Los mapuches: La más larga resistencia." In *Anuario IEHS* 11. Facultad de Ciencias Humanas, Tandil: Universidad Nacional del Centro (1996), 303–38.

———. "Chiapas: La revolució de les dones." *Veus alternatives* 11 (Barcelona, 1998): 26–31.

Latcham, Ricardo E. *La organización social y las creencias de los antiguos araucanos.* Santiago de Chile: Museo de Etnología y Antropología de Chile, 1924.

Lázzari, Axel, and Diana Lenton. "Etnología y nación: Facetas del concepto de araucanización." *Avá: Revista de antropología* 1 (2000).

Mandrini, Raúl. "Procesos de especialización regional en la economía indígena pampeana (s XVIII y XIX)." *Boletín Americanista* 4 (Barcelona, 1991).

Mansilla, Lucio V. *Una excursión a los indios ranqueles (1870–71).* Buenos Aires: Peuser, 1964.

Montecino, Sonia. *Sol viejo, sol vieja: Lo femenino en las representaciones mapuche.* Santiago de Chile: Sernam, 1995a.

———. *Voces de la tierra, modelando el barro: Mitos, sueños y celos de la alfarería.* Santiago de Chile: Sernam, 1995b.

Radovich, Juan Carlos, and Alejandro O. Balazote. *La problemática indígena.* Buenos Aires: Centro Editor de América Latina, 1992.

Rilque, Silvia. Interview with author, Chile, 23 September 2000.

Robertson, Carol E. "The Ethnomusicologist as Midwife." In *Music in the Dialogue of Cultures: Traditional Music and Cultural Policy,* ed. Max Peter Baumann. Wilhelmshaven: Noetzel, 1991.

Rolandi de Perrot, D. S., ed. *Cultura mapuche en Argentina: En recuerdo de Susana Chertudi, septiembre 1981–marzo 1982.* Buenos Aires: Edit. Ministerio de Cultura y Educación, 1981.

Zurita, Rosa. Interview with author, Chile, 22 June 1988.

MARÍA J. RODRÍGUEZ-SHADOW ✪

Women's Prayers

The Aesthetics and Meaning of Female Votive

Paintings in Chalma

In Mexico, there are at least 168 sanctuaries that receive pilgrimages and which exhibit painted ex-votos,[1] but the most popular remain those at Our Lady of Guadalupe (Mexico City), Our Lord of Chalma and the Holy Child of Atocha (Zacatecas), the Sanctuary of the Lord of Villaseca and the Christ of the Lord of the Hospital (Guanajuato), Our Lady of San Juan de los Lagos (Jalisco), Saint Francis of Real de Catorce (San Luis Potosí), and the Black Christ (Veracruz). The present article will focus on the painted ex-votos housed in the sanctuary of Chalma, exclusively those commissioned by women. This will allow us to explore the motivations, interests, and concerns of twentieth-century women from a specific region and social class. These women have found painting to be the ideal, most affordable means to express their gratitude to Christ for favors granted. Although some ex-votos simply allude to instances of divine intervention without going into detail, others state the times, places, and circumstances that surrounded a miraculous occurrence.

Ex-votos, tokens of gratitude from humans to their gods, have figured within the records of humanity since ancient times.[2] In different religions,[3] eras,[4] places[5], and social strata,[6] votive offerings have adopted a range of sizes,

forms, and types.[7] The term *ex-voto* derives from the Latin, *ex* and *votum,* which signifies a "promise of faith." It denotes an object placed by believers at a sacred location as an acknowledgment of benefits received from the sanctuary's particular patron deity.[8]

Although there is an enormous diversity of ex-votos, I shall focus here on painted ex-votos, which probably originated in Italy during the mid-fifteenth century and which are created to thank heavenly beings for help received or petitions conceded. The paintings depict the occurrence of events considered miraculous, or which otherwise presuppose supernatural intervention.[9]

Such painted ex-votos are works of art, usually produced by self-taught artists at the request of donors for the express purpose of being displayed in a church or sanctuary. They have served as inspiration for a variety of artists, many of whom—such as Jaime Saldivar, Roberto Montenegro, Miguel Covarrubias, Juan O'Gorman, Diego Rivera, and Frida Kahlo—have now achieved international recognition, although they created their works for very different purposes.[10] A number of researchers have been increasingly drawn to these small paintings over the last few decades,[11] fostering a renewed appreciation of their historical,[12] sociological,[13] and aesthetic[14] merits, and encouraging their inclusion within a number of popular art exhibitions[15] and catalogs.[16] Nonetheless, analyses remain incipient.

These touching testimonies of gratitude toward divinity, frequent throughout the Catholic world, have been present in Mexico since the sixteenth century and offer a clear reflection of Spain's religious legacy. Until the end of the eighteenth century, Mexican ex-votos in the era of the viceroys were painted on canvas and were almost exclusively the province of aristocrats or other members of the upper classes.[17] After the Council of Trent in 1660, the introduction of European tin sheets as a backing for paintings allowed the production of much cheaper ex-votos, and they soon acquired popularity among laboring groups and the middle classes, becoming a characteristic feature of churches and sanctuaries.

Thus, prior to independence and until the mid-nineteenth century, ex-votos crossed social and cultural barriers of the age, achieving a "new popularity which represented and combined human experience with divine intercession."[18] During the nineteenth century, the production of votive paintings on tin sheets spread even further. Pilgrims soon covered the walls of their favored sanctuaries with them, and they gradually became an artistic and religious form of expression favored almost exclusively by the most impoverished and vulnerable of social groups.[19] During the twentieth century, the wealthier segments of the population turned away from the manufac-

ture of painted ex-votos, preferring different means to display their devotion. Over time, the definitive adoption of this pious practice by the rural and urban masses has propitiated certain stylistic determinants, which have remained unchanged for more than a century.[20]

Many ex-votos have been lost or damaged due to the high iron content of the tin sheets produced in Mexico, which frequently results in oxidation and in the deterioration of the images that they bear. Although the terms *ex-voto* and *retablo,* or retable, have been interchangeably used by the faithful and even by specialists,[21] important differences exist between them in terms of usage, function, form, design, technique, appearance, and significance. The retable, whose name derives from the Latin, *retro tabulum,* meaning "behind the table or altar," is popularly known as *lámina* (sheet), *imagen pintada* (painted image), or *santo* (saint). These terms denote the set of painted or sculpted decorative figures placed behind an altar,[22] domestic altars included.[23] Thus, retables constitute sacred objects while ex-votos do not.

Although ex-votos were initially painted on wood, a range of materials has presently come into use, including tin, wood, cardboard, card, and plywood among others. However, due to fragility, commercial appeal, and outright looting, many of the oldest ex-votos have been steadily disappearing in a process exacerbated by a lack of awareness regarding their cultural and historical significance.[24] Their study and analysis has consequently become not only necessary but also vital.

When a human being commissions a painting in order to express his or her gratitude for the kindness displayed by a supernatural power, be it Christ, a virgin, or a particular saint, and then exhibits this painting in a church or sanctuary, the act is no longer an individual one, but one that has entered the social realm. In this way, the artists and donors become creators and promoters of an art that perpetuates an important element of their existence, a "fragment of their feeling."[25] These are usually anecdotal paintings offered as symbols of devotion and thankfulness for beneficial instances of magical or miraculous intervention in mundane affairs on the part of a particular heavenly being. For the most part, they are executed in oils on tin; their dimensions are variable, although they tend to fluctuate between approximately thirty-six by fifty centimeters and six by ten centimeters.

An ex-voto's depiction of miraculous events will almost always include the beneficiaries, portrayed symbolically rather than realistically. Their imprecisely rendered physiognomies suggest the irrelevancy of faithful representation. The ex-voto will also present the divine personage whose intercession is commemorated. Usually, the artists stray little from the conventional fea-

tures of religious images imposed by the Catholic church, although they are often prone to change certain ornaments and attributes, such as the color of a cloak, the arrangement and length of a hairstyle, or the presence of bleeding wounds and luminous halos.

The analysis of such offerings sheds light not only on the nature of certain portents attributed to specific religious figures but also on the social history of an entire region, on rural and urban landscapes, and on the day-to-day existence of subjects who have protagonized miraculous incidents — their ethnic and social groups, their diseases and sufferings, plagues and natural calamities, accidents, problems, and sense of social injustice.[26] They also provide clues toward the subjectivity, the collective imagination, and the motivations of the donors. In aesthetic terms, they offer an opportunity to analyze the iconography of religious art, to examine the candid visions of their authors as well as their pictorial dexterity, the evolution of styles, audacious chromatic selections,[27] and data regarding the materials employed.[28] Ex-votos, which combine a narrative character with a great wealth of formal and expressive elements, can be viewed as a true popular art form. Their study should yield a wealth of data regarding regional artistic production and the symbolic systems of the social groups that generate it, social processes, gender relations, and the transformation of stylistic conventions, among other things. In brief, they allow for the study of social products within their cultural context.

In general terms, ex-votos consist of three fundamental elements: human characters, caught in the act of witnessing a miraculous event; one or a group of divine images; and a written text describing the extent of human gratitude in greater detail. The divinity responsible for the depicted portent is usually located at the top, centered or to one of the sides, surrounded by an ethereal atmosphere. Below and to the center, we find the earthly plane, which is to say the graphic depiction of miraculous events that have saved or otherwise benefited humans. In the lowest part of the ex-voto, we usually find a written text detailing the events commemorated above.[29] The complexity of the scenes represented by these ex-votos varies considerably. Some lack human figures entirely; others portray one or various kneeling figures, prostrated before a heavenly apparition. Some depict those afflicted by illnesses, lying in their sickbeds, while still others may present the various characters involved in the events surrounding the miraculous act. Although the time and place captured by the painting can vary enormously, we can distinguish at least three main variations: those where the scene depicts the very instant of the miraculous event; those showing some moments prior or some time after the event; and, finally, those that portray a long-lasting situation, where the past,

the future, and even different geographic localities are compressed into a single continuum.[30] Occasionally, the written text can be limited to a donor's name, a date, and a place. Most ex-votos are unsigned, although some exceptions exist.[31] The texts, pervaded by the charm of popular language, provide a unique window into a peculiar form of symbolizing the religious universe, into the manner in which both painters and donors conceive and link the sacred and profane orders.[32] These texts, which often include grammatical errors, provide information that supplements the purely graphic portrayal of events.

Artists creating ex-votos usually lacked formal training and were consequently less likely to be restrained by the canons of academic painting. These artists captured, with greater or lesser dexterity, miraculous events as narrated by a person whose life was saved, perhaps, or who recovered from an illness or other ailment as a result of divine intercession. Although painted ex-votos are characterized by a nonacademic handling of spaces, colors, and light, this does not suggest the absence of technique; rather, it points to the existence of a *different* technique, a life experience that does not exclude but rather reaffirms the ex-votos' belonging to the realm of religious art. These are fine paintings, technically unpretentious, elegant, naïve, clear, and simple.[33] Perspective, space, and time are frequently skewed or exalted by the artist's imagination as a means to transmit the narrative and to emphasize the magnitude of the remembered portent.

Today, artists willing to portray and commemorate the gratitude of a human being whose plight has come to the attention of a divine being have grown increasingly scarce. Nonetheless, some demand for their work still remains, as is evinced by the ex-votos left behind by migrants, which detail many of their obstacles and triumphs during the arduous trip north in search of employment.[34] However, the religious function of these ex-votos remains intact. Although their aesthetic quality has dropped to some extent, the faithful continue to pack shrines and churches with small samples of their devotion. The placement of ex-votos is conditioned by the religious fervor of the faithful, linked to the miraculous reputation of the images housed in a particular sanctuary, and to the nature of the location where they are worshiped. These personal testimonies, full of a naive sincerity, dramatic strength, and vigorous composition have long been celebrated by the pilgrims and believers who flock to sanctuaries and churches.[35] Their subject matter generally concerns miraculous cures, accidents in vehicles or at work, economic or moral problems resolved, dangers past, or legal situations overcome. Some instances acknowledge divine intervention without further detail.

Although ex-votos have flowed continuously into the Sanctuary of Chalma since the sixteenth century, its collection today numbers no more than three hundred pieces.[36] The oldest example dates from 1894, the most recent from 2000. The ex-votos' scarcity is explained by the fact that many are now in private collections, while the ravages of time have demanded their tribute from others. Crafted in inexpensive materials and with a humble attitude, they have rarely stood in high regard, particularly with the local priests. This unfortunate situation, however, is barely unique to Chalma.[37]

Only one of the ex-votos in the sanctuary's collection is signed by the artist, although most of the donors have felt compelled to record their names. In Chalma, as opposed to other locations, most of the donors have been male; only a small proportion was commissioned by women,[38] of which the oldest dates from 1904 and the most recent from 2000. Chalma, as well as Plateros in Zacatecas,[39] is a place for the reception rather than the production of ex-votos. Bartra has suggested that the most ancient of these ex-votos display the most figurative styles, while the more recent examples display a tendency toward a so-called primitivism and *art naïf*.[40]

In general terms, ex-votos created prior to the 1940s manifested the use of greater skills and dexterity, integrating a larger number of elements and with a more sophisticated handling of perspective and chromatic balance. Clearly, some were crafted by individuals who had mastered their trade. More recent pieces often seem to be made by amateurs or by the donors themselves. They lack technical refinements or formal education; characters remain wooden and unshaded. A bright color palette is frequently employed with some abandon. This deterioration in the artistic and expressive merits of such pieces may well result from the low esteem in which the trade is held. Minimal profits have forced many artists to seek a living by other means.[41]

The artists who paint ex-votos work only on commission. Although most of them work at home, in improvised family workshops, usually in small, rural communities, one also finds a limited number of itinerant artists. The women who donate these pieces will most likely have provided an oral narrative of the events surrounding the portent to serve as basis and inspiration for the artist's portrayal. Once completed, the piece is paid and brought before the eyes of God. Many donors may also have created their ex-votos themselves. Clearly, the depictions of Christ have almost always been copied from a printed model. Only the artist's skill can on occasion breathe some

life into these stereotyped images of the Lord of Chalma. However, spatial organization, composition, and color scheme still provide ample room for creativity.

Can we know if any of these pieces were collectively manufactured, or if women were involved in their production?[42] Unfortunately, the answer is no. Nothing in the ex-votos of Chalma allows us to shed some light on this matter.[43] The notion that women may have somehow participated in the creation of these works of art is not without foundation; women collaborate actively in the manufacture of a vast range of household items, crafted in home workshops and traded in local markets, such as textiles, wax items, pottery, or woodwork, to name but a few examples. Nonetheless, it is only recently that some women have finally agreed to sign their works, as do the female artisans of Ocumicho.[44]

In this regard, we should note that none of the painted ex-votos found at Chalma depicts a member of any of the ethnic groups that traditionally visit the sanctuary during feast days (Otomies, Nahuas, and Matlazincas, among others). And of course, none of the women portrayed is dressed in the traditional costumes worn by the indigenous peoples who flock to the sanctuary in collective pilgrimages. Can one argue that the practice of donating painted ex-votos is limited to ranching groups, peasants, and impoverished urban communities? I will post this as a preliminary hypothesis.

Bartra has correctly pointed out that ex-votos reflect social realities,[45] but they also incorporate certain interesting psychological aspects. Artists will imbue their work with facets of their own subjectivity, as can be seen, for example, in a painting donated in 1904, which very simply depicts a couple kneeling before the crucified image of Christ. The woman is dressed from head to toe in black, draped in a rebozo. The man wears a brown suit. The text informs us that this couple was freed from the "jail at Orizaba" ("la cárcel de Orizava"), where they had been incarcerated due to a wrongful accusation. It seems very likely that whoever commissioned this painting wanted a clear depiction of the portent; and yet, the artist decided to provide no more than the skimpiest of graphic renderings.

Why do women elect to give thanks? Through the intermediation of these ex-votos, women, and particularly impoverished women, have learned that they can create links of interchange and reciprocity with the Lord of Chalma in order to ease their harsh social and economic realities and to search for health, protection, and comfort. In this way, ex-votos provide a privileged female space, where women can express their gratitude for divine assistance

rendered in moments of great need or dire peril. They also open a window through which we can glimpse something of these womens' ailments and concerns, feelings and desires.

Clearly, as Arias has argued,[46] variations exist in the motivations of the women who have commissioned these ex-votos reflecting the traditions and regions where the diverse sanctuaries are located, but there have surely been a number of continuities. Although the ex-votos constitute an authentic and spontaneous testimony, both intimate and sincere, allowing women to air a range of troubles and tribulations, they make for encoded histories, which is to say that they are profoundly regulated in that they only divulge matters socially permissible. Only very occasionally do we find veiled references to certain inadmissible topics, such as domestic violence or the sexual abuse of minors.

In my sample, we find at least three central subject matters: illnesses,[47] accidents, and violence. There is a total of twenty-six ex-votos giving thanks for a successful return to health; five which commemorate salvation from accidents; six from violence; two which express gratitude for their subjects' release from jail; and one which does not specify the nature of the portent. Ex-votos dedicated to the healing of illnesses are clearly the most numerous. The Christ of Chalma's fame as a "very miraculous" image soon drew a great number of people with the widest range of ailments. Unfortunately, the specific medical nature of the ailment is only rarely mentioned. There exist no more than three such instances in the Chalma collection: one woman recovered from a skin condition, another favorably weathered an operation on her finger, while a third's foot had been healed. Although six ex-votos refer to successful surgical procedures, and two to dire illnesses cured by the Christ of Chalma, there are few details. The texts often state that these were very delicate operations, where death was narrowly averted only by the most miraculous circumstances.

In twelve of the forty ex-votos, women requested favors for others: in five for their children, in three for their husbands, in two for siblings, in one for a son-in-law, and in one for a mother. Thus over half these samples are tokens of gratitude for petitions granted to the donor herself, and the rest for their loved ones or domestic animals. In some cases, the pieces give thanks for having avoided a prison sentence; in others, for having emerged unscathed from robberies or traffic accidents; and in at least two instances, for surviving domestic violence. There is an almost equal proportion of rural (twelve) and urban donors (thirteen). Fifteen of the ex-votos do not provide this information. Eleven ex-votos were commissioned by women from Mexico City, and

five came from the state of Mexico; others hailed from Puebla, Guerrero, Morelos, and Veracruz. Eighteen do not provide this information. On average, the period between the miraculous event and the delivery of the ex-voto is about a year, although it can be longer.

The ex-votos in Chalma are not presented in chronological order, as is the case at the sanctuary of Cata, where the oldest are at the top of the wall and the most recent along the bottom. In Chalma, many of the newest are juxtaposed with the most ancient. This is because many paintings have been removed from the wall for various reasons, with new ones placed in the gaps. In any case, this fact allows the observation that the essential features of formal structure and composition have been carefully preserved over time. The sanctuary of Chalma's collection of ex-votos has become a powerful means to convey the miracles attributed to this image, a space where believers and devotees can express their gratitude to the Lord of Chalma, as well as the context that allows us to place these products of popular creativity within a specific cultural dynamic.

Illnesses

An analysis of the ex-votos of Chalma as a group clearly reveals that women are among the most vulnerable of social groups; many of them lack the resources needed for adequate medical attention. Here I find, for example, the case of Mrs. Trejo of Mexico City who, aged twenty-five (in 1911), was "about to perish from a terrible illness, and as she had no one, she pleaded to the Lord of Chalma, who granted her miracle." Or that of a woman who in 1935 declared her "sincere gratitude to the miraculous Lord of Chalma for having brought me back to life." In 1930, Encarnación Fernández suffered from an unspecified affliction, but she commended herself "to the Lord of Chalma, and with his help I was soon healed." Ignacia Quezada de Montoya thanks him for "returning my life when death seemed inevitable."

Many cures have been attributed to the Lord of Chalma, and his assistance is particularly sought after by those who face life-threatening operations. For example, both Enriqueta Vega in 1938 and Agustina Sánchez in 1968 thanked the lord for helping them through "very delicate" operations (see fig. 1). Carmen Guerrero was granted "the miracle of a successful finger operation." In 1992, Saula Moreno Hernández donated an ex-voto that reads, "I come in good faith to thank you for helping me heal . . . and letting the operation come out well" [bengo de todo corazon a darte las gracias por aberme ayud-

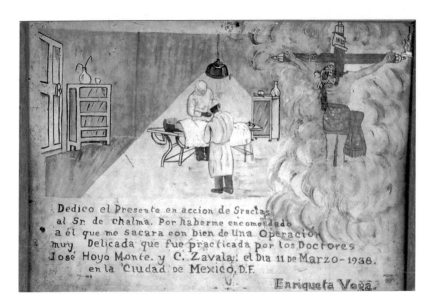

1. "Dedico el presente en acción de gracias al Sr. de Chalma. Por aberme enco-
mendado a el que me sacara con bien de una operación muy delicada que fue
practicada por los doctores Jose Hoyo Monte y C. Savala. el día 11 de marzo-1938.
en la ciudad de México D. F. Enriqueta Vega." [I dedicate the present as an action
of thanks to the Lord of Chalma. For having commended myself to him,
I emerged successfully from a very delicate operation, which was carried out
by Drs. Jose Hoyo Monte and C. Savala, on 11 March 1938, in Mexico City.]
Photograph by María Rodríguez-Shadow.

ado a curarme . . . y que la operacion saliera bien]. On occasion, the women
received divine assistance and were able to forego their operations entirely,
as was the case with Francisca Montoya in 1940 and of María Felix Ocampo
from Tepecingo, Morelos, in 1962. The Lord of Chalma has also successfully
cured mental disturbances. Tiburcia Parra, of Tlamacazapa, Guerrero, do-
nated an ex-voto in 1967, thanking the Lord for his assistance in healing a
difficult mental problem.

I have already noted that these predominantly rural women are not wholly
and exclusively concerned with their own well-being or that of their loved
ones; their animals, a vital part of their domestic economies, are also an im-
portant concern. Other sanctuaries house a number of ex-votos testifying to
the Lord of Chalma's extraordinary ability to heal creatures such as cows or

pigs. Margarita Rodriguez commissioned an ex-voto "as a prayer of gratitude for the miracle of having saved a cow."

Although the Christ of Chalma is reputed for his generosity, he has also been known to mete out punishment. Pilgrims know better than to complain of the rigors of the road, for the Lord of Chalma may well impose physical tribulations on those who do not suffer in silence. Thus a woman donated an ex-voto in 1946, stating that "every year I have kept the promise to visit the Lord of Chalma with all my children. Last year, I did not bring one of them, and the Lord punished me with a serious illness. I begged Him to allow me to return home, and was instantly healed, although I became ill again once I had arrived."

As opposed to the findings of Zárate in his pioneering research on faith-based healing,[48] the women who donated Chalma's ex-votos did not leave everything in the hands of their benefactor; many of them also resorted to whatever medical procedures were available, and a variety of the ex-votos present a well-equipped operating room as the scene of miraculous intervention. This is not to make light of the fact that at least nine of these ex-votos simply portray a woman lying in her sickbed. Three include other women praying nearby. This is to be expected in the case of women from rural areas with only the most precarious of health services, for whom many diseases had to be treated using traditional remedies. For these women, pilgrimages, prayers, and promises to the Christ of the sanctuary of Chalma became a means to acquire the certainty that they could, somehow, overcome adversity and disease. Clearly, the concept of disease—which necessarily occupies a central role in the lives of rural, marginalized groups whose access to modern medicine is severely limited—is inherent in many of these painted ex-votos. There are at least four distinct means to combat disease: (1) consult a doctor, (2) consult a faith healer or local witch doctor, (3) use herbs and traditional healing remedies, and (4) pray for a miracle. Many of the women in our sample evidently resorted to this final strategy.

Accidents

Many women have been saved from terrible accidents by commending themselves opportunely to the Lord of Chalma. Ymelda Fuentes, for example, was saved from "certain death" in 1946, when she and her horse tumbled into a precipitous canyon on the way home from the sanctuary. He also "mi-

raculously" saved a young woman from drowning on 22 May 1935. Josefa Garcia found cause to be grateful to the Lord of Chalma for delivering her safely through a terrible storm in 1947. The following ex-voto proves extremely illustrative: "We dedicate the present retable to the Holy Lord of Chalma who saved us in the precise moment of perishing in a fatal accident on March 19, 1959, when the truck we were driving around the peak of Malinalco lost its brakes and plunged backwards over a cliff. By invoking His Holy Image we were saved. Toluca, 24 May, 1960."

Violence

A recurring question in our fieldwork was, does the absence of female ex-votos containing references to violent situations (such as rape, kidnapping, sexual abuse, or domestic violence) indicate that the female population of Mexico did not in fact suffer such ills? I believe that it does not. Bartra who examined the ex-votos of Chalma looking for instances of women who had been saved from male aggression, has argued that male abuse of women remains a social taboo, a matter not to be broached.[49] Given the unfortunate pervasiveness of abuse against women in Mexico, its absence from the ex-votos of Chalma indicates either that this sort of concession is not one of the "specialties" of the Lord of Chalma,[50] or that male aggression against women is seen as a private matter, a natural affair consequently condoned by society.

Arias has noted that between 1930 and the 1960s, conjugal aggression, which on occasion reached near homicidal levels, found mention in a surprisingly open manner.[51] What happened then? Why have ex-votos referring to conjugal violence against women vanished from the sanctuaries closest to large urban centers? This author believes that repression has been responsible for the steady disappearance of ex-votos on this subject. It also seems possible that as such attacks became criminal felonies that could be judged and sanctioned by the proper authorities, society increased its pressure on women to silence the issue. Apparently, female reticence to voice such matters prevails in urban areas, where conjugal violence is more likely to entail legal consequences, more than in rural milieus.

I do not believe that the ex-votos found in Chalma on the subject of violence against women are representative, either quantitatively or qualitatively, of social realities; rather, I maintain that they show simply the tip of an iceberg. Agustina Alvarado had an ex-voto made, on which was inscribed, "on July 19 of 1938, at 11 A.M. . . . she was preparing her meal when an evil [illeg-

ible] from her own family appeared clutching a machete he threw the machete cleaving her head and at that instant she commended herself to the Lord of Chalma [illegible] complete health thanks to the Lord I dedicate this as a memory" (fig. 2). There is also the case of Luisa Zavala who expressed the following on an ex-voto in 1939: "Thanks to the Lord of Chalma for the patent miracle he made when I was with my child on the road of Tlalpan just by the police station in Tasquena. We were caught by his father and a cousin of his who took us to a solid place [*sic*]. I was beaten by both, and the cousin was taking the child. I commended myself to the Lord of Chalma, begging him that if the child had to suffer, better to take him, and in thankfulness I dedicate this retable" (fig. 3).

I maintain that although conjugal crises and tensions are an extremely common aspect of Mexican life, they rarely figure in the Chalma ex-votos.[52] The most frequent subjects for ex-votos are dangers threatening family life or livelihood.

Loved Ones

Offspring and family occupy a very special spot in the female mind, and consequently I find many prayers for loved ones and relatives who are ill or in trouble. As Arias has correctly pointed out, "Mothers display little tendency to judge the misfortunes that have pushed their children into jail";[53] for them, what is miraculous is that their errant child has been finally released. Concepción Rico, for example, donated an ex-voto in which she "fervently thanks the Lord of Chalma for having saved my child from the sentence passed down in juvenile court."

Evidently, freedom, or lack of it, is not the only cause of anxiety regarding offspring; there are also health and well-being. Senorina Briceño thanked "Our Heavenly Father Saint Martin of Porres and the Lord of Chalma for having saved my child, Antonio Valdes Briceño, who fell from a fourth-story window." The lord produced another miracle, commemorated as follows:

I dedicate this to the Lord of Chalma for having performed a true miracle for which I shall always be thankful. We were asleep in our home at 5 A.M. on May 3 1952 when we heard suspicious noises. My son Joaquin went out and found three individuals and when he asked them what they wanted, with obscenities they told him they came to fight and immediately set upon my son, another of my sons coming to his defense. Joaquin immediately received a mortal blow with a brick

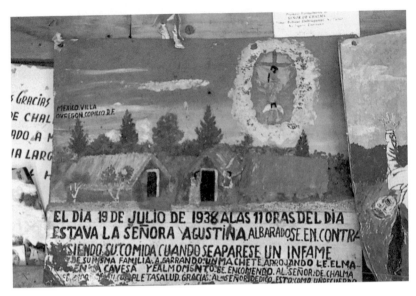

2. "El dia 19 de julio de 1938 alas 11 oras del dia estava la señora Agustina Albarado se encontraba asiendo su comida cuando se aparece un infame [unreadable] de su misma familia agarrando un machete arrojandole el machete en la cavesa y almomento se encomendo al señor de chalma [unreadable] completa salud gracias al señor dedico esto como un recuerdo." [On 19 July of 1938, at eleven hour of the day, Mrs. Agustina Albarado was preparing her meal when an evil (unreadable) from her own family appeared clutching a machete he threw the machete cleaving her head and that instant she commended herself to the Lord of Chalma (unreadable) complete health thanks to the Lord I dedicate this as a memory.]
Photograph by María Rodríguez-Shadow.

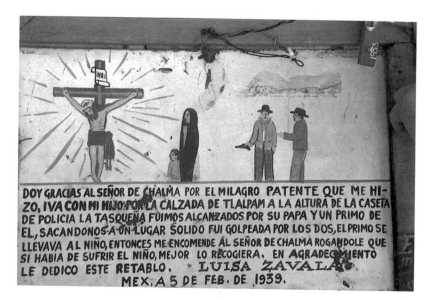

DOY GRACIAS AL SEÑOR DE CHALMA POR EL MILAGRO PATENTE QUE ME HI-
ZO, IVA CON MI HIJO POR LA CALZADA DE TLALPAM A LA ALTURA DE LA CASETA
DE POLICIA LA TASQUEÑA FUIMOS ALCANZADOS POR SU PAPA Y UN PRIMO DE
EL, SACANDONOS A UN LUGAR SOLIDO FUI GOLPEADA POR LOS DOS, EL PRIMO SE
LLEVAVA AL NIÑO, ENTONCES ME ENCOMENDE AL SEÑOR DE CHALMA ROGANDOLE QUE
SI HABIA DE SUFRIR EL NIÑO, MEJOR LO RECOGIERA, EN AGRADECIMIENTO
LE DEDICO ESTE RETABLO. LUISA ZAVALA.
MEX, A 5 DE FEB. DE 1939.

3. "Doy gracias al señor de Chalma por el milagro patente que me hizo, iva con mi hijo por la calzada de Tlalpam a la altura de la caseta de policia la Tasqueña fuimos alcanzados por su papa y un primo de el, sacandonos a un lugar solido fui golpeada por los dos, el primo se llevava al niño, entonces me encomende al Señor de Chalma rogandole que si habia de suffrir el niño mejor lo recogiera, en agradecimiento le dedido este retablo. Luisa Zavala Mex. A 5 de Feb. De 1939." [I give thanks to the Lord of Chalma for the patent miracle he realized when I was with my child on the road of Tlalpam just by the police station in Tasqueña when we were caught by his father and a cousin of his who took us to a solid place I was beaten by both, the cousin was taking the child, and I commended myself to the Lord of Chalma, begging him that if the child had to suffer, better to take him, and in thankfulness I dedicate this retable. Luisa Zavala Mex. A 5 of Feb. of 1939.]
Photograph by María Rodríguez-Shadow.

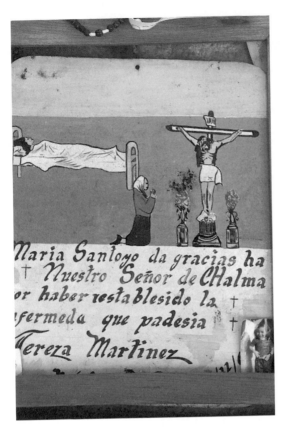

4. "La dedica Marí Santoyo. Da Gracias a nuestro señor de Chalma por aber restablecido la enfermedad que padecía. Teresa Martínez, 1964." [Dedicated by María Santoyo. She gives thanks to the Lord of Chalma for having helped her through the illness she suffered. Teresa Martínez, 1964.] *Photograph by María Rodríguez-Shadow.*

to the left side of his eye with a lot of blood. We believed him to be dying, so we commended his soul to the Lord of Chalma, and he was instantly saved.

No less intense are the worries and prayers motivated by the diseases or perils suffered by husbands. This is evinced in a number of ex-votos. Lucina Rojas thanks the Lord of Chalma for "the miracle of having saved my husband, who was bitten by a pig." Another recorded that her husband had been saved "from a shotgun blast at the hands of a cowardly individual." Another afflicted woman was grateful to the lord for having helped her husband through a dangerous operation in 1956. Although children and husbands occupy a particular place in female concerns, siblings are also the object of prayer. In March 2000, Guadalupe Peña Bernal de Tenancingo dedicated an ex-voto testifying that "I thank the merciful Lord of Chalma for the favor

he did me when my brother Martin was about to lose a leg due to diabetes. I implored his kindness and he was cured so I dedicate this retable."

Occasionally, women will commission an ex-voto to beg for divine intercession, rather than to thank the lord for favors or petitions conceded. Such was the case of Mrs. Ignacia Hernández, who "dedicates this to the Lord of Chalma to help heal my mother if that is His will." Arias has observed that very few male children offer prayers for their mothers.[54] The preceding example is an instance of a woman praying for maternal health. Chalma confirms Arias's notion that male ex-votos are firstly personal and only secondarily concerned with wives or offspring.[55] There are no ex-votos in Chalma which give thanks to the lord for having found jobs, or sobriety for women's husbands,[56] although I know that such ex-votos do exist.[57] I don't believe that this is because all husbands have jobs or remain sober; rather, it is because such matters do not constitute an acceptable subject for public discussion. In any case, I realize that in any serious investigation into the nature of addictions or alcohol abuse in men, or in women, what should be checked are the detailed records kept by the sanctuary of people who have made vows of abstinence.

As has been pointed out above, an additional topic for female ex-votos relates to problems with the judicial system and incarceration. In this regard, we have the case of Mrs. Dolores Martínez, who donated an ex-voto in 1904, noting that "having been wrongfully accused and jailed in Orizaba, we miraculously invoked the image of the Lord of Chalma and were freed." Nonetheless, it would appear that women are less likely to be involved in delinquency than men.

In what way is the day-to-day nature of the female condition reflected in the Chalma ex-votos? I suspect that what we find in these paintings offers more of an image, a social representation of reality. The domestic violence evidently suffered by many women is not reflected here. Neither are diseases of the female reproductive system, psychosomatic ailments, or many of the social problems that ail society: alcoholism, unemployment, financial concerns, prostitution, crime, drug addiction, unwanted pregnancy, or AIDS, among other things. Consequently, unlike Arias, we do not believe that female ex-votos can be conceived of as a space for women to introduce themes that differ from the hegemonic narrative. We base this opinion on the fact that the collections in these sanctuaries are subject to a wide variety of conditioning factors. Firstly, all pieces must survive the ravages of time; secondly, they must be acceptable to the local priests, who will undoubtedly

review them for subjects considered improper or immoral; thirdly, they must not be ancient or aesthetically interesting, or they will swiftly find themselves removed from the sanctuary and integrated into a private collection.[58] As we study a particular sanctuary's collection of ex-votos, we must bear in mind that the pieces have necessarily undergone a rigorous and systematic selection process, both human and temporal. Surely the friars scrutinize the samples on view at Chalma very closely, removing those that should be censored, those aesthetically uninteresting, or those too damaged. What is undeniable is that womens' ex-votos can constitute a peephole, albeit a limited and partial one, through which we can glimpse their perceptions, concerns, and motivations, in any case anything that they wish to reveal.

What is the purpose of the retables? It would seem that these small pictorial works prove valuable on a number of levels. They have a practical utility, a religious function, and aesthetic merit. They hold of immense practical value for the women who donate them, for they constitute a means through which they can thank the lord for petitions conceded. They are of enormous usefulness to students of culture, for they contain a wealth of valuable data for the analysis of certain aspects of living conditions and religious ideology among specific sectors of the population, and of their artistic forms of expression. For those who acquire them on the market, they have only an aesthetic function, or are considered collectible. For the artists, they constitute a source of income that supplements others, most likely agriculture, crafts, or other forms of employment. They may also provide satisfaction on a personal level, as a means to express creative longings and ideas. There could be additional considerations if the artist personally worshiped the depicted icon.

I shall now explore the plastic space of the painted ex-votos offered by the women of Chalma, whose composition obeys a need to organize elements in a space open to the public, where the images are exposed to the exterior in a way that makes them maximally visible for viewers.

Artistic Aspects

An ex-voto's formal characteristics, such as those of any artistic creation, refer to the resolution of its elements as regards content and expressive strength; they appear as that which preserves the transmitted experience, and up to a point, the nature of the materials also limits them.[59] What follows is an analysis of the plastic space: composition, volume, illumination, line, color, execution, and text.

Plastic agents (colors, lines, illumination, rhythms, and tensions) are ordered in a manner consistent with the message transmitted. In general terms, one can say that the artists succeeded in combining the diverse elements within a harmonious and balanced arrangement; when necessary, they even established a sense of movement, as in the case of a young lady from 1935 who narrowly escaped drowning. The diverse elements that compose an ex-voto are limited to the most essential. As I have pointed out above, they fall within one of three distinct registers: the human, the divine, and the textual. The artists must be at their most creative in order to render the supernatural plane and to depict instances of divine intervention that transcend reality, which can only be understood through the logic of faith.[60]

In most ex-votos, the redeemer's figure occupies the upper section. In every case, this image is of a free-floating apparition, surrounded by clouds or by luminous halos, endowing the presented events with a sense of enormous drama. Although the divine figure is usually larger than the human characters, this may vary if the artist wishes to create a sense of distance or perspective. The repetition of images with little variation preserves the icon's primary goal — to serve as an intermediary between the worldly and spiritual planes and as a token of devotion and faith.[61] Humans, animals, and their physical context are firmly supported on the ground: one might suggest that the composition of ex-votos is organized on hierarchical scales. Although artists sometimes ignore the rules of perspective, scale, and proportion, the viewer very rarely finds superfluous elements. Details provide atmosphere and are specifically positioned so as to contribute to the overall effect. The artists willingly adapt the image of the Lord of Chalma, but they do not stray from the conventions of Christian iconography. Due to the ex-votos' descriptive nature, and to the artists' distinctive style and technique, volume is only rarely used to enhance the depiction of heavenly beings, which for the most part seem somewhat flat and static. Coloring is applied in a uniform manner, although in some instances artists have sought greater subtlety through the use of shading and blurring. This proves especially effective when applied to landscapes or natural objects such as trees or clouds.[62] Some ex-votos are particularly beautiful, boasting a combination of skillful coloring with vigorous composition. One example of an aesthetically valuable ex-voto is that donated by María de Jesús Trejo in 1911. Here, perspective, volume, balance, lighting, tonality, and shading all contribute to an extraordinarily subtle and harmonious whole. Chromatic juxtaposition is ably employed: cold colors contrast and set off warmer shades, such as yellows, oranges, and reds against a blue backdrop.

Few ex-votos in this sample depict light sources that illuminate the represented scene. Although certain tonalities and shadows are used, helping to generate a sense of volume, for the most part light depends on color, in a technique known as color-light. Occasionally, it is hard to tell if color variations respond to a modification in the quality of the depicted matter or to different levels of illumination that create areas of light and shade. Very rarely, the artists have used lines as divisive elements between one color zone and another. Yet this is the case with the ex-votos commissioned by Tiburcia Parra (1967) and Teresa Martínez (1964).

In the most successful ex-votos, the artist captures the full emotionality of the anguished female narrative, as well as the happy event propitiated by the prodigious intervention of the crucified Christ. These paintings thus manage to conjugate past and present within a single graphic instant. The very representation of the two temporal dimensions suggests the comprehension of a moment synthesized in time, somehow inexact, and refers to an imaginary reality.

Although these ex-votos have been executed in oil, none of the artists appears to have felt the need for corrections or amendments. Evidently, final results vary: some examples are sketchy and careless, while others clearly reflect greater care and attention. Not one of the Chalma ex-votos lacks a written narration of the commemorated miracle. This evident need for a text to support the painted image is particularly interesting in view of the fact that most of the pilgrims and worshipers who view these images are either illiterate or semiliterate. Many are indigenous, with a limited knowledge of Spanish; others are urban laborers, whose education is precarious at best. The inclusion of a text elucidating the nature of the depicted events probably reflects the women's vehement urgency to communicate the extent and character of the conceded miracle. As in most ex-votos, the written section holds enormous importance: writing skills and grammar offer important clues as to the donors' cultural and social contexts.

Although the authors of these texts appear unconcerned with legibility, clarity, syntax, or grammar, and despite their use of a solemn and stilted language, their narratives prove sincere, candid, and moving. They are evidently genuine expressions of faith in the supernatural capacities of this celestial being.[63] Errors in grammar or syntax in the texts result from the limited scholastic preparation that prevails among the most underprivileged sectors of society, although the mistakes do not exclusively affect them. The texts vary in length, although they remain brief for the most part. Occasionally, they are rendered illegible by deterioration and age.

They are written as they are pronounced: *averme, aberme,* or *verme* for *haberme* (having as in "having found myself"), *Consepsion* for *Concepción* (Conception), *caveza* for *cabeza* (head), *asiendo* for *haciendo* (done), *padesia* for *padecía* (suffered), *debuelto* for *devuelto* (returned), *ha* for *a* (has), *salbado* for *salvado* (saved). Or else they may separate single words into two, as in *en ferma* for *enferma* (ill), or join separate words into one, as in *coneste* for *con este* (with this one), or *alas* for *a las* (at). However, these grammatical errors do not detract from the messages of the faithful. The texts round out a history which, in their view, would have been incomplete as a graphic depiction alone. The set of texts allows us to distinguish a narrative style.[64]

Conclusions

Contemporary painted ex-votos belong to the milieu of folk art. Such art, free from technical or formal refinements, is created by members of the poorest levels of society. The artists are both underpaid and unacknowledged in social terms—most of their works remain anonymous. The role of this art is to satisfy the needs of a particular social group. Its production is based on ancient techniques and aesthetic notions handed down from generation to generation. Such skills or trades are born of a long practical experience obeying its own laws, and the manufactured items are consequently both useful in practical terms and offer an important source of identity.[65] The painted ex-votos of Chalma use popular language, both pictorial and written, to express the faith and gratitude of subjects, generally from the most underprivileged social sectors, who plead for practical considerations: health, assistance, and protection.

These anecdotal paintings, created by self-taught artists, mostly painted in oils onto tin sheets of various sizes, depict events narrated by female lips, although the narrator is not always the protagonist. The latter, however, is invariably presented as being in grave peril or facing adverse circumstances. These graphic dramas, executed by the protagonists themselves or commissioned from popular artists, depict the portents of the Lord of Chalma in a simple manner involving all of the personages or animals concerned. The female ex-votos of Chalma are considered here as items of popular art with an inherent, intrinsic value, not only due to their nature as unique works of art but also due to the fact that the artist has managed to convey his or her worldview longside that of the donor who protagonized the events considered "miraculous."

Ex-votos, then, conjugate the efforts of two main actors: the women who commission them, and the artists who paint them. The women employ the full range of their narrative talents in order to convey a prodigious event of great religious strength and deep emotional content, while the painters capture these events, depicting with greater or lesser skills the most essential aspects of the impassioned tale. Occasionally, perhaps due to a specific narrative's inherent complexity, the text is limited to a laconic "doy gracias" (I am thankful).

The elements presented by these ex-votos arise from two distinct human universes: day-to-day existence, and its burdens of disease, accident, or violence, and popular religiosity, with its emphasis on the repeated image of the Lord of Chalma, to whom both artists and donors are devoted. Evidently, faith—as part of a treatment to recover health, solve problems, and ease anguish—has been present since the most ancient times. The ex-votos of Chalma reveal that the faith-based method, among others, remains in use today.

Notes

This essay was translated by Julián Brody.

1 Báez-Jorge (1998, 95–104).
2 Giffords (2000) has argued that the earliest offerings consisted in the sacrifice of animals or humans who were later replaced by zoomorphic figures. It has also been suggested that certain female figurines unearthed in Europe, more than 12,000 years of age (Soffer 1998), zoomorphic objects found in Babylonia, dating back to the eighth century B.C. (Giffords 2000, 11), figurines rescued from Tlatilco and western Mexico, and many of those discovered in Aztec ceremonial centers are in fact ex-votos. Art historians believe that certain fifteenth-century paintings are also ex-votos (Rosa María Sánchez 1990, 26; Parés 1989, 424).
3 In the Mesoamerican religious system, in pre-Christian beliefs, in Shintoism, and in Judaism, among others.
4 Most distinct historic periods have produced their own specific variety of ex-votos.
5 In Egypt, Mesopotamia, Greece, Japan, Germany, France, Italy, Portugal, Spain, and Mesoamerica.
6 Offerings have varied according to social class (Ortiz 1999, 42; Rosa María Sánchez 1990, 25).
7 Ex-votos are considered as the range of objects (crutches, prostheses, braids, bridal bouquets, plastic flowers, garments, rosaries, baby shoes, letters, photo-

copies of diplomas, or photographs) that the faithful leave for their benefactor in sanctuaries and churches. Many ex-votos are small, metallic figures—usually silver, gold, or tin—in the shape of the particular body part that most requires heavenly assistance: eyes, heads, legs, arms, and hearts. We also find complete figures of living beings, where the afflicted region can be indicated, as well as images of domestic animals: cows, goats, pigs, dogs, and cats. A number of authors have researched these ex-votos, such as Egan (2000, 1991), Thomsom (1991), and Oktavec (1995).

8 Ortiz (1999).

9 Zarur (2001, 19), Giffords (2000, 11), Ortiz (1999), Rosa María Sánchez (1990), Arias (2000), Parés (1989, 425).

10 Rosa María Sánchez (1990, 15).

11 The most relevant articles are by Bartra (1995), Giffords (1974), and Arias (2000).

12 See Bélard and Verrier (1996), Luque and Beltrán (2000), Arias (2000), Arias and Durand (2000), Burke (2001), Alberro (2000), Durand (2000), Durand and Masey (1990, 2000), and Escobar (1997).

13 See Zárate (1997), Ortiz (1999), and Olimón (2000).

14 See Tibol (1992), Westheim (1951), and Aceves (1956).

15 A recent, extraordinary exhibition at the Amparo Museum in Puebla—*El Cristo Negro de Xido* [The black Christ of Xido]—included a variety of ex-votos dedicated to the Lord of the Hospital of Salamanca. This exhibition was coordinated by Armando González M. (1999).

16 In this regard, we can consult the following publications: The special issue of *Artes de México* on ex-votos (2000) and *Retablos y exvotos* (2000).

17 Giffords (2000, 12).

18 Zarur (2000, 4); see also Bartra (1995, 80).

19 Giffords (2000, 13), Zarur (2001, 17), and Parés (1989, 424).

20 Rosa María Sánchez (1990, 31).

21 As in Rosa María Sánchez (1990).

22 Rosa María Sánchez (1990, 19) and de la Maza (1950).

23 Zarur (2001, 18). It should be noted that Rosa María Sánchez (1990, 19–20) and Zarur (2000, 4) maintain diametrically opposed positions. Here I follow the latter. This issue is also discussed by Parés (1989, 424).

24 The Augustinians, for example, have removed Chalma's most beautiful and ancient ex-votos from public exhibition; those at Ocotlán have long vanished. The ex-votos at San Miguel del Milagro are being removed, as is the case at La Villa. A similar process has occurred in Spain. See Arregi (1989, 328), Cano (1989), and Parés (1989, 424).

25 See Romandía de Cantú (1978, 5).

26 Ortiz (1999).

27 Montenegro (1950, 12).

28 Rosa María Sánchez (1990, 13).

29 Parés (1989, 432).

30 Parés (1989, 435).

31 We know the paintings of Hermenegildo Bustos (see Durand 2000; Tibol 1992; Aceves 1956; and Westheim 1951), Gerónimo de León (see Baños 1996), Jesús Quiroz, Miguel Angel Rivera, G. Ruiz Robles, José Lezama, and Vicente Barajas (see Rosa María Sánchez 1990, 60, 70).

32 Rosa María Sánchez (1990, 13).

33 Rosa María Sánchez (1990, 14, 31).

34 See Durand (2000) and Durand and Masey (1990, 2000).

35 Ortiz (1999).

36 Some are in a room not open to public exhibition.

37 Zárate (1998, 61) has reported a similar problem at the sanctuary of Soriano, at that of the Holy Child of Atocha, at Zapopan, and at Talpa.

38 The male ex-votos shown at Chalma were commissioned by poor peasants or urban laborers. Many are thankful for having been saved from accidents at work or gunshot wounds; for having been released from jail; or from having emerged victorious in a physical confrontation. According to Zárate (1998, 70), the situation is reversed in the sanctuary of Soriano and in the sanctuaries of Catalonia visited by Parés, where more ex-votos are donated by females.

39 Rosa María Sánchez (1990, 69).

40 Bartra (1995, 76). Rosa María Sánchez (1990, 15) holds a similar view.

41 Parés (1989, 432).

42 This matter lies at the heart of the investigations carried out by Bartra (1994, 1998) and Fabiola Sánchez (1999).

43 Although Rosa María Sánchez (1990, 42) has argued that women play no part in the creation of ex-votos, I agree more with Giffords (1974) and Bartra (1995).

44 See Bartra (1998, 75–93).

45 Bartra (1995, 71–90).

46 Arias (2001, 67).

47 Unfortunately, if we analyze the spectrum of diseases suffered by the donors of the Chalma ex-votos, we will find that none refers either to contagious diseases or epidemics. Symptoms are almost never described, and there are no references to ailments of the female reproductive system. The research of García and Martín (1989), Luque-Romero and Cobos (1989), Parés (1989), Arregí (1989), Erkoreka (1989), Cano (1989), Jesús-María (1989), for Spain, and, for Mexico, Zárate (1998), Escobar et al. (1997), Fabiola Sánchez (1999), Arias (2000), and Mendieta (1971) shed a great deal of light on such matters.

48 Zárate (1998, 73).

49 Bartra (1995, 87).

50 It is well known that different saints have different miraculous specializations. Certain virgins are known to care for pregnant women, others for cripples or the disabled. Others are protectors of crops or animals, and still others are known

to shelter pilgrims from violent storms. Thus women who hope for an uncomplicated childbirth must pray to Saint Librada, Saint Marina, Saint Lucia, Saint Ramon Nonato, and Saint Roman. Speech impediments can be solved by Saint Andrew, while Saint Anthony of Urkiola and Saint Peter Zariquete of Zalla provide protection against evil spirits. Bad dreams can be cured by Saint John of Gorozika or Saint Bartholomew, and Saint Engracia is a useful resource against spells or the evil eye. Headaches can be healed by Saint Agueda or Saint Stephen, while prayers to Our Lady of the Antigua of Ondarroa or Saint Rose can help relieve skin diseases. Rheumatism is the province of Saint Eufemia, and earache that of Saint Gregory and Saint Christopher. Saint Blas can relieve sore throats, Saint Apollonia toothache. Saint Roque is known to dispel plagues, and Saint Lawrence to heal burns or banish warts (Erkoreka [1989, 338, 352]; Arregí [1989, 327–37]).

51 Arias (2000, 72).

52 In his sample, Arias (2001, 70) found at least two.

53 Arias (2000, 68).

54 Arias (2000, 69).

55 In very few ex-votos do males pray for divine intervention in matters going beyond that which relates strictly to themselves. It is also very rare for male ex-votos to allude to situations prior to conjugal union. This is reflected by an ex-voto in which a male thanks the lord for having allowed him to marry the woman of his choice.

56 For example Arias (2000).

57 I have an interesting anecdote in this regard. In the town Tlautla, near Cholula in the state of Puebla in Mexico, I found a devout worshiper of the Lord of Chalma who told me that she had prayed to the lord for twenty-five years, asking him to help her husband stop drinking, until one fine day the husband died. She told me this story as evidence that the lord had heard her pleas, for her husband no longer drank. As far as I know, this lady has yet to commission an ex-voto.

58 Parés (1989, 428).

59 Ibid.

60 Moyssén (1980, 26).

61 Zarur (2001, 21).

62 Rosa María Sánchez (1990, 49).

63 Ibid.

64 See also Zárate (1998, 65).

65 Rosa María Sánchez (1990, 34) and Parés (1989, 442).

Reference List

Aceves, Pascual. *Hermenegildo Bustos: Su vida y su obra*. Guanajuato: Imprenta Universitaria y Sánchez, 1956.

Alberro, Solange. "Retablos y religiosidad popular en el México del siglo XIX." In *Retablos y exvotos*, 11–31. Mexico City: Museo Franz Meyer/Artes de México, 2000.

Arias, Patricia. "El exvoto femenino." *Artes de México: Exvotos* no. 53 (2000): 64–73.

Arias, Patricia, and Jorge Durand. "Revolucionados." *Artes de México: Exvotos* no. 53 (2000): 56–63.

Arregí, Gurutzí. "Rituales de protección en ermitas y santuarios de Bizcaia (país vasco)." In *La religiosidad popular: Hermandades, romerías y santuarios*, vol. 3, ed. C. Alvarez, María Jesús Buxó, and S. Rodríguez, 327–37. Barcelona: Anthropos, 1989.

Artes de México: Exvotos no. 53 (2000).

Báez-Jorge, Félix. *Entre los nahuales y los santos*. Xalapa: Universidad Veracruzana, 1998.

Baños, Francisco, ed. *Gerónimo de León: Pintor de milagros*. Guanajuato: Empresarios S. A. de C. V., 1996.

Bartra, Eli. *En busca de las diablas. Sobre arte popular y género*. Mexico City: Tava/Universidad Autónoma Metropolitana Xochimilco, 1994.

———. "Fe y género: La imaginería en los exvotos pintados." In *México imaginario*, ed. Carmen Nava and Alejandro Carrillo, 71–90. Mexico City: Universidad Autónoma Metropolitana Xochimilco, 1995.

———. "Más allá de la tradición: Sincretismo, género y arte popular en México." In *Estudios interdisciplinarios de América Latina y el Caribe* 9, no. 1 (1998): 75–93.

Bélard, M., and P. Verrier. *Religión y cultura: Los exvotos del Occidente de México*. México: El Colegio de Michoacán/CEMCA, 1996.

Cano, Mercedes. "Exvotos y promesas en Castilla y León." In *La religiosidad popular: Hermandades, romerías y santuarios*, vol. 3, ed. C. Alvarez, María Jesús Buxó, and S. Rodríguez, 391–402. Barcelona: Anthropos, 1989.

de la Maza, Francisco. "Los retablos dorados de Nueva España." In *Enciclopedia mexicana del arte* 22. Mexico City: Ediciones Mexicanas, 1950.

Durand, Jorge. "Los retablos de Hermenegildo Bustos." *Artes de México: Exvotos* no. 53 (2000): 46–55.

Durand, Jorge, and Douglas S. Masey. *Doy gracias: Iconografía de la emigración México–Estados Unidos*. Guadalajara: Programa de Estudios Jalisciences, 1990.

———. "Migrantes agradecidos." *Artes de México: Exvotos* no. 53 (2000): 74–80.

Egan, Martha. *Milagros: Votive Offerings from the Americas*. Albuquerque: Museum of New Mexico, 1991.

———. "Milagros: Antiguos iconos de fe." *Artes de México* no. 53 (2000): 24–39.

Erkoreka, Anton. "Patologías por las que se recurre a santuarios en el país vasco." In *La religiosidad popular: Hermandades, romerías y santuarios,* vol. 3, ed. C. Alvarez, María Jesús Buxó, and S. Rodríguez, 338–52. Barcelona: Anthropos, 1989.

Escobar, Agustín, et al. *Gracias y desgracias: Religiosidad y arte popular en los exvotos de Querétaro.* Querétaro: Gobierno del Estado de Querétaro, Instituto Nacional de Antropología e Historia, 1997.

García, Carolina, and María Teresa Martín. "Religiosidad Popular: Exvotos, donaciones y subastas." In *La religiosidad popular: Hermandades, romerías y santuarios,* vol. 3, ed. C. Alvarez, María Jesús Buxó, and S. Rodríguez, 353–68. Barcelona: Anthropos, 1989.

Giffords, Gloria Fraser. *Mexican Folk Retablos: Masterpieces on Tin.* Tucson: University of Arizona Press, 1974.

———. "Editorial." *Artes de México: Exvotos* no. 53 (2000): 8–23.

Jesús-María, José Angel. "Los exvotos pintados. Una plástica particular: Los milagros de la ermita del remedio de Utiel." In *La religiosidad popular: Hermandades, romerías y santuarios,* vol. 3, ed. C. Alvarez, María Jesús Buxó, and S. Rodríguez, 403–22. Barcelona: Anthropos, 1989.

Luque, Elin, and Michele Beltrán. "Imágenes poderosas: Exvotos mexicanos." In *Retablos y exvotos,* 35–53. Mexico City: Museo Franz Meyer/Artes de México, 2000.

Luque-Romero, Francisco, and José Cobos. "Los exvotos de la provincia de Córdoba: Tipología y catalogación." In *La religiosidad popular: Hermandades, romerías y santuarios,* vol. 3, ed. C. Alvarez, María Jesús Buxó, and S. Rodríguez, 369–90. Barcelona: Anthropos, 1989.

Mendieta, Angeles. *Sociología del arte: Los retablos o exvotos populares.* Mexico City: Universidad de Nuevo León, 1971.

Montenegro, Roberto. *Retablos de México.* Mexico City: Ediciones Mexicanas, 1950.

Moyssén, Xavier. "La pintura popular." *Cuarenta siglos de arte mexicano. Arte popular,* vol. 2. Mexico City: Herrero-Promexa, 1980.

Oktavec, Eileen. *Answers, Prayers, Miracles, and Milagros along the Border.* Tucson: University of Arizona Press, 1995.

Olimón, Manuel. "Luces en el desierto: Predicación de las órdenes religiosas y arte del retablo mexicano." In *Retablos y exvotos,* 55–68. Mexico City: Museo Franz Meyer/Artes de México, 2000.

Ortiz, Silvia. "Los exvotos." *Diario de Campo* 17 no. 4 (1999).

Parés, Fina. "Los exvotos pintados de Cataluña." In *La religiosidad popular: Hermandades, romerías y santuarios,* vol. 3, ed. C. Alvarez, María Jesús Buxó, and S. Rodríguez, 423–45. Barcelona: Anthropos, 1989.

Retablos y exvotos. Mexico City: Museo Franz Meyer/Artes de México, 2000.

Rodríguez-Shadow, María J., and Robert D. Shadow. *El pueblo del Señor: Las fies-*

tas y peregrinaciones de Chalma. Toluca: Universidad Autónoma del Estado de México, 2000.

Romandía de Cantú, Graciela. *Exvotos y milagros mexicanos.* Mexico City: Compañía Cerillera La Central, 1978.

Sánchez, Fabiola. *Las figuras de cera en el arte popular de San Cristóbal de las Casas.* Mexico City: Conaculta, 1999.

Sánchez, Rosa María. "Los retablos populares." In *Exvotos pintados.* Mexico City: Instituto de Investigaciones Estéticas, Universidad Nacional Autónoma de México, 1990.

Soffer, Olga. "New Women of the Ice Age." *Discover,* April 1998, 62–69.

Thomsom, Helen. "Milagros: A Book of Miracles." In *Mexican Devotional Retablos from Peter's Collection,* ed. Joseph Chorpenning. Philadelphia: St. Joseph University, 1991.

Tibol, Raquel. *Hermenegildo Bustos: Pintor de pueblo.* Mexico City: Conaculta, 1992.

Westheim, Paul. "Hermenegildo Bustos." In *Catálogo de la exposición Hermenegildo Bustos.* Mexico City: Museo Nacional de Artes Plásticas, 1951.

Zárate, Guadalupe. "Como veras de su corazón. Exvotos pintados del siglo XIX de enfermos que consiguieron su alivio." *Dimensión Antropológica* 14 (1998).

Zarur, Elizabeth. "El favor de los santos: Altares, retablos y exvotos de la Universidad de Nuevo México" (brochure). Puebla: Museo Amparo, 2000.

Zarur, Elizabeth, and Charles Muir Lovell. Introduction to *Art and Faith in Mexico: The Nineteenth-century Retablo Tradition,* 17–29. Albuquerque: University of New Mexico Press, 2001.

Earth Magic

The Legacy of Teodora Blanco

For more than forty years, women's mythical, magical, life-affirming forms have emerged from the kilns of Santa María Atzompa and received international acclaim. Created almost exclusively by women, these unglazed red clay forms vary from palm size to commanding heights of four and five feet. Entirely hand-built, these sculptures are elaborately embellished with flowers, birds, and animal spirits. They represent a joyful and romantic glorification of women's dreams and reality as they integrate ancient myths and contemporary activities. Through the years, responding to individual commissions and commercial demands, market women, Virgins, angels, and mermaids have evolved as consistent themes interpreted by each artisan with some personal variations. Through their arduous creative work and sales, these Atzompa women have become the main economic contributors to their families. As a result, the power structure within the family and community is gradually changing, with positive and negative results.

I first encountered flower-decorated Virgins and market women during a *Semana Santa* (Holy Week) visit to the Oaxaca region in 1976. The church altars were then lavishly adorned with candles, palm branches, flowers, clay figures, and pots with corn, bean, or rice seedlings, placed at the feet of the Virgin. Here Easter represented not only Christ's resurrection, but also the annual regeneration of the soil and the fertility of all life forms. Through the years, I wondered who made the clay figures, but it was not until 1990

that I first had the opportunity to trace their evolution. I returned eleven years later in 2001 to see the changes and transformations in the art and lives of the artisans previously interviewed.

When I first arrived in the city of Oaxaca, market vendors informed me that clay products were produced in the village of Santa María Atzompa, primarily by the family of Teodora Blanco. To my dismay, I was told that Teodora had died ten years ago. However, I decided to visit Atzompa in order to learn how her aesthetic expression had evolved from those who knew her best.[1] I soon became aware that Blanco's legacy had continued, especially through the work of Berta, her sister, Luis and Irma, her son and daughter, as well as in that of in-laws and friends.

In some ways, routines have changed little for the 6,000 residents of Atzompa since 1926, when Teodora was born. Located five miles from the city of Oaxaca, this village is nestled in the foothills of Monte Albán, an indigenous Zapotecan archeological site visited annually by thousands of tourists. The road was paved twenty-one years ago, electricity installed thirty-one years ago, but men and oxen continue to plow the surrounding fields of corn and beans as they have for centuries. A Catholic church and a marketplace dominate the homes made of adobe and thatch. Most unusual were the green-glazed ceramic heads of domestic animals gazing down from the top of the sixteenth-century church wall, perhaps a reminder of the residents' pre-Columbian ancestors' beliefs in protector spirits. On Sunday, the church is filled with fresh flowers to honor the priest's arrival, and the mass includes guitar music and songs.

There is much excitement on Tuesdays and Fridays, the local market days, when people bring produce, animals, and pottery to trade or sell. These two centers of activity, the church and the marketplace, inspired the monumental sculptural forms, market women and Virgins, initiated by Blanco in 1978. They seem to explore emotional diversity and assertiveness in contrast to subdued inner reflection. The sculptures also incorporate ancestral beliefs in *nahuales* or animal spirits. When *nahuales* are imaginatively integrated into the bodies of the market women, these forms transform into mythical earth goddesses. Leonore Hoag Mulryan explains the legends associated with *nahaules:*

> Each person has a *nahual.* At night the mother and father put the newborn baby on the ground. Then they sift a circle of ashes around the baby. The first animal to cross the ashes is the *nahual* of the baby and will protect the child for the rest of its life. One can tell what kind of animal it is from the paw prints. At night the

nahual leaves the human body in search of the person's rival, to attack him. If the rival wounds or kills the *nahual,* the person at home is injured or dies.[2]

Angélica Vásquez of Atzompa, whose sculpture is also inspired by *nahuales,* confirmed this in a story she told me: "According to Zapotec legend, when a child is born, the parents must search for an animal spirit to become the child's protector. The placenta is laid along a straight line made from fire ashes outside the house. Whichever animal first crosses that line is the protector spirit. If something terrible happens to our protector animal, we suffer too!"[3] Though Teodora's descendants did not speak of their current belief in *nahuales,* I was told that the beliefs persist in nearby villages where indigenous languages instead of Spanish are still spoken. Angélica Vásquez stated that *nahuales* "represent local spirits that are active in daily life"; spirits that are believed to explain sudden illness, or death, and the high infant mortality rate.[4]

Dora Martínez Virgil, a friend of the Blanco family, explained people's personal connection with the earth. She related that after the birth of her children, the umbilical cord was ritually buried in a small clay pot in the courtyard of her Oaxaca home. "Therefore, when people say, 'I have a great love for my pueblo,' it also refers to their personal link with the earth. Now many traditional indigenous people feel that with babies born in hospitals and the placenta discarded, people are like lost souls. They don't have a sense of belonging to the earth, and that's why the world is so crazy."[5] Teodora's daughter Irma confirmed this personal connection with the earth during my second visit to Atzompa. She pointed to the place in her courtyard where the umbilical cord of the oldest of her seven children, a daughter born at home, was buried in a very small clay pot. "It is well covered," she said, "to prevent dust from falling in so that the child's eyes will not be affected with problems, and the *olla* [or jar] is small so that the child will eat normal, not too much."

In 1999, a health clinic was established in Atzompa with an active outreach program for promoting and maintaining community health. Select adobe walls throughout Atzompa were painted with images and slogans encouraging checkups for tuberculosis, examinations for cancer of the womb, and information on child nutrition. Changed eating habits due to increased financial resources and stores have provided too many opportunities for junk food snacks and soda in place of wholesome, natural foods. However, the market women sculptures do not reflect this transition.

Why did Atzompa evolve as a significant pottery center? What were the

personal factors that led Teodora Blanco to create monumental, mythical clay figures in contrast to most Atzompa women, who still produce utilitarian wares for home use, trading, or selling? I will consider these questions before reviewing the work of Teodora's descendants.

Alongside farming—with its unpredictable results due to inconsistent rainfall and soil depletion—most residents engage in pottery making as their major occupation. This is easily observed in each family compound, a series of mud brick rooms surrounding a central courtyard. In the center stands a circular stone-and-adobe kiln, approximately four feet in height. Turkeys, goats, dogs, and donkeys also commonly inhabit the courtyard. There is no indoor plumbing, and big, sturdy clay jugs hold water obtained from the central unpaved street or courtyard spigot. Other significant courtyard features are two mounds of soil: the first mined by men in the nearby hills, and the second purchased from San Lorenzo, a nearby village, and brought to Atzompa in pickup trucks. As long as residents can remember, these two soils, when pounded, sifted, and mixed together with water and then kneaded into a clay mass, have provided the basis for the development and flourishing of this local pottery industry. Male family members or hired help usually provide the labor for pounding, sifting, and mixing the clay, while women devote themselves to the pottery design and production, as well as the care and maintenance of the children and household.

Production wares vary from ashtrays and candlestick holders to tall flower vases, decorated bowls, plates, cups, saucers, casseroles, or thick, flat *comales* for cooking tortillas. Most of the utilitarian pottery is covered with a traditional green glaze made from a local vegetable dye into which the pieces are dipped and fired for a second time. Another popular item is the production of planters enormous in girth and height, elegantly decorated with relief floral designs. The women make their pottery with a coil method, while the few men who produce pottery between periods of agricultural work (except for Luis Blanco) use kick wheels. The rainy season slows the clay drying process and firing, also affecting the family income. In the past, wholesale dealers with trucks regularly brought these wares to Mexico City, paying the artisans minimally for their creativity. This relationship changed dramatically in 1993 with the formation of a local artisan market and administrative union.

Pottery-making skills are passed from one generation to the next by the parents. Seated on floor mats indoors or on a shaded veranda, most women make pottery, interspersed with child care and household chores, approximately four to eight hours daily, except Sunday, the day reserved for church

and rest. They use a matrix or flat inverted saucer, placed on a large plate that permits rotation. The pottery base is formed by punching and flattening a small clay ball, then adding *longas* (clay coils) to raise the walls according to the desired form and function. The figurative forms are hollow and also created with this same coil method. When applying surface decoration or "embroidering" the clay with threadlike coils, timing proves crucial. The basic form must remain sufficiently moist for the embellishments to bond. Completed pieces require at least a ten-day drying period. Only on the day of firing are the pots carried outside for several more hours of drying in the intense sunlight. They are then loaded into the kiln, from the top, and interspersed with clay shards until completely covered. *Acahual*—long, thin wood scraps procured from a nearby mill—are placed in the kiln opening beneath the pottery. During the short, two-and-a-half-hour firing period, the heat is slowly raised, intensified during the last hour, until black smoke billows forth. After a brief cooling period, the kiln is uncovered with the use of two long paddles (one contains a metal hook) for the removal first of the shards and then the pottery. Men, when available, assist with the firing process, a precarious undertaking as uneven heat or a wind can cause breaks or damage.

In some households focusing on utilitarian wares, the production process is shared among family members based on skill or personal preference. One produces the basic form, another adds surface embellishments, and a third may do glaze application, which is now expanding from the basic green to other natural earth tones such as white, brown, and ochers. However, by the mid-1990s, conforming to what they perceived as tourist preferences, some families began to experiment with the application of bright acrylic paint to their fired clay forms. A small, popular souvenir is a wall cross painted bright blue with two or more clay relief calla lilies painted white and the word OAXACA in yellow. In "Molding Our Lives from Clay," Ramona Pérez states,

> Tourism is presently one of the largest income-producing entities. The limited infrastructure, continued and abandoned several times in the history of the Valley, continues to place the market and distribution of craft products as a primary income producer for Oaxaca City and its peripheral communities. Though many of the craft products have been replaced with cheaper, mass-produced items for daily use, others have increased in importance due to their aesthetic value, as "traditional workmanship" or preference in durability.[6]

Earth Magic: The Legacy of Teodora Blanco

The mythical, magical legacy of Teodora Blanco began with her mother Carmen Núñez Ramírez, who came to Atzompa as a child, later marrying Amado Blanco and having five children. At eight years, Blanco learned from her mother to work with clay by making small toys or figures to illustrate the stories told by her grandparents. As a young girl, Blanco's feisty spirit was evident when she decorated ashtrays produced for market with original love poems that others helped her write, as her own education was brief. When her father became ill, her clay work became an important supplement to the family income. Fortunately, her unique ashtrays were received well, and she was asked to make larger and more varied forms. At first she decorated ashtrays with little figures, and eventually she created the larger and more personal forms of market women that she gradually adorned with flowers and animals. The demand for her work steadily increased. As Dora Martínez Virgil remembers, "The potting area was her stage where she loved to talk about the figures and tell stories as she formed them. They related to aspects of her life, the *mercaderas* (market women), mothers with babies, women and their *nahuales,* and caricatures of people."[7] Blanco's son Luis recalled, "Mother used to say she was not alive unless she was working with clay." He also noted, "On her weekly trip to Oaxaca City, she sometimes went to the archaeological museum to look at collections from Mitla and Monte Albán." Surely she was inspired by the anthropomorphic figures in those collections, reflecting her own indigenous heritage.

During the decades after World War II, Mexico underwent many changes. With the construction of the Pan-American Highway and cheaper air transportation, tourism increased, followed by a demand for souvenirs. Foreign markets for craft production also opened up, and the Mexican government began to encourage artisans to develop quality products. Regional folk art museums (*museos de artes populares*) were established in the 1960s, and FONART (Fondo Nacional para el Fomento de las Artesanías) initiated annual regional and national competitions. Blanco's work gradually became well known not only in Oaxaca but also in Mexico City, and she was invited to participate in national and international competitions.

In her personal life, Blanco had five children with Antonio García Reyes, but they never married. Antonio eventually left Blanco to marry Angelina González Cruz, with whom he had ten children (one of their sons married Angélica Vásquez, the youngest and most innovative of the Atzompa figurative artisans). Antonio was responsible for teaching Angelina the pottery

skills he had learned from Blanco. According to Luis, Antonio still accompanied Blanco to many official events, but Blanco alone was responsible for the maintenance of the five children he had fathered, a pattern later repeated in the son's marriage to Angélica.

Through the years Blanco won many prizes, medals, awards, and diplomas for her extraordinary figures. Two events highlight her career. Irma Blanco recalls how in 1975 she accompanied her mother and Antonio García Reyes to a world ceramics meeting held in Morelia in the state of Michoacán. Blanco was invited by the government to represent Mexico to exhibit and compete for the world prize awarded for the construction of a clay form. She became a world finalist, competing ultimately against a U.S. American. The latter's wheel-formed pot was very tall and grand, but, much to everyone's amazement, it fell down, and he was disqualified. Indeed, Blanco won the coveted world prize with one of her anthropomorphic market women. Martínez Virgil recalls, "Teodora never gave much importance to her collection of diplomas and awards. They were never displayed but casually stored, like ordinary papers." She also remembers Teodora being "unusually open-minded and a very strong woman who held the family together."[8] Everyone worked for Blanco in the family house, which was also their workshop. Luis Blanco recalls, "Teodora preferred to work from three until eleven A.M. When she began a figure, the images would just flow from her imagination. She had a talent, a gift from God."

Her son described the second major event, which occurred two years before Blanco's death at fifty-two, when Nelson Rockefeller came to Atzompa to meet her. Luis proudly showed me the photograph in which he stands between his mother and "Señor Rockefeller," who through the years had collected over 175 pieces of her work. The family was told the day before Rockefeller's visit to expect him. And sure enough, police on motorcycles and bodyguards arrived first, followed by helicopters. Then, "ten minutes later, Señor Rockefeller arrived in a chauffeured car." Blanco's son remembers his mother saying to Rockefeller, "How is it possible that a millionaire would come to visit a simple, humble woman like myself?" Rockefeller told her how much he appreciated her work, "It is my pleasure to meet a woman as famous as you, whose work I really value. I came especially to meet you." Rockefeller then invited Blanco to New York to see his collection and display of her work, but she declined, as she was then already too sick to travel. Unfortunately, an intermediary interceded so she never received all of the money Rockefeller paid her for the new pieces he bought during this visit. According to Luis, Blanco was taken advantage of many times.

Blanco suffered severely for two years, enduring several kidney operations, before she died. The last year was particularly difficult, with the family spending most of the year in the hospital at her bedside. Blanco was worried that someone had cast an evil spell on her since many people envied her success. She died penniless; she had enjoyed spending her money on her children's weddings and for the patron saint's day fiestas in Atzompa. Marian Harvey described Blanco as, "a warm hearted happy person and a serious energetic artist. . . . At times her interest in rich baroque decoration resulted in a banquet of form and detail. Teodora's sculptures were indeed a part of herself. . . . She reflects the Spanish as well as Indian heritage."[9] Mulryan discusses the significance of Blanco's work from another perspective: "Blanco's figures of nurturing women and tutelary deities were meant to be protective, guarding the spirits of the people of Atzompa and others who experienced her work. . . . She also expressed a sense of humor and her positive attitude toward life or her beliefs about the soul."[10]

The darker side of the mother or guardian spirit that can be linked to illness and impending death was revealed in one of Blanco's last clay figures, completed a year before her death. This market woman, over five feet in height, remains in her son's collection, along with an angel. Most unusual is the formation of the woman's head within the open jaws of a jaguar, whose teeth form a scalloped edge around her face. However, the woman's gaze is calm, as if acknowledging and accepting her fate. She wears thick clusters of earrings that hang like ripe fruit, and her dress is ornately embellished with flowering vines and paired doves. The hands are large, and each finger is solidly formed. One peasant-worker hand holds a rooster playing a violin, the other a hen playing a guitar.

Luis informed me of a major commission he and Teodora completed, an eight-foot-tall fertility goddess, for the 1975 inauguration of a government building in Oaxaca, the Casa de Cultura (House of Culture). This figure with multiple breasts was never fired, and, through the years, it was mishandled and parts broke off. However, I found it standing in an alcove along a broad stairway and once again noted the figure's thick, strong fingers, her hands reaching out to the world. In the House of Culture there also stands a bronze bust of Blanco (unlabeled), with kind and smiling features, her thick hair braided in a traditional style with ribbons encircling her head. I regretted there was no accompanying exhibit of her work or photographs to preserve her aesthetic achievements, as she is indeed a folk heroine, a significant role model for future generations. Her vision was extraordinary, and her creative

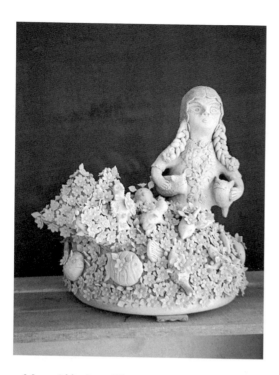

1. Mermaid by Irene Blanco.
Photograph by Betty LaDuke.

expression dignified women as strong, powerful individuals, a refreshing contrast to the commercial media exploitation of women as passive sex objects. Blanco also dignified working with clay.

For the past ten years, Blanco's descendants have continued to create sculptures of market women, Virgins, angels, and sirens (mermaids) that reflect individual expressions, including humor. Their self-pride is always evident as their connections with the world beyond Atzompa continue to expand through exhibits, competitions, and commissions (including a sculpture of Michael Jordan) that benefit the entire family. This global connection and communal consciousness as an important clay production center accelerated with the Artisan's Market (Casa de Artesanías), which opened in 1993 and is now a popular road stop for tourist buses en route to Monte Albán. Ramona Pérez also notes that "women are the primary foundation of the community's economy, political ties to the global economy, historical identity, and the re-

production of its future generations; they are just beginning to understand and exercise their power in the creation of the community's future."[11]

Casa de Artesanías

The Casa de Artesanías has proven a significant aid for the Atzompa pottery makers, living in one of Mexico's most economically depressed regions. In 1993, a union was also created for the casa's administration and the promotion and sale of the artists' work. Martín Mario Enríquez López (Mario) serves as elected president.

At seventy, Mario is also the husband of Tomasa Ruiz, known for her decorative fruit bowls and large planters. Married for thirty-six years, Mario and Tomasa have five children, three daughters and two married sons. Based on Atzompa tradition, the daughters and the married sons, and their wives and children, all live with Mario and Tomasa, and all participate in the ceramic production, including Mario. While Tomasa creates the elegantly shaped planters, Mario applies the surface decoration. Mario was the *presidente municipal,* or mayor, of Atzompa from 1978 to 1980, and he is not shy about telling you that he is the catalyst for many of Atzompa's recent improvements, such as the newly painted church, the enlarged marketplace, the second-story addition to the municipal building, a remodeled plaza for community events, a taxi collective, and the development of the Casa de Artesanías. There is a calculated sense of selective progress as he and the artisans and residents try to control and balance the transitions they consider beneficial, while maintaining some traditions that attract tourists to Atzompa. Television, commercial interests, and Atzompa's proximity to Oaxaca City promote the push toward modernization. This beneficial location has increased the educational and professional opportunities for many Atzompa children.

Mario described how, in the not-too-distant past, artisans always depended for the sale of their wares on intermediaries from Oaxaca who came with trucks and bought their production at one-third the selling price: "But they didn't pay us all at once. So I felt we were being oppressed and strangled, and I said, 'Let's do our own market.' 12 October 1988, we had our first meeting, and fourteen women showed up."[12] At this time, the national government was gradually undergoing a policy change, considered by Ramona Pérez to be "a position reversal from the past four hundred years of colonial transculturation . . . to increased identification with its indigenous ances-

try." This resulted in the development of museums in the outlying pueblos in the late 1980s and early 1990s, which also "drew tourists out of the city and into more remote pueblos."[13] The Casa de Artesanías was funded and constructed over a period of three years with federal, state, and artisan contributions. In addition to a display gallery, the casa has expanded to contain a restaurant (rented as a private business), public sanitation, and a courtyard for ceramic demonstrations. Mario proudly relates how the governor came in February 2001 for groundbreaking ceremonies.

The casa interior is lined with shelves to accommodate the diverse work of the ninety artisan families, each with an identifying name visible above their wares. Seated outside in the shade of a veranda are six artisans who greet individuals or busloads of tourists, answering questions, accepting payment, and wrapping purchases. While the artisans take turns, approximately one day per month, a salaried accountant and assistant are always present to keep careful records. Each artisan now receives 95 percent of the selling price for his or her work.

The artisans interviewed appeared very excited about the craft market. For most families the financial rewards of increased sales, receiving higher prices for their work—95 percent instead of 33 percent—and regular payment has resulted in better nutrition, clothing, and health care, and it has created the opportunity for some sons and daughters to receive advanced professional education in Oaxaca. Ramona Pérez points out that

> for thousands of years, craft production has been primarily women's work. Oaxaca has focused on the female body in its tourist literature, creating an image of the unchanged indigenous woman toiling contentedly over the maintenance of her family and home. This imagery induces tourists to buy items that produce a romantic vision of life that is diametrically opposite to their own, while at the same time it justifies the unequal conditions under which they are produced.[14]

Yet the significance of women's craft production for generating income has also led to women's growing autonomy and political power. On the local level, this has meant a woman's occasional inclusion in the planning and enactment of religious fiestas, an important community power and status symbol.

Interviews with Teodora Blanco's Descendants

Not expecting to be remembered eleven years after I first met and interviewed Teodora Blanco's descendants in 1990, I brought with me the result of these early interviews, published in my book *Women Artists, Multi-Cultural Visions*.[15] I also presented each woman with a Xeroxed copy of the chapter containing many photographic illustrations of them and Teodora Blanco's "earth magic legacy." Wanting them to know that I was not an anthropologist but an artist, I also gave each one a note card with reproductions of my paintings and my home address. Remembering Ramona Pérez's comment about "how the many female tourists who pass through the community, unaccompanied by a male, signify to local women a lonely end result to feminist actions of empowerment,"[16] I wanted to clarify my family status with a readily available photograph of my daughter and youngest grandchild. Then, when appropriate, I showed this photo and explained that I was a mother of two and grandmother of five but, as a university professor, I traveled alone for my research. They seemed to appreciate this explanation, along with my artwork.

BERTA BLANCO NÚÑEZ

Berta Blanco Núñez (Teodora's sister) is a stocky, cheerful woman whose face frequently lights up with a broad smile. At age forty-six in 1990, she had received recognition in her own right, though her early career was overshadowed by Teodora's. In the family workshop, her productions were signed with Teodora's name, her fame commanding a higher price. This is a commonly agreed-on practice, but resentment did arise when one of Berta's clay sculptures won first prize in a competition, but it was given to Teodora. For the past twenty years Berta has been working on her own but feels she doesn't "produce too much because I take a long time with all the details." She is also proud that apprentices from the United States and Europe have come to live and work with her, and that photos of her work appear in the book of the Dutch anthropologist, Wer Denton Besult, *Cerámica mexicana*.[17] Berta's sense of humor is one of her special characteristics, evident in the following three pieces (all candleholders, twenty-four to sixteen inches in height): (a) the *Bride,* in which a veiled young woman clutches to her breast two small figures, a priest and the groom, (b) the *Woman Holding a Man Who Plays the Violin,* which portrays a woman in charge of her destiny—her head is just slightly tilted as she embraces a man who is playing a violin, (c) the *Bull with*

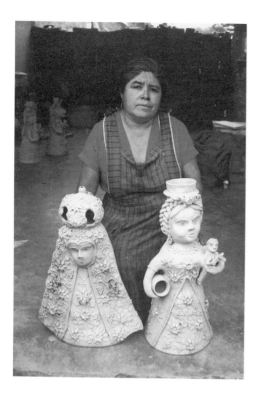

2. Berta Blanco Núñez.
Photograph by Betty LaDuke.

San Lucas features the head of a bull perched on a woman's body, carrying a small figure of Saint Lucas under one arm and a small cow, playing the violin, under the other.

Eleven years after I had laid eyes on her for the first time, it was as if nothing had changed in the physical aspects of her household. In her dark patio workshop, a series of sensual, barebreasted mermaids stood on the earthen floor, drying, waiting to be fired. Hovering over the mermaids was a tall, elaborately robed angel, with her crowned head bowed as she gazed on a flower in her hands. "All done for commissions," Berta informed me when I inquired about earlier themes like the *Bull with San Lucas*. She complained that others had copied her ideas and, besides, "There were no commissions for them at this time."

Berta talked of "many sacrifices," and how life was "very expensive"; the youngest of her four children, a daughter, was studying to be an orthodontist

in Oaxaca, requiring school fees, books and supplies, and daily commuting costs. There was also the lack of dependable labor. However, on vacations the daughter helped produce the smaller clay pieces." Berta seemed to do all the planning for materials, creating her pieces, and firing alone, as her husband continued to farm their land with mixed results. Between her many chores, she was also concerned that their thirty-eight goats be taken to pasture. As soon as that was resolved, she sat on a mat on her earthen studio floor, and as we talked, she began another commissioned mermaid.

IRMA GARCÍA BLANCO

Irma García Blanco maintains her mother's legacy through her own clay images which are lively and full of detail. In 1990 she showed me a series of black clay figures, approximately twenty-four inches in height, representing the seven regions of the state of Oaxaca. Each figure is portrayed with typical regional garments and hairstyles. Lavishly ornate, Irma's female figures sometimes contain an overabundance of decorative details on their proportionally short torsos. Irma claims she is never bored with thematic repetition, because each time she does the work a little differently. Some examples include the *Virgin of Asunción,* which seems overwhelmed by a large crown; *Market Woman,* depicted with three little pigs, one on her head and one under each arm; *Velorio,* which depicts a deceased person in a coffin surrounded by a grieving family; nativity scenes; and the *Sirena* [Mermaid], a rare expression of sensuality. As Mexico undergoes rapid modernization, strongly influenced by the United States, Irma's representations of traditional and mythical women continue to reflect pride in her cultural heritage and serve as a refreshing affirmation of her self-identity.

Like most village potters, Irma has only a second-grade education, but I learned that the two oldest of her seven children are now studying medicine and architecture in Oaxaca. In the intervening years between my visits, Irma's professional status received a significant boost as the only Atzompa artisan included in the 1996 book publication *Grandes maestros del arte popular mexicano.*[18] Her family, including her husband, is very proud of her. For twenty-seven years, Irma's husband worked in Mexico City as a factory sales person and commuted home on the weekends. Forced into retirement when the factory closed recently, he seems pleased to be home and actively supports his wife's career, which has become the family's main source of income.

New shelves line two patio walls to display her finished pieces. A small, almost completed addition to the house will serve as an indoor gallery. Prepar-

ing ahead for this year's celebration of the Day of the Dead, she has already completed a series of tall figures with large, brimmed hats and hollow-eyed, skeletal faces that glare at visitors from one top shelf. In contrast, on another shelf stands a row of sensual, smiling mermaids whose ample fishtails are profusely embellished with small-petaled flowers hiding many tiny fish. Several four-foot-tall market women with their *nahaules* were also included in this patio exhibit. These earth mothers painted in earth tone clay colors contrast sharply with the bright, acrylic-painted, and flower-embellished planters. Irma mentioned that the paint was applied by one of her older daughters. I felt that some of Irma's children would enjoy other professional opportunities, but others might choose to continue her legacy.

ANGELINA GONZÁLEZ CRUZ

Now seventy-five, Angelina González Cruz has been creating clay images for fifty-two years, beginning after her marriage to Antonio García Reyes in 1948. In addition to farming, where sometimes, Antonio says, "everyone's hands are needed," he, like most Atzompa men, in the early years was very involved in pottery. He mined the clay, procured the wood, loaded and fired the kiln, and then packed the figures for shipping. He made all of the business contacts. The market for the family pottery continued to expand, and for many years this family received large annual commissions from shops in New York City. Now, eleven years later, it seems that time has worn heavily on them, and Antonio is less able to do the physical work, but Angelina persists. Angelina recalls that when their ten children were small, she frequently created clay sculptures while carrying them on her back. Working on the open veranda of the family home, her daughter Lourdes continues to assist by forming the clay strips or coils with which Angelina constructs her four-to-five-foot monumental figures.

In 1990, I particularly admired Angelina's group of four market women and the sense of proportion and balance achieved between the upper and lower parts of the body. The market women's heads are large, and their eyes gaze ahead. Their lips are usually tightly closed, but breasts protrude, emphasizing nurturance. Myth and fantasy envelop each sturdy market woman; emerging from each one's ample body is a great variety of *nahuales:* armadillos, cats, owls, sheep, lizards, and porcupines. Facial expressions vary; some remain tight-lipped, while others smile. A fantasy parade of *nahuales* moves down the center of the women's bodies, and the long trunk of an elephant reaches upward to snatch a large flower from below a porcupine's nose. Each

market woman is well designed; the hollow spaces between arms and body, thick braids and neck, are balanced with the ample, skirted torso below. Each projects an aura of vitality and spiritual harmony with nature. Angelina insists they have no special significance outside of her experiences.

At this time, Angelina, who prefers that Lourdes speak for her, seems somewhat more tired and withdrawn. Most of her current work is smaller in scale, with the mermaid theme most prominent. As she says, "They sell better." Her workspace, the same shed of years past, is also a temporary home for a hen and chicks. The old shed seems hardly noticeable in contrast to the additions of several small huts crowded around the courtyard and rooms added onto the main adobe structure for her married sons, their wives, and many children. Angelina's fingers still appear to love sculpting the clay, but her work seems repetitious and has lost some of the elegant proportions of times past. In her two just completed tall market women, one supports a cat on her head and the other an owl, which appear too heavy, like the weight of time and continuous work without reflection and renewal. While I admired her tenaciousness, I wondered how well her daughters would develop their own skills, maintain production, and initiate new works in the future.

ANGÉLICA VASQUEZ

Angélica recalls the early years of her marriage when she lived at the home of her husband's parents, Angelina González Cruz and Antonio García Reyes. All her work was claimed as theirs, including prizes that her pieces garnered when entered at competitions. Occasionally they paid her small sums for her work. Angered by this situation and by her husband, who drank heavily and left to work in the United States, she decided not to remain submissive, and left their household with her children. Pérez notes: "Abuse—physical, mental, and psychological—against daughters-in-law has been a form of oppression for generations. Within the last few years, as women have gained economic and social power, they have begun to demand autonomy from the patriarchal compound. This includes not only homes of their own, but also separate sources of income and distribution."[19] Angélica returned to her parental home for several years, where she assisted her parents with their pottery production as well as continuing with her own work. She credits her parents for her skills and creativity, as well as Teodora Blanco. As a very young girl, she worked for Teodora when the latter had large commissions to fulfill.

Angélica's intricately detailed ceramic sculptures are small in scale but monumental in conception. A petite and very articulate woman, Angélica is

divorced, and the sole support of the four children fathered by the son of Angelina and Antonio. The complex themes and forms of her sculptures are conceived in her mind before she begins to create. She says, "I love to work. It gives me pleasure, and I can forget all else. I am always thinking and dreaming about what I should do next." She frequently awakens at two or three in the morning to create her images. She told me, "I base myself strongly in my religion," which becomes evident in her detailed symbolic portrayal in *The Wedding,* eighteen inches in height. A winged angel's form encompasses approximately twenty-five ceremonial participants including the bride and groom, in-laws on either side carry presents of coins and a flower wreath to unite the couple, and the bride's parents and godparents hold a *metate* for grinding corn and a chest for storing clothes. Beneath them stands a woman supporting a large bread-filled basket on her head, while others carry turkeys and jugs of strong liquor and *atole,* a drink made from corn. Below, in a semicircular shape supporting the wedding group, stand a large band of musicians playing instruments. In *Natividad,* once again an angel's form encompasses the traditional nativity scene, while in the angel's upraised palms rest a small ram and a rooster. There is a maze of figures, but all are harmoniously contained within the well-proportioned contours of the angel's body. *The Church,* Angélica's least complex clay sculpture, also has many finely rendered details, a trademark for which she is gaining recognition in prizes and awards in regional and national competitions.

At forty-three during my second visit, Angélica's circumstances have changed dramatically. While living in her parents' home, she commuted to work part-time at Manos Mágicas, a store that features the best craft work from all over Oaxaca. I am sure this experience proved good exposure. She then moved out of her parents' home almost ten years ago to live with an American, John Kemner, an enthusiastic supporter of her professional career as well as of her two teenage sons, who live with them in a home they built on a hilltop overlooking Atzompa. In contrast to the other Atzompa artisans, who still wear their traditional dresses, aprons, rebozos, and keep their hair combed in braids, Angelica has cut her hair short, wears pants, and rides a bicycle. She takes pride in creating all her pieces alone without the help of her children. She is not a member of the Casa de Artesanías, as "I raised my kids alone, and I never had time to join groups." Nevertheless, she has a growing number of patrons and clients who continue to collect her work.

Nothing she does seems mass-produced, not even her many small angels painted with contrasting red slip and grouped together on one wall of her house. They all have individual expressions. Particularly noticeable about all

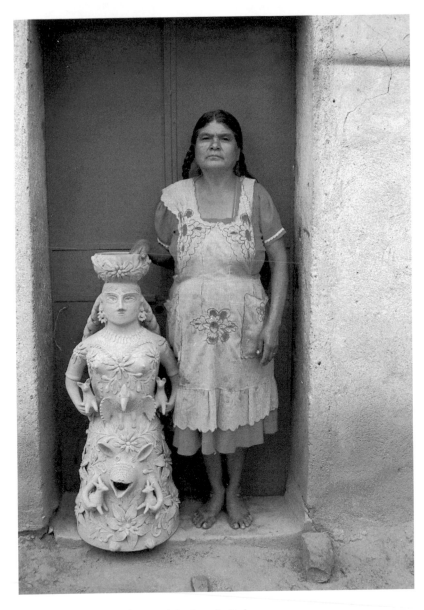

3. Angélica Vázquez. *Photograph by Betty LaDuke.*

her work is a fluid sense of body movement, from outstretched arms to varied head positions. Each year she produces only eight to ten major pieces on themes both old and new which are complex in form and challenging for her as she pushes to achieve new meaning and expression. For example, instead of a woman, a male carrier of produce wearing a protective hood over his head and neck dominates *Spirit of the Market,* a pyramidal form approximately twenty-four inches in height. His body contains dozens of vendors, or other little figures, each one bargaining for or selling a great variety of produce—a frenzy of activity that duplicates Oaxaca's famed Saturday Abastos Market, one of the largest in Mexico.

Angélica was one of six artisans featured in the book *Oaxacan Ceramics: Traditional Folk Art by Oaxacan Woman.*[20] In discussing Angélica's frequent use of the mermaid theme, Lois Wasserspring parallels the mermaid with Angélica's life: "An Oaxacan legend, the mermaid is created when a young girl is transformed into one for disobeying her mother. But rather than viewing the mermaid as a symbol of disobedience, Angélica sees her as a celebration of freedom: a symbol of female daring in a society that values obedience in women."[21] As one of the youngest artisans, Wasserspring points out that "Angélica Vásquez has won a host of recent honors, four prestigious first place awards in state and national artisan competitions in the past year, including an impressive award from a national cultural foundation for innovation in ceramics."[22] To some people in Atzompa, Angélica will be considered a symbol of the disobedient mermaid, but I see her as a mermaid celebrating freedom, and I look forward to seeing more of her work in the future.

LUIS BLANCO AND MARÍA ROJAS DE GARCÍA

Most of Luis García Blanco's early life was intertwined with Teodora Blanco's career. As a young child he learned to work with clay under his mother's tutelage. Later, toward the end of her life, he assisted her with major commissions, until her death in 1980. Luis was then twenty years old and although he had the opportunity to study accounting and English in secondary school, he chose to work in clay.

When Luis and María Rojas de García were married in 1978, they lived with Teodora, during the last two years of her life, in order that María could learn to work with clay from her mother-in-law. The couple now has five children and has encouraged their three oldest to make clay figures and toys. Luis told me, "Now many people don't want their children to work with clay.

It's hard, demanding work. But I do. It's a wonderful talent to develop." After Teodora's death, Luis experienced many difficulties in reestablishing commercial connections with galleries and stores, and he feels that his work is now better known in the United States than in Mexico. In 1984 he was invited by the Museum of Folk Art in Santa Fe (where Teodora's work forms part of the permanent collection) to exhibit and offer workshops demonstrating his clay techniques. In 1990 he completed a commission of a clay cross for the museum's permanent collection, approximately two feet in height "with very fine detail," which was "well received."

Meanwhile, María continued to develop her talent, but all her work was signed "Luis Blanco" in order to bring a better price. In her series of strong market women, she incorporated turtles and lizards, but more unusual is *The Narrator*, an example of cross-cultural exchange. *The Narrator* consisted of a mother who sits, with her legs spread wide, with many little children clambering over her and each other to listen to the story she is telling. Luis explained, "Sometimes when I play my guitar and tell my children stories, they are very happy and dance." Therefore, *The Narrator* was a natural theme for María to explore, one whose image she will in time, I'm sure, personalize. A possible influence is the work of Helen Cordero of Santa Fe, New Mexico. Luis admitted to having seen the work of this famous Native American ceramic sculptor who has created very similar "grandfather-storytellers" for several decades. Luis plans to expand his house (formerly Teodora's) to include a gallery dedicated to her, but it may be many years before he can realize this dream. Meanwhile, he and María enjoy the challenge of developing new themes for select competitions and commissions, expanding both the Blanco family name and the legacy of earth magic in Mexico and abroad. "No more narrators," I was told during my return visit, as María was exploring new themes, especially the iguana motif innovatively featured on the top of the heads or under the arms of some of her market women, or playfully seeming to crawl along the surface of her large planters. María now signs her own ceramic pieces with her name, and for the past five years, since their children are older, she accompanies Luis for his annual invitational sales and demonstrations at Jackalope Art Center in Santa Fe, New Mexico. They are very proud that one of their daughters is studying graphic arts in Oaxaca and equally pleased that some of their children seem interested in continuing the Blanco legacy.

After forty years, the mythical, magical legacy of Teodora Blanco's clay forms continues, having evolved from ashtrays and palm-held figures to four-foot-tall, spirit-inhabited market women. Blanco exemplifies how one individual can inspire and significantly contribute to the creative vision of other artisans and the economic development of a community. Since the Atzompa artisans have organized a cooperative market and benefit from increased sales to a steadily growing number of tourist visitors, will they keep repeating popular forms or risk developing new icons reflecting social change? The economics of pottery making is precarious. Wasserspring sadly states:

> Why is it, for example, that pottery garners the lowest price of all the major crafts in Mexico? . . . In general, pottery is made by women, raising some interesting questions about being female in Mexico. . . . In fact, it is not just in the craft world of clay that women's artisan efforts take a back seat. In all branches of artisan work, women's contributions are often hidden or devalued. . . . Throughout the artisan world, when females paint or polish or construct, their efforts are simply considered a normal part of family responsibilities. Along with this exception of women's natural assistance comes an assumption that their creative endeavors do not require acknowledgement or pay.[23]

Pérez refers to Charlotte Stolmaker's 1973 research and the concept of economic progress from two different perspectives: "Mobility in Atzompa is of two types: purely economic advancement, and status advancement. Status advancement is usually achieved through higher education. Occupation confers prestige, primarily insofar as it enables a person to give up pottery. This traditional activity is held in low esteem, not only because it's dirty and costs much physical effort, but also because it is repetitive and boring."[24]

I wondered if Pérez and Stolmaker had considered the limits of factory work and regimentation, which didn't allow for creative innovation or personal use of time. Pérez points out, in classic catch-22–style, that "ceramic production became the primary source for the acquisition of ties beyond the pueblo. In addition, the continuing decline of Mexico's economy, resulting in a focus on tourism, has moved artisan production into a new source of economic and political power at the state level."[25]

Within the family, the effect of female professional recognition and increased economic power has allowed the younger generation, including women, more opportunities for technical and university education, leading to new career choices. However, many still prefer to continue with clay pro-

duction. Wasserspring also points out that "quite in contrast to the more typical expectations of female invisibility, these women are increasingly visible and prominent. Their careers are on a roll. . . . Their art can be found in museums, galleries, and private collections in Mexico and around the world."[26]

At this time, most artisans maintain the traditional indigenous physical appearance expected by tourists, wearing a *mandil* (apron) over their dresses, combing their hair in long *trenzas* (braids), and using a rebozo. However, most of their children have opted for modern styles, encouraged by the media, especially television, and interaction with other students in the urban Oaxaca environment. During the past few years, even Atzompa has not remained immune to graffiti on walls and some youth gang activities, as the population expands with new neighborhoods of urban residents that do not have a secure financial base.

While I did see one new commissioned sculpture—an eighteen-inch Michael Jordan in red shorts and shirt, standing beside his basketball hoop—angels, Virgins, market women, and mermaids continue to dominate. Perhaps these forms are also an outlet for female romantic fantasy, exploring and expressing varied emotions, from the Virgins' piousness to the angels' celestial reach, or the mermaid's eroticism as she captures and captivates fish and men. And, of course, the market women are always spunky, with their surprising variety of *nahaules*, as they proudly confront the world.

Notes

1 All interviews with Teodora Blanco's family took place in Santa María Atzompa during July 1990 and May 2001 in their home workshops.
2 Mulryan (1982, 99).
3 Vásquez (1990).
4 Ibid.
5 Martínez Virgil (1990).
6 Pérez (1997, 58).
7 Martínez Virgil (1990).
8 Martínez Virgil (1990).
9 Harvey (1987, 85).
10 Mulryan (1982, 99).
11 Pérez (1997, 229).
12 López (2001).
13 Pérez (1997, 68).
14 Pérez (1997, 117).

15 LaDuke (1990).
16 Pérez (1997, 27).
17 Besult (1986, 52, 53).
18 Calderón, Sarmiento, and Alvarez (1996, 82–85).
19 Pérez (1997, 25).
20 Wasserspring (2000).
21 Wasserspring (2000, 72).
22 Wasserspring (2000, 19).
23 Wasserspring (2000, 17).
24 Stolmaker (1996, 80).
25 Pérez (1997, 83).
26 Wasserspring (2000, 19).

Reference List

Besult, Wer Denton. *Cerámica mexicana*. Amsterdam: El Puente, 1986.
Blanco, Luis. Interview by author, Atzompa, Mexico, July 1990.
Calderón, Cándida Fernández de, Alberto Sarmiento, and Victoria Fuente de Alva-
 rez. *Grandes maestros del arte popular mexicano*. Mexico City: Grupo Financiero
 Banamex-Accival D. R. Fomento Cultural Banamex, A.C., 1996.
Harvey, Marian. *Mexican Crafts and Crafts People*. Cranbury, N.J.: Associated
 University Presses, 1987.
LaDuke, Betty. *Women Artists, Multicultural Visions*. Trenton, N.J.: Africa World
 Press, 1990.
López, Martín Mario. Interview by author, Atzompa, Mexico, 2001.
Martínez Virgil, Dora. Interview by author, Oaxaca, Mexico, July 1990.
Mulryan, Leonore Hoag. *Mexican Figural Ceramists and Their Work, 1950 to 1981*.
 Los Angeles: Museum of Cultural History Gallery, University of California at
 Los Angeles, 1982.
Pérez, Ramona. "Molding Our Lives from Clay: Re-defining Gender and Com-
 munity Identity in the Artisan Pueblo of Santa María Atzompa, Oaxaca." Ph.D.
 diss., University of California at Riverside, 1997.
Stolmaker, Charlotte. *Cultural, Social, and Economic Change in Santa María
 Atzompa*. Nashville, Tenn.: Vanderbilt University, 1996.
Vásquez, Angélica. Interview by author, Atzompa, Mexico, July 1990.
Wasserspring, Lois. *Oaxacan Ceramics: Traditional Folk Art by Oaxacan Women*.
 San Francisco: Chronicle, 2000.

Tastes, Colors, and

Techniques in Embroidered

Mayan Female Costumes

The pre-Colombian world of Mesoamerica gave birth to a great universalizing tradition, as successful as that of the European Old World. And one of its most eloquent offshoots was subsequently developed by the Mayans, whose descendants still survive today in Mexico,[1] Guatemala, Belize, and the west of Honduras. It would be hard to suggest that we could presently identify a Mayan society unique in linguistic or cultural terms. What we find instead is a mosaic of rural enclaves, each of which maintains branches of the original vision posed by its members' forebears. However, a peek at antiquity will allow us to perceive the unity of the Mayan world; and we will often be surprised to discover that despite the diversity of contexts in which they appear, the ancient Mayan notions regarding the order of the world of human beings, of gods and ancestors in the Other World, as well as the origins of corn as the substance of Mayan body and soul exhibit a coherence and integrity (Freidel, Schele, and Parker 1999).

In Yucatán, we find that such ideas regarding the cosmos configure the spiritual life of the Mayan people and are directly expressed both in ritual and in day-to-day practices. Important activities, such as the manufacture of the *hipil*—the female costume—have deep mythical foundations which explain the sacred origins of this occupation. Thus we find an oral memory

that describes a foundational myth associated with the embroideries of the goddess Xchel,[2] the goddess of weaving. The technique of *xoc-bil-chuy*,[3] or "cross-stitching," is attributed to this Mayan deity, as is the rainbow color scheme that characterizes the Mayan *hipil*. Xchel, it is believed, discovered these colors accidentally, watching a drop of water pierced by a ray of sunlight.

Embroidery is a fundamental activity among Mayan women, which brings us to the very heart of gender and cultural definitions. It is an activity so crucial that some have argued that it sustains the definition of Mayan womanhood, in the same manner that the *milpa* (cornfield) defines the Mayan man (Nadal 2001). But embroidery is also a source of income, part of a Mayan family's spectrum of economic activities. Embroidery can provide either a central source of income or a supplementary occupation. Women engaged in embroidery can thus work full time or on a variable schedule adaptable to their needs. This inherent flexibility in the production of commercial embroidery has created a range of productive forms used by Mayan women to insert themselves into the market. The two most important are home labor and social enterprises.

A woman's occupation as an embroiderer is submerged in a series of social assumptions or prejudices that set a limiting framework for her development, both professionally and as a woman. It is said, for example, that a woman works "to help her husband" in order to benefit the family as a whole, an evaluation that firmly portrays women engaged in embroidery as "non-workers" (Mies 1998, 48).[4] This is particularly so among women working individually and at home, who are placed within a socially determined classification that depicts them as housewives "whiling away the idle hours" and where embroidery is viewed not as an occupation but rather as a form of entertainment.

This situation affects hundreds of anonymous Mayan embroidery workers disseminated throughout the Yucatán Peninsula, who supply and nourish small *maquiladora* networks despite the fact that they work at home. In Valladolid during the 1960s, for example, an incipient embroidery industry, run by a small number of female local traders, was able to reap juicy profits while extending its sales market well beyond the Mexican border. A single such trader, who had acquired complete control over the string-and-thread market in this town, also employed almost four hundred women from the surrounding areas.

Although the expansion of tourism has pushed many Mayan women into the commercial production of embroidery, it is extremely difficult to find

any record of their existence. Almost every community houses at least some women who produce embroidery for extra income, hidden by the anonymity of the *maquila* system or independent sales.[5] An intermittent pace of production, made necessary by the laborers' conditions, further obscures their existence as working embroiderers.

However, we can discern women who are grouped in cooperatives or who sign onto state-run programs for economic support.[6] In the west of Yucatán alone, for example, there existed thirty-two registered embroidery cooperatives in 1994, with an average of twenty-five to thirty members per group. Under the auspices of a range of NGOs, such embroidery associations have now sprung up in various parts of Yucatán, although they remain concentrated in the west.

Having emphasized the importance of embroidery for Mayan women, I shall now explore the particular history of the Mayan *hipil,* tracing the transformations that have led to the designs we find today.

Some Aspects of the History of the *Hipil*

Firstly, it should be noted that although the traditional attire of indigenous women is known as *wipil* in many parts of Mexico, in Yucatán the term is *hipil.* The word *wipil* comes from the Nahuatl *uipilli,* which means garment or dress. The term *hipil* derives from the same word, which in Mayan loses its *w* to prevent cacophony in combination with the second person singular, that is to say, *u-ipil,* which means "your *hipil,*" where the *h* is soundless.[7] However, there is yet another term, used in pre-Hispanic Mayan society to denote the female garment: *k'ub* for the coat over the back, and *pik* for the dress or skirt. The use of the *hipil* or *k'ub* was restricted to certain social classes in Mayan times, and many of the poorer women did not bother to hide their breasts, as we can see in the ancient Dresden Codex. Great ladies, on the other hand, wore a black *hipil* and skirt, both finely decorated with feathers and colored thread. The conquering Spaniards generalized the *hipil's* use throughout Mayan female society as a means to end prior social structures, thus homogenizing hierarchical differences in order to dominate with greater efficiency. The Spaniards referred to the *hipil* as *guayapil,* which also means "dress." During the early nineteenth century, the differences between the garments worn by the Indian and the mestizo populations became increasingly marked. Attire accentuated the distinction be-

1. Mestiza *terno. Photograph by Martha Medina Un.*

tween the dominators and the dominated (Millet Cámara and Quintal 1994). The *hipil* worn by today's Mayan women consists of a square, sleeveless coat of white cloth, embroidered around the sleeves and lower hem. This attire is complemented by the dress or skirts, the rebozo, the *sorongo* (rolled into a bun) hairstyle, gold jewelry, and shoes. The *terno,* a variant on the *hipil,* is as described above, although this more elegant version boasts an edging of brightly colored flounces and embroidered details, usually executed in silk, around the neck and around the body and lower hem of the skirts. All of the pieces that integrate this attire require a production process based on traditional techniques resulting from historical evolution and guided by cultural cross-pollination and changes imposed by modern society. Such processes have gradually led to the garment that we now see in present-day Yucatán.

Attire in Pre-Hispanic Times

Although the Mayans—both male and female—wore only a few items of clothing, these were often finely decorated with feathers or cotton thread dyed with roots, bark, or plant resins. Fray Diego de Landa, a Spanish chronicler, noted that attire was simple and that the Indians were more concerned with body decoration. Such decoration consisted of patterns and tattoos painted onto the face and body, executed in black, red, or blue, according to context. Noses, lips, and ears were often pierced, and hair was worn long. Religious rites or other celebrations called for the wearing of tiny metal or clay bells.

Women's attire varied according to region and social extraction. Women from the coast, particularly from the provinces of Bacalar and Campeche, covered their entire bodies using two items: a square cloth folded and tied beneath the armpits to cover the breasts, and a long skirt, usually tied just below the waist. In different regions, most women simply wore a long, wide skirt, cut down the sides and tied below the waist.

Colors used to decorate the body, which matched the chosen attire, each had a specific significance. Historical sources suggest that black was related to marriage and chastity; blue, on the other hand, was associated with mourning rituals. Dead relatives were clothed in blue shrouds by their families, who would also wear blue during the funeral rites. Children destined for sacrifice were also painted blue. Red, however, was a sign of beauty (Spencer 1980). Diego de Landa observed that the Indians would paint their bodies and faces in scarlet for grand occasions or celebrations.

It seems very likely that the significance of specific colors to some extent still remains alive among present-day Mayans, for certain values such as elegance, for example, are still associated with the color red. The preference for red or scarlet *hipiles* among today's Mayan women can be clearly appreciated in almost any Indian community in Yucatán.

Attire during the Colonial Era and the Nineteenth Century

Not three decades after the conquest and the foundation of the city of Valladolid, the Spaniards had already imposed the *hipil* or the *guayapil* for women and the shirt, *zaragüelles* (trousers), hat, and cloth cape for men. In the colonial period (between the sixteenth and the early nineteenth centuries), the

attire worn by the Indian and the mixed-blood populations became increasingly differentiated. The Indian *hipiles* had very simple or no embroidery, and the *justán* (skirt) grew longer, dropping almost to the ground. Women also wore a *toca* (toque) of white linen, occasionally embroidered, which was used to cover the head, cheeks, breasts, and arms. Bead necklaces and rosaries of red coral, interspersed with amulets carved from bone or boar tusks, complemented this attire (Pacheco Cruz 1960, 8–9).

The mestizas in the more urban areas quickly mastered the European embroidery techniques imported by the Spaniards, and embroidery and cotton weaving rapidly became their most important economic activities. Many of the techniques used to embroider present-day *hipiles* have European origins; learned by mestiza servants employed in grand Spanish homes, they gradually spread throughout the population. Spencer's written account of his travels through Yucatán in 1834 notes the fusion of European and Indian styles of embroidery, a fusion that gave rise to our existing technological heritage in the production of *hipiles* (1980, 10, 38). The women, he observed, were extraordinarily hardworking and clean, clad in gleaming white garments.

This author also describes the characteristic male attire of the time, which consisted of a well-pleated vertical shirt floating over a wide pair of shorts. The middle classes wore white or colored jackets, while the well-to-do followed the fashions prevailing in the United States, importing their suits from New York. Spencer also noted that Mayans in close proximity to Spanish towns, or "advanced towns," as a means of avoiding social marginalization tended to adopt the attire imposed on the mestizo population, abandoning the classic *uiit* (pre-Hispanic loincloth), which was the sole garment worn except in cold weather. Once the *uiit* was abandoned, a pair of broad shorts, vented down the sides and falling just below the knees, took its place. This new garment—known as *cul-eex*—was in turn covered by a decorative apron (Pacheco Cruz 1960, 8–9).

The Baron of Waldeck, who visited Yucatán during the first half of the nineteenth century, observed that the attire worn by city and country mestizo women was remarkably similar and that the only difference lay in the materials. In rural areas, *hipiles* were made of rough, homespun cotton, while city women used fine percale, or even batiste. Women in Mérida wore no head comb, and they could, on occasion, be seen wearing leather or even gold or silver lamé shoes, though for the most part they went barefoot (Waldeck 1930, 146).

It was not unusual to find *hipiles* made of homespun cotton linen well into the first part of the twentieth century. This tradition, however, gradually suc-

cumbed before the massive importation of textiles, the decay of the weaving industry in Yucatán, and the ensuing drop in cotton cultivation.

The *Hipil* and the *Terno*

It has already been noted that from the earliest days of the colonial era, the different levels of white and Indian society in Yucatán sought to emphasize their social and ethnic stratification. The adoption of specific garments and general attire played an important role in the establishment of such distinctions. There was, furthermore, a discrepancy between the *hipil* as worn by rural Indian women and by their urban mestizo counterparts. City dwellers enjoyed both better materials, as Waldeck observed, and a greater number of embroideries and lace decorating both the *hipil* and the skirts, as Hernández Fajardo noted in the *Enciclopedia Yucatanense*. Such differences eventually produced two distinct variants of the female garment—the Indian item, known as *hipil,* and the mestizo piece, which was termed *terno.*

Certain researchers (Millet Cámara and Quintal 1994) have noted that it was not until the second half of the nineteenth century that the *hipil* or *terno* worn by the white or Indian women of Mérida became an identity symbol for the state of Yucatán. This historical fact reflects a search among members of the dominant society in this state for a national symbol expressing social unity between whites and the mestizo population, a social pact which ignored the Mayas, main protagonists of the so-called Caste War,[8] who were consequently vilified and erased, both from the official history and the identity of Yucatán. A variety of social mechanisms, and in particular carnivals, allowed the white women of Mérida to display their *ternos* in a public forum; and in fact, this garment was also frequently worn at home (Millet Cámara and Quintal 1994).

Mestizas and *Catrinas* in the Present Day

The Caste War and the reclusion of rebel Mayans in the territory of Quintana Roo signaled a fundamental stage for the definition of contemporary society in Yucatán. The mestizo population and the more peaceful Indians were pressured into either taking sides or migration. The so-called *vecinos* (neighbors) were mestizo citizens with Spanish surnames who, living in cities, gradually adopted the Spanish tongue as well as the urban form of attire. The

pacific Indians viewed themselves as mestizos and as distinct from the rebel Mayans, who called themselves the *macewal-oob,* or *macewales* (workers). The discriminatory ideology of the elite in Yucatán defined these *macewales* as the true or legitimate (*wi'it'oob* or *wi'it'es*) Indians, a term which retains a pejorative character (Hervik 1999). Unlike in the rest of Mexico, in Yucatán the mestizos are the Indians, for in the early twentieth century the mestizos had become a significant mixture of Indian elements integrated into a white world. Consequently, the principal categories into which the population of Yucatán divides itself, particularly in rural areas, are those of mestizo and *catrín.* These categories do not denote two distinct ethnosocial groups, but rather different forms of attire. *Catrín,* a term which forms part of the broader category of mestizos, specifically refers to women who have abandoned the *hipil* in favor of European-style clothing; and in fact both mestizos and *catrines* constitute two modalities of a single ethnic group (Hervik 1999). Outsiders are known as *j-waach,* gringo, or *t'suul.*[9]

Traditional attire underwent a gradual transformation during the twentieth century, and the *hipil* began to disappear from public spaces in the city of Mérida, being relegated to the domestic milieu as a garment "for relaxation." The *terno* began to appear only in traditional rituals of popular religiosity, or during carnival, at a celebration known as "regional night." Today the *catrinas* of Yucatán will also wear their *ternos* during certain political rituals and events, as a symbol of regional identity.

Thus we now acknowledge the traditional attire of rural or mestizo Mayan women in its two variants: the *hipil* for day-to-day usage, and the *terno* for ceremonial wear or special occasions. Both serve as emblems of Mayan identity, and consequently any woman who wears a *hipil* or *terno* is known as a mestiza, while those who wear Western-style attire are termed *catrinas* or *desvestido* (wearing a dress). In cultural terms, the mestiza attire is not only a garment; it forms part of a larger Mayan worldview, in contrast with the city values that presuppose an appreciation of the *catrina* or *desvestido* styles.

Embroidery Techniques

Mayan craftswomen are skilled in a wide range of production techniques, using methods often subtly but importantly distinct. Different forms of blending, for example, can be used to create the color combination in a particular *hipil,* increasing or decreasing its value and complexity of production. Although such differences are meaningless for tourist buyers, they have sig-

nificance for local shoppers. The lack of knowledge in the tourist market—which views all *hipiles* as basically identical and is concerned only with the quality of materials rather than technical execution—tends to push down the average price for these garments. Nonetheless, the embroidery techniques in a *hipil* from Yucatán constitute the very essence of the garment, for they condense a hybrid knowledge born of the ancient Mayan culture and the attitudes of colonial Europe. As I have already noted, many of the embroidery techniques we find today have European origins, having first been acquired by mestiza servants in Spanish homes and later transmitted to the population at large.

Hipiles also vary in terms of color. Different regions tend to produce different combinations, despite an apparent homogeneity in the design of these garments. It has been argued that the "least contaminated" or most traditional aesthetic prevails in the east of Yucatán, whose *hipiles* are characterized by embroidered flowers in a range of colors, hued in brilliant and contrasting tones (Terán 1988).

Traditional designs can be found in hand-embroidered *hipiles,* incorporating techniques such as *xoc-bil-chuy* or *xoc-chuy* (cross-stitching or counted string), *chuy-ká* (solid stitch), *jul-bi-chuy, x-molnicté,* which is extremely elaborate, *xul-puudz,* and others. These colorful and magnificent styles characterize the luxurious *hipiles* worn by local mestizas at parties or community events.

The manufacture of such *hipiles* is a process requiring between three and six months. Their production costs can rarely be recovered from the tourist trade, and they are generally specifically commissioned from the embroiderer, although some craftswomen may prepare one or two extras for special buyers. The price for such a *hipil* varies according to the breadth of the embroidery and the number of strings. A *xoc-bil-chuy hipil* of "one quarter" breadth (approximately ten centimeters) is worth between 800 and 1,000 pesos (approximately 80 to 100 U.S. dollars). A *terno* using a similar technique will cost between 3,000 and 4,000 pesos (300 to 400 U.S. dollars).

Hipiles made on a sewing machine are more commercial and are consequently favored for everyday usage, though many are also extremely beautiful. The most frequent techniques are solid embroidery or simply *bordado* (embroidery), hemstitching (*but-bil-chuy*), "shadow" embroidery, and a great range of sieves, such as the *gripure* (a type of French lace) or the recently introduced *araña* (spider).

Typically, certain styles will predominate in particular regions. In the south of Yucatán, we find shaded and monochrome *hipiles.* Some, extremely luxu-

2. Mestiza next to a tortilla machine. *Photograph by Lourdes Rejón Patrón.*

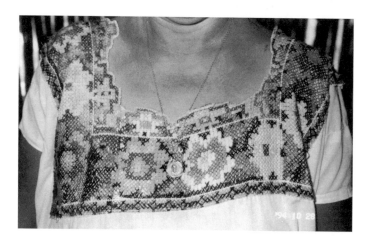

3. Everyday *hipil* with hand-embroidered *xoc-bil-chuy* or cross-stitching technique. *Photograph by Lourdes Rejón Patrón.*

4. Patterns for the edges of a *hipil. Photograph by Martha Medina Un.*

rious, are hand-embroidered using the *xoc-bil-chuy* technique. Machine-embroidered examples can have solid-stitch embroidery, shadow embroidery, or a variety of sieve known as renaissance. In Maxcanú, a municipality located in the west of Yucatán, we find two- or three-color as well as shaded *hipiles.* Here, machine embroidery techniques predominate, particularly renaissance work, sieves, and solid embroidery. Handmade examples are worked in variations on the cross-stitch, such as the *x-puuch-kan* (snake's back), *xok-chuy* (counted string), and *x-mool-pek* (four crosses). Certain techniques, such as *x-manik-beem* (open stitching) and *jul-bi-chuy* (hemstitching) appear to be gradually disappearing; their complexity and lack of market value have diminished their appeal among younger artisans.

In the north of Yucatán, in the so-called ex-sisal (*henequén*) production zone, less elaborate, machine-made *hipiles* predominate. Some of these simpler techniques include shadow stitching, where only the edges of the flower patterns are embroidered. These *hipiles* are sometimes narrow, and their range

of colors is limited. Hand-embroidered *hipiles* using cross-stitching can be found, although they are thinner and less shaded. Mostly we find the strip *hipil* or ornamental *hipil*, a decorative item made with simple and cheap industrial embroidery adhered to the cloth. Everything seems to indicate that the region's poverty is reflected in its womens' attire.

In actuality, the greatest expense in the manufacture of a *hipil* is the "drawing," or its illustrated patterns, executed in pencil or colored pens on white paper, depicting the flower motifs that will grace the finished item. Some years ago, women would copy the patterns for *hipiles* from *dechados,* linen strips beautifully embroidered in a catalog of different styles, stitches, and patterns. These *dechados,* frequently true masterpieces in the art of embroidery, were crafted by successive generations of women who would inherit them from their mothers while adding to the sample.

Today's embroiderers will place their paper drawings onto the cloth in order to trace the pattern. Such patterns are stored with great care in cardboard boxes and plastic bags until their next usage. When an artisan receives a commission, she will display her drawings to the prospective customer or her intermediaries, who choose between them. The colors will also be selected, and the final result will usually be a combination of details from various patterns, according the desired range of flowers and ornaments.

As for the *justán* that complement the *hipil*, these are usually decorated with a strip embroidered along the edge. Such skirts are now frequently being fashioned from a single piece of cloth, because "that's how the *catrinas* like them."

Fashion and the *Hipil:* Forms of Consumption
among Mayan, *Catrina,* and Tourist Women

For the mestizas of Yucatán, social events due to religious celebrations, such as feasts dedicated to the community's patron saint, or their associated profane activities, such as *corridas* (bullfights) or popular dances and cowboy dances, provide occasions that call for beautiful new *hipiles. Hipiles* must be ordered some months in advance, or a mestiza may make her own. On commission, the embroiderer will also usually receive the cloth to be used.

The choice of materials is guided by criteria that include the garment's practicality and comfort. It must provide some respite from the inclemencies of Yucatán's tropical climate, it must be washable, and the embroidery must not run. A rising demand for synthetic wool yarn among the mestizo

population derives largely from the fact that this material meets the above specifications while remaining affordable.

In general terms, the *hipil* makes for an extremely comfortable garment, which has remained fashionable among *catrinas* for almost two centuries. A mestiza clad in a *hipil* can comfortably execute almost any movement with little regard for composure. Thanks to the *hipil*'s breadth, she can sit on the floor and remain covered; she can wash clothes or draw water from the well by tying the *hipil* to the waist using the skirts; or she may breast-feed a baby in any situation with relative ease. The rebozo, which replaced the ancient toque, also has practical as well as decorative uses. It provides protection from the elements; it can be used to wrap and carry heavy objects; or it may serve as a hammock for a traveling baby.

Although the *hipil* is one of the essential signifiers of Mayan identity, it has been subjected to constant transformations, along with a broader cultural context of which it is but a part. In this regard, the *Enciclopedia Yucatanense* has suggested that it is the *terno* that has undergone the greatest changes in the name of fashion (Hernández Fajardo 1971, 831). The *hipil* as worn by younger women became shorter and tighter at some point during the 1970s. This coincided with a movement among the *hipil* traders of Valladolid, who were trying to promote sales for this garment in the rising tourist market.[10] The *catrinas* of Yucatán also adopted this fashion, leading to a reappearance of the *hipil* in urban areas outside the domestic milieu. The mini-*hipil*, also known as the "*hipil* for *catrinas*," proved successful among younger mestizas, who now also wear the mini-*hipil*, characterized by a design narrower than tradition dictates and which often incorporates embroidery in unconventional tones. Nonetheless, older mestizas still wear the wider, broader *hipiles* that fall below the knees. Clearly, the mini-*hipil* has gained acceptance among younger, rural Mayan women, as well as the poorer *catrinas*. National and foreign tourists tend to prefer the more traditional or stylized designs, such as dresses embroidered with Mayan motifs.

It should be noted that for Mayan women who favor the more traditional *hipiles*, "there is no such thing as fashion"; or, in any case, fashion is a question of choice from a specific and well-defined range of patterns, colors, and techniques: the *hipil* itself is always the same, changeless. These were the words of Doña Rosa Canul of Maxcanú when I asked her about *hipil* fashion. For the traditional Mayan woman, the concept of fashion does not apply to the *hipil*: it is a Western concept that has a bearing on Western styles of attire. The variety of colors described above forms part of a search for beauty which

5. Mayan woman with *hipil. Photograph by Lourdes Rejón Patrón.*

respects nature while reflecting features of Mayan female identity associated with territorial spaces and other dimensions of Mayan ethnic identity.

One can speak of fashion in the *hipiles* of the *catrinas,* for whom the *hipil* is but one of many possible attires, a fashionable choice replaceable without transforming the wearer's self-image. In Yucatán, *catrinas* who wear *hipiles* are always seen as *catrinas;* their *catrina* identity remains unaltered. They can freely choose among traditional *hipiles* or the more stylized variations in-

tended for tourists. This variation includes the change of "fashion" according to what the market of symbolic goods indicates.

Tourists prefer handmade *hipiles* in bright colors and natural materials, representing the acquisition of a folkloric item that will provide a talking point and confer distinction on the wearer during social gatherings back in her original culture. The consumption of *hipiles* among tourists takes place in an arena of relaxation and vacationing, imposing a specifically Western nature onto such transactions. This form of consumption unconsciously breaks with the established norms for the acquisition and usage of traditional attire, without this resulting in any form of moral sanction for the wearer. This situation has proved a potent influence for the local *catrinas,* who have now begun to wear this traditional garment in spaces or during social events previously considered inappropriate, such as churches, supermarkets, shopping malls, workplaces. Thus the evolution and growth of tourism has contributed to a transformation in the consumption of *hipiles* among the *catrinas* of Yucatán.

Notes

Julián Brody translated this text from Spanish.

1 In Mexico, the Mayan people can be found in the states of Yucatán, Campeche, Quintana Roo, and Chiapas. On the Yucatán Peninsula alone, the Mayan population is estimated at around 500,000. A further 80,000 live in the state of Quintana Roo, including the 32,000 descendants of the Caste War of 1847, who now survive in the municipality of Felipe Carrillo Puerto. Another 70,000 individuals live in the state of Chiapas.

2 In Mayan mythology, the goddess Xchel, wife of Itzmaná was also the goddess of the moon, of death by suicide, of pregnancy, and of human and earthly fertility.

3 The technique of *xoc-bil-chuy* is representative of traditional embroidery in Yucatán. The native inhabitants of the Yucatán Peninsula still associate this form of embroidery with the skin patterns of the rattlesnake, which Mayan culture considered a sacred creature.

4 In a study on women lace-makers in Narsapur, India, Maria Mies shows that this work, and the time invested in it, is "invisible" to exporters, as well as to the women's husbands, because they define it as "no work," done by women in their spare time.

5 In 1990, the INI's (Instituto Nacional Indigenista) coordinating center, based

in Valladolid, carried out a census of crafts production in the area. It found twenty-nine populations involved in the production of *hipiles* and hammocks.

6　Although many of these state programs—such as the UAIM (Unidad Agricola Industrial de la Mujer, or Women's Agricultural Industrial Union)—do encourage the formation of production groups and societies, their existence is too frequently ephemeral. Other cooperatives, such as those in western Yucatán, have achieved greater levels of socioeconomic consolidation and self-leadership.

7　I am thankful to anthropologist Juan Ramón Bastarrachea, specialist in Mayan linguistics, for this observation.

8　The Indian uprising known as the Caste War broke out in Yucatán in 1847 and lasted for over half a century. The rebel Mayans took refuge in the state of Quintana Roo, setting up their own social and military organizations, guided by the messianic cult of the Talking Cross. These rebel Mayans have since viewed themselves as somehow different from other Mayans in a situation that generates profound divisions in terms of culture and identity for Mayans throughout the Yucatán Peninsula.

9　The term *j-waach* denotes Mexicans not born in Yucatán; *gringo* refers to white foreigners and tourists, who are also known as *ch'el*. The term *t'suul* denotes a stranger, but with an undertone of greater social hierarchy.

10　The initiation of a major tourist development project in Cancún in 1970 generated a growing market for handcrafted items from the east of Yucatán. A number of women traders from the municipality of Valladolid radically transformed the design of the *hipil* in order to adapt it to tourist tastes.

Reference List

Barrera Vásquez, Alfredo, ed. *Diccionario Maya Cordemex: Maya-Español, Español-Maya*. Mérida: Cordemex, 1980.

De la Garza, Mercedes, et al., eds. *Relaciones histórico-geográficas de la gobernación de Yucatán: Mérida, Valladolid y Tabasco*. 2 vols. Mexico City: Universidad Nacional Autónoma de México, 1983.

Freidel, David A., Linda Schele, and Joy Parker. *El cosmos maya: Tres mil años por la senda de los chamanes*. Mexico City: Fondo de Cultura Económica, 1999.

Hernández Fajardo, José. "Historia de las artes menores." In *Enciclopedia Yucatanense* 4:823–99. Mérida: Ediciones Oficiales de Gobierno del Estado de Yucatán, 1977.

Hervik, Peter. *Mayan People within and beyond Boundaries: Social Categories and Lived Identity in Yucatán*. Amsterdam: Harwood, 1999.

Instituto Nacional de Geografía e Informática (INEGI). *Censo general de población y vivienda 1990*. Mexico City.

Landa, Fray Diego de. *Relación de las cosas de Yucatán*. Mexico City: Porrúa, 1973.

Mies, María. "La dinámica de la división sexual de trabajo y la acumulación de capital: Las trabajadoras del encaje de Narsapur, India." In *Estrategias femeninas ante la pobreza,* ed. Florencia Peña, 31–53. Mexico City: Instituto Nacional de Antropología e Historia, 1998.

Millet Cámara, Luis, and Ella Fanny Quintal. "Traje regional e identidad." *I' INAJ Revista de divulgación del patrimonio cultural,* no. 8 (1994): 8–25.

Nadal, María José. "El bordado maya comercial: Economía solidaria y espacio público para las mujeres." Paper presented at La Feria del Bordado Maya Comercial 2001, UNIFEM/Asociación Tum Ben Kin, Mérida, September 2001.

Pacheco Cruz, Santiago. *Usos, costumbres y supersticiones de los mayas.* Mérida: Sociedad de Geografía y Estadística de Méjico y de la Geografía e Historia de Guatemala, 1960.

Spencer, Herbert. *El antiguo Yucatán*. Mérida: José Díaz Bolio, 1980.

Terán, Silvia. "Milpa, religión e indumentaria tradicional en Yucatán." *Revista de la Universidad Autónoma de Yucatán* 167 (1988): 57–62.

Waldeck, Federico de. *Viaje pintoresco y arqueológico a la provincia de Yucatán.* Mérida: Carlos Ruz Menéndez, 1930.

Contributors

ELI BARTRA is a professor at the Universidad Autónoma Metropolitana–Xochimilco, Mexico City. She is cofounder and director of the Research Program on Women and the graduate program in women's studies at UAM–X. The author of *Mujer: Ideología y arte* (1987) and *En busca de las diablas: Sobre arte popular y género* (1994), and co-author of *Feminismo en México: Ayer y hoy* (2000), she has also edited a book, *Debates en torno a una metodología feminista* (1998), as well as several issues on women and gender studies for the journal *Política y cultura*.

RONALD J. DUNCAN is a professor of anthropology and museum management at Oklahoma Baptist University and a curator with the Mabee-Gerrer Museum of Art, St. Gregory's University. He lived and worked in Colombia for ten years and has done research there for more than twenty-five years. He has been the dean of academic affairs for the InterAmerican University of Puerto Rico, and he has published eight books on social change and the arts and crafts in Latin America. His most recent work, *Crafts, Capitalism, and Women: The Potters of La Chamba, Colombia* (2000), has been nominated for the 2001 Wheeler-Voegelin Prize in ethnohistory and for the 2001 Association for the Latin American Art Book award.

DOLORES JULIANO is a professor of anthropology at the Universidad de Barcelona. She has worked for many years on themes of gender and is particularly interested in the analysis of social change. Her books include *Cultura popular* (1986); *El juego de las astucias: Mujer y construcción de mensajes sociales alternativos* (1992); *Educación inter-cultural: Escuela y minorías étnicas* (1993); *Chiapas: Una rebelion sin dogmas* (1995); *La causa saharaui y las mujeres* (1998); and *Las que saben . . . subculturas de mujeres* (1998).

BETTY LADUKE is a professor emeritus of art at Southern Oregon University. The author of five books and an artist who has mounted over two hundred national and international exhibits of her own paintings and prints, she has also traveled widely, researching, collecting, and organizing the work of other women artists for circulating exhibits. These exhibitions, *Compañeras: Women, Art, and Social Change in Latin America* (1985) and *Africa through the Eyes of Women Artists* (1992), are composed of photographs and collected art related to book publications with the same titles. Her

own art has been documented in *Multi-cultural Celebrations: The Paintings of Betty LaDuke 1972–1992* by Gloria Orenstein (1993) and in the videotapes, *An Artist's Journey from the Bronx to Timbuktu* and *Africa between Myth and Reality*.

SALLY PRICE is Dittman Professor of Anthropology and American studies at the College of William and Mary. She spends four months each year in the United States and the rest of her time in Martinique, where she pursues and writes her Caribbeanist research. She is the author of *Co-wives and Calabashes* (1984), winner of the Hamilton Prize in Women's Studies, and *Primitive Art in Civilized Places* (1989), which has now been published in six languages. Books she has written jointly with her husband, Richard Price, include *Two Evenings in Saramaka* (1991), *Equatoria* (1992), *On the Mall* (1994), *Enigma Variations* (1995), and *Maroon Arts* (1999).

LOURDES REJÓN PATRÓN is senior researcher at the Instituto Nacional de Antropología e Historia in Yucatán, Mexico. She has published a book on the Tabi hacienda of Yucatán, as well as articles on folk art and gender studies relating to Mayan women. She is currently engaged in a research project on the ethnography of the Mayan on the Yucatán Peninsula.

MARÍA J. RODRÍGUEZ-SHADOW is senior researcher in the department of ethnology and social anthropology, Instituto Nacional de Antropología e Historia, Mexico. She has authored four books, including *La mujer azteca* (1988) and *El estado azteca* (1990), as well as numerous articles dealing with politics, popular religion, and interethnic and gender relations in ancient and contemporary Mexico and northern New Mexico.

MARI LYN SALVADOR is chief curator at the Maxwell Museum of Anthropology, University of New Mexico, and a professor in the department of anthropology at the University of New Mexico. Her publications include *Yer Dailege! Kuna Women's Art* (1978); *Festas Açoreanas: Portuguese Religious Celebrations in the Azores and California* (1981); and, as editor, *Cuando Hablan los Santos: Contemporary Santero Traditions from Northern New Mexico* (1995) and *The Art of Being Kuna: Layers of Meaning among the Kuna of Panama* (1997).

NORMA VALLE is an associate professor at the University of Puerto Rico's School of Public Communications, Río Piedras campus. A Puerto Rican journalist and author, she hosts a show at Radio Universidad de Puerto Rico, WRTU-FM. She was a visiting professor at York College, CUNY, in 1998–99. She has published four books and numerous articles in academic journals and has received a grant from the Freedom Forum (United States) and the Joel MacGruder Scholarship (Overseas Press Club of Puerto Rico).

DOROTHEA SCOTT WHITTEN is a research associate at the Center for Latin American and Caribbean Studies, University of Illinois at Urbana-Champaign. A sociologist, she is cofounder of the Sacha Runa Research Foundation, a not-for-profit organization, and coauthor of *From Myth to Creation: Art from Amazonian Ecuador* (1988), and coeditor of *Imagery and Creativity: Ethnoaesthetics and Art Worlds in the Americas* (1993), both with Norman E. Whitten Jr.

Index

Borja Cevallos, Rodrigo, 80, 89
Bossen, Laurel, 151
Bourdieu, Pierre, 149, 150
Brody, J. J., 105, 108
Brown, Lady Richmond, 51

Cahil, Rick, 109
Cajigas, Virginia, 39
Cajigas, Zoilo, 38, 39
Calabash carving, 29–31
Caminata of 1992, 80–82, 86, 89. *See also* March for Land and Life
Cancino, Claudia, 107, 118
Candelaria, Virgen de la, 41
Canelos Quichua, 77; and aesthetics, 93; and art, 92; and beauty, 92; cosmology, 75, 92; and creativity, 84; and education, 84; and life cycle, 84; men's art of, 75; and symbolism, 75, 83, 84; women making aswa and ceramics, 82
Carving(s), 19, 22, 29, 30, 31, 33, 35, 37–44, 75, 79, 159; and gender differences, 43; techniques, 39; tools, 20, 21, 30, 31, 39
Casa de Artesanías, 205–7, 213
Casas Grandes, 101, 102, 104, 105, 108, 109; tradition, 107, 117
Caste War, 226
Catholic(s), 43, 171; church, 37, 72, 166 n.4, 180, 198; dogma, 159; organizations, 157; radio, 86
Catrina, 227, 232, 233
Centro de Acopio, 110, 113, 114. *See also* Pottery
Ceramics, 136–38; and apprenticeship, 84, 88, 89; as art, 83, 85, 87, 92, 132; and cultural values, 83; decoration, 87; and designs, 106, 117; and fertility, 129; figures, 136, 144, 145; and images, 88, 91; and investment, 99; and life cycle, 134, 135; modeling, 148; motifs, 87; ornamental, 104; and quality, 118, 119; selling, 84, 85; and symbolism, 87, 135. *See also* Clay; Pottery

Cereceda, Verónica, 9
Chango, Alfonso, 77, 78
Chango, José Abraham, 81, 89
Chayat, Sherry, 108
Chiapas, 132, 151, 155, 234 n.1
Chicha house, 48
Chihuahua, 101, 102
Chile, 9, 10, 158, 160
Christian: art, 142, 143; iconography, 187
Christianization, 78
Ciudad Juárez, 101, 102
Clay, 73; embroidering the, 201; extraction, 102, 103; figures from Atzompa, 197; and humoral elements, 133, 134. *See also* Ceramics; Pottery
Clifford, James, 3
Colombia, 11, 78, 127, 129, 132, 137–40, 142, 143, 145, 146, 150–52
Colón, 55, 67
Communications: and Canelo's mobility, 80
Comuna San Jacinto del Pindo, 78, 79, 85, 87–89
CONFENIAE (Confederación de Nacionalidades Indígenas de la Amazonía Ecuatoriana), 80, 81
Consumer goods, 70, 103, 199
Cook, Scott, 151
Cooperativism, 70
Cordero, Helen, 216
Corona, Sara, 115, 116
Covarrubias, Miguel, 104, 105, 170, 171
Craft, 126, 137–39; and aesthetic quality, 137; circulation, 164; ethnic, 107; and industry, 139; selling, 33, 155, 160, 207, 212; traditions, 126. *See also* Folk art; Handicrafts
Creel, Enrique, 102
Cross-cultural, 11, 130
Curenguequel, 158

Dagua, Estela, 73, 74, 80, 85–87, 92
Deere, Carmen, 150
Denis, Balbina, 61, 71
Díaz, Porfirio, 102
Díaz Polanco, Héctor, 156

Library of Congress Cataloging-in-Publication Data

Crafting gender : women and folk art in Latin America and
the Caribbean / edited by Eli Bartra.

p. cm.

Includes bibliographical references and index.

ISBN 0–8223–3182–9 (cloth : alk. paper)

ISBN 0–8223–3170–5 (pbk. : alk. paper)

1. Folk art—Latin America. 2. Folk art—Caribbean Area.

3. Women atists—Latin America. 4. Women artists—

Caribbean Area. I. Title: Crafting gender II. Bartra, Eli

NK802. C7 2003

745/.082 21